PARIS
MÉTRO
PHOTO

Foreword by
ANNE-MARIE GARAT

Texts by
JULIEN FAURE-CONORTON

PARIS MÉTRO PHOTO

From 1900 to the present

ACTES SUD

While the Paris of the Belle Époque, which saw the coming of the Métro, may well have been the city of high spirits famous in legend—joyful illuminated boulevards, vulgar cabarets, economic expansion and colonial wealth, invention of the airplane, the gramophone and the motion picture—it was also, we have forgotten, the daily nightmare of a city paralyzed by traffic congestion. The public transportation existent at the time failed to provide for the daily migration of a population that had doubled in thirty years. Private cars overwhelmed the city with stench and pollution, and since no real code of conduct or ordered system of traffic signals had yet been established, the roads developed insoluble jams involving automobiles, buses, horse-drawn trams, carts, trucks and bicycles; the city resounded with the racket of backfiring engines and anarchic clacking traffic signals on the streets, which were for the most part still made of wood and very noisy. While all these evils were not new, they had gotten worse. Now, though, at this turn of the century, the colossal event of the Paris Exposition was about to take place. It attracted leading figures and brought visitors from all over the world, and would make Paris the beacon of modernity: building a subway was a matter of urgency.

They had thought of it before, but ever since the 1870s the intentions of City and Nation had diverged: all projects—including some futuristic ones that Jules Verne would not have disdained—ended up being shelved. The examples of New York, London and especially Budapest, cities that were pioneers in underground railroads with electric traction, relaunched the ambition to endow the French capital at last with a public transit system worthy of its renown. The well-named and extremely diligent engineer Bienvenüe ("Welcome") realized the feat of constructing Line 1 in seventeen months; it was opened to the public in 1900. In the years that followed, five other lines were opened one after the other, completing the network, whose success was immediate. And so from 1898 to 1910, Paris experienced an upheaval the extent of which today's Parisians, annoyed by the slightest sign of roadwork, can't begin to imagine. It was this chaotic Paris with its rutted banks of the Seine, bristling with cranes and scaffolding, with its streets and avenues excavated and exposing their innards to the light of day, that the first photos in this book illustrate, inaugurating the long history of love and fascination between Métro and photo.

For, coincidentally, in that last decade of the nineteenth century, the camera, which had long been a luxury item and the privilege of the elite, quickly became affordable for everyone. It was now lighter and easier to use, and its speed of exposure made snapshots possible. Its uses grew myriad—advertising, sports, photojournalism and domestic use that filled up family albums. Artists were not to be outdone in that era of pictorialism; the public infatuation with postcards, which was then in full swing, popularized typical views obeying a sense of the picturesque that soon became fixed into a cliché—any curiosity, any novelty, the slightest event, had its photographers, skillful or makeshift; this

Photo~Métro

ANNE-MARIE GARAT

was all the truer for this phenomenon that was busy digging chasms and trenches into Paris. By a sort of grace, though, the Métro transgressed conventional imagery, as if this new subject went beyond stereotype and offered a new place for formal propositions, reverie and fantasy. True, the first photos in this collection fall into the well-established tradition of architectural photography—like the records of Haussmann's clearing of whole neighborhoods, or the construction of the Opéra—but here, following the example of the Eiffel Tower or the Samaritaine department store, the focus was on the materials of industrial modernity—cast iron, iron and steel applied to architecture, defying academicism by revealing the structural elements, the facings and rivets. These representations, today part of the cultural heritage, were at the time objects of curiosity and polemics, even scandal.

Ten years earlier, the Eiffel Tower had prepared the way in popular imagination, but the Métro was not a single building that could be seen from afar in its solitary erectness: the Métro's horizontality extended into a labyrinth, boring through the underground with tunnels next to sewers and conduits, a dark underbelly of the city associated with miasma and cesspool vermin, carved up into dubious chambers, abandoned quarries, even ancient burial sites. This was a secret underside to which the Métro added its tunnels like a giant mole undermining surface bedrock, emerging suddenly from its night to straddle the Seine with viaducts, disembowel train stations, overhang boulevards before burrowing its tracks underground again to follow an invisible network that wove beneath the city a twin map of streets and arteries following its own logic of circulation, and gave rise to a whole imagined world—like the tentacles of some vast empire, or like a descent into the underworld. This was a fear that still had to be overcome by frequent use, at the risk of accidents. And accidents there certainly were—such as, in the early days, a tragic fire in the Couronnes station. Without a doubt, the Métro was a source of apprehension, as well as pride in the audacity of such an innovative project, inspiring its photographers—Parisians and foreign visitors, amateurs as well as illustrious artists. Their visual inventiveness is apparent even today; photographs continually captured instants of time, ordinary or unusual scenes of life under the city and above ground, technological innovations, aesthetic and social transformations, the violence of collective history that marked it and the human variety of passengers transported by the millions throughout the century, making the Métro a definitive symbol of the Parisian landscape. Organized in chronological sections, the book divides the century into twenty-year periods, revealing the extraordinarily photogenic quality of an unusual space that, beneath its prosaic appearance, holds a number of optical surprises. Photography confronts this, questioning the familiar strangeness of this space that is by definition transient, where the brief time of travel is spent in company with the long time of history, a world of depths and surfaces, dark and light—the very language of photography—peopled with many presences and solitary ghosts, the quintessential place of chance, flux, collisions and shiftings of anonymous crowds, circulation of fevers, electric desires in overcrowding, the popular intermixing of work and pleasure, the softness and harshness of materials, bodies, gazes, a vector of unknown fates channeled, lost and found according to chance meetings; a huge poetic metaphor as well as an exemplary archive of a cross-section of urban history.

The first photos in the book were commissioned by the City of Paris (through its Service technique du Métropolitain) for the lines operated by the CMP ("Compagnie du chemin de fer métropolitain de Paris," the Metropolitan Railroad Company of Paris). Most of these photos are preserved at the Bibliothèque historique de Paris and at the RATP ("Régie autonome des transports parisiens," the Paris transport authority) photographic library. These views constitute a remarkable photographic documentary resource that follows the process of the construction work, illustrates the various methods and resources used on the site, the technological advances and the difficulties encountered: the fragility of the underground terrain formed of clay, limestone or sand; sudden leaks from outside; and, of course, the terrible flood of 1910 that submerged tunnels and Métro entrances along with the rest of the city. Some photographs, more utilitarian, had the purpose of answering the complaints of residents denouncing the precarious sidewalks made of planks just below apartment buildings, the disruption of business, the danger of sinkholes and open trenches, the shaking caused by the heavy machinery, the cracks and all sorts of damage. These photographs, taken together, testify to the colossal laboratory that a city so recently aligned by Haussmann's urban planning was everywhere turning into, pulled apart and disfigured by the yawning chasms of the excavation, the drilling, the scaffolding and worksite huts, the rubble, the mud. Wavering between the repulsive and fascinating beauty of an earthquake or a ruin and the exaltation of the great work of the builders, between fear and admiration for the marvelous, the photographers record the huge scope of the spectacle.

Below, there is the darkness of the tunnel, in which a gap in the ceiling outlines the overexposed sky, the shafts of daylight falling perpendicularly stylizing the backlit silhouettes of tunnelers among the concrete struts, or the lamps shedding harsh light on the clutter of tools and castings. On the surface, the frame widens to encompass the whole of the landscape, contrasting the massive with the linear, true to a construction dramatized by contrasts, the whole coarse apparatus of a worksite and its aesthetic nobility that plays off light, mass, the bristling hoists and cranes, an unattractive appearance softened now by the sleek water of a canal or river, now by the steam of the boilers, plumes of smoke, fog — a glossy daylight distributing its glaze over the crests of beams.

In these images, a wisdom of near and far is exercised that, without losing its documentary goal, is tempted by the physical beauty of the rough outlines — their geometry, their promise of strength and balance — a design taking shape among the old framework of apartment buildings, monuments and bridges banished to the shadowy background, by that look of a permanent winter of quavering greys, skies dulled by long exposure. On the other hand, the foreground exalts the virtuosity of the lattice patterns of a viaduct's ironwork, the riveted armature of its curves, the angle of a base plate, the oiled arc of the tracks, the cast-iron colonnades, and the skeletal framework of metal caissons, the formwork, the layers of waterproofing, the enormous frames being sunk in place… The play of depth of field and perspectives integrates the physicality of the Métro, the coarse crushed-in quality of its tunnels as well as the aerial festoons of its footbridges, its flights, its vitality, symbols of its structural dynamics: even without the cameraman being aware of it, the documentary photograph expresses the emotion of forms, the intuition of an aesthetic transcendence.

Even when it comes to the trains and tracks themselves, aside from their documentary interest, the images achieve a formal beauty. Primitive trains with three and then eight wooden cars with their dubious comfort and noisy bogies are followed by sleek carriages with sliding—and, later on, automatic—doors, and their more comfortable seats; out-dated engines give way to new machines equipped with air brakes; the material the carriages are made of—at first red and green glazed sheet metal, or yellow, depending on 1st or 2nd class (carriages with these colors soon disappeared)—is replaced by a chassis that's gradually made uniform into the multipurpose blue and white of aluminum facing, sometimes covered in graffiti—a sign of the times that affected the Métro before it was prepared for it; this inventory of technology writes all by itself the history of public transportation, its constraints, its industrial resources, its solutions adapted to the ever-increasing numbers of people using the system, while at the same time the adventurous focus of mental travel and imaginary voyages were taking shape, all the fictions its appearances inspired.

Ever since the RATP took over management of the Métro in 1949, the corridors, station stops, tunnels and train yards forbidden to the public—the whole hidden life of the Métro—has undergone constant adjustments to improve the passenger's safety and transit, not without encountering a number of difficulties. Lighting, first of all, the inherent problem of the underground: how to shed light on these places so quickly yielding to the nearby darkness of tunnels, which open up their gaping blackness at each station stop? A challenge to illumine this labyrinth deprived of natural light, to reassure and guide travelers by guaranteeing them optimal visibility.
Visibility, the very definition of the photographable, a basic requirement for its invention, is dependent on daylight, on the quantity and intensity of light capable of activating the apparatus, leaving a trace of its imprint. It took photography a long time before it went down into the caves and mines and slums and catacombs to confront the opacity of the natural and social night, before magnesium powder permitted the existence of flash photography at the end of the 1880s and the increased speed of exposure and sensitivity of emulsions allowed nighttime views. Underground photographs are consequently rare before the 1930s, and even then they show the grey tones peculiar to a lack of light, the fault of mediocre electric lightbulbs hung at intervals from the station ceilings, forcing the photographer to negotiate between film speed and time of exposure. One of these photographs illustrates the crucial dilemma: the roof pierced with weak halos of light—insufficient for photographs—fleeing into a dark background, and in the foreground the backs of travelers spattered by the flash, at the very brink of overexposure.
Another lighting solution that we don't often remember is the welcome invention of the white square tile, whose beveled edges multiply reflective surfaces and diffract and amplify electric light, a standard feature installed at the very beginning of the Métro. Unsurpassed despite attempts using various mosaics, it still covers hallways and ceilings, with variations of colored friezes and frames for advertising billboards. Without the traveler being aware of it, this beveled white square contributes to the specific luminous ambiance that welcomes us along corridors and in each station, a subtle shimmering and a gentle glow that attenuates thankless public space and optimizes its lighting. Aside

from overhead passageways, it's still this subdued light of the trains that casts its reflections on the bars and windows, heavily shadowing faces that turn into strange pensive masks, before fluorescent lighting and then modern LEDs came to pose other problems (of saturation and iridescence), from which photography draws fantastic effects: a magical wake of colors whose prism conveys the movement of the tracks, of bodies propelled, the energy of speed that makes reality abstract by the ghostly stretching of a thread: the Métro poses to photography the constant challenge of its setting, of the optical treatment of its artificial light.

Every photograph keeps the indelible imprint of the present moment as it is being shot; at the same time, it declares the present is past, already past at the very present of the shutter's click—and one considerable quality of these photographs is that each one provokes an atmospheric recovery of the long-ago and the never-more, impregnates with a mental nostalgic sepia the *given moment* forever fled. At a certain point, this was the state of the urban landscape, stamped with the seal of its time by its façades and storefronts, its pavement, its vehicles, its signage, its streetlights, the lighting of the sidewalks and cafés, of the Métro stations under the mean incandescent lightbulbs and, later on, its frosted globes. Such was the "banjo"-style signal or the oil lantern hanging over the overhead railroad tracks. Such were the ways of being and doing of the riveter, the mechanic, the ticket-puncher at the gate with his punch, the passerby at night, the tired woman or the smart girl, their look as well as the taste, the style and fashion of the clothes, the distinctive accessories of a milieu whose prominent features the photographic instant reveals at the "specific moment" it is taken.

Even when the Métro is not really the subject of the photograph, it appears as the setting for commonplace street scenes, like a circumstantial theater of history. Hence this photograph of a crowd pressed together entering a Métro station in 1919. At a time when no one went out bareheaded, the swooping effect makes the human flood look like a multitudinous human carpet of hat-wearing heads—men's hats, fedoras, boaters, civilian caps and berets, soldiers' kepis and helmets, women's hats, among them a few mourning veils many women wore at the time—an instant in time taken just after the butchery of the Great War. Then, too, we see the man with no legs, perhaps mutilated by that same war, offering a May lily-of-the-valley to the beautiful indifferent woman being swallowed up in the stairway; the profile of the street urchin with a Front Populaire cap smoking his cigarette under a blurred passageway of the overhead Métro; or the crowds rushing to the bomb shelters in the Métro during the warning sirens of the Occupation; sandbags piled against the Belleville station behind which French Resistance fighters are crouched; the strikes and the riot police charges of 1968…

By taking note of the objective realities that are contemporary to it, photography gives voice to states of mind, mentalities, dreams, private climates, convulsions and collective dramas of an era, whose original power no reconstruction, in photography or cinema, can equal or truly naturalize its *local color*. As informed as it may be, as serious its methods, imitation remains inauthentic compared to the old image, whose incomparable documentary value stems paradoxically from its melancholy condensation of an instant of the past.

No doubt the great photographers—Capa, Brassaï, René-Jacques, as well as Kertész, Cartier-Bresson, Doisneau, Tabard, along with Lartigue, Erwitt, Freund, Caron, Atwood, Depardon, Plossu, Koudelka—and so many other lesser-known photographers who appear in this collection adjusted their art to what was in the process of taking shape in front of their eyes because there they were "in the thick of it"—in their photography and in the living reality about to come to fruition. The photographs by anonymous photographers, however, testify to being in the right place at the right time, just barely, as well as to experimental urgency, as if the subject, the background or, rather, the course events were taking left them no choice; it's as if the subject were waiting for them in ambush on the station platform, at the corner of a corridor, from the top of a walkway or staircase, and had won them over. In a way, the photograph takes the photographers as much as they take it; they're surprised *in flagrante delicto*, exposing their own secret—taking a photograph is, first of all, the act of photographing oneself, signing one's presence by the gaze one directs at things.

This is what confers on this collection of images, from such varied times and production, its profound unity, as if all photographers confided the password to one another through the years, obeying the same trigger-impulse, its speed and instinct: however long the pose took, the deliberate arrangement of the frame, the tension of the hunter of images waiting patiently for the accidental, the reflexive shot, or the excitement of one who moves curiously forward, stealthily, to take the occasion by surprise from the rear, regardless of the mastery or improvisation, there is that single instant of shutter-release snatching an extraordinary quality of the surreal from the banality of the day, even in the most ordinary, most widely shared snapshots. Pierced with the halos from lampposts, the gleam of rain highlighting the tracks—that outline of Métro track that still fascinates photographers a hundred years later—and reflections of the pavement, roadways mantled in snow: this classic repertory is enhanced by a timeless poetry forever associated with the sign of the Métro and all that comes with it, its street lamps, its entrance signs lit up in the night.

It was an excellent idea to entrust the design of all 141 Métro station entrances throughout Paris to Hector Guimard. It was a rare opportunity for this Art Nouveau artist to make his work accessible to the public: by transferring to the urban setting a decorative art that until then had remained the privilege of a few wealthy patrons, he placed it in a way on the sidewalk, democratized it into an art for the people, raised it suddenly to the level of shared property, a collective reference that can be identified in every neighborhood, that gives it its local singularity while keeping its general quality. It took a belated leap of awareness in the 1960s to understand this good fortune, the extraordinary added value of this artwork of the street, and save from their planned demolition the 86 or so entrances that, even today, make Métro access a matter of national heritage.

A large number of photos take the Guimard entrance, opening right onto the sidewalk, as subject, with its instantly recognizable accompaniments: on three sides the dark-green, cast-iron railings bending with their ornamental curves, with their signage and sinewy, flower-like moldings, integrating the initial M into vegetal fluidity. The arch bearing the Métro sign is framed by two lampposts like lily-of-the-valley stems, topped with a floral hood housing orange lightbulbs made of molded glass. For it was the characteristic of

this aesthetic to borrow its vitality from nature, to inflict on metal the freedom of nature's lines, its sensuous twisting, its tendrils; likewise, the elegant public shelters, most of them gone today (with a few exceptions), joined a brick and cast-iron structure with glass awnings, their ribbing inspired by Japanese art, so well nicknamed "dragonflies." In this way, the Guimard team introduced into the architectural rigor of the urban space a provocative sensuality and seduction, a joyful feeling of disorientation that, spreading to its living organism, humanize functionality and eroticize imagination: there's no doubt that every traveler, in his haste to get from one place to another, subliminally notices these signs of loving welcome, perceives the stimulating invitation to enjoy the transport with his senses at the same time as his utilitarian journey. Later stairways are more subdued, with classic stone guardrails or, in the 1930s, concrete structures, but it's the works by Guimard that win out over the long run, augmented later on by Art Deco streetlights with their opaline globes by Dervaux, totems and modern masts with the M circled in yellow and the red frame indicating MÉTRO, a system of signs—a language, rather— spelled out by photographers who are more than usually sensitive to this visual hook: against a rediscovered fraction of sky stand out the tops of buildings, the stylized profile of a tree or a lamppost, a streetlight or the arch of the Métro, which have become the graphic motif par excellence.

Entrance to the Métro is one of the most significant subjects. These *gateways to the night* grafted onto the uniformity of the streets, the gaping shadow opening onto the sidewalk or the metal arches of the overhead stations, are so many boundaries between outside and inside, above and below, with all the anxiety produced by this link between two worlds, the swift threshold of the stairway down which one "is engulfed," but also a zone of exchange that attracts to its vicinity small trade, newspaper kiosks, hawkers, crowds of *flâneurs*, people pausing to consult the map, waiting for a lover, time for one last embrace, the last or first kiss. Above all, though, the flights of stairs emphasize the obsessive theme. Steps being climbed up or down by passengers, compelling that bending of the knee that destabilizes posture, weighing the silhouette down or making it look lighter, offering the welcome sight of the curve of a woman's calf and the suggestive seam of a stocking, the strange flight of a nun's coif like a straying seagull: this extraordinary place of descent or ascent offers a location apt for all sorts of optical variations, depending on the veil of rain or the sword of sunlight slicing through shadow and multiplying fantastic intersections. The plunging point of view closes down the horizon, crushes the plane of the pavement, shortens silhouettes, alternates low-angle shots with their opposite, repeated a thousand times, shifting perspectives, exasperating the lyricism of lines of flight and breaking up the rhythm of gridwork like footlights, magnified in backlighting by the black and white, the black of charcoal, grainy, coal-black, silkiness of lacquer, qualities of black that seem the native color of the Métro. Although colorizing and then later color photography interpret our modern chromatic scale, black and white continues to compose and stylize its figures—up to the point of that photo where the steps of an escalator articulate their grooves in a fuselage at the limits of abstraction. Only the darkness of the background manages to evoke the atmosphere of the Métro with its haloed globes…

This collection is also a book of bodies, faces as they are metamorphosed by the underground world: a catalogue of expressions, gestures and behaviors that turn the traveler into a photographic curiosity, captured as he is changed into himself by the *Métro*. A descent into the depths induces a troubled relationship with space, a loss of surface landmarks that also disturbs your sense of time passing. It is a fragmented tension, perpetuated by the play of signs marking destinations and transfer points on every level; these sensations are increased by the hazards of a temporary, fluctuating community, forced into crowdedness depending on rush hour or slack times, the closeness of too-close foreign bodies suddenly dispelled in the scattering at station stops… This environment offers a spatial disposition ready-made for snapshots like so many time-lapse sequences, pieces of reality transposed into fiction, fiction contaminating reality, slices of life that photography borrows from literature, and vice-versa — the works of Sophie Calle — as well as from cinema — some images in this collection are photos of movies being shot — as if a scenario were prowling through the *Métro* of which any traveler could be the author or main character in the anonymity of the crowd, given over to furtive encounters, ephemeral contacts, the enigmatic hero of a story in progress, the actor with all the risks and dangers of an erratic narration in search of its climax, embodying the novelistic equivocations of suspense, of shadowing someone — as a detective or lover does — of the hunt and the pursuit, a fugitive wandering through the labyrinth of corridors, spotted on the flights of stairs, suddenly beached on a station platform, trapped behind the windows of the moving train.

One constant is that absorbed look people in the *Métro* adopt, absent both to strangers encountered by chance and to themselves. They take on that false air of oblivion protecting the self, immersed in reading — so frequent during travel — or in the vaguely sorrowful withdrawal produced by the downward gaze, or else, taken by surprise, the gaze's sudden, piercing intensity aimed at the photographer; comical facial expressions, laughter. Finally, there are the lovers in the *Métro*, always as if they are alone in the world, with stolen or freely given kisses. They offer themselves as a spectacle like a declaration of intimacy in the public sphere, for their amorous transports are also collective transports.

Throughout the century, these images form a chain linked to the continuity shots of the cinema: with its jump cuts, its ruptures of frame, it offers a magnificent inventory of characters that every *Métro* traveler becomes. Including the seedy or pathetic figures haunting its corridors and platforms, sometimes not even there for transportation — poor wrecks, homeless people, accordion buskers, beggars for charity, or simply someone hanging out on a station platform, anonymous solitary figures who find in the stations a refuge from their distress, from the aggressions of the street, bad weather. They seek the illusion of human warmth shared in the indifference of the mass, and often the haven of sleep and oblivion on the precarious refuge of benches, rare today. Around them, the crowd ebbs and flows, each person intent on his journey while they, motionless, seem sentinels outside of time; for them, too, the *Métro* is a national heritage, a place of belonging, last of the secular asylums.

Finally, the *Métro* is the living museum of all the forms of art and culture throughout the century. The decorative arts with their accompaniments and furnishings, but also

the poster art that came to the fore at the end of the nineteenth century, inaugurating a street art to which painters, sketch artists and typographers gave legitimacy — especially the poster artists Cassandre and Cappiello — artists whose works covered the Morris columns and walls like a giant picture rail of printed images, making the city into the surface for a polysemous text drawn from the catalogue of all the typographical inventions and fonts of the century, like immense *calligrammes* among the forest of commercial signs, theaters, cafés, taxis and betting parlors. This visual cacophony enchanted artists, Surrealists alert to the rupture of the ordinary everyday world by the poetic subversion of signs, Cubists de-structuring space, adept at collage. Their spirit is widespread in the Métro, a true artistic field that photographers don't fail to use, isolating fragments, words, slogans whose enigmatic ellipsis serves as a caption to their pictures.

The Métro is also a favorite spot for fashion photography, which displaces the model's elegance, distinction and sophistication into the context of the subway, pretending to dynamite the border between luxury and the prosaic, a pretense of egalitarianism, which has by now become an aesthetic cliché. Finally, many photos of the Métro cite in joyful visual tyranny music-hall stars, titles of shows, films of the time, ads for forgotten brands — Bec Auer, Ovomaltine, Quinquina — which were briefly popular, and then the contemporary iconography that projects its illusory promises of merchandized happiness, the ideal youth of laughing couples, suggestive female bodies and faces of stars imported into the gloomy space of the stations. These erotic fetishes offered up for consumption electrify the ordinariness of the day, at the same time providing a record of sociological and cultural history.

These posters were triumphant until, torn down, ripped apart, vandalized, plastic artists like Hains or Villeglé got hold of them and used them as a sort of wild pictorial material. As archeologists of urban life, they reveal the pathetic beauty and violence of the torn poster, revealing under its glue the erased layers, its Lettrism and anarchic messages. Ripped from the public space and set up in the museum, these recomposed tatters shifted the gaze, transformed the poster into a collective creation, made the Métro passerby a spectator of spontaneous works of art, opening his eyes to urban palimpsests, to their political and poetic impact.

In this way, one by one, the photos in this book testify to the era of the Métropolitain from its beginnings to the present day, a formidable visual reservoir mingled with emotion, surprise, fascination, reality turned into dreamlike visions, obsessive technical details converted into a graphic vocabulary: segments of bricks between metal joints; the omnipresent rivet, scattered by the thousands throughout the slightest photo; and in the midst of all this, the ticket itself, the old punched ticket, kept like a sentimental talisman linked to Serge Gainsbourg's popular song "Le Poinçonneur des Lilas," fetish of some souvenir of youth, some fatal episode. It is an inventory whose great virtue lies in alerting our perception to disseminated signs — always present despite transformations — punctuating the secular episodes of a narrative that combines aging with transformation, the ephemeral with the lasting, tragedy with the smile, the great illustrated book of the Métropolitain's fabulous history.

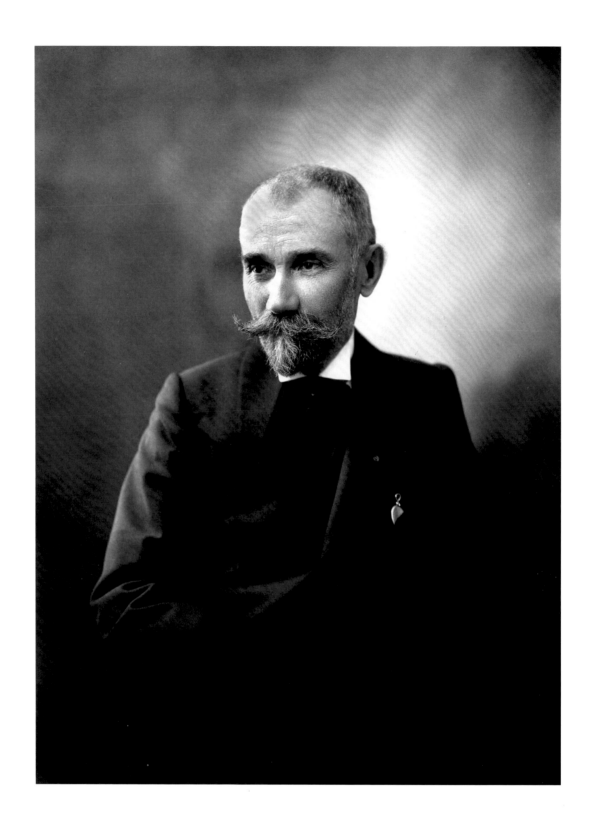

NEURDEIN - *Engineer Fulgence Bienvenüe, father of the Métropolitain*, circa 1900-1910

CONTENTS

I went down into the Métro. I plunged into that underground world and discovered a city within a city…. strolled through the platforms, paced the corridors, wandered from one line to another, my eyes riveted on my viewfinder. Just watching the subway move, come to life. And taking photos, capturing instants I came across during my peregrinations, under the earth, where the light is always the same.

JOHANN SOUSSI,[1]
Aller-Retour, Paris, 2010, p. 1
(*Nuit Blanche* 2010 exhibition catalogue).

Few are those who get up one morning and say to themselves: "Today I'm going to photograph the Métro." The subway is usually a chance subject, not a premeditated one. It imposes itself on the photographer because suddenly—at the bend of a station entrance, a stairway, a corridor, an escalator, a platform or a train—it summons him, surprises him, moves him, charms him, saddens him, shocks him, amuses him, repels or attracts him. Of course, the Métro is a world. A world of infinite richness that continually stimulates the gaze, from the curve of the green cast-iron vines imagined by Hector Guimard, to the gleam of the cars whose bright colors blur and mix with each other as the train arrives at the station, to the advertising posters that readily lend themselves to the most edifying comparisons. Then there are the people. These men, women and children you meet for the space of a moment, whom you don't know but with whom you share a journey, whom you brush against at station entrances or in corridors on the way to a transfer, or bump into without noticing, or stumble against when they block your way, absorbed as they are in their own passage. The photographer observes these wayfarers. He is the silent witness to a gaze, an attitude, a gesture that reverberates in him and that he then resolves, like a conscientious entomologist, to capture. Back at home, he will judge the qualities of the specimen collected.

Métro~Photo

JULIEN FAURE-CONORTON

"MÉTRO" / "PHOTO": the obvious analogy between these two nouns is worth noting. Two words, two worlds, two abbreviations that, by apocope, have supplanted the full word, thereby emphasizing the familiarity and the intimacy of the public towards these two methods of transport—one physical, the other mental. Just as "PHOTO" covers a multitude of realities, "MÉTRO" is a protean term that serves both to qualify this method of transportation as a whole and to designate its particular elements: trains, platforms, transfer corridors, station entrances and external architectures all constitute "the Métro" of Paris. Light is another element that unites these two realms. Indispensable to photography, which cannot exist without its action, it is also a determining factor for the Métro, city under the city, an essentially underground world that the rays of the sun will never reach.

From 1900 to 2016, from the inauguration of the Metropolitan railroad of Paris to the publication of this book, *Paris-Métro-Photo* sets out to be an anthology of photographs of the Parisian Métro. The fruit of iconographic research carried out among various entities (institutions, agencies, photographers, collectors), the selection gathered here does not aim to be exhaustive. That would be an illusory aim, in any case, since photographs on the theme are countless. The works chosen here were selected above all because of their photographic interest, which took

precedence over any other consideration. That does not mean we have ignored or denied the subject's historical dimension, but simply that our first concern was to choose images that say something about what constitutes the very essence of the photographic. This book is therefore not a history of the Parisian Métro through photography, but a book of photographs dealing with the Parisian Métro.

The Métro is not just a huge, invisible underground labyrinth. It encroaches upon urban space, with its elevated lines and bridges over the Seine, and everywhere it opens its hundreds of mouths at our feet. Thus, the reader will find gathered here photographs taken in the Métro as well as those taken in its vicinity. At times, the reader might be surprised by the Métro's secondary or anecdotal quality in the composition, as in the admirable *Pluie, rue de Rivoli (Rain, Rue de Rivoli)* by Maurice Tabard (p. 184), for example, or in the *Marché aux oiseaux et aux fleurs (Bird and Flower Market)* by Marcel Louchet (p. 165). These examples are there to emphasize that the Métro, via its shelters and its signposts, constitutes an essential element of the Parisian landscape, a symbol of the French capital along with the Eiffel Tower, with which photographers have often liked to associate it (from André Kertész [p. 122] to Willy Ronis [p. 200], Izis [p. 193] and Frank Horvat [p. 201]).

While the photographs gathered in this book share a common theme, they differ in a variety of ways, from the objectivity of the technological statement to the subjectivity of poetic interpretation. Presenting them without discrimination, organized only according to their chronological order, allows us to look at them in a new way: to highlight, for example, the modernism of the photographs of the 1900s, the avant-gardism of the news agencies, the surrealism of documentary photos, the technological excellence of photos that aimed to be aesthetic—in brief, to stress the porosity of categories that have solidified over time and let us rethink the history of photography.

The 300 or so works that make up this collection also reveal the tendencies that characterize the treatment of this subject. Although some of the Métro's aspects have been dealt with many times and are widely represented in this book, others prove rarer. This is especially true for photographs of details, particularly the details of the Guimard elements, even though they are emblematic of the Parisian Métro. Aside from the incomparable creations by Brassaï (pp. 85, 117 and 119), these details have only rarely attracted the attention of photographers. Moreover, certain forms of expression have been explored only a little, such as the still life, represented here by a single example (p. 157). The gathering together of such an ensemble also makes us realize the uneven photogenic quality of the Métro stations, the way one might note the uneven charm of a portrait artist's models. Thus the Opéra station is one of the most appreciated by photographers, from Robert Doisneau (p. 214) to William Klein (pp. 236-237), Édouard Boubat (p. 211), Willy Ronis (p. 164) and Giancarlo Botti (p. 235). Likewise for the Passy station, which captivated Ergy Landau (p. 138), François Kollar (p. 87) and Michael Kenna (p. 319), among so many others. Finally, comparisons are

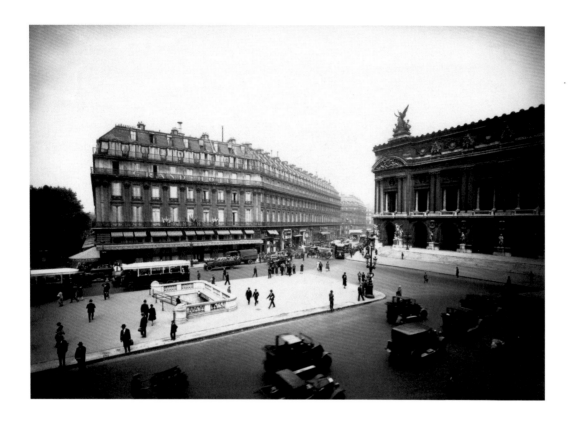

ANONYMOUS - *"Paris: Place de l'Opéra and Rue Auber,"* 1920s

established, parallels revealed, and it is interesting to note how different photographers—such as Willy Ronis and Henri Cartier-Bresson (pp. 198 and 199)—have been attracted by the same motif and produce quite distinct visions of it, the fruit of their personality. These connections are made within the same chronological period, of course, but also throughout the century, as with those couples of lovers pretending to be surprised by the camera lens, in 1953 by Robert Doisneau (p. 196), in 2014 by Scott Stulberg (p. 379).

The ultimate general lesson one can draw from this selection is that the history of the Parisian Métro, as it is told to us through these photographs, is less that of its historical and technological evolution than of its aesthetics, its uses and users. It is, above all, the incidental story of the Métro that interests photographers, the everyday, the ordinary—life, in short. From the height of its 116 years, the Parisian Métro observes all this. Its confirmed characteristics and strong identity make it a veritable character, by turns a protagonist and a witness to a history that it accompanies. It is a familiar, constant landmark; a world of motion, of lines and lights; an ever-accommodating and surprising model that seems to say to the photographers, "Go on, you will never exhaust all my secrets."

Editor's note:
Original captions are indicated by
quotation marks. They come from various
sources: author's title, handwritten
or printed notation appearing on the
photograph or its mount, publication of the
time (or reference work), popular title, etc.

When the construction of the Métropolitain began in 1898, photography was getting ready to celebrate sixty years of its existence. Practiced everywhere by everyone, it was as commonly used at the time as the bicycle. The technological conditions of its use had been simplified considerably during the second half of the nineteenth century, especially after the appearance of silver gelatino-bromide that paved the way for the snapshot and for the miniaturization of cameras. As soon as photography was introduced in 1839, it imposed itself as a method of unequaled precision and fidelity to reproduce, document or archive objects, actions, events. Thus, all large-scale public works that were begun in the French capital were minutely immortalized by the camera, offering photography some of its masterpieces, from the extension of the Louvre palace (Édouard Baldus) to the progressive disappearance of the old Paris (Eugène Atget) via the transformations of Baron Haussmann (Charles Marville) and the construction of the Opéra Garnier (Louis-Émile Durandelle).

1900-1920

JULIEN FAURE-CONORTON

Construction of the Métro was far from escaping this pattern. On the contrary, it led to the creation of hundreds of photographs retracing the successive phases of construction of the first lines of the network. Commissioned by the City of Paris (through its Service technique du Métropolitain) for the lines operated by the CMP ("Compagnie du chemin de fer métropolitain de Paris," the Metropolitan Railroad Company of Paris), these photographs, meant to be gathered together into albums, appear on pieces of cardboard on top of which is printed: "Construction du chemin de fer métropolitain municipal de Paris" ("Construction of the Municipal Metropolitan Railroad of Paris"). Under the print is the detailed description of the particular stage of the work represented, along with the exact date the picture was taken (p. 22). Documenting the progress of these monumental construction sites day by day, these photographs are linked chronologically so that sequences of a cinematographic nature sometimes appear, where a delicate or essential operation is broken up into several successive shots taken from the same perspective. The albums record the different phases of work: the digging of underground tunnels, the assembly and then placement of metal caissons (pp. 31 and 34-35), the construction of bridges and viaducts (pp. 38 and 39), and the laying out of the platforms and stations (p. 57). The unexpected is also dealt with, such as accidents (p. 29) or certain marginal aspects of construction, like the decorative elements made for the Passy bridge, photographed in 1905 "in the sculptor's studio." We see the sculptor—Gustave Michel (1851-1924)—proudly posing

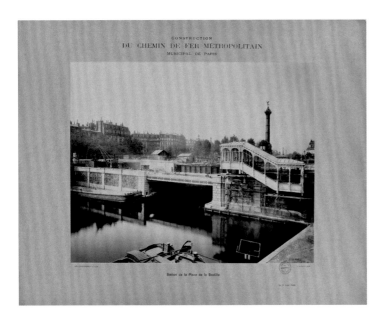

UNION PHOTOGRAPHIQUE FRANÇAISE - *"Place de la Bastille station,"*
June 5, 1900

MAISON ROUX - *Construction of Line B of the Nord-Sud: "Complaint lodged by Mlle Noël: Shaft No. 7 avenue de Clichy,"* December 4, 1907

next to one of his "blacksmith-riveters" (p. 49), a glorified heroic version of the builders of the Métro. The builders are clearly not the subject of the photographs collected in these albums, which, regarded as topographical and technological records, have no interest in social issues. The construction sites seem peopled more by officials in frock coats (pp. 26-27) than by workers in shirtsleeves (p. 57), a sign that the arrival of the photographer often coincided with the inspection tour of engineers, architects or managers. Generally, human presence is there only by default or to testify to the scale of the elements represented (p. 39).

Despite their large number, spread out over time (from 1899 to about 1910), the photographs of the construction of the Métropolitain present great unity—one that indeed was fostered by the systematic quality of their presentation, but it goes beyond that. The prints are either p.o.p. (printing-out paper) (pp. 56 and 57) or silver bromide prints (pp. 38 and 39), obtained from 18 × 24 cm glass negatives, a format that requires the use of a large camera mounted on a tripod (not a trifling constraint, especially on a worksite). Most of these photographs are in landscape format, an orientation perfectly adapted to the subject represented: architectural views in an urban environment. The frames are wide, privileging vistas that offer a global view of the work under way. The shots are executed just as well in broad daylight as underground, in the shafts or tunnels under construction, since the magnesium flash (ancestor of the flashbulb) had just recently allowed photography to probe the darkness (p. 60). These hundreds of prints are clearly responding to precise specifications: the subject is in the center, the focus is sharp, the point of view meticulously chosen. Their shared characteristics contribute to their unity, even though they are the works of different photographers: some were taken by the Union photographique française (a collective that specialized in public commissions and urban planning), while others—the most remarkable

ones—are by Charles Maindron. These photographs play a threefold role: documentary (chronicle of the construction as it went on), historical (testifying to the radical transformation Paris was undergoing), but also promotional (proving the excellence and modernity of this ambitious project). This latter point is essential, since the network was meant to be expanded; thus these prints were widely distributed, as testified by their presence in various national collections.[1]

In 1902, the company responsible for Lines 12 and 13 was created, the Société du chemin de fer électrique du Nord-Sud (Society for the North-South Electric Railroad). Like the City of Paris for the lines operated by the CMP, it commissioned photographs documenting the construction of its network. The archives of the RATP ("Régie autonome des transports parisiens," the Paris transport authority) preserve a collection of almost 1,300 images that is exceptional as much for its rarity—these photos seem not to appear in any other collection—as for the quality of the photographs gathered together. Taken for the most part between 1906 and 1911, the photos are of a very different kind from those taken for the City of Paris. While some testify to the progress of the construction (pp. 30 et 33), most show streets, façades or sidewalks, and at first sight they seem not to bear any relation to the execution of an underground railroad network (pp. 68 and 69). This is due to the fact that they deal not with the construction per se, but with its attendant circumstances. They were, in fact, taken as a record to document the complaints made by residents about nuisances or defacement.[2] Presented as irrefutable proof, photography is used here as an official record—a role that is materialized, in images, by the recurrent presence of a calendar indicating the date of shooting (a date that is usually copied onto a corner of the negative). The location, identity of the plaintiff and motive for the complaint are written on the back of the mount, which also bears the author's stamp (the Maison Roux[3]). These are silver bromide prints taken from large-format glass negatives (24 × 30 cm). They testify to a great sense of composition on the part of their author(s), whose technical mastery is also evident. While some prints are stylistically very close to works by Eugène Atget (pp. 66, 67 and 78), others reveal an originality of vision, even an audacity, uncommon for their time (p. 59).

1.
For instance, in Paris, the École nationale des ponts et chaussées, the library of the Hôtel de Ville, the archives of the RATP and the Musée Carnavalet (whose first prints were offered to the Commission du Vieux Paris by the "chief engineer of the Métropolitain").

2.
It should be pointed out that the Nord-Sud was not buried as deeply as the rest of the network, in order to reduce construction costs.

3.
F. Roux was a photographer and publisher who specialized in the reproductions of works of art. His studio, located at 9 quai Malaquais, was adjacent to the École des Beaux-Arts. Upon Roux's death, the Roux Studio became the Widow Roux Studio, then, after the widow remarried, Studio L. Roux - F. Derepas. In 1913, the couple retired, and the business was sold (cf. L'Information photographique, 1913, p. 149).

ALBERT HARLINGUE - *Station entrance at the Rond-Point, Champs-Élysées*, circa 1910

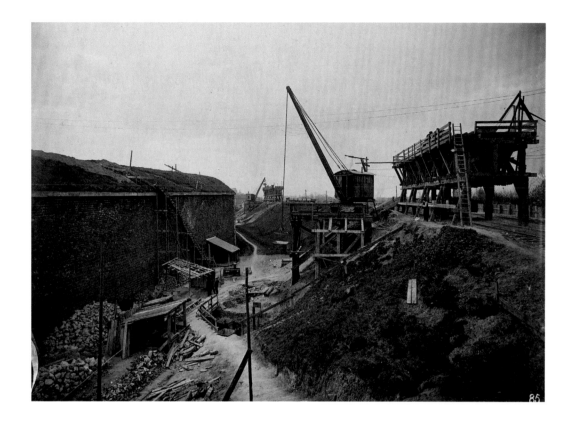

CHARLES MAINDRON - *"The Porte de Clignancourt Loop: worksite in the fortification ditch, digging the inner loop; shot taken from the trench looking west,"* April 13, 1906

4.
This is true for Léon Gimpel, but also for Émile Sainte-Claire Deville, an amateur who had a passion for nighttime photography and for whom the Métro was the opportunity to capture "the play of multiple reflections illuminating the ceilings" ("La photographie nocturne dans Paris," *Annuaire général et international de la photographie*, 1907, p. 401).

At the same time as these commissioned works, other photographers, both professional and amateur, became interested in the Métro. Images of the Métro were widely disseminated by means of the postcard, a medium that was immensely popular in the 1900s and that some companies specialized in (Neurdein, p. 72; Léon et Lévy, p. 54). Jacques Boyer, "scientific publicist," focused on the technological dimension of the subject (pp. 50, 51, 52 and 55), while others saw the Métro tunnels as an opportunity to explore the possibilities offered by artificial lighting.[4] When current events justified it, press agencies documented some aspects of the subject; articles ranged from a report on the flood of 1910 (p. 47) to an investigation on men's professions exercised by women during the First World War. On this theme, the photos of a female ticket-puncher on a Nord-Sud train are notable, especially the one taken from the platform that reveals, in the reflection of the car's window, the arm of the photographer holding the flash (p. 76). Eager for comical and unusual subjects, amateurs also were quick to record the transformations the Métro brought to Paris, from construction sites to the spectacles of stallholders in front of the stations (p. 25). Then there are all those who, in a deliberate manner, took

scrupulous care to avoid the subject. This is the case for Atget, whose abundant production documents the most insignificant corner of old Paris but ignores not just the construction of the Métro, but also the external signs of its existence.[5] The same is true for French pictorialists like Robert Demachy or Constant Puyo, who, during their frequent strolls through Paris, exclude the Métro stations from their compositions the way we avoid scaffolding or an ugly road sign today. This choice can easily be explained by the motivations of the individual authors: Atget was interested only in the traces of an old Paris that was in the process of disappearing, while the pictorialists, desirous of producing photographic works of art, dreamed of a timeless Paris. These two examples perfectly highlight the novelty the Métro embodied at the time; for these photographers, it was unbearably contemporary.

Taken from a purely technological, documentary perspective, without any artistic pretensions (which does not mean without any aesthetic qualities), the photographs of the construction of the Parisian Métro charm our contemporary eyes for reasons that are entirely different from the reasons they were taken: we are drawn to the fantastic nature of these surreal scenes peopled with steel monsters, the extensive foregrounds cluttered with construction materials or wooden logs, the harmonious symmetry of metal structures with repetitive geometric shapes. Undeniably, the most striking are those that reveal aesthetic elements that are generally attributed to the photography of the 1920s and '30s: shots taken from ground level, framing that is tightly cropped (pp. 58 and 64), views taken from a higher viewpoint (p. 60), close-ups that bring the subject to the edge of abstraction (p. 65). Thus, Germaine Krull would probably not have scorned the intertwined metal beams observed by Neurdein on the Place Saint-Michel (p. 72) or that curve of the Austerlitz viaduct magisterially rendered by Charles Maindron (p. 73). These examples reassert what recent studies have demonstrated for other periods: that the modernity of photography does not date from the period between the two world wars, since it is intrinsic to the specificities of the medium; while these specificities have evolved over time, they were present at the very inception of photography.

5.
Three photographs by Atget, however, can be linked to this subject. Vintage prints can be found in the collections of the Bibliothèque nationale de France. Taken on the Place de la Bastille around 1900, they show less the Métro itself than the crowds of Parisians intrigued by this new method of transportation.

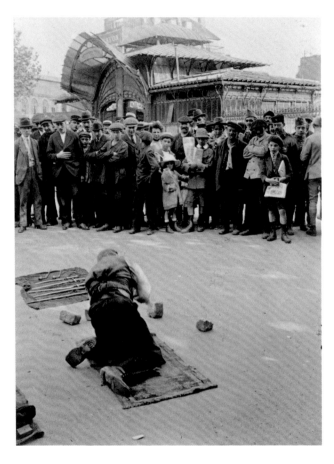

CHARLES LHERMITTE -
Crowd gathered in front of a street performer, Place de la Bastille, 1913

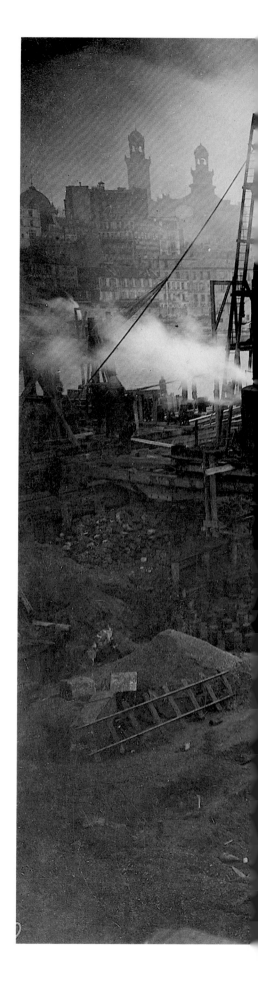

CHARLES MAINDRON - *"Pont de Passy: worksite on the tip of the Île aux Cygnes; looking upstream,"*
December 23, 1903

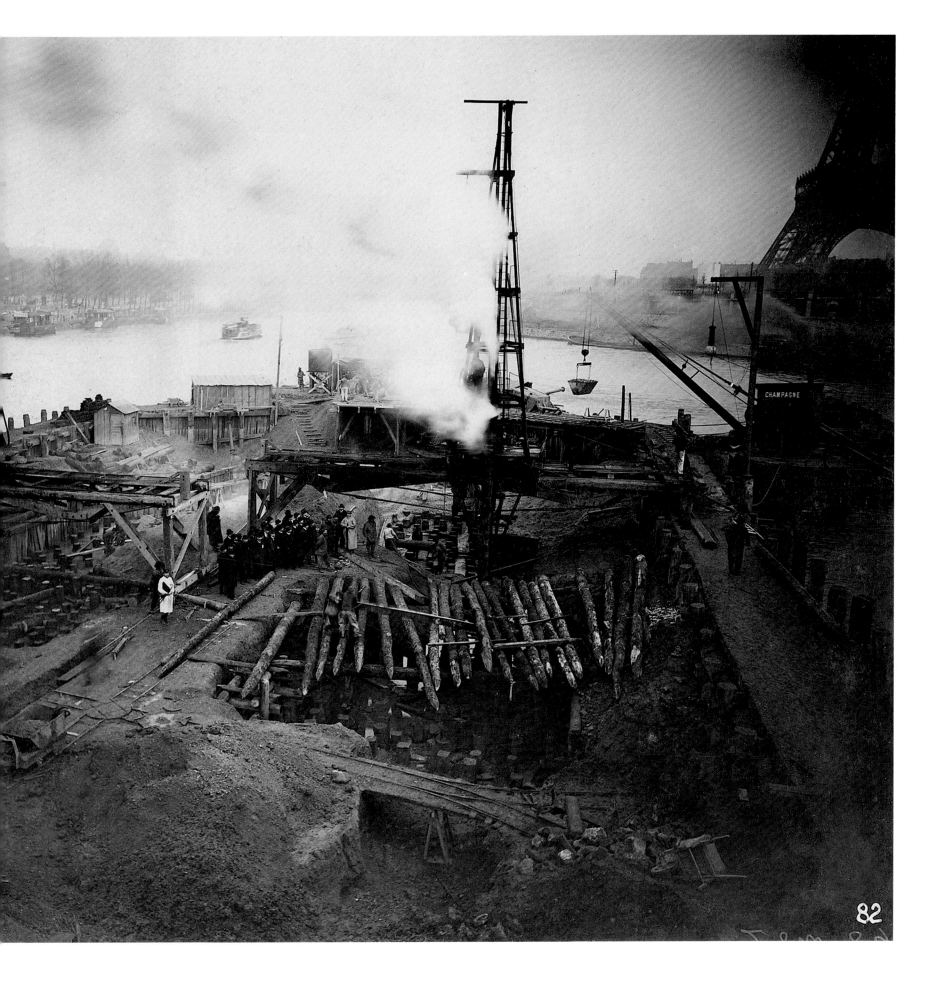

82

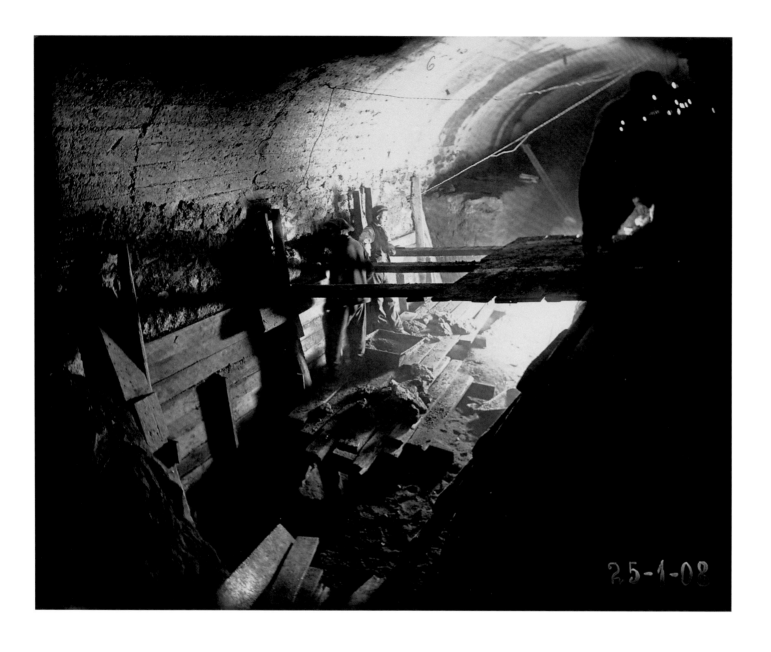

MAISON ROUX - *Construction of Line A of the Nord-Sud: "0 k 760, right abutment pier being fitted in place,"* January 25, 1908

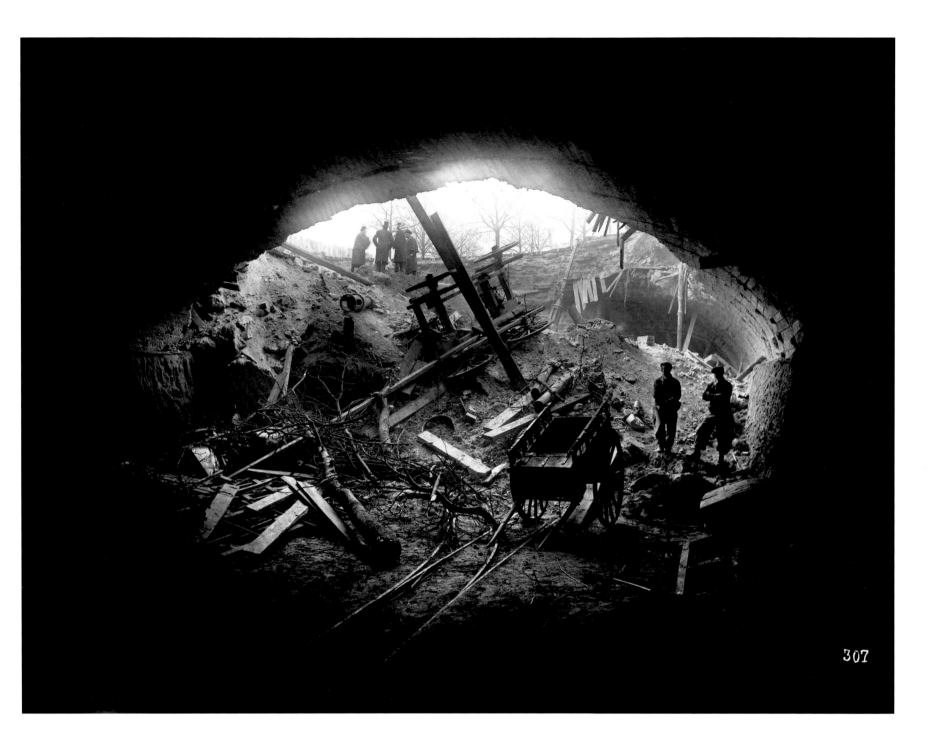

307

CHARLES MAINDRON - *Construction of Line 1: "Accident at l'Étoile,"* December 11, 1899

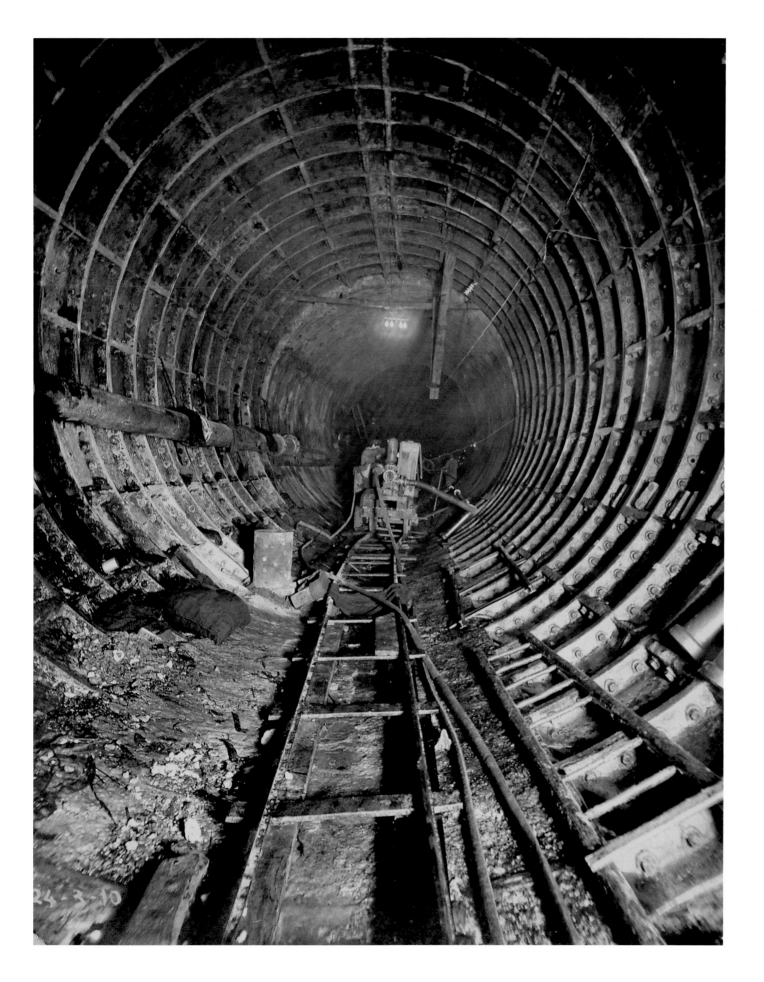

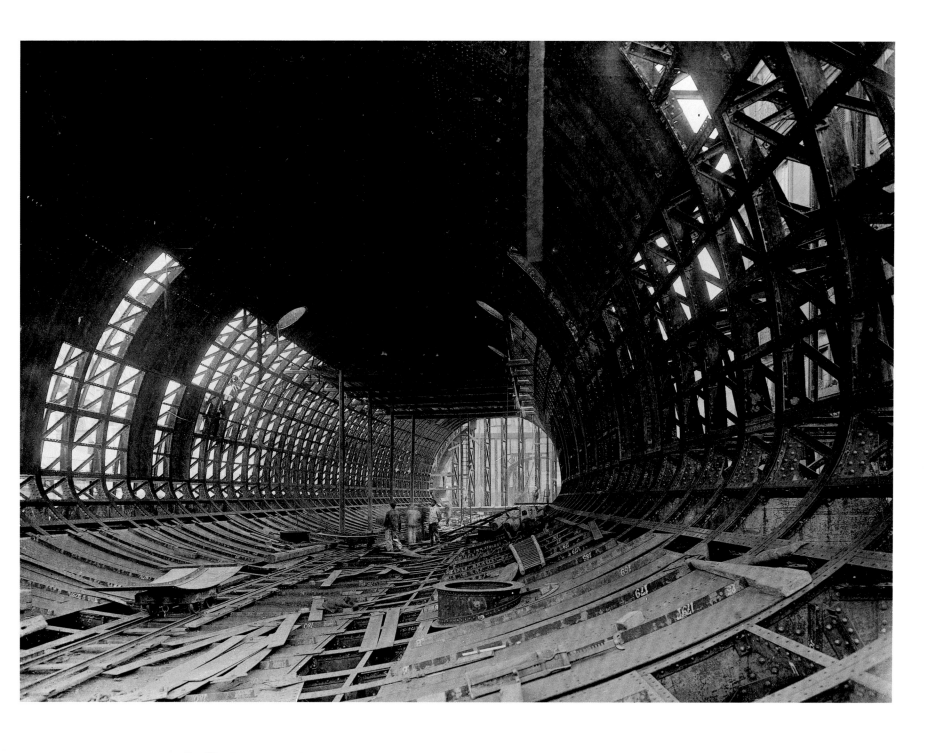

Opposite: MAISON ROUX - *Construction of Line A of the Nord-Sud:* "*Floods — Tunnel No. 1 under the Seine,*" March 24, 1910

Above: CHARLES MAINDRON - "*Crossing the Seine to Châtelet: Place Saint-Michel, mounting the caisson for the station (interior view); towards the Porte de Clignancourt,*" August 30, 1906

MAISON ROUX - *Junction between Lines A and B of the Nord-Sud: construction of the Saint-Lazare rotunda*, May 17, 1910

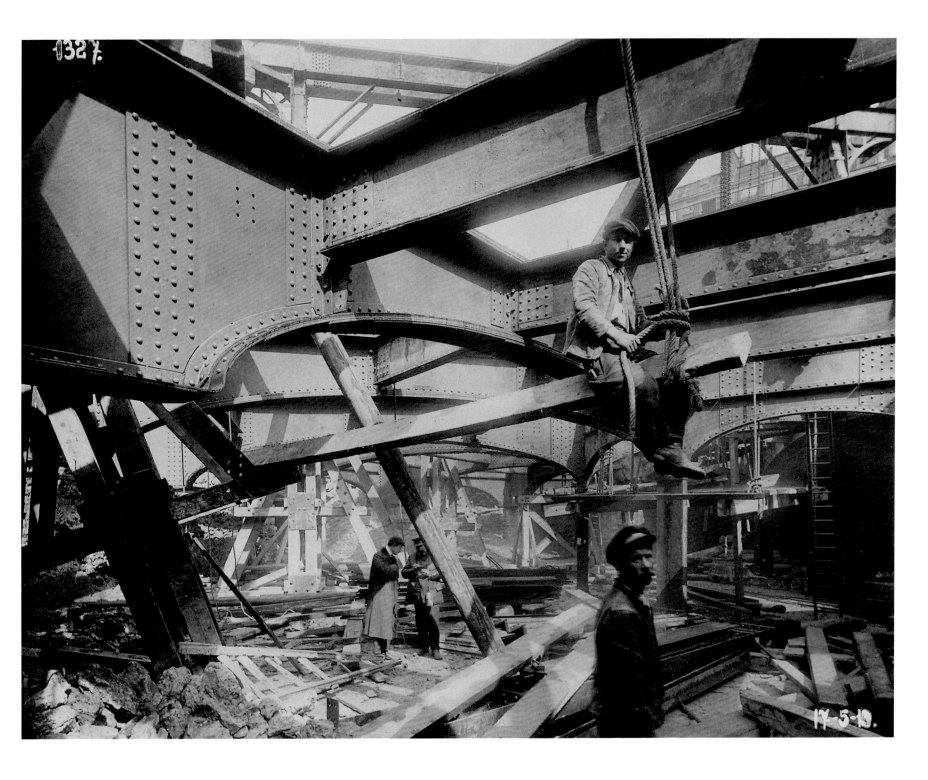

CHARLES MAINDRON - *"Crossing the Seine to Châtelet: Place Saint-Michel station, mounting the elliptical caisson at the end of the station; towards the Porte de Clignancourt,"* March 5, 1907

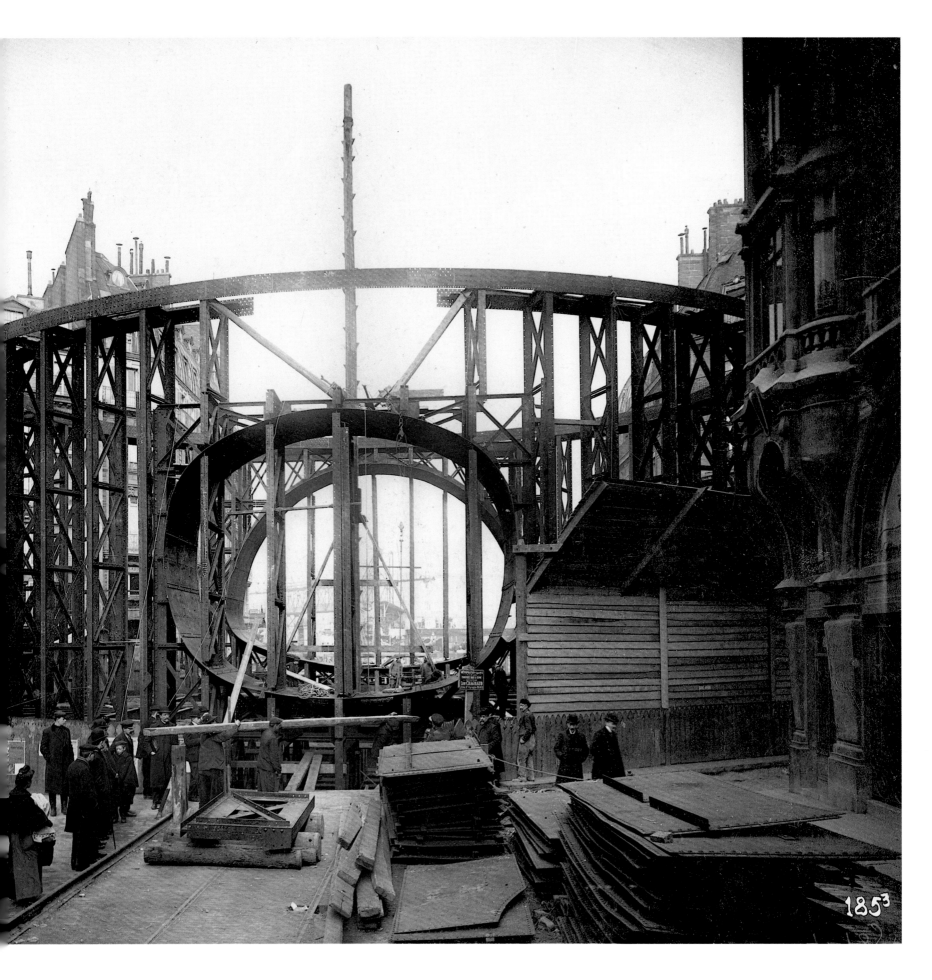

1853

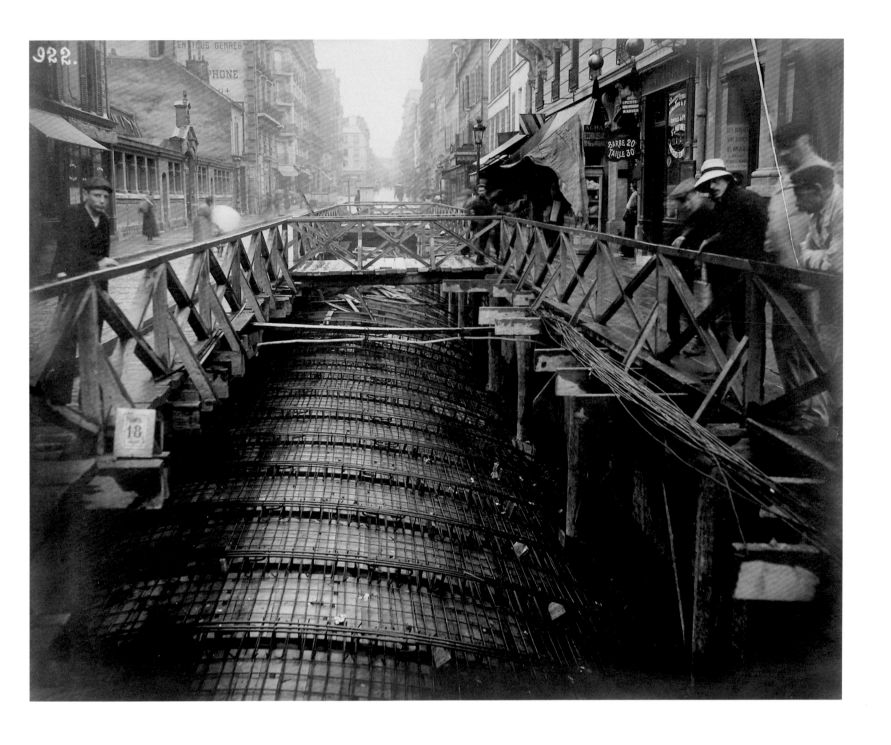

MAISON ROUX - *Construction of Line A of the Nord-Sud: Volontaires station (in front of 198 rue de Vaugirard)*, July 18, 1908

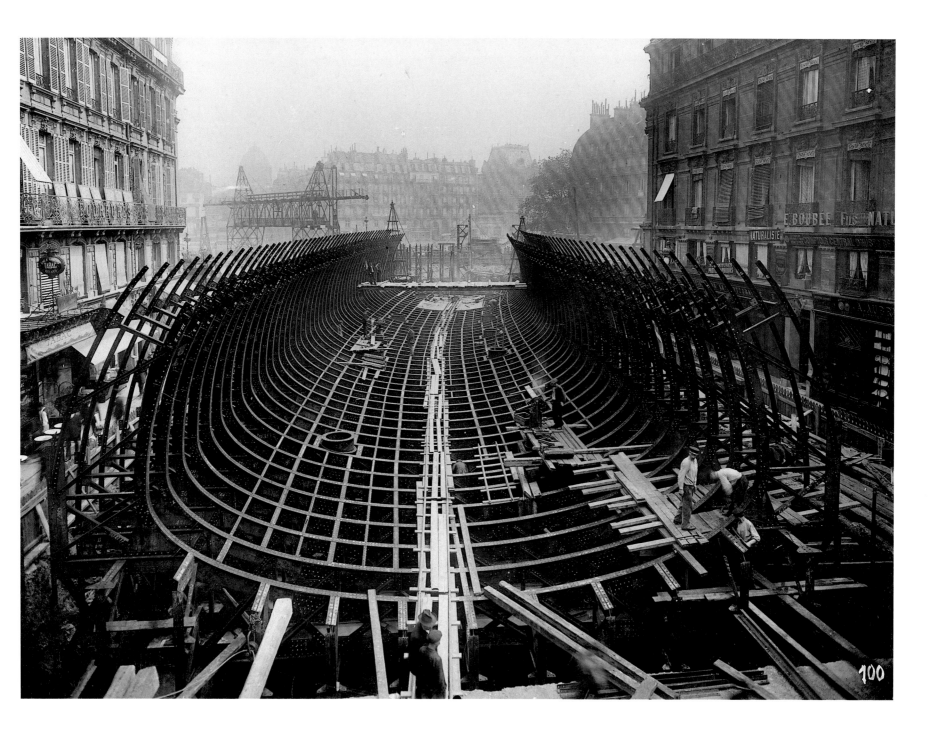

CHARLES MAINDRON - *"Crossing the Seine to Châtelet: Place Saint-Michel, mounting the caisson for the station; towards the Porte de Clignancourt,"*
July 6, 1906

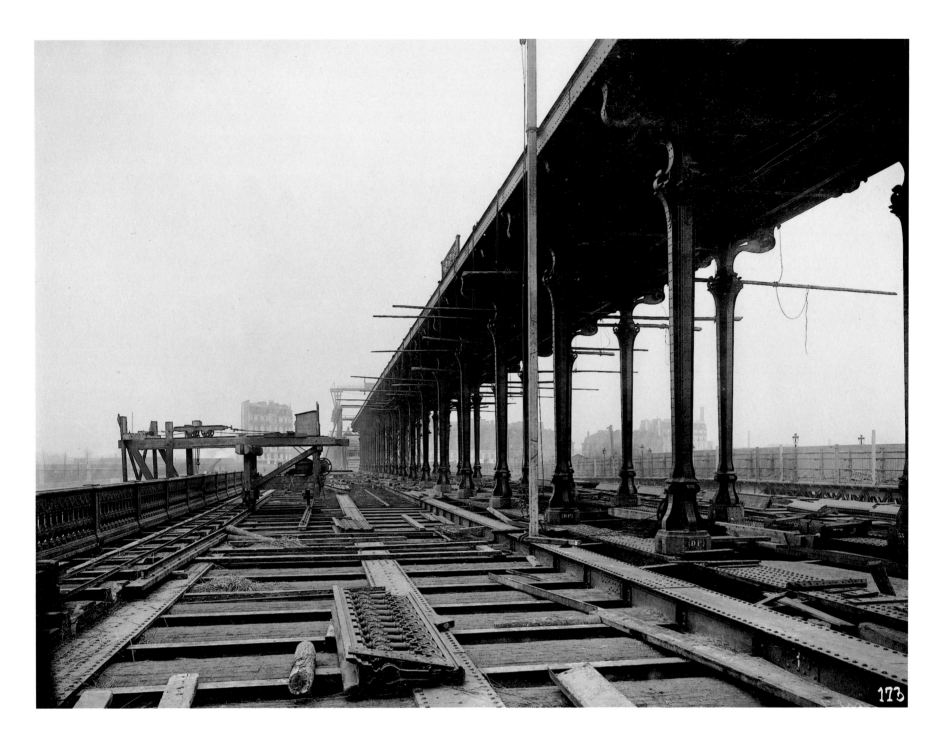

CHARLES MAINDRON - *"Pont de Passy: upper roadway over the main span, from the right bank upstream; looking towards Grenelle,"* January 28, 1905

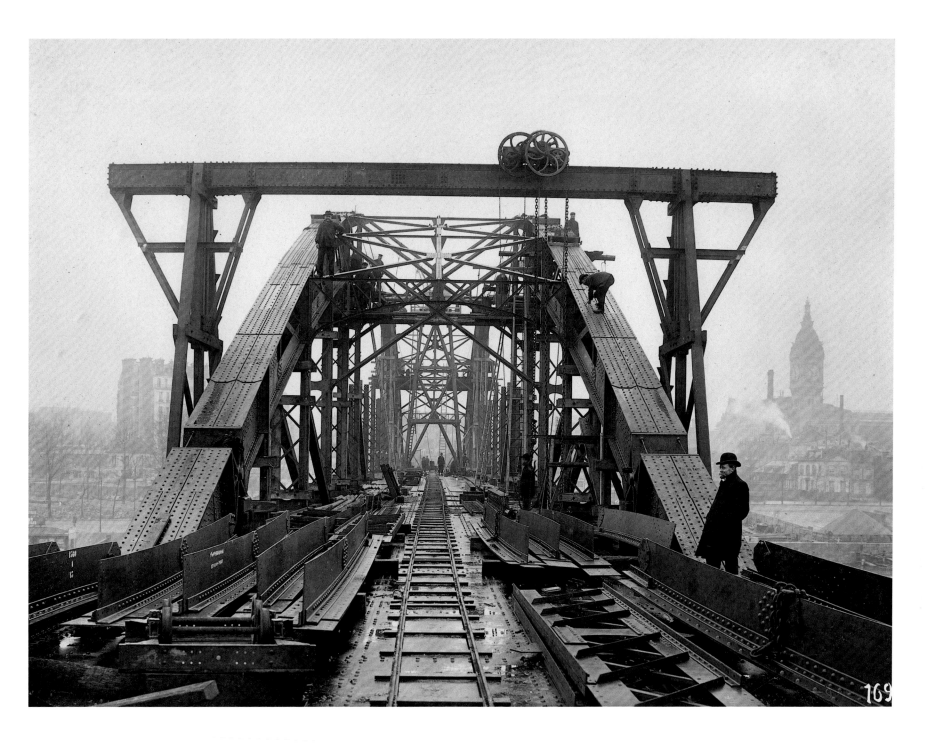

CHARLES MAINDRON - *"Pont d'Austerlitz: shot from the end of the arches being fitted in place; looking towards the right bank,"* December 10, 1904

SÉEBERGER BROTHERS - *Under the elevated Métro, Boulevard de Grenelle,* January 1910

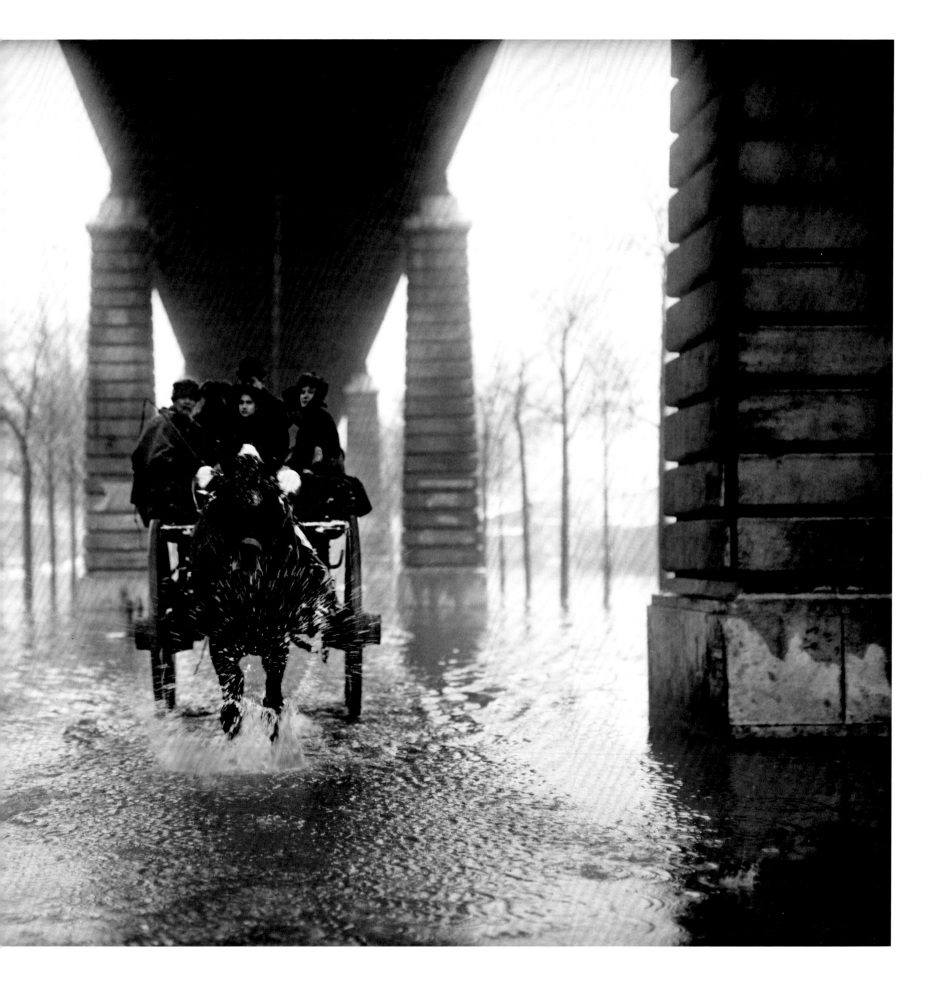

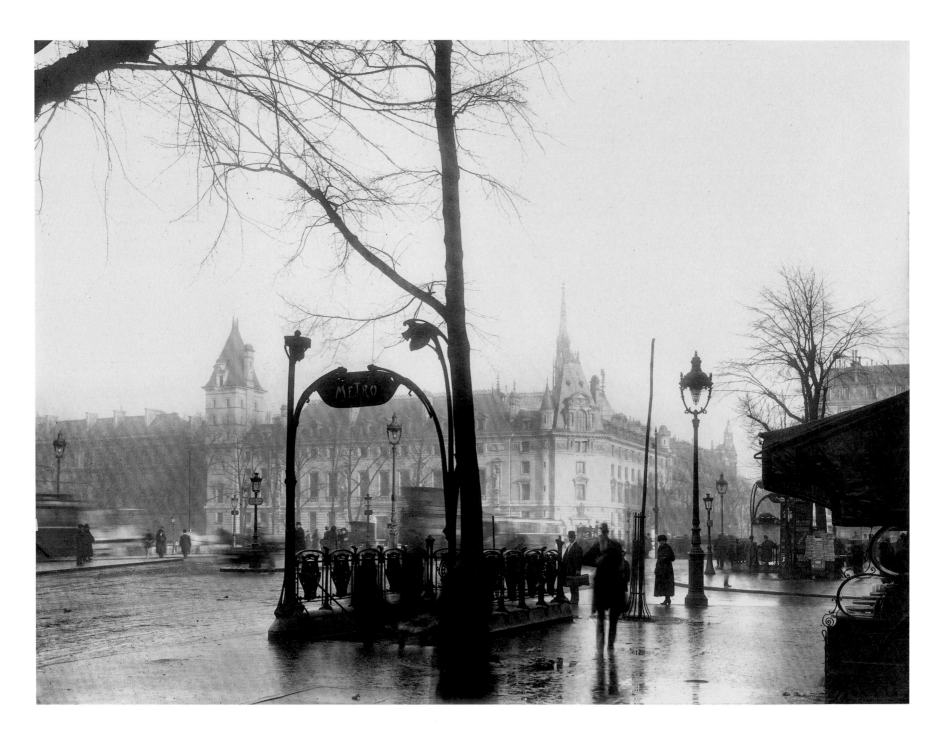

CHARLES LANSIAUX - *"Palais de Justice,"* circa 1910

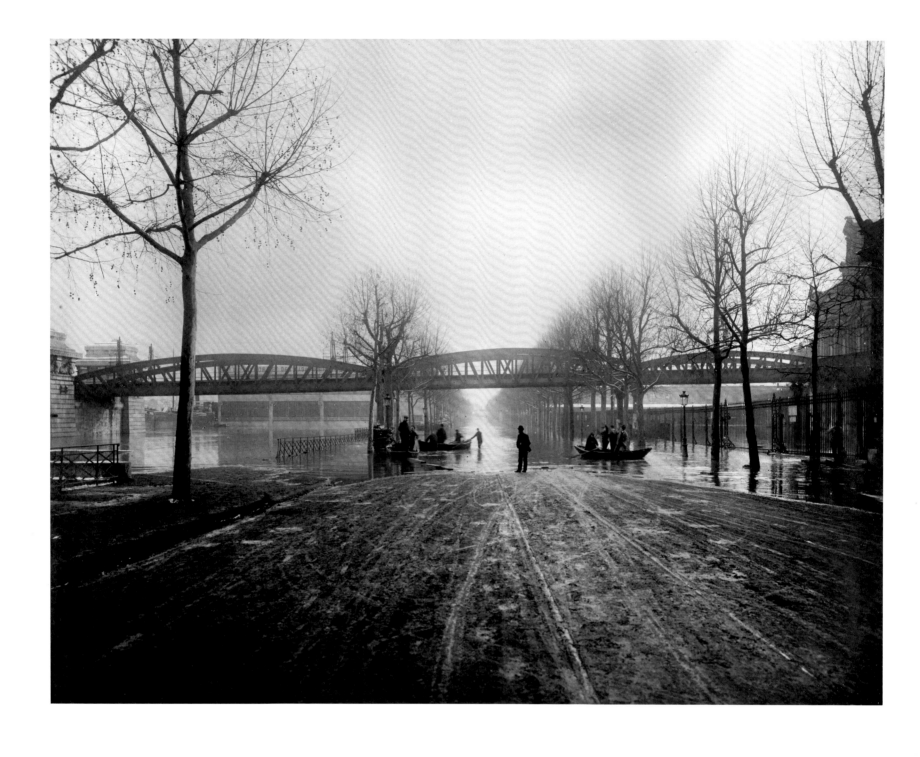

PRÉFECTURE DE POLICE DE PARIS. SERVICE DE L'IDENTITÉ JUDICIAIRE (PARIS POLICE HEADQUARTERS. CRIMINAL RECORD OFFICE) - *The flood of the Seine, Quai d'Austerlitz*, January 1910

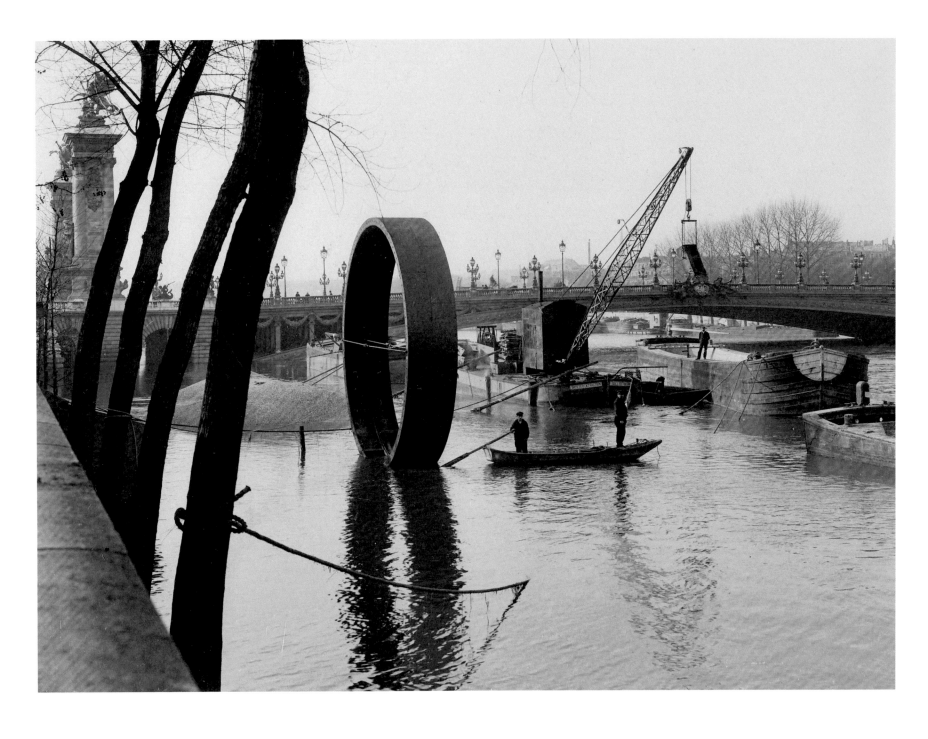

CHARLES MAINDRON - *"Crossing the Seine downstream from the Pont Alexandre III: manipulating the cast iron casing mounted on the Quai d'Orsay dock after the Seine flood; looking downstream,"* January 1910

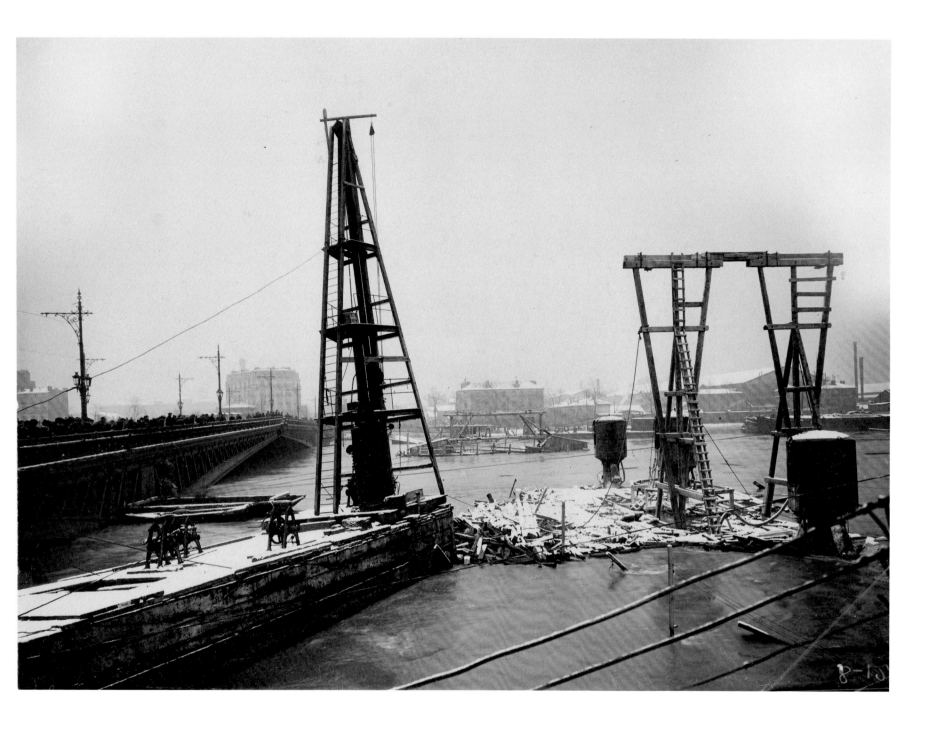

CHARLES MAINDRON - *"Crossing the Seine at the Pont Mirabeau: view of all the worksites during the Seine flood,"* January 1910

ROL AGENCY - *"The Seine flood: exit from the Gare Saint-Lazare station. The water has reached the top of the exit, wood can be seen floating in it,"* January 31, 1910

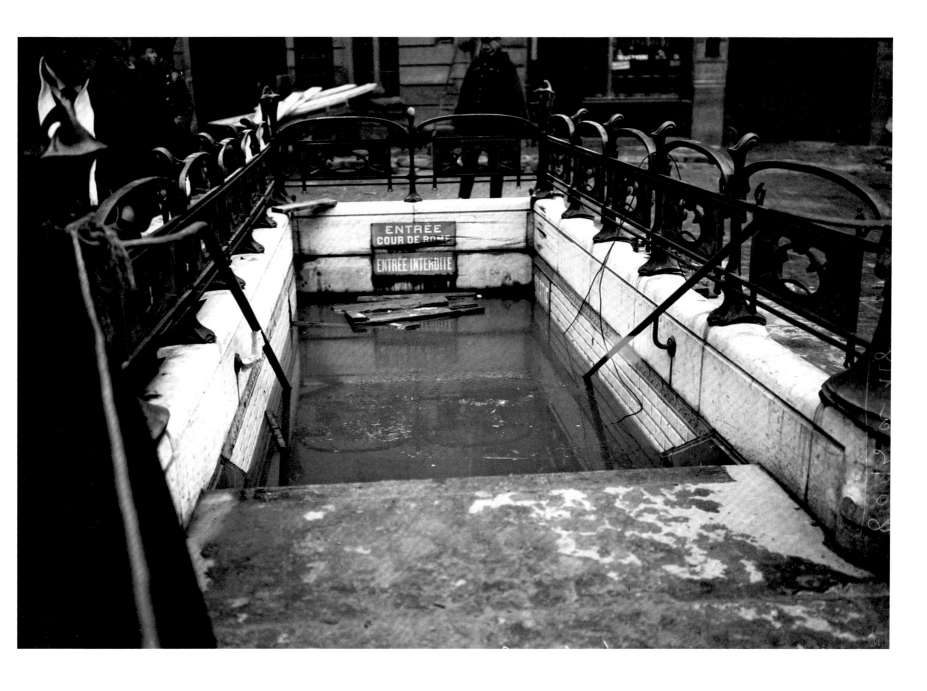

CHARLES MAINDRON - *"Pont de Passy: decorative motifs for the tympanums, clay model of a figure; in the sculptor's studio,"* July 7, 1905

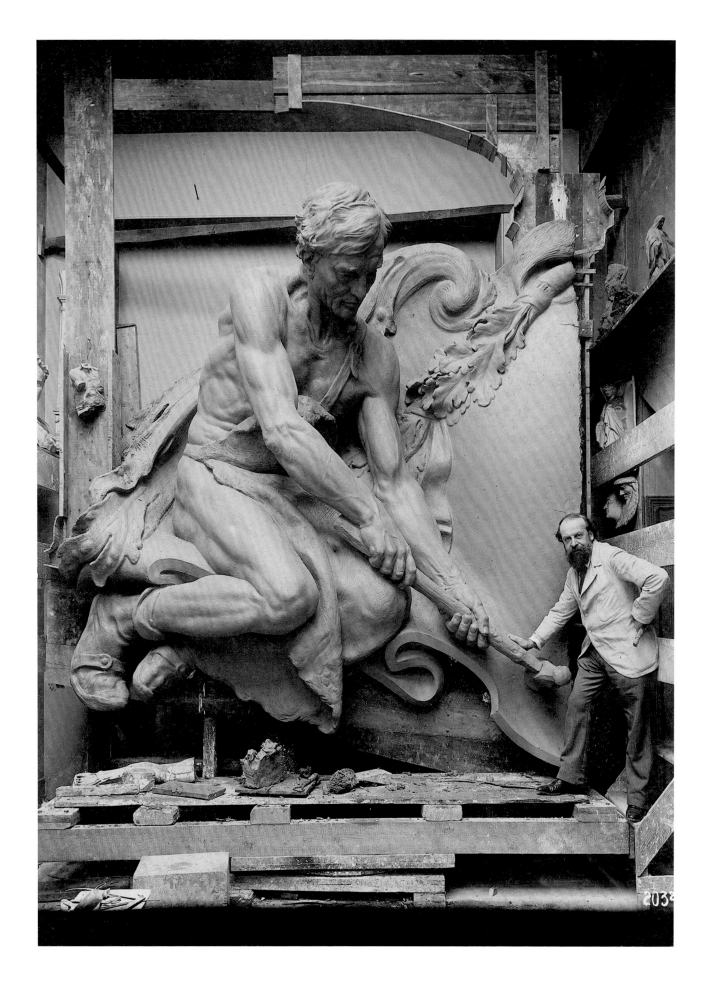

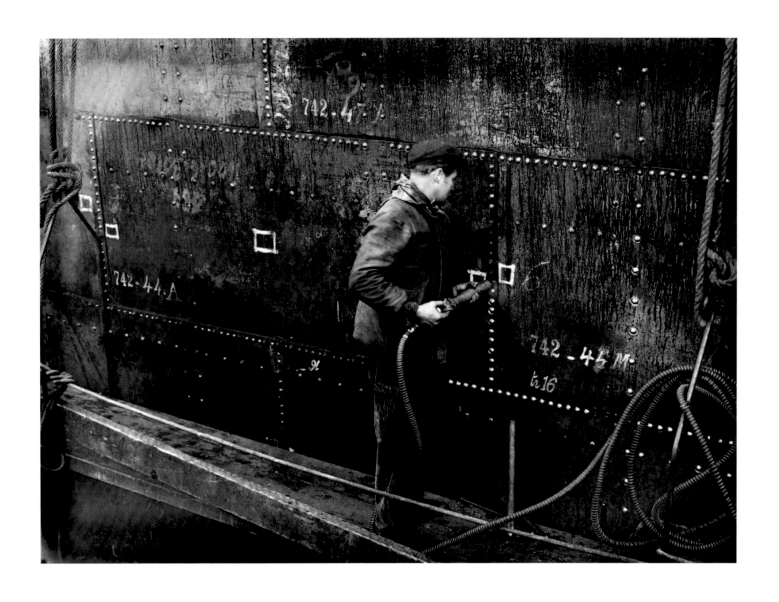

Above: JACQUES BOYER - *Pneumatic riveting of a caisson*, 1905

Opposite: JACQUES BOYER - *Machine room at the electrical works of the Metropolitan Railroad Company of Paris*, 1907

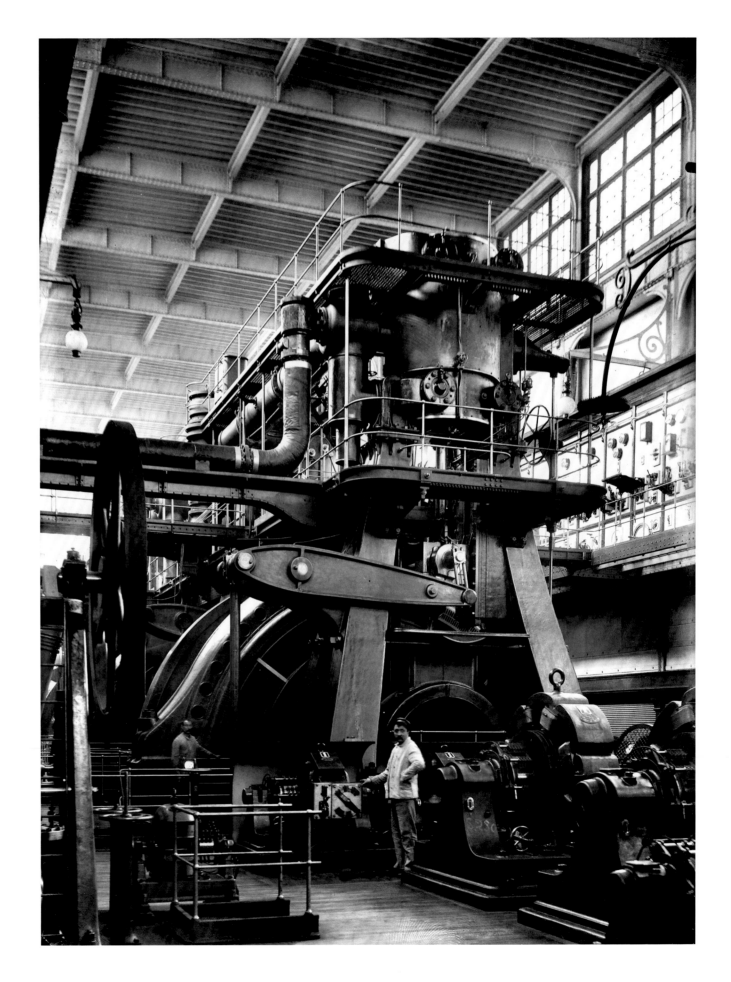

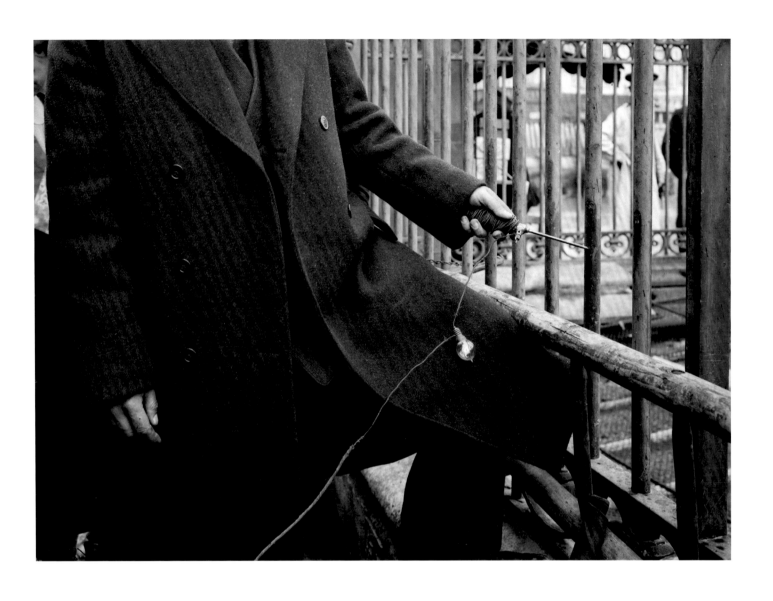

Above: JACQUES BOYER - *Bastille station: warning light used to determine the presence of electrical current in the railings*, 1914

Opposite: ALBERT MOREAU - *"Métro service yards, Rue des Maraîchers: worker checking the coupling of the cars,"* March 28, 1917

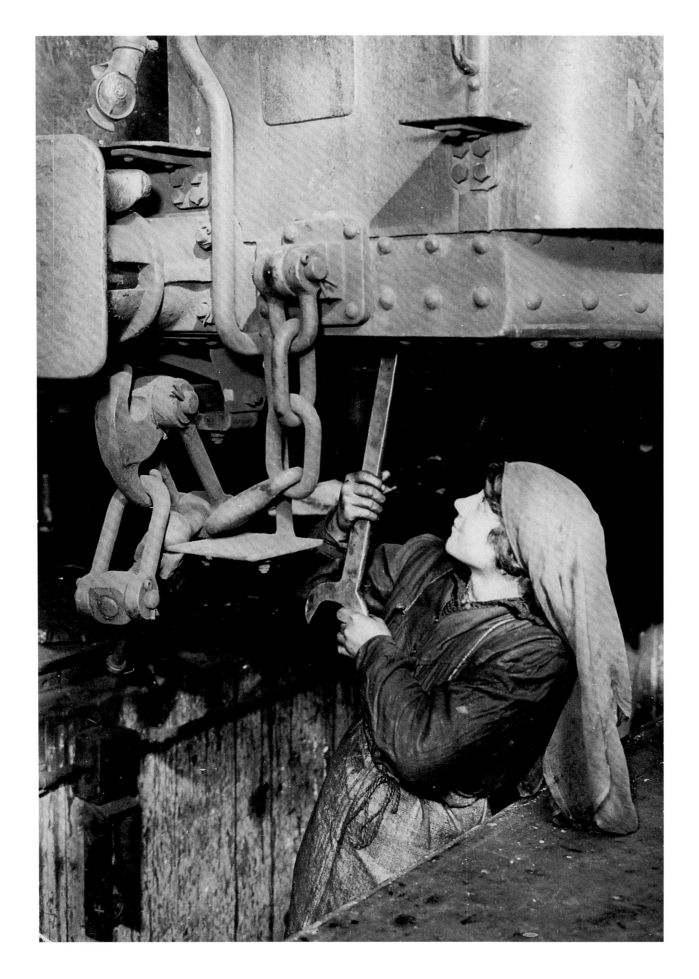

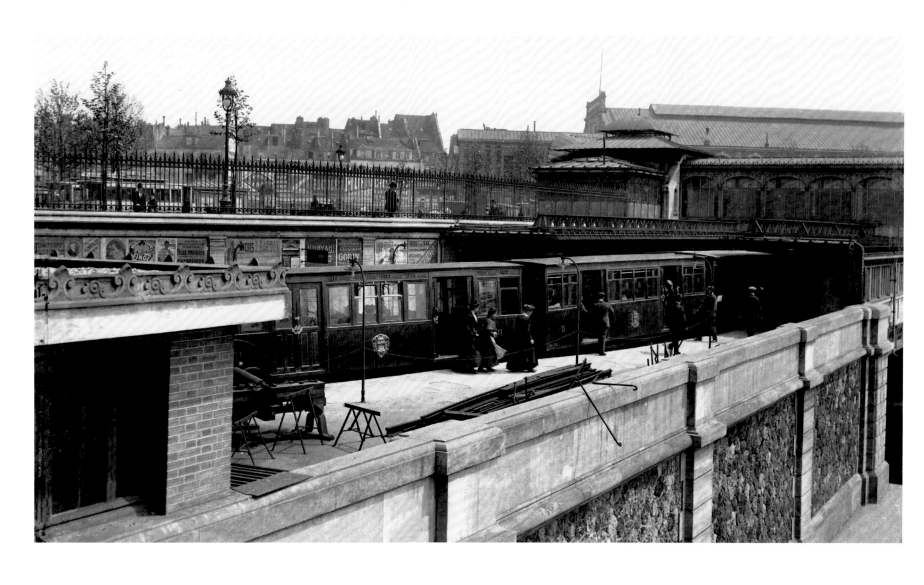

LÉON ET LÉVY - *"Bastille station,"* 1900s

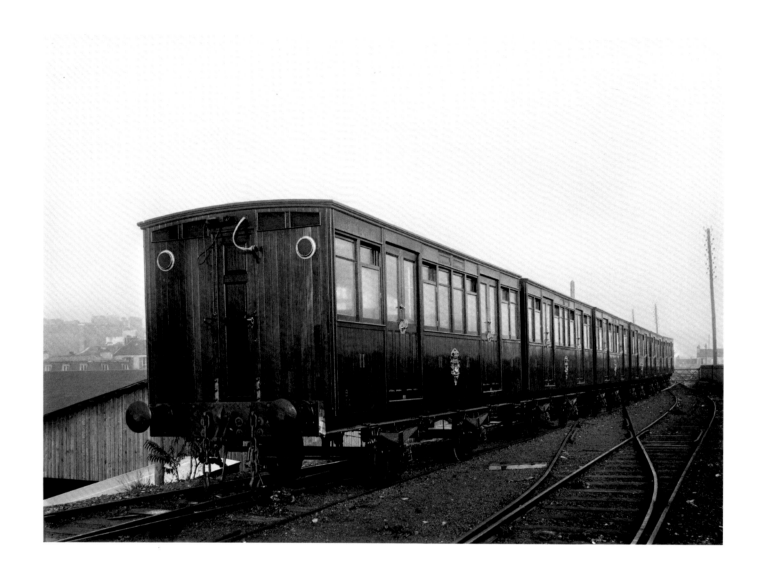

JACQUES BOYER - *Métro cars*, 1901

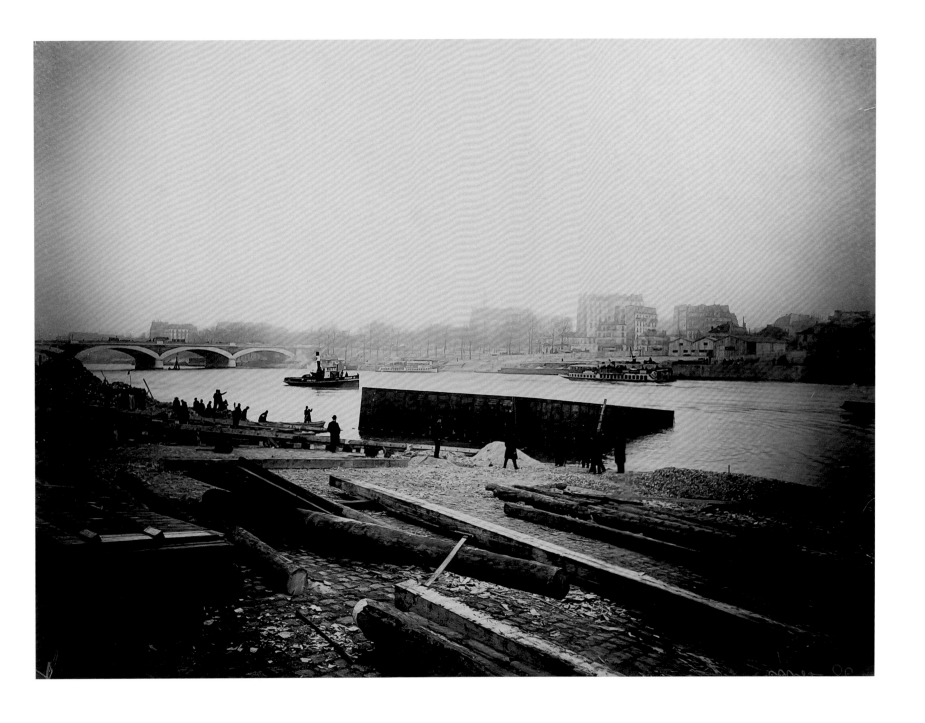

CHARLES MAINDRON - *"Pont d'Austerlitz: left bank caisson immediately after launching; looking downstream,"* January 7, 1904

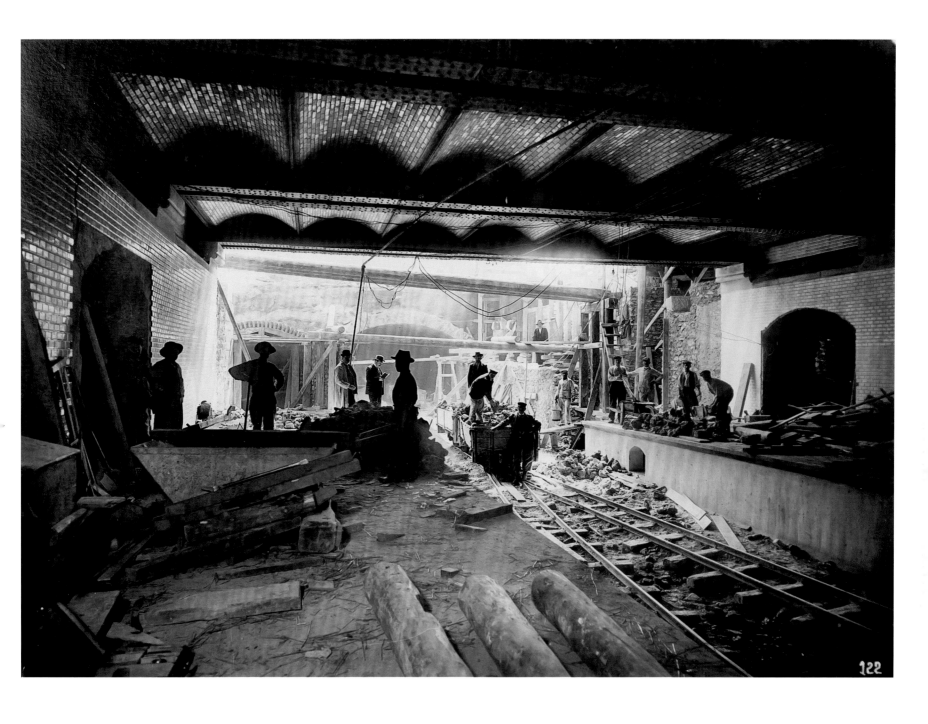

CHARLES MAINDRON - *"Opéra station: construction of the entrances; looking towards Ménilmontant,"* April 29, 1904

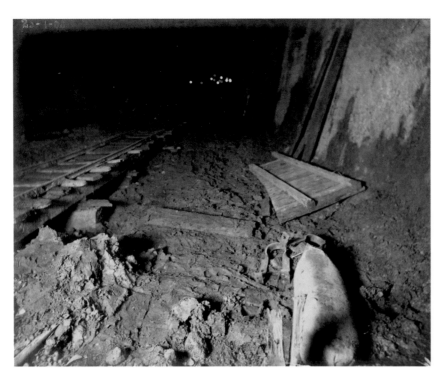

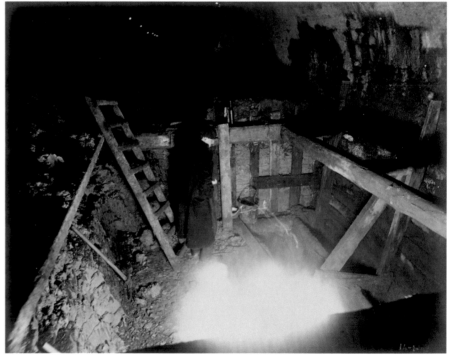

MAISON ROUX - *Construction of Line A of the Nord-Sud: "0 k 380, concrete being poured on the track bed,"* January 25, 1908

MAISON ROUX - *Construction of Line A of the Nord-Sud: "Rue de Vaugirard: Full ring under construction (0 k 519),"* January 14, 1908

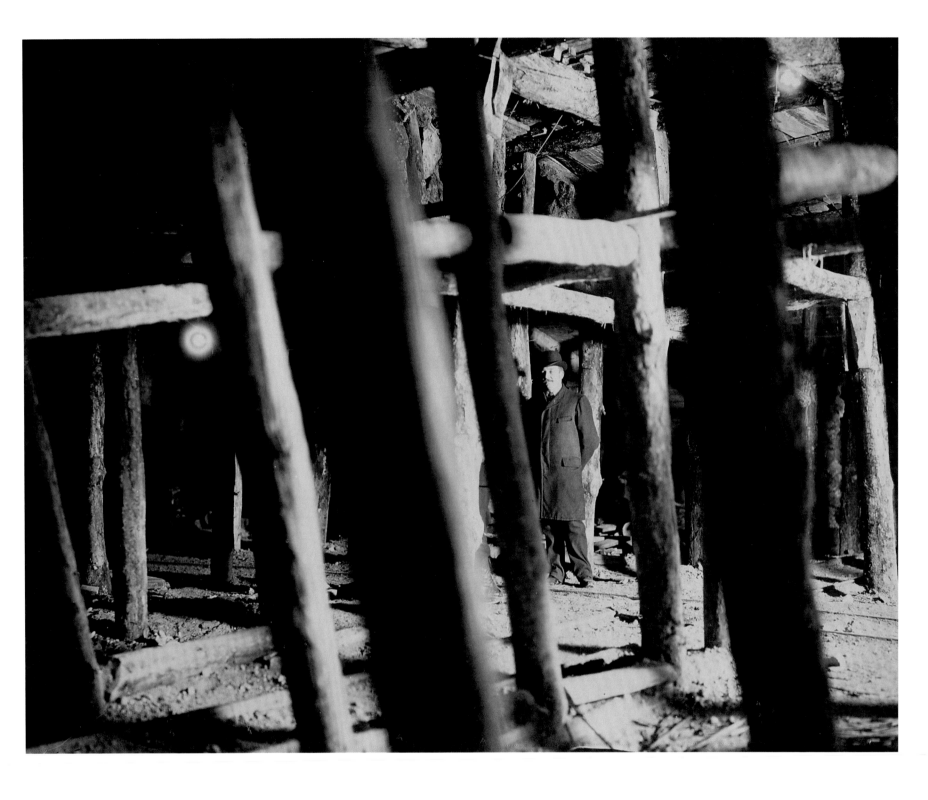

MAISON ROUX - *Construction of Line A of the Nord-Sud: "Marcadet station,"* April 24, 1907

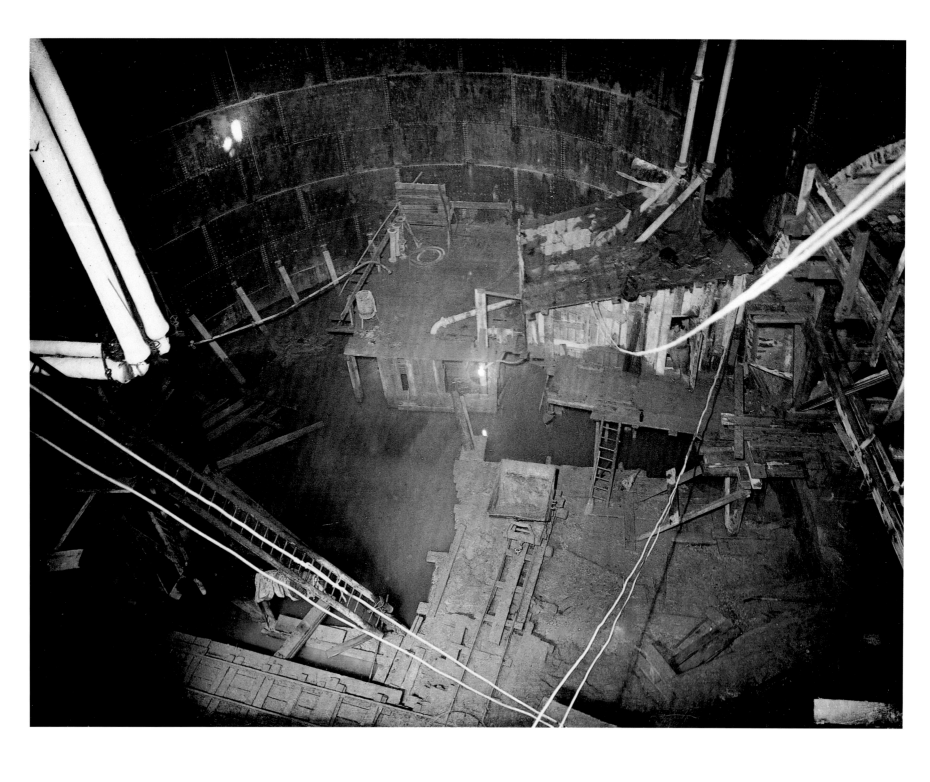

CHARLES MAINDRON - *"Crossing the Seine to Châtelet: Place Saint-Michel station, first elliptical shaft (high-angle view); on the left-hand, Porte de Clignancourt side,"* May 28, 1909

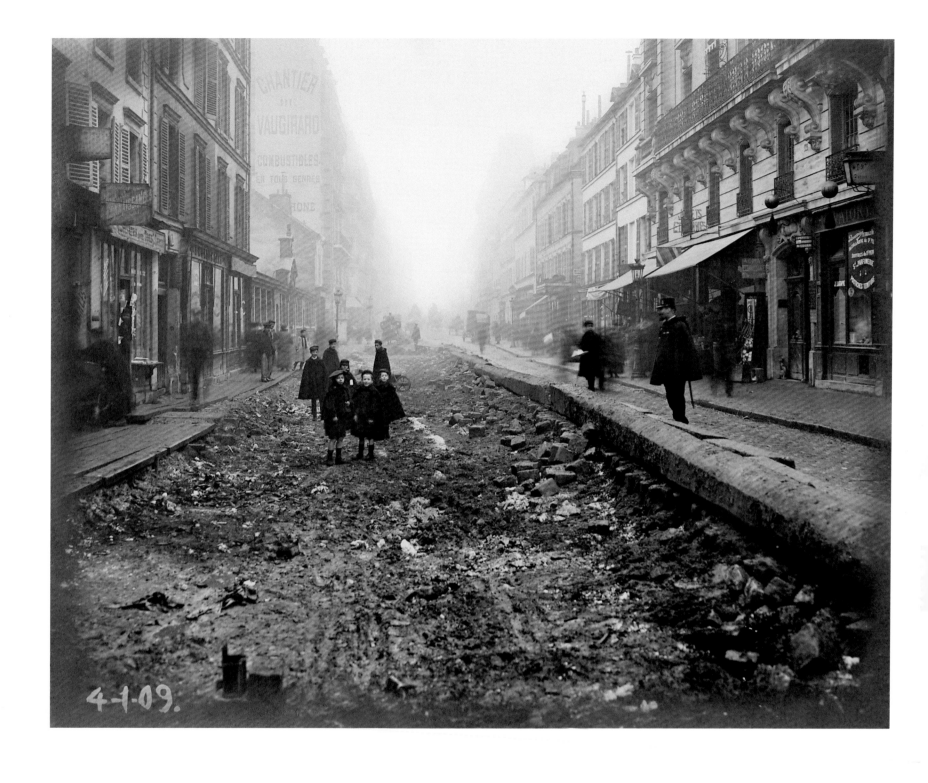

MAISON ROUX - *Construction of Line A of the Nord-Sud: "Volontaires station; embankment completed at the location of the temporary bridge,"*
January 4, 1909

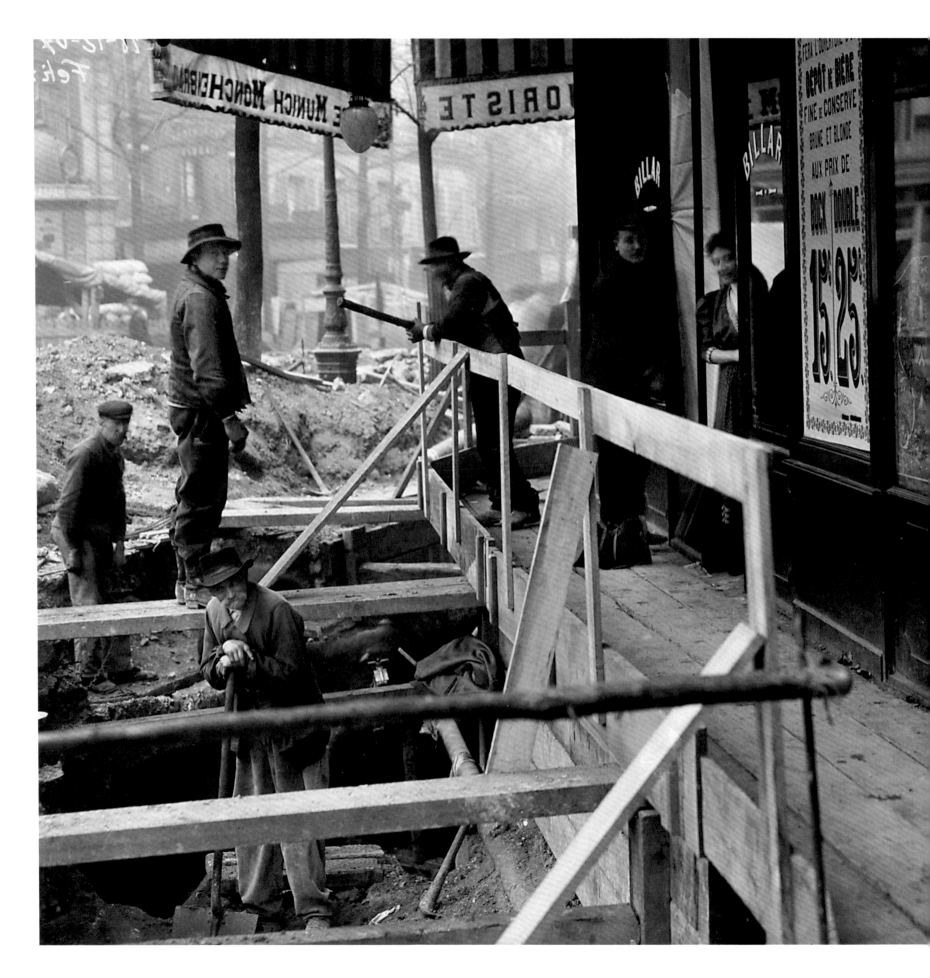

MAISON ROUX - *Construction of Line B of the Nord-Sud: "Walkway in front of Café No. 2, Avenue de Saint-Ouen, seen from the Avenue de Clichy side,"* December 18, 1907

Next pages:

Left: MAISON ROUX - *Construction of Line A of the Nord-Sud: "Building on Rue Frochot (corner of 9 place Pigalle) Café Monico; photographic print showing the stress fractures where pressure has occurred,"* April 3, 1909

Right: MAISON ROUX - *Gutted building at the corner of Saint-Florentin and Saint-Honoré streets (on the route of Line A of the Nord-Sud),* October 14, 1910

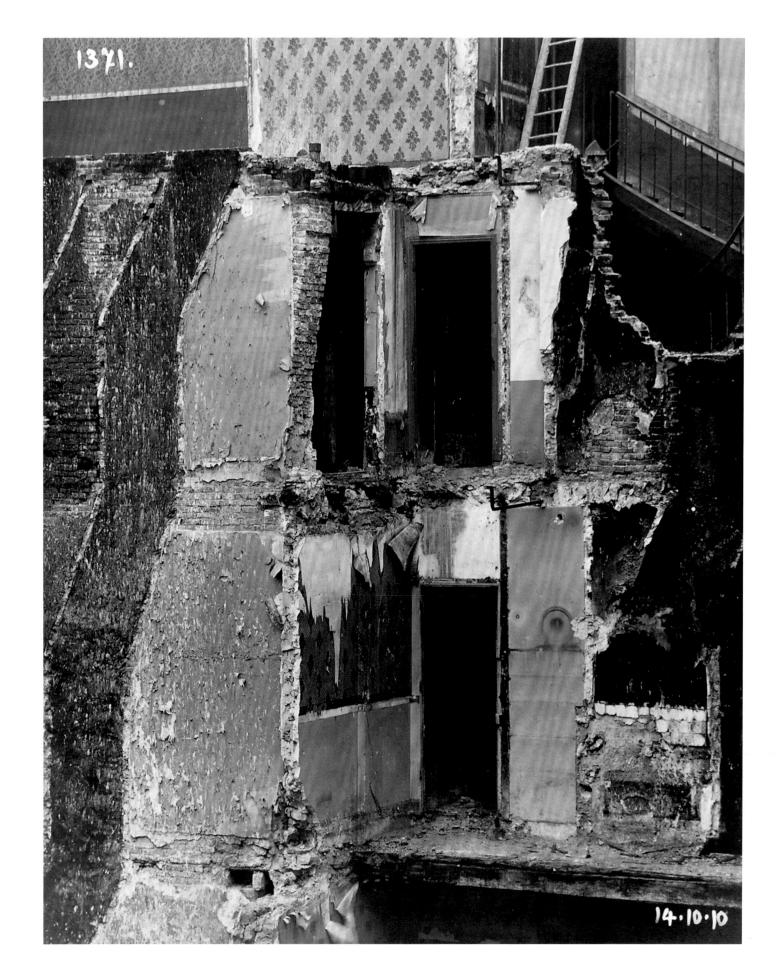

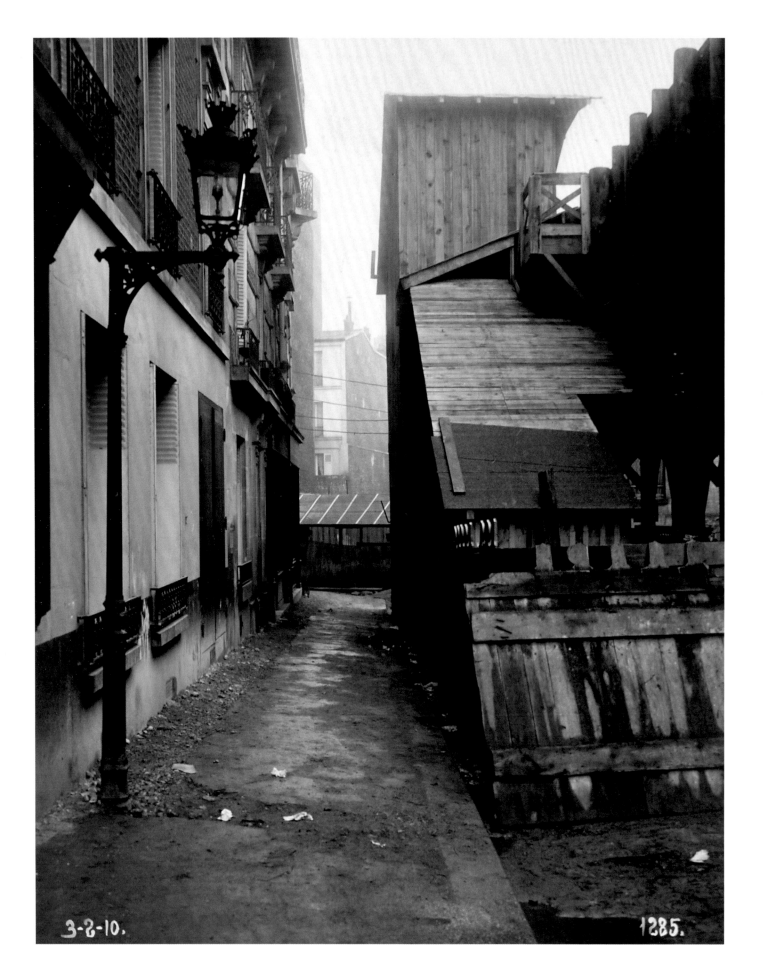

3-8-10.

1285.

Opposite: MAISON ROUX - *Construction of Line A of the Nord-Sud: "Stockade on Rue Darwin – Tortelier complaint, 8 rue Darwin,"* February 3, 1910

Above: MAISON ROUX - *Construction of Line A of the Nord-Sud: "Shaft No. 39 rue Duhesme – complaint by Arnaud Auto Rental,"* February 3, 1910

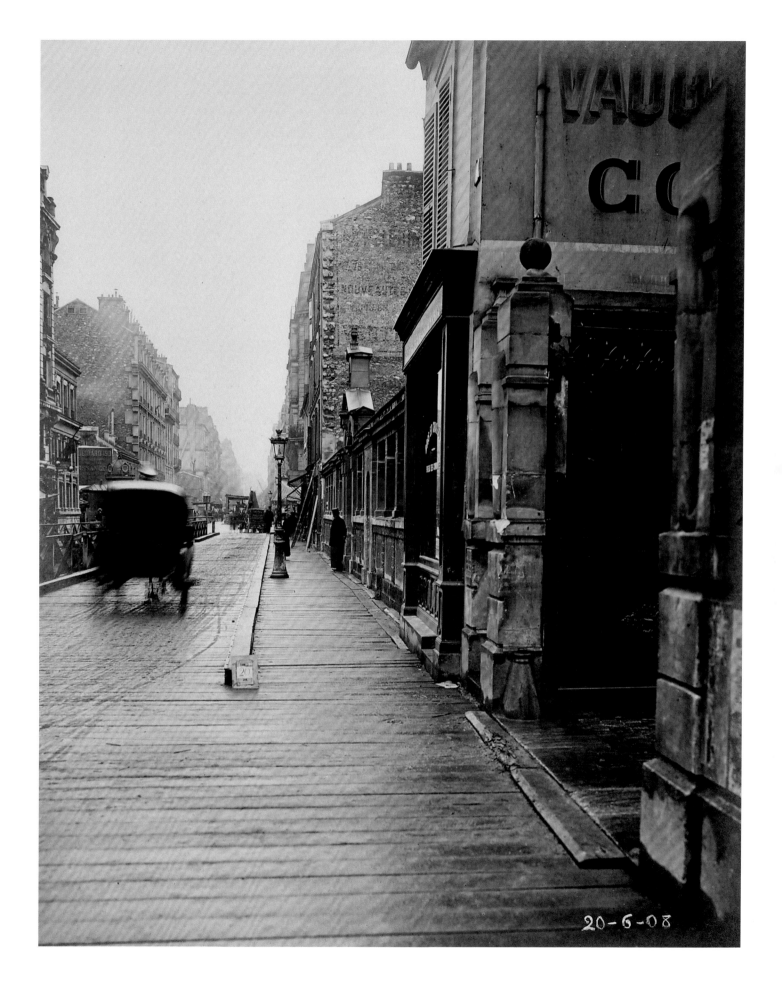

20-6-08

Preceding pages:

Left: MAISON ROUX - *Construction of Line A of the Nord-Sud:*
"Volontaires station; open shafts in front of 202 rue de Vaugirard,"
February 1, 1908

Right: MAISON ROUX - *Construction of Line A of the Nord-Sud:*
"Volontaires station; taken from the temporary bridge on the odd-
numbered side of the street," June 20, 1908

CHARLES MAINDRON - *"Departure yard at the Gare d'Orléans: the bridge*
entering the main building; looking towards the Place d'Italie," April 13,
1906

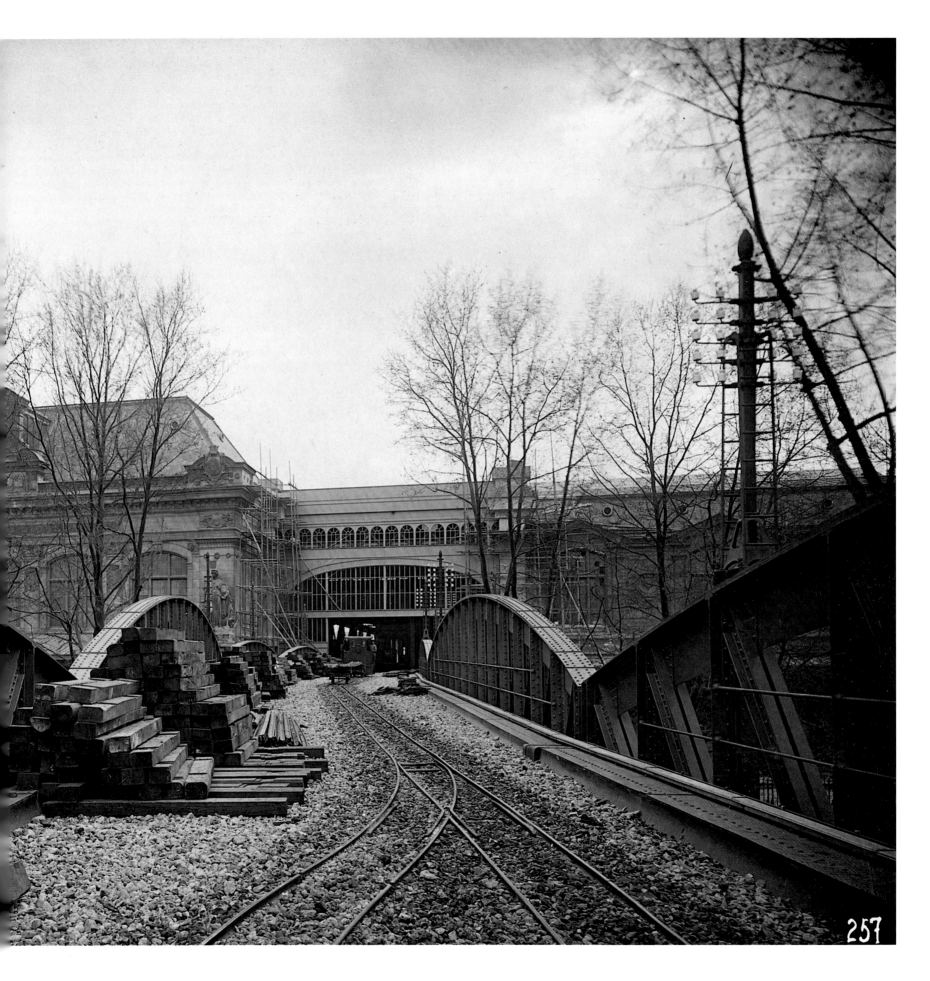

257

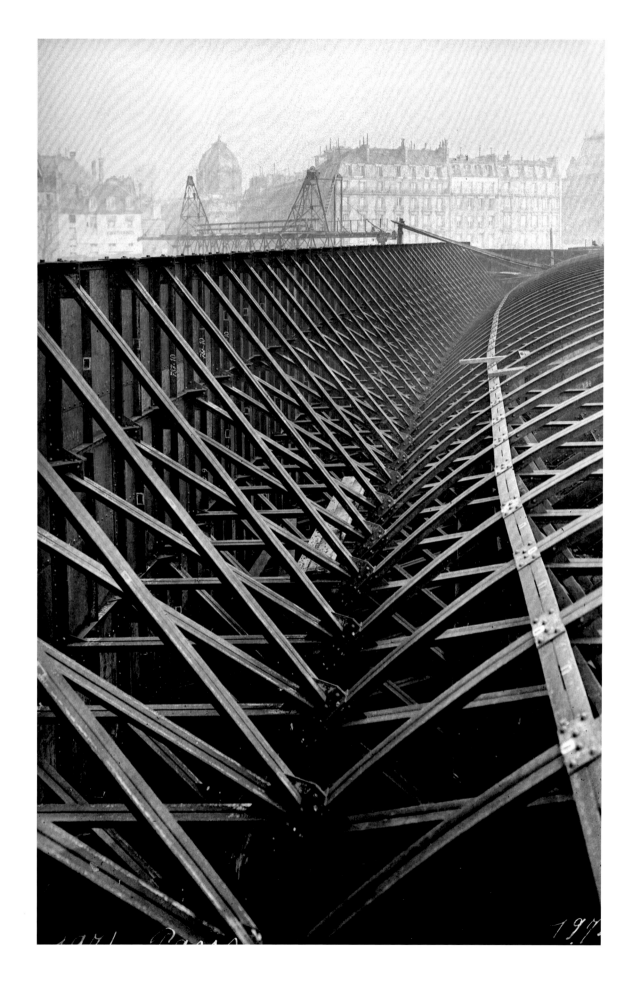

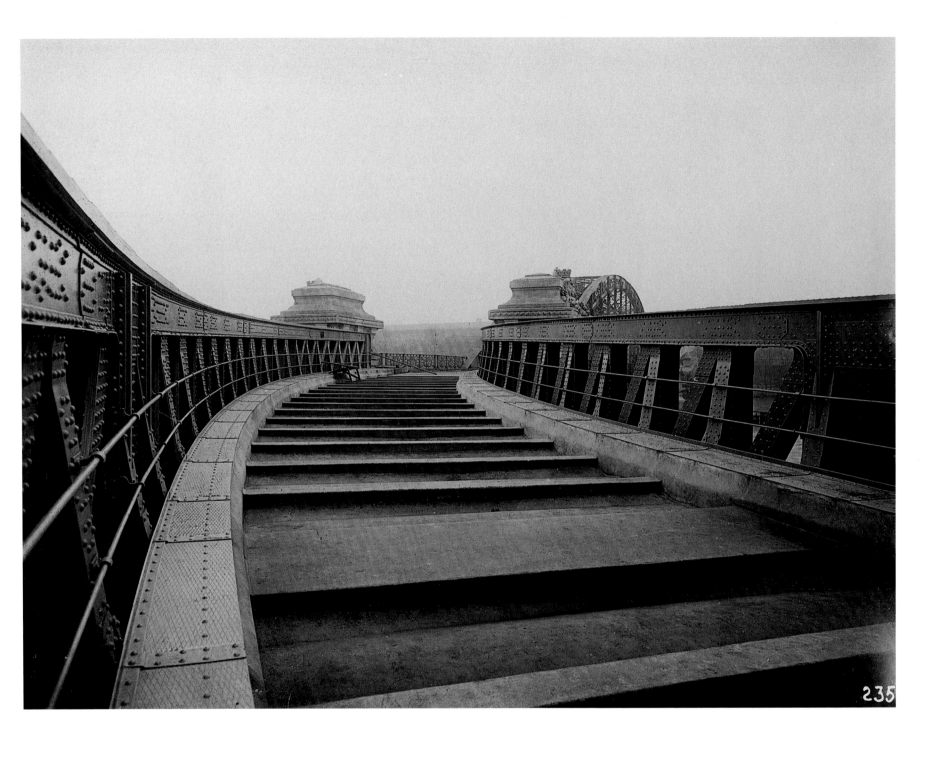

Opposite: NEURDEIN - *Construction of Line 4: "One of the sides of the station caisson at the Place Saint-Michel, before it was sunk in place,"* 1906

Above: CHARLES MAINDRON - *"Pont d'Austerlitz: helical girders on the right bank, taken from the middle of the girders; looking towards the Gare d'Orléans,"* December 20, 1905

MEURISSE AGENCY - *People waiting at the Opéra station during a transportation strike, 1919*

Next pages:

Left: MAURICE BRANGER - *Ticket-puncher in a 1st-class carriage on the Nord-Sud line, 1914-1918*

Right: ROL AGENCY - *Nord-Sud station able to serve as a refuge in case of an air raid, 1918*

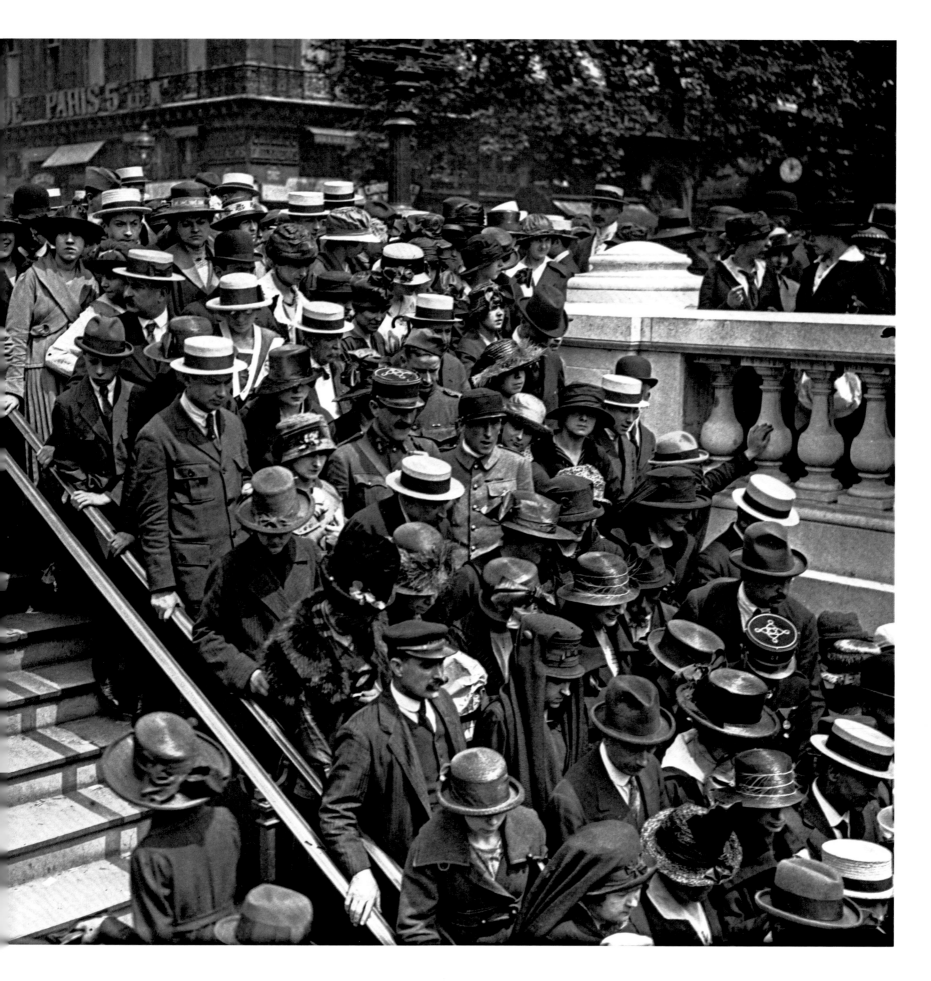

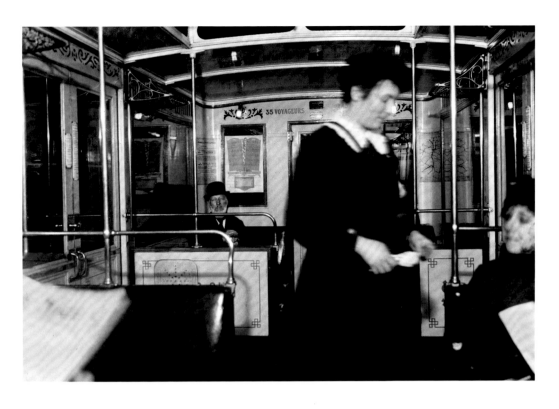

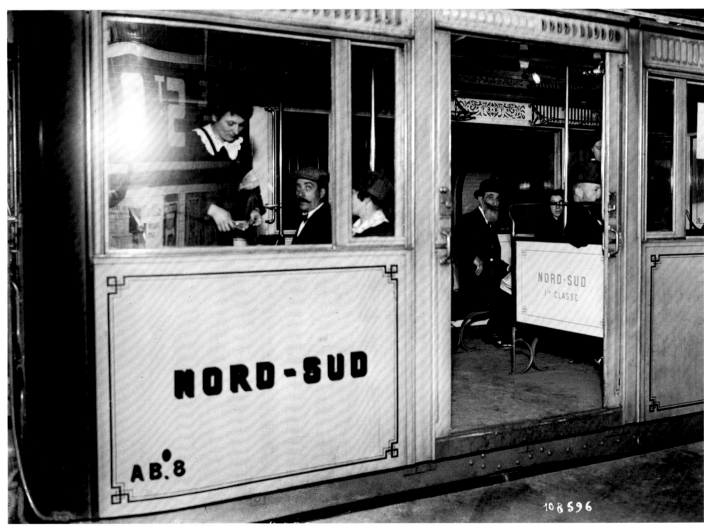

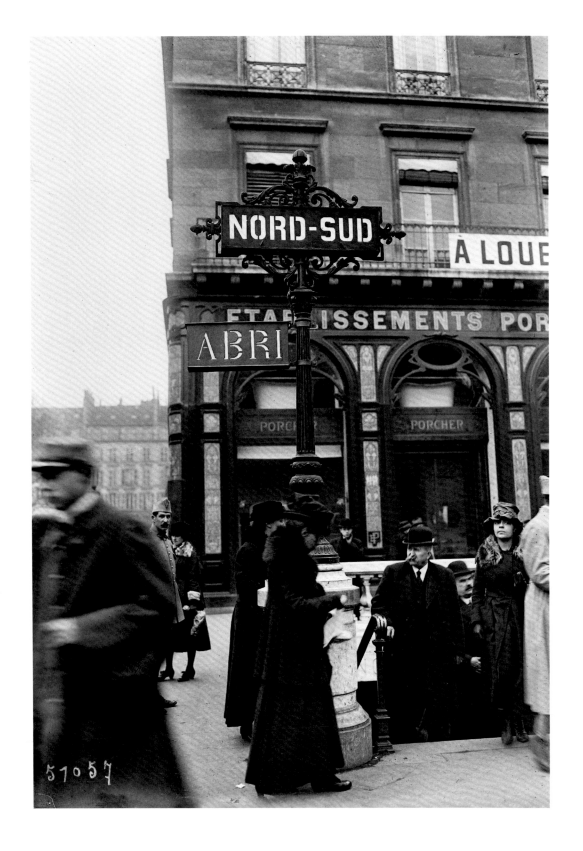

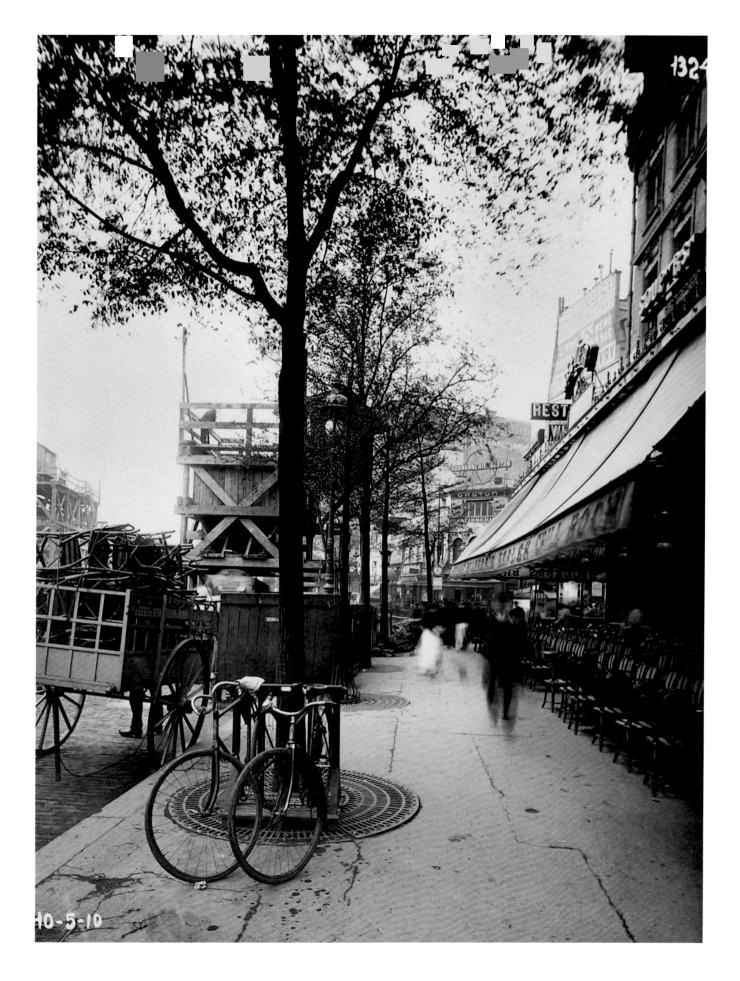

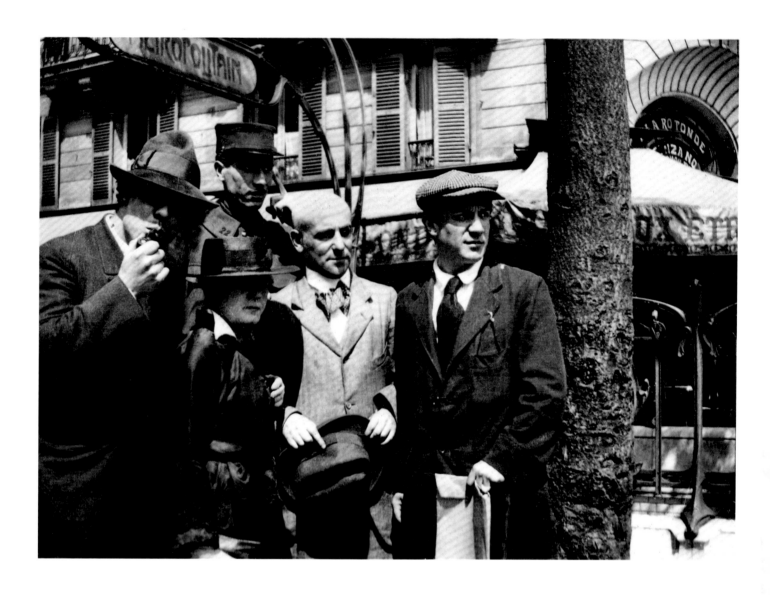

Opposite: MAISON ROUX - *Construction of Line B of the Nord-Sud: "Place de Clichy entrance; Wepler worksite,"* May 10, 1910

Above: JEAN COCTEAU - *Manuel Ortiz de Zarate, Henri-Pierre Roché, Marie Vassilieff, Max Jacob and Pablo Picasso in front of La Rotonde café,* August 12, 1916

ROL AGENCY - *Peyrusson performing his death-defying leap into the Seine from the Île aux Cygnes*, August 4, 1912

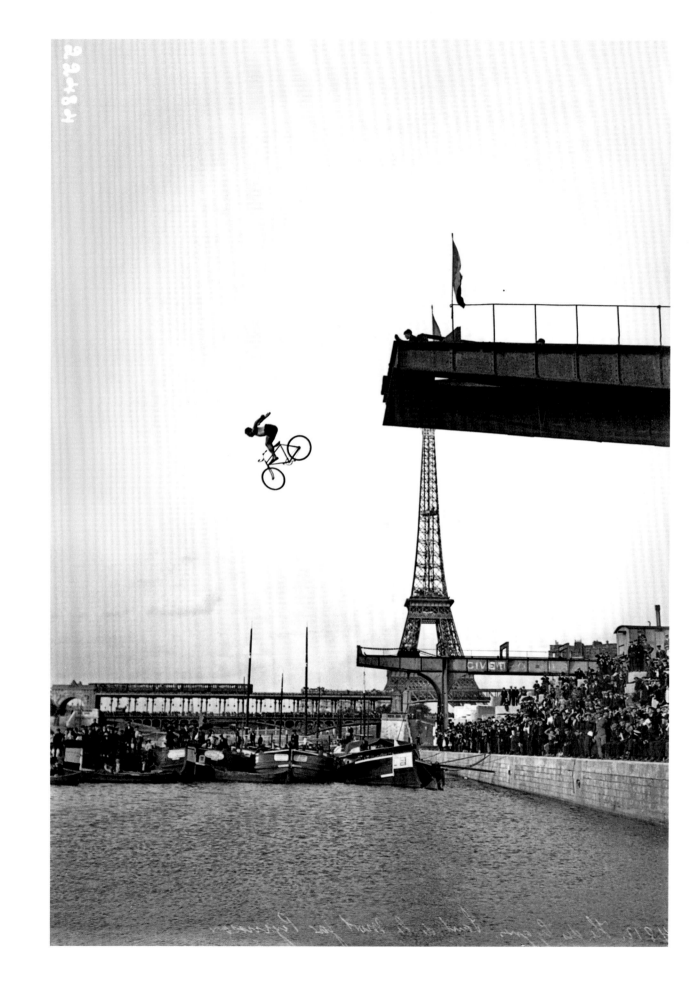

A time of artistic effervescence, the period between the two world wars is marked by a profound renewing of photographic aesthetics. Helped along by the commercialization of small, light, easy-to-handle cameras that allowed precise framing, such as the Leica or the Rolleiflex, this "New Vision" (*Nouvelle Vision* in French) became widespread throughout Europe and the United States, from the walls at exhibitions to the pages of magazines and books, as well as in advertisements. It presents characteristic traits that, while they were not without precedent, shift from isolated experimentation to an avant-garde practice with an artistic goal. An aesthetic specific to the New Vision appears that takes advantage of photographic properties, overturning along the way traditional codes of image construction. The most notable signs of this new photographic language are experiments with framing (de-centering the subject, close-ups) and point of view (higher and lower viewpoints), but also a marked interest in whatever interrogates the very nature of the medium in its relationship to inversion (negative/positive, high/low, left/right): shadows, reflections, night. All these elements can be found in the photographs of the Métro taken during this period. The examples gathered here perfectly depict the evolution of the photographic aesthetic between 1900-1920 and 1920-1940. They also bring to light another particularity of the period between the wars: the extraordinary attraction of Paris, veritable capital of the arts, cosmopolitan and multicultural. The Métro was explored and photographed at the time by a number of foreigners recently arrived in France, whether Hungarian (Paul Almasy, Brassaï, André Kertész, François Kollar, Ergy Landau, André Steiner), Romanian (Eli Lotar), German (Marianne Breslauer, Germaine Krull) or Canadian (Margaret Watkins). This inventory also highlights the central role women played in the blossoming of this photographic avant-garde.[1]

The Métro is an ideal subject for the New Vision, fond as it was of the harmonious geometric balance of industrial motifs and manufactured objects—"Metal, Inspirer of Art," as the magazine *L'Art vivant (The Living Art)* titled an article in 1929. This article was accompanied by photographs by Germaine Krull; she had just published *Métal*, which has since become a legendary book, a veritable manifesto of a new gaze. In 1928, the German photographer presented a vision of the Métro exemplary of the contemporary style: elevated point of view, close-cropped composition softened by a harmonious ballet of curved lines running side by side, opposing each other, meeting each other, guiding the gaze through this underground landscape where electricity

1920-1940

JULIEN FAURE-CONORTON

1.
On these subjects, see the foundational books by Christian Bouqueret, especially *Paris, capitale photographique 1920-1940 (Paris, Capital of Photography, 1920-1940)*, Paris: La Martinière, 2009, and *Les Femmes photographes de la Nouvelle Vision en France (Women Photographers of the New Vision in France)*, Paris: Marval, 1998.

takes the place of the sun (p. 135). Electricity is indispensable for underground views of the Métro, making them possible by exposing the negative with its rays. Electric lighting also plays a major aesthetic role, as in this instance where its brilliance makes the tiled ceiling gleam and turns the tracks into a negative of themselves. The following year, in a similar spirit, Ergy Landau offers us from the very photogenic Passy station a modernist vision made almost abstract by recourse to tightly cropped framing and strong contrast that focuses attention on the implacable symmetry of the two sets of tracks and their station platforms, whose roofs, by the miracle of shadow and light, are like two giant feathers (p. 138). In that same year, 1929, Marianne Breslauer, standing on the upstairs terrace of the Galeries Lafayette, captured the incessant ballet of pedestrians swarming around the Chaussée-d'Antin station like an entomologist observing the life of an anthill through a magnifying glass (p. 96). This choice of an elevated point of view, combined with a plunging perspective, confuses our bearings and notion of scale while, in a tangle of geometric lines, the passersby drag their shadows behind them. The result is a particularly charming image for the eye and mind that seems the work of some Gulliver with a camera. Proof of the photogenic power of such a subject, it caught the attention of a number of other photographers, who captured similar scenes either from the same point of view (Roger Parry, Fred Stein) or from a lower level (a photographer from the *Excelsior* for an article on road safety), even from the windows of the second floor of La Rotonde (Paul Almasy).

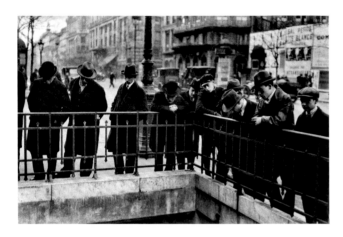

ELI LOTAR - *Paris*, circa 1927

2.
"On a dark 'outer boulevard', spanned by a Métro bridge, the station-lights offer their reassurance to the nervous wayfarer." (Brassaï, *Paris by Night*, New York: Pantheon Books, 1987, trans. Stuart Gilbert, caption to plate 47.)

3.
Idem, caption to plate 38.

The period between the wars is also characterized by a keen interest in nighttime photography, where artificial lighting triumphs, especially that of the glowing signs that transform Paris into a huge crossword puzzle (pp. 97, 98, 123). The high point of this fascination for the potential aesthetic of darkness is *Paris de nuit (Paris by Night)*, the result of Brassaï's nighttime strolls, published in 1933; the book gathers together several views of the Métro, whose lights hold the promise of a refuge for "the nervous wayfarer."[2] The oppressive grip of the night diminishes once the platform is reached, and "at 1.1 AM the 'last train out', the impecunious nightbird's last resort, enters the Palais-Royal station" (p. 134).[3] Substituting shadow for light, black for white, the night fascinates photographers, whose medium seems regulated by the same rules. But that is not the case at all, and "night is not the negative of day," as Paul Morand proclaims in the beginning of his introduction to *Paris by Night*: "Black surfaces and white are not merely transposed, as on a photographic plate, but another picture

altogether emerges at nightfall."[4] And, in fact, nocturnal subjects, when photographed, do not offer to the gaze an exactly opposite counterpart of their daytime aspect, so true is it that night transforms things, conferring a surreal quality on them.

A product of the 1920s and '30s, Surrealism impregnated the photography of the time, and some works by Brassaï are closely linked to it. This is especially true for his remarkable series devoted to the Métro entrances designed by Hector Guimard. Some served as illustrations for an article by Salvador Dalí published in December 1933 in the journal *Minotaure* under the evocative title, "On the Terrifying and Edible Beauty of Modern-Style Architecture."[5] Without equivalents in the history of photographs of the Parisian Métro, these compositions transfigure Guimard's vegetal architecture, whose traceries become by turns a bird of prey, a praying mantis, an African mask (p. 85) or a giant leaf (p. 117). One of the most striking, entitled *Mange-moi!* (*Eat Me!*, p. 119), possesses a power of evocation rarely equaled, a misshapen mask with empty eyes that stare unflinchingly out at us. Equally phantasmagorical is the man with the hat hidden in a pillar in the Corvisart station (p. 118). The print presented here, lesser known than another version in landscape format,[6] is remarkable in every point. Brassaï reframed his negative to keep only the profile formed by the pillar's shadow, thereby transforming his landscape into a portrait. This apparition, in which Brassaï saw the profile of an Easter Island statue, was published in 1935 in *Minotaure*.[7] Despite the obvious Surrealist quality one can find in these different works, they above all exemplify the power of interpretation of reality unique to the photographic medium. Nonetheless, Brassaï always defended the realistic dimension of his photographs.[8]

Brassaï was unquestionably attentive to reality. He scrutinized all its aspects, without prejudice. He is one of the first to represent a tramp in the Métro (p. 109). Even in this seemingly "socially conscious" subject, though, Surrealism is not far away, through the play of mental associations produced by the intrusion of text into the image: "Chemin" ("Path"), "Menier," "Rome"… In 1932, the image was published in *Paris-Magazine* with the caption, "Tous les chemins mènent à ROME" ("All roads lead to ROME").

Another emblematic figure of the New Vision, the Hungarian André Kertész also turned his attention to marginal people whose isolation echoed his own status as an immigrant with a poor mastery of French—hence the poster-man near the Galeries Lafayette (p. 105) or the lily-of-the-valley seller in 1929 on the Champs-Élysées (p. 111).

4.
Introduction by Paul Morand in *Paris by Night*, New York: Pantheon Books, 1987, trans. Stuart Gilbert. 5.
S. Dalí, "De la beauté terrifiante et comestible de l'architecture modern'style," *Minotaure*, No. 3-4, December 1933, pp. 69-76 (illustrations by Brassaï and Man Ray).

6.
Cf. Centre Pompidou, Paris (AM1995-237) and the Metropolitan Museum of Art, New York (1980.1029.7).

7.
Cf. "Il n'est pas encore trop tard" ("It Is Still Not Too Late"), *Minotaure*, No. 7, June 1935, p. 31.

8.
Cf. F. Béquette, "Rencontre avec Brassaï" ("Meeting with Brassaï"), *Culture et communication*, No. 27, May 1980, p. 15.

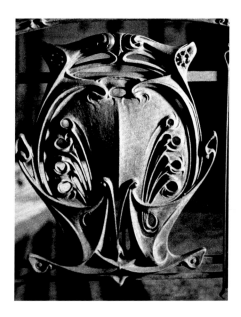

BRASSAÏ - *"Métro" (Guimard escutcheon)*, 1931-1933

Like a good gardener,[9] Kertész was patient, hardworking and methodical. His photographs were not taken casually, but thought-out and ripened by recording several aspects of the subject, of which only the most successful was finally chosen to be printed and distributed. In the case of the lily-of-the-valley seller, the series includes six different shots, three of which show the conclusion of a sale. But the photo Kertész chose to keep is that of a man invisible to the eyes of a Parisian woman rushing to catch her train.

Modernity of vision, as well as a surrealist quality, are mostly inherent to the very nature of the photographic, since many images that present those very characteristic traits were actually conceived of from a purely "documentary" or "informational" perspective. This is especially true for certain views of worksites, whether they were taken for the CMP (pp. 86 and 136) or for press agencies in search of stories (pp. 88, 91 and 137). And what could be more surrealistic than that suspicious package at the Vaugirard station (p. 103), where the offensive object looks more like a box of *petits fours*?

The period between the two world wars is also a time when richly illustrated newspapers and news magazines proliferated (thanks to the development of the rotogravure). Spotlighting photoreports, these publications with their elaborate and often innovative page designs would be the main field of expression for photography of the time, whose modernity and experimental nature they encouraged and even provoked. The goal was to constantly interest readers, who were eager, as they leafed through their weekly magazines, to be surprised, captivated and amused at every page. It was thanks to the articles commissioned by these journals that photographers like Kertész, Krull, Brassaï, Lotar and Roger Schall made their living. The subjects dealt with in the pages of these magazines were numerous and varied, and they included, of course, the Métro. In 1931, the continuation of Line 8 towards the Porte Dorée for the Vincennes Colonial Exhibition prompted *Voilà*, the "weekly news magazine" that had just been created, to publish "The Lights Under the City," a Jules Verne-like story about the author's visits —Henri Danjou— to the underground worksites of the Métro.[10] Taking up two pages, the article is accompanied by eight photographs (uncredited), which for the most part are commonplace, with the exception of one showing, from a dizzying and destabilizing

UNIDENTIFIED PHOTOGRAPHER (RATP COLLECTION) -
Reinforcing the Pont d'Austerlitz, 1935

9.
Cf. M. Frizot, "Jardinier. Mine de rien" ("The Unassuming Gardener"), in *André Kertész. Ma France*, Paris: La Manufacture, 1990, pp. 153-163.

10.
H. Danjou, "Les lumières sous la ville," *Voilà*, No. 3, April 11, 1931, pp. 14-15.

perspective, a bucket being lowered into a gaping hole made in the pavement ("The tub descends into the gutted shaft," p. 91). In 1932, *L'Image* in turn took an interest in the Métro through an article painstakingly illustrated by Schall and cutely titled "Ants at Night."[11] It was again the mysterious nocturnal life of an underground railroad that, in 1937, was revealed to the readers of *Regards* in a "cover story" with a promising title: "Behind the Scenes at the Métro." Eight photographs, uncredited and given purely technical captions ("Aluminothermy: welding operation on the third rail," p. 90), illustrate the subject.[12] This is, above all, a praise of the hard labor of the Métro workers; their bravery is foregrounded by *Regards*, a journal whose founding was spurred by the Communist Party. So it was not the daily life of the Métro and its incessant flow of passengers that interested the illustrated magazines, but rather the promise of the unusual, the aspects that were inaccessible to its users. Some articles, however, adopted a different tone. This was the case in 1940 in *VU* with "In the Métro," a literary story by Francis Carco. Here, there is no copiously illustrated article (only one photograph, uncredited, appears above the text), but a piece of fiction with the feel of a detective story in which the narrator shares the Métro car with a man who is behaving strangely, who turns out to be a murderer.[13]

Finally, the 1920s and '30s marked the beginning of a poetization of the Métro by photography, a tendency that would assert itself after the Second World War, even becoming emblematic of the period. This romantic vision of an eternal Paris is particularly obvious in certain photographs by Brassaï (p. 123) or Schall (p. 94), but especially in René-Jacques (p. 124), whose remarkable snowy view of the elevated Métro was used as a cover for Carco's book *Envoûtement de Paris (Enchantment of Paris)* in 1938 (p. 125).[14] Numbering among the most extraordinary photographs of this period, Roger Parry's images also stem from this poetic tendency, combined with a rare originality of vision. Unusual perspectives and long exposures produce highly fantastic and resolutely modern images, where deserted platforms mingle with phantom travelers and will-o'-the-wisps (pp. 140 and 141).

11.
D. Abric, "Fourmis nocturnes," *L'Image*, No. 29, 1932, pp. 5-8.

12.
J. Fouquet, "Les coulisses du métro," *Regards*, No. 156, January 7, 1937, pp. 12-13. A ninth photograph, credited "photo Léveille," is reproduced on a full page on the magazine's back cover.

13.
Francis Carco, "Dans le métro," *VU*, No. 631, April 17, 1940, p. 244.

14.
Francis Carco, *Envoûtement de Paris*, Paris: Grasset, 1938. Illustrated with 112 photographs by René-Jacques whose captions are excerpted from the text.

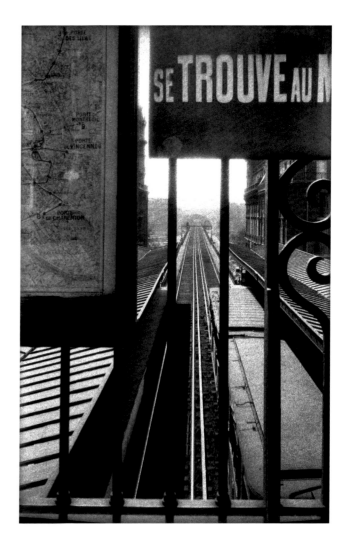

FRANÇOIS KOLLAR - *Passy footbridge (from "The Railway" series for* La France travaille [France Works] *commission)*, 1931

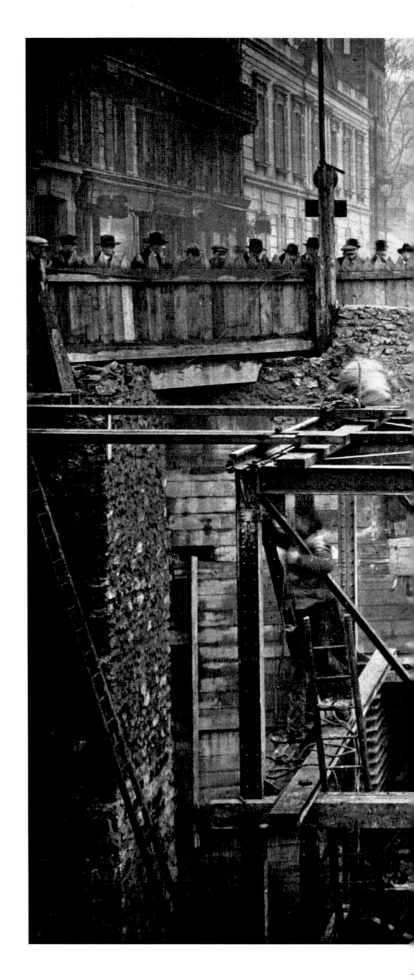

MEURISSE AGENCY - *Opening the roof of the Métro during the demolition of the Batignolles tunnel*, 1923

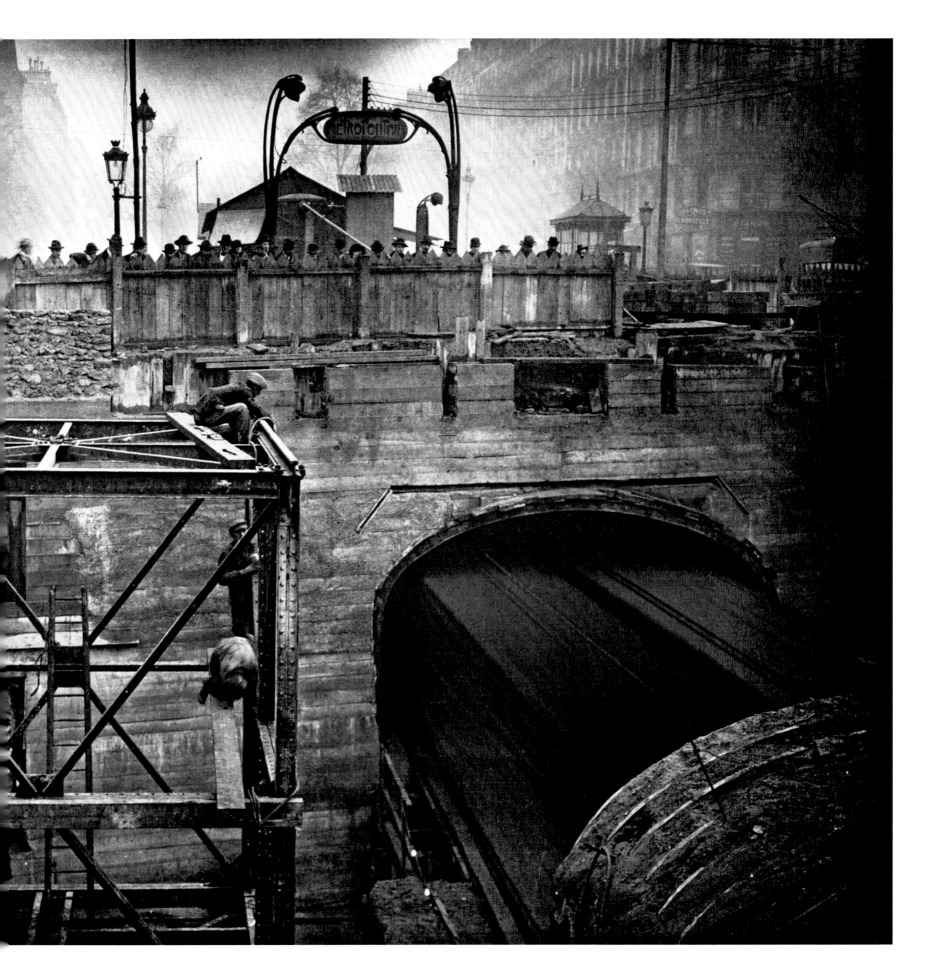

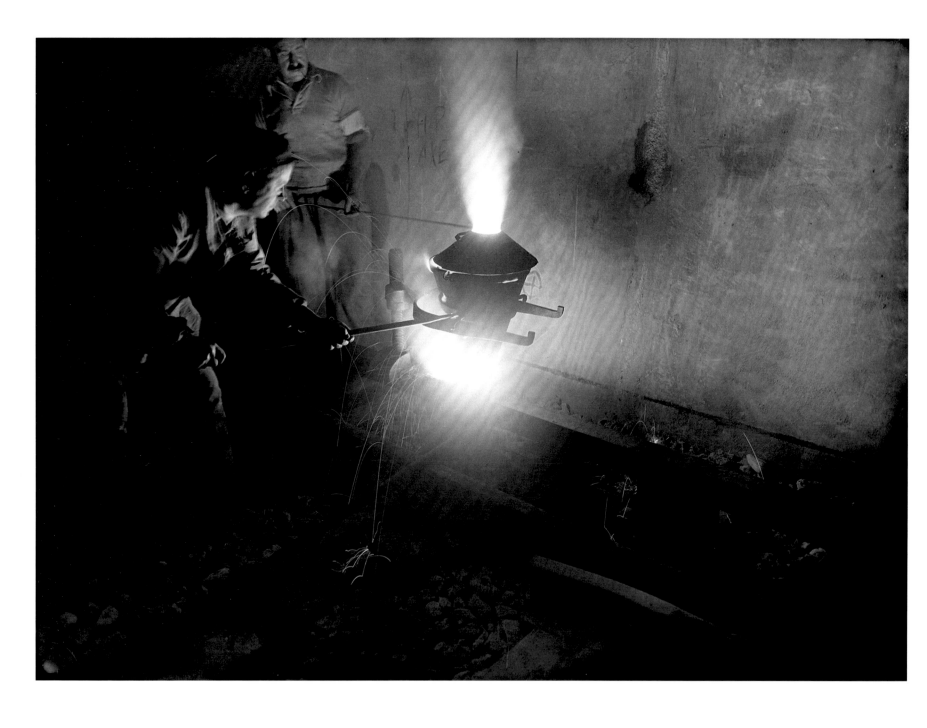

UNIDENTIFIED PHOTOGRAPHER (RATP COLLECTION) - *"Aluminothermy: welding operation on the third rail,"* November 7, 1934

KEYSTONE AGENCY (PARIS) - *"The tub descends into the gutted shaft,"* 1929

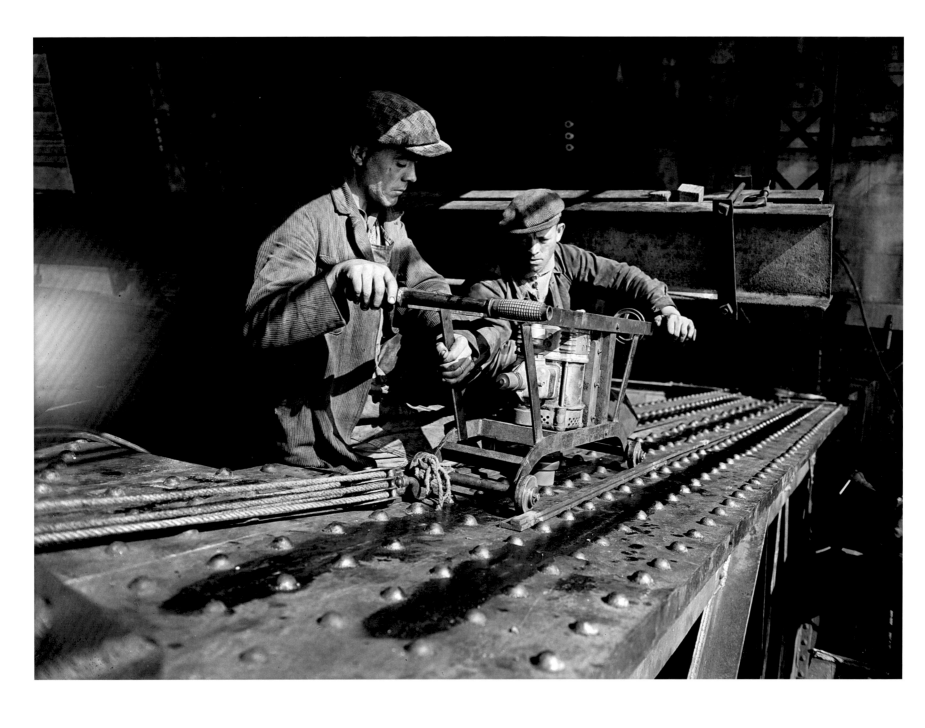

UNIDENTIFIED PHOTOGRAPHER (RATP COLLECTION) - *Preparing to set in place the reinforcing structure under the springing arches of the Pont d'Austerlitz (grinding)*, September 6, 1935

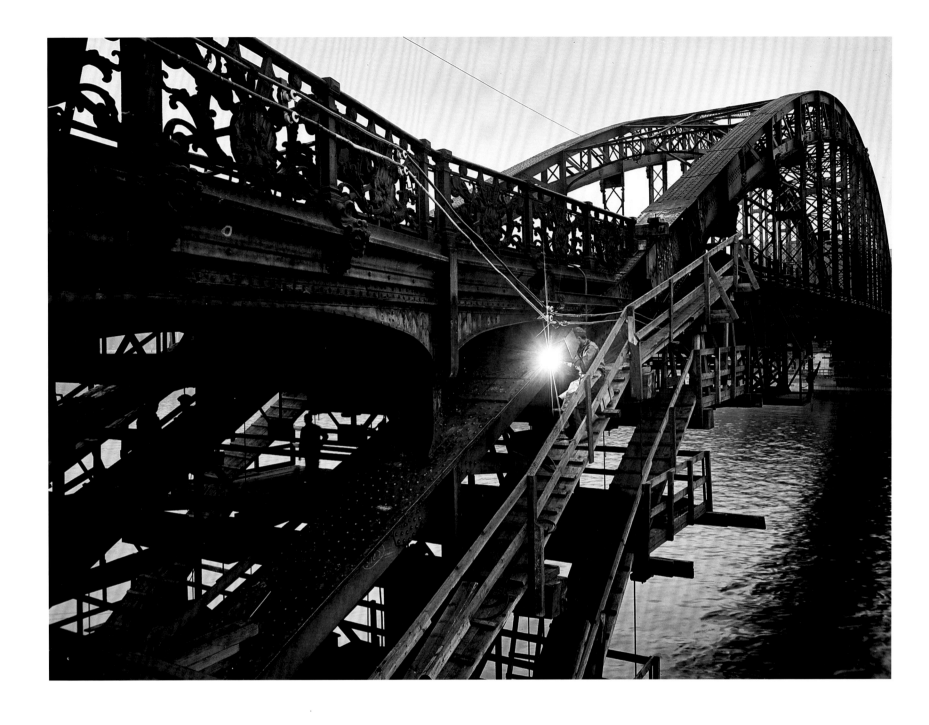

UNIDENTIFIED PHOTOGRAPHER (RATP COLLECTION) - *Preparing to set in place the reinforcing structure under the springing arches of the Pont d'Austerlitz (welding)*, July 1, 1935

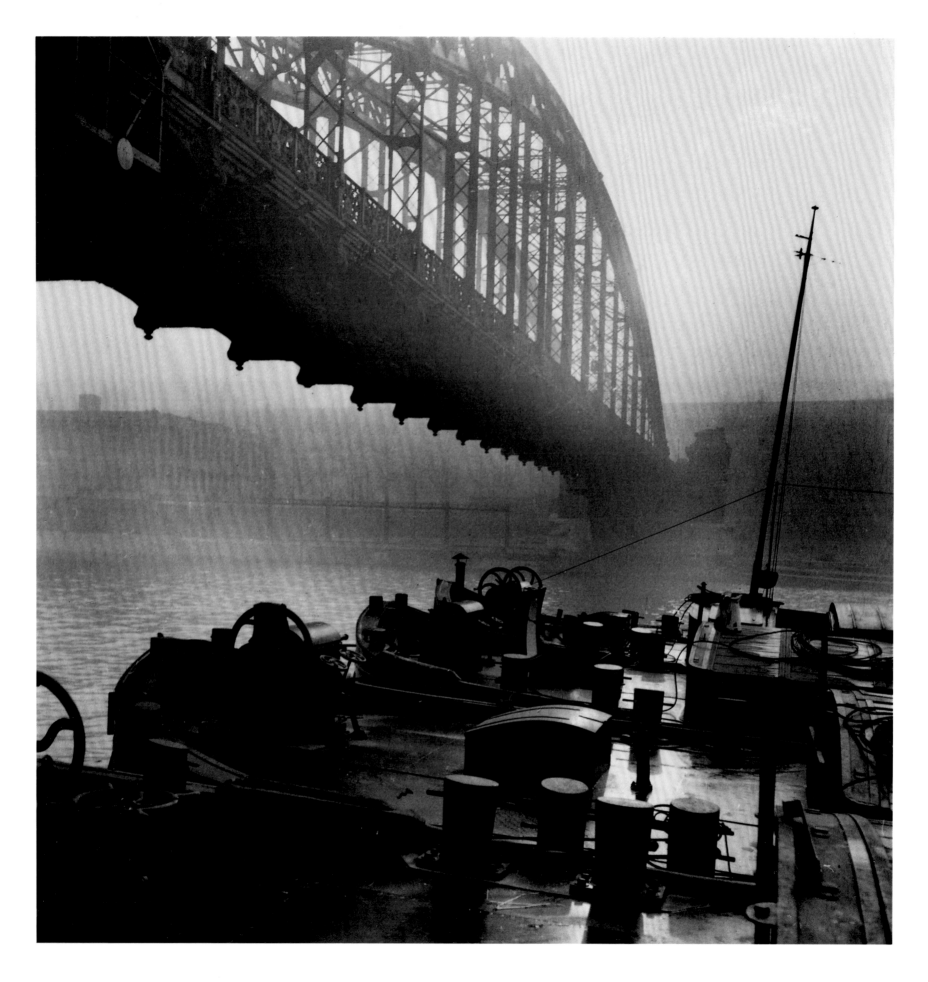

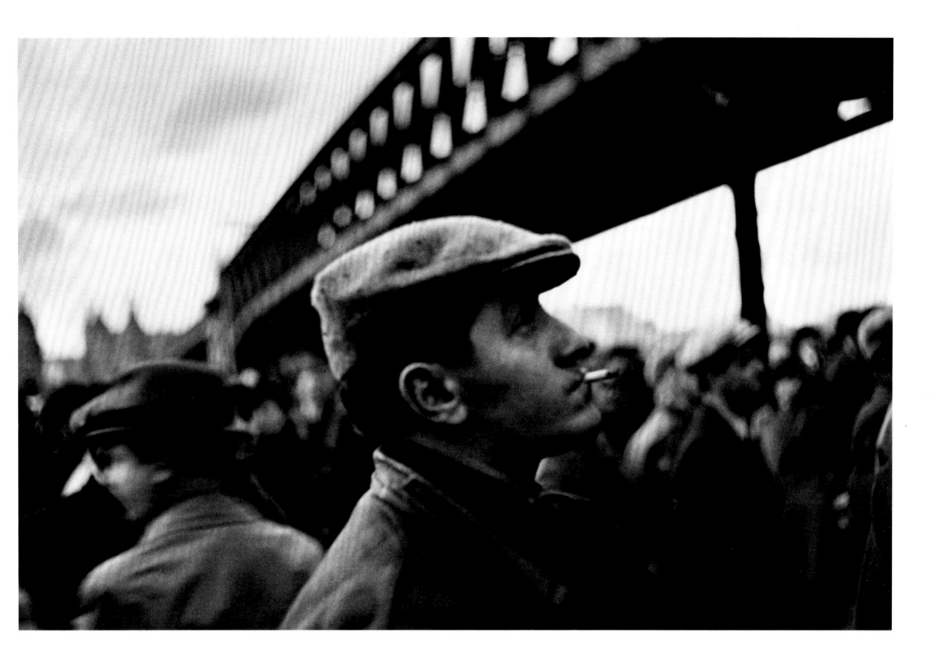

Opposite: ROGER SCHALL - *Fog on the Pont d'Austerlitz*, 1937

Above: ROBERT CAPA - *Workers on strike, Quai de Grenelle*, May-June 1936

Next pages:

Left: MARIANNE BRESLAUER - *La Rotonde*, 1929

Right: ROGER SCHALL - *Richelieu-Drouot crossroads at night*, 1935

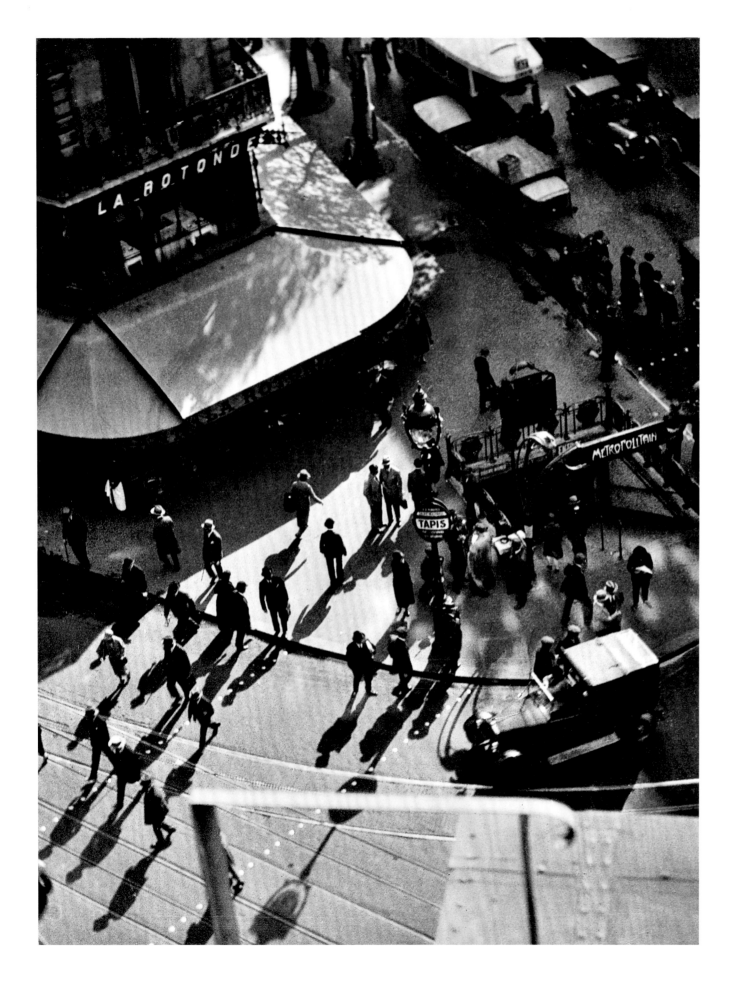

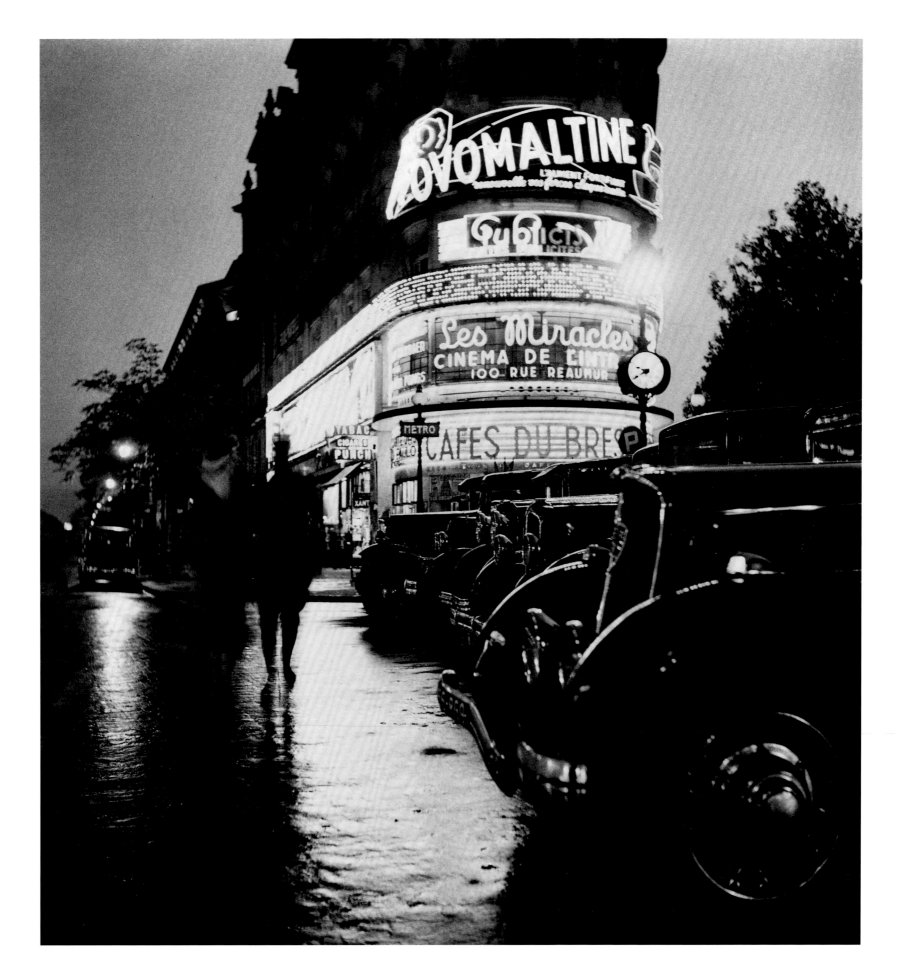

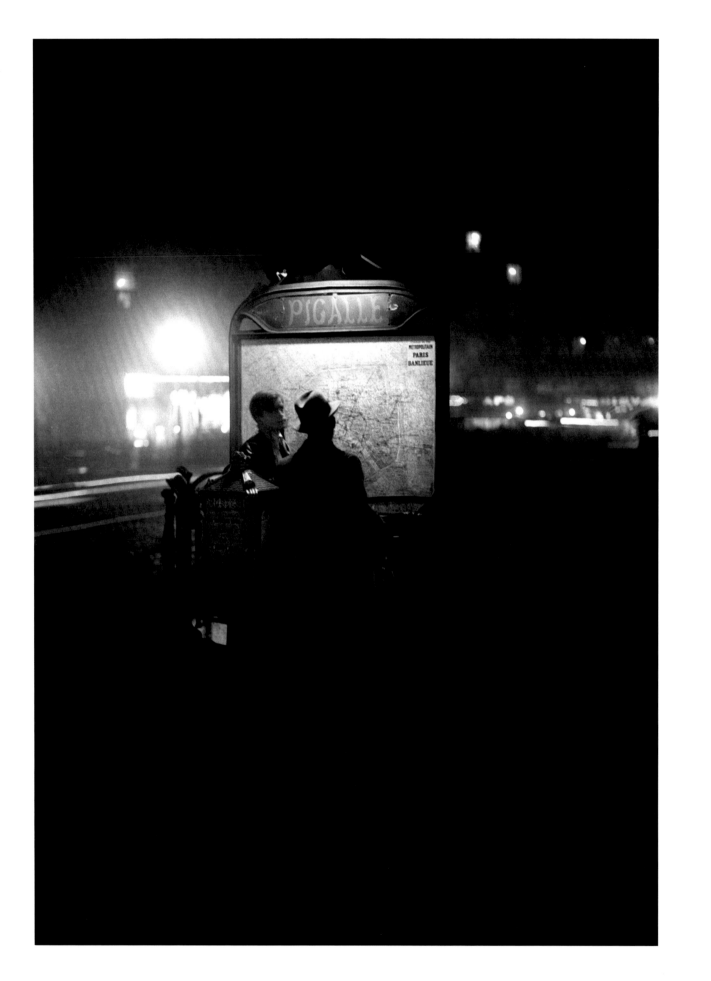

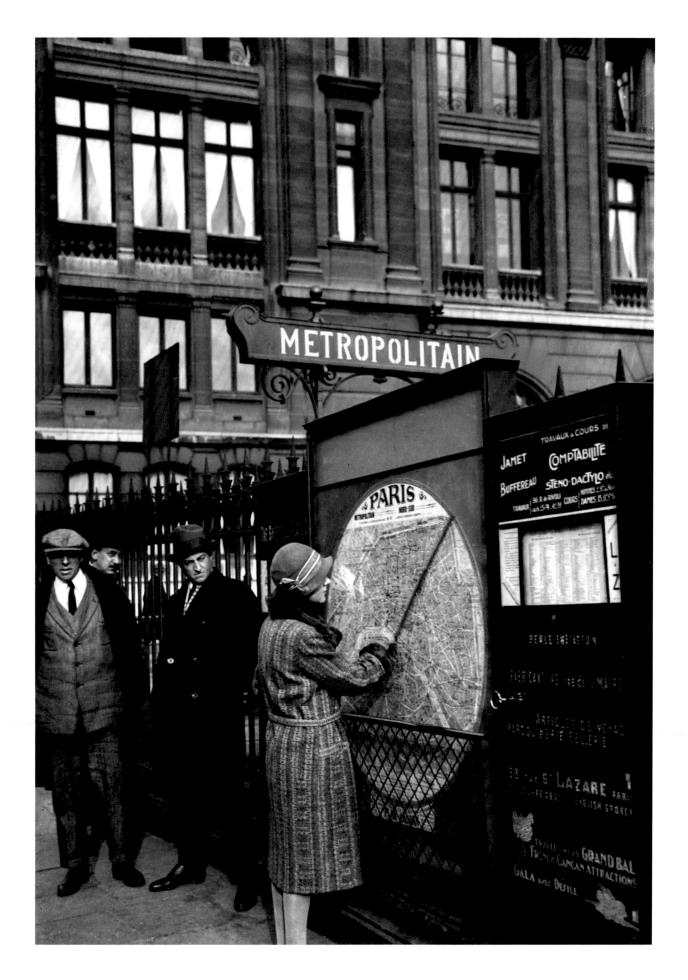

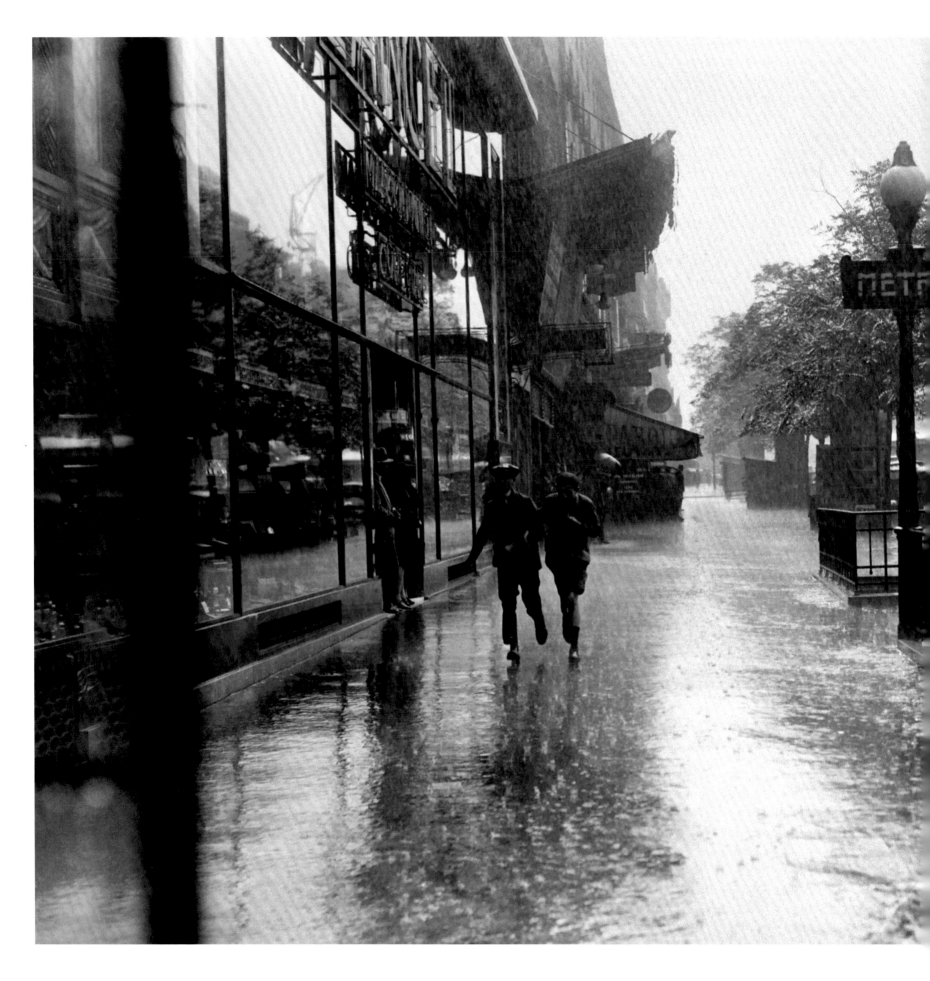

Preceding pages:

Left: HENRI MARTINIE - *Pigalle station at night*, 1930

Right: UNIDENTIFIED PHOTOGRAPHER - *Map guide with planimeter at the Gare Saint-Lazare station*, 1930

KEYSTONE AGENCY (PARIS) - *Rainy day*, July 1929

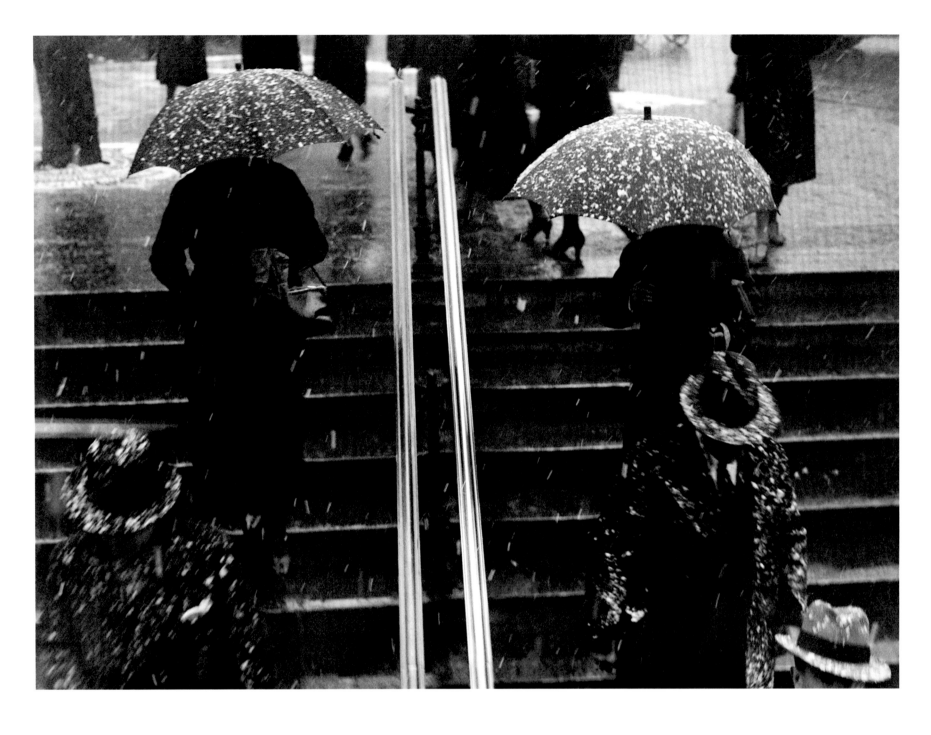

KEYSTONE AGENCY (PARIS) - *Snow in Paris*, February 1933

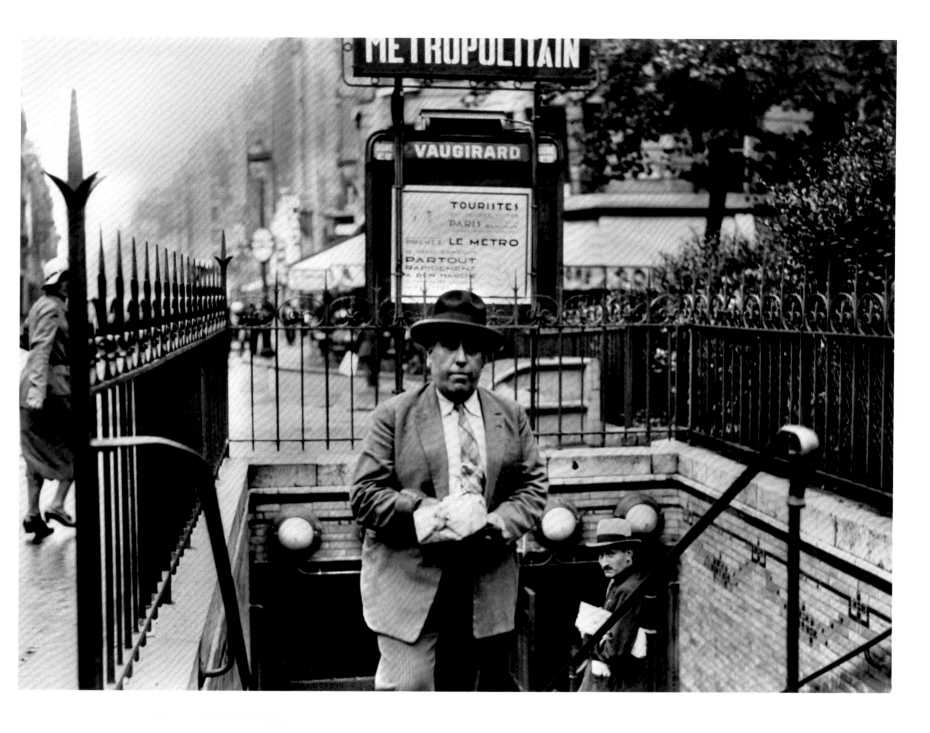

KEYSTONE AGENCY (PARIS) - *Suspicious package at the Vaugirard station*, 1934

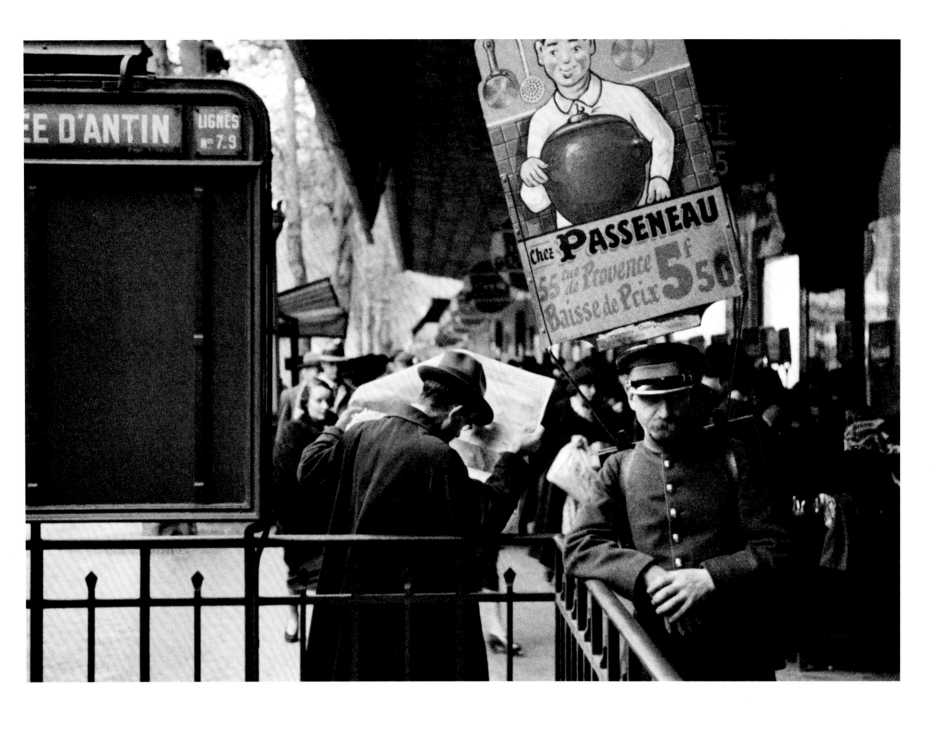

Opposite: ROGER PARRY - *Let's drink a Coke (closed station)*, 1939-1945

Above: ANDRÉ KERTÉSZ - *Near the Galeries Lafayette*, 1928

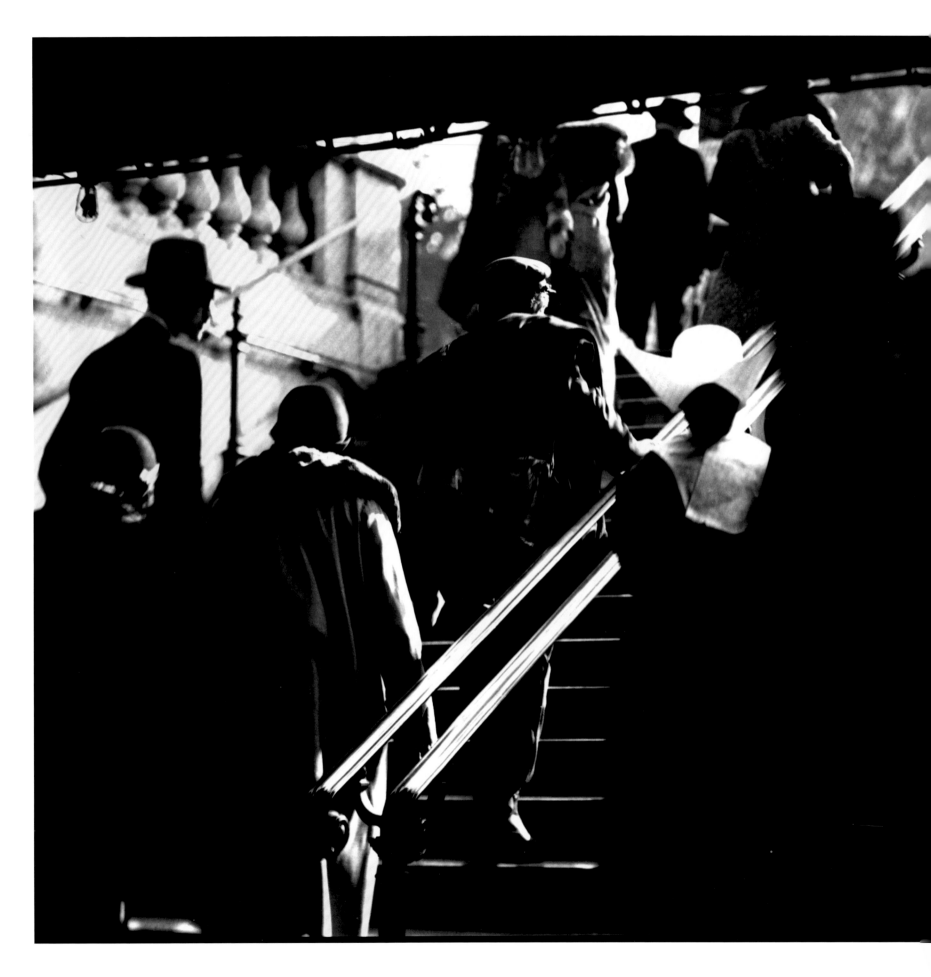

MARGARET WATKINS - *At the Métro exit*, 1930s

BRASSAÏ - *"All roads lead to ROME,"* circa 1932

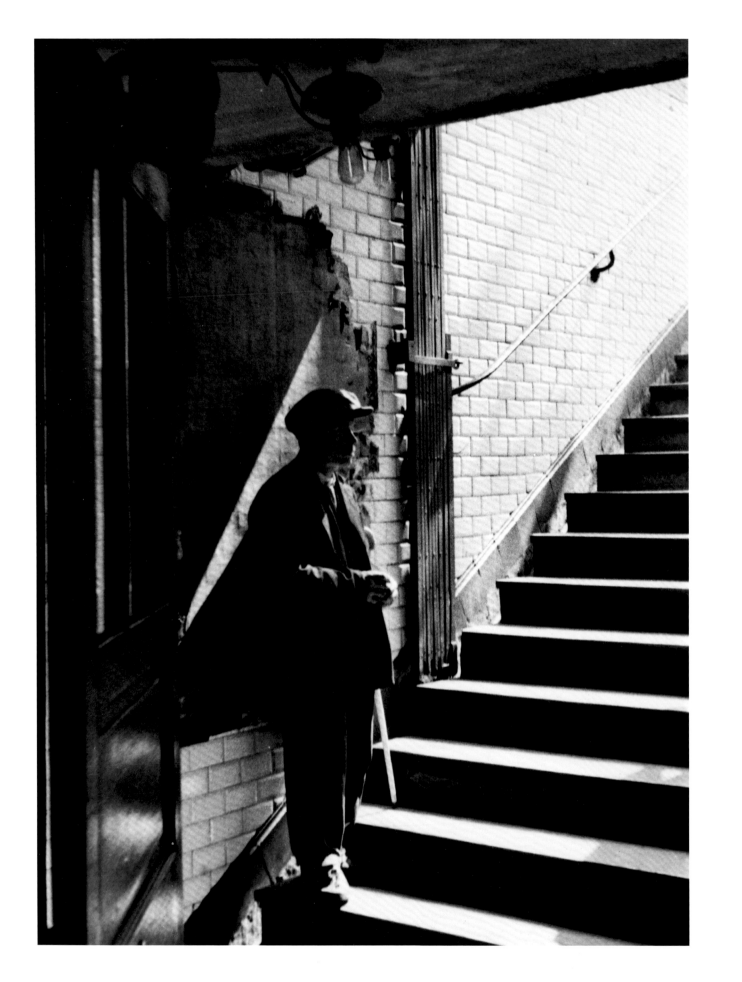

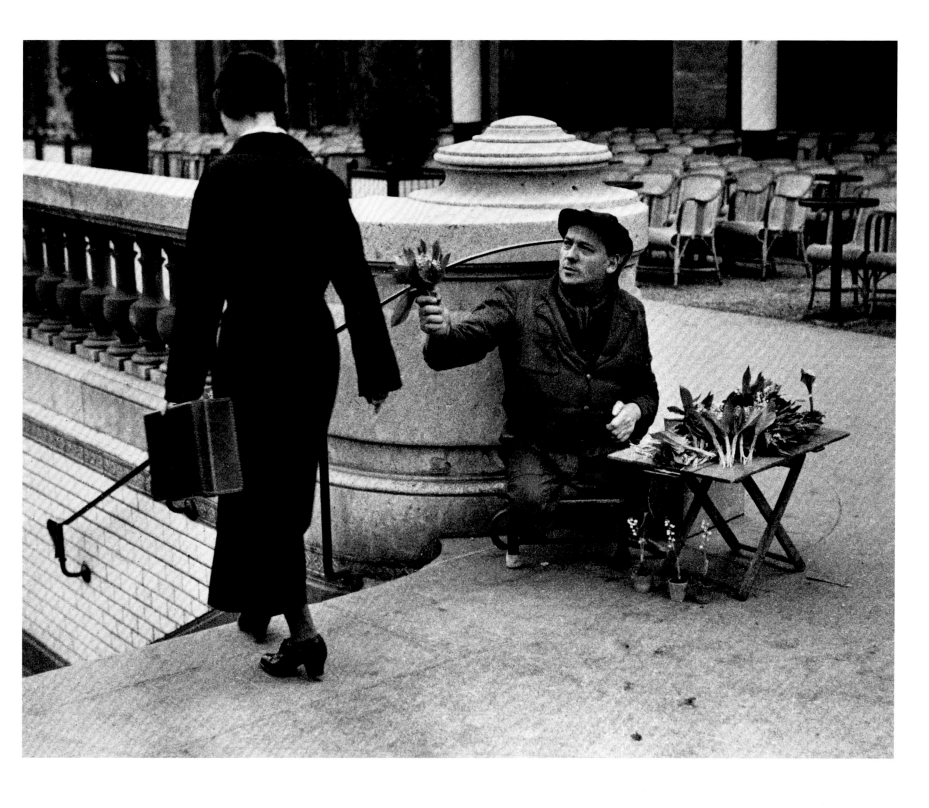

Opposite: ANDRÉ STEINER - *Blind beggar at a Métro exit,* 1935

Above: ANDRÉ KERTÉSZ - *"Champs-Élysées,"* May 1, 1929

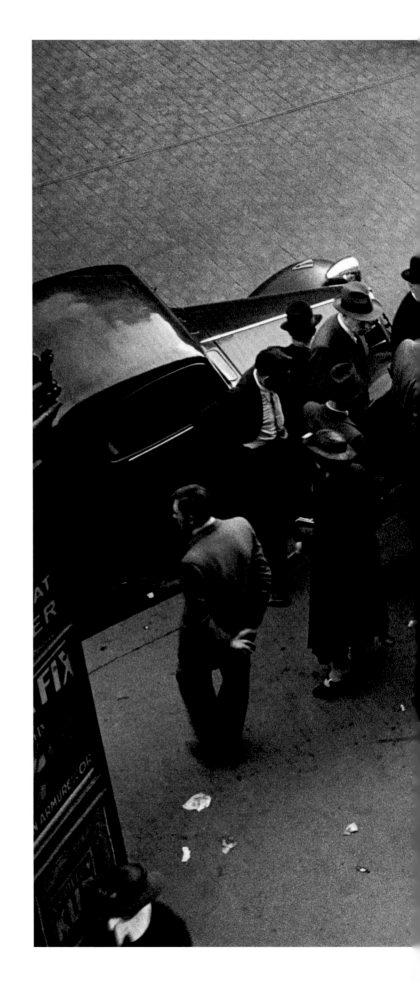

PAUL ALMASY - *Outside the Rue Montmartre station (from the "Odd Jobs in Public Spaces" series)*, 1937

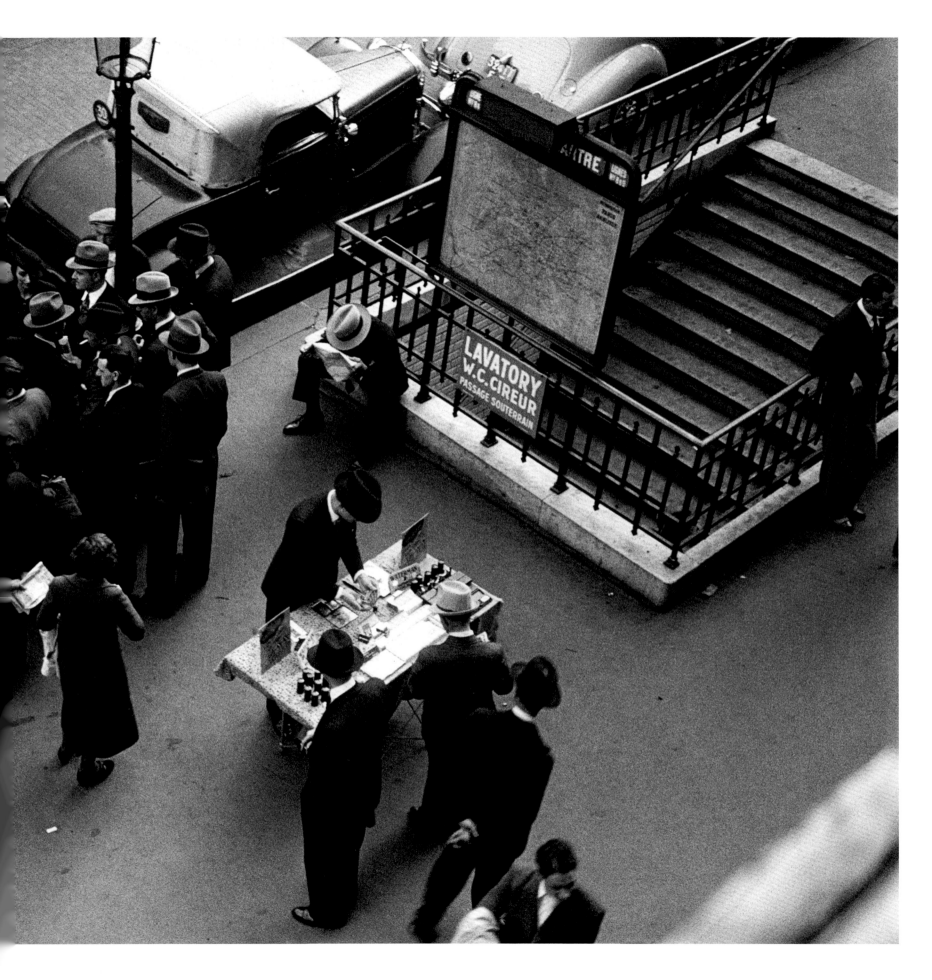

UNIDENTIFIED PHOTOGRAPHER - *Porte de Vincennes station*, 1934

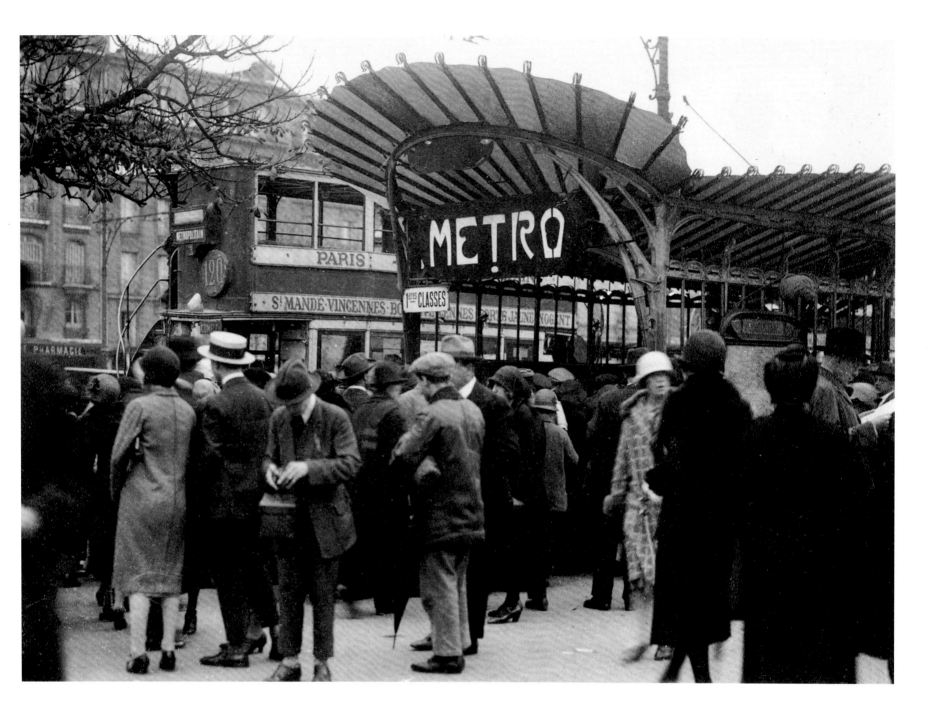

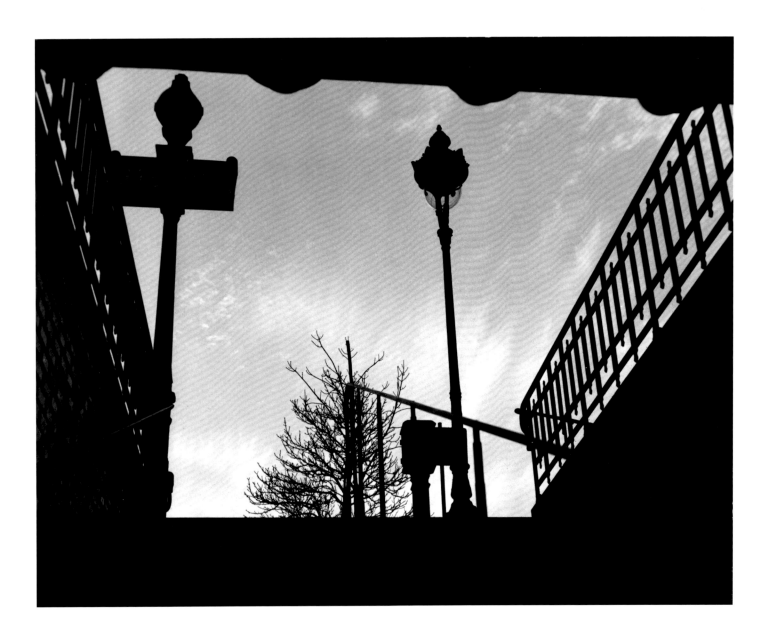

Above: ROGER PARRY - *Métro entrance*, December 1939

Opposite: BRASSAÏ - *"Bastille Station,"* 1931-1933

Next pages:

Left: BRASSAÏ - *Pillar under the Corvisart station,* 1934

Right: BRASSAÏ - *"Eat Me!",* 1933

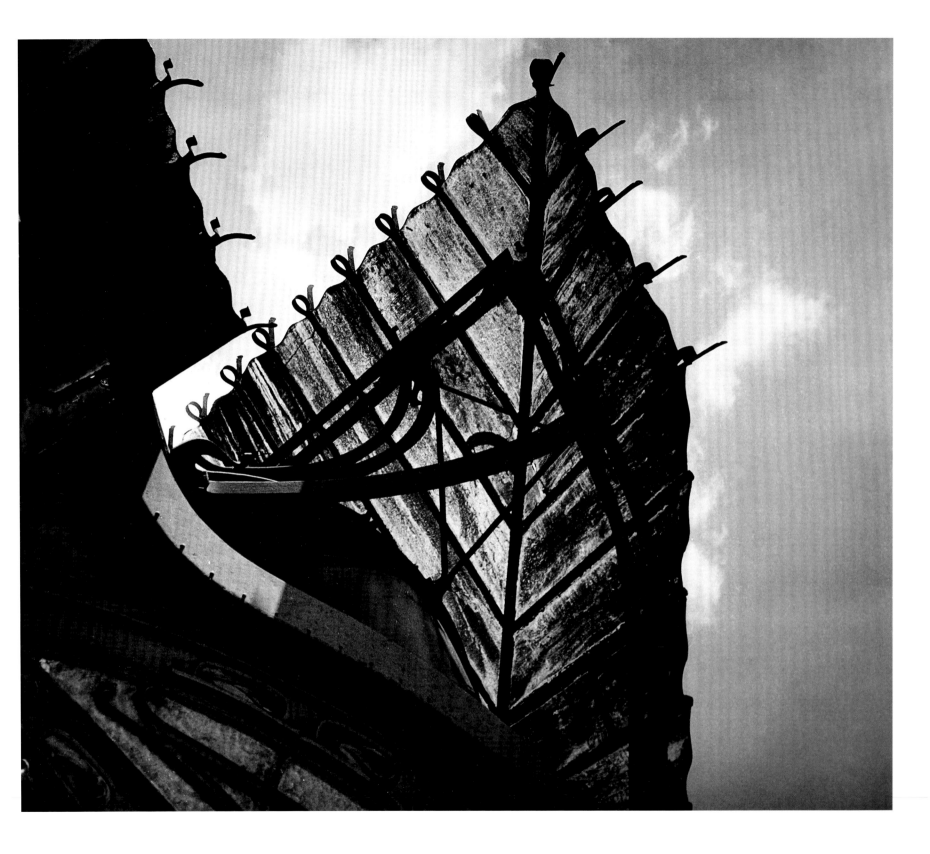

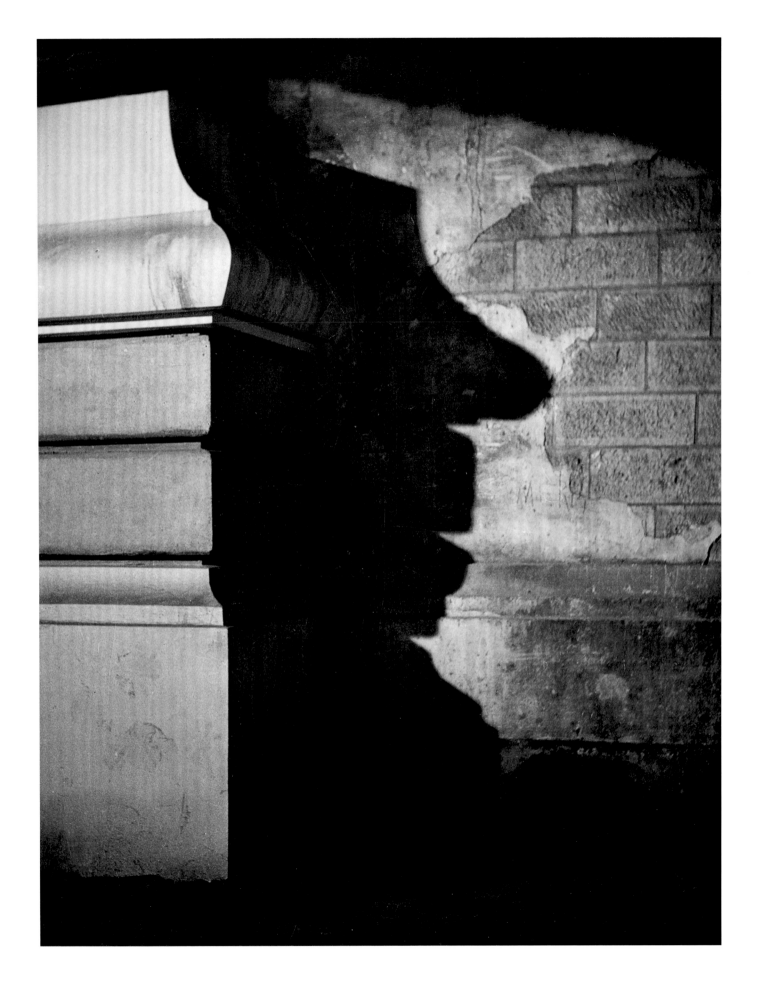

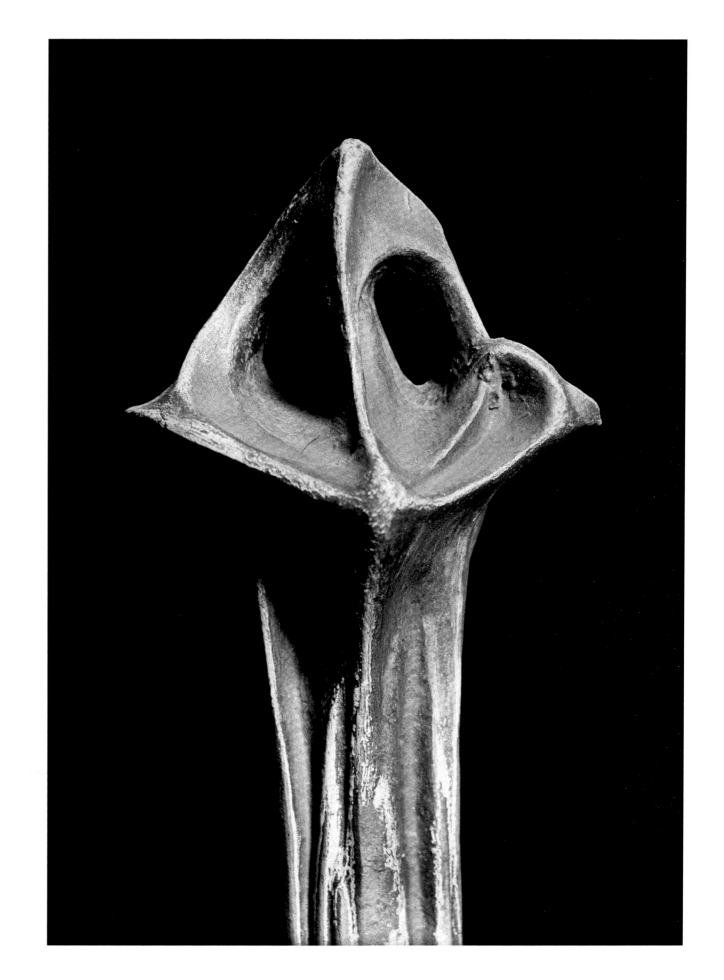

FRANÇOIS KOLLAR - *Unloading sand at the Quai de Passy (from the "Bargemen and Ferrymen" series for* La France travaille [France Works] *commission), 1931-1934*

Next pages:

Left: ANDRÉ KERTÉSZ - *Eiffel Tower and elevated Métro, 1933*

Right: BRASSAÏ - *Pont de Grenelle, 1930-1932*

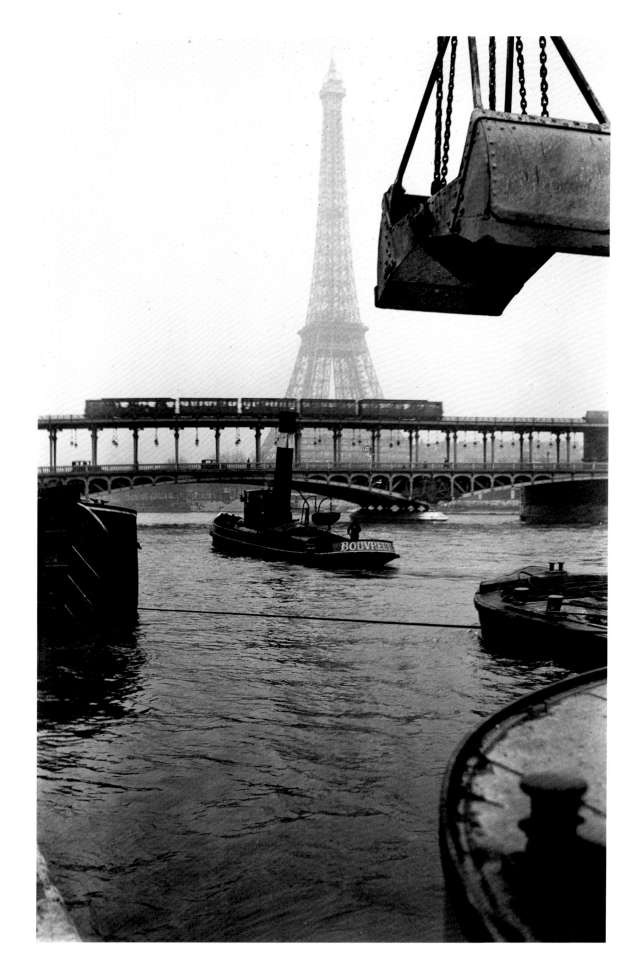

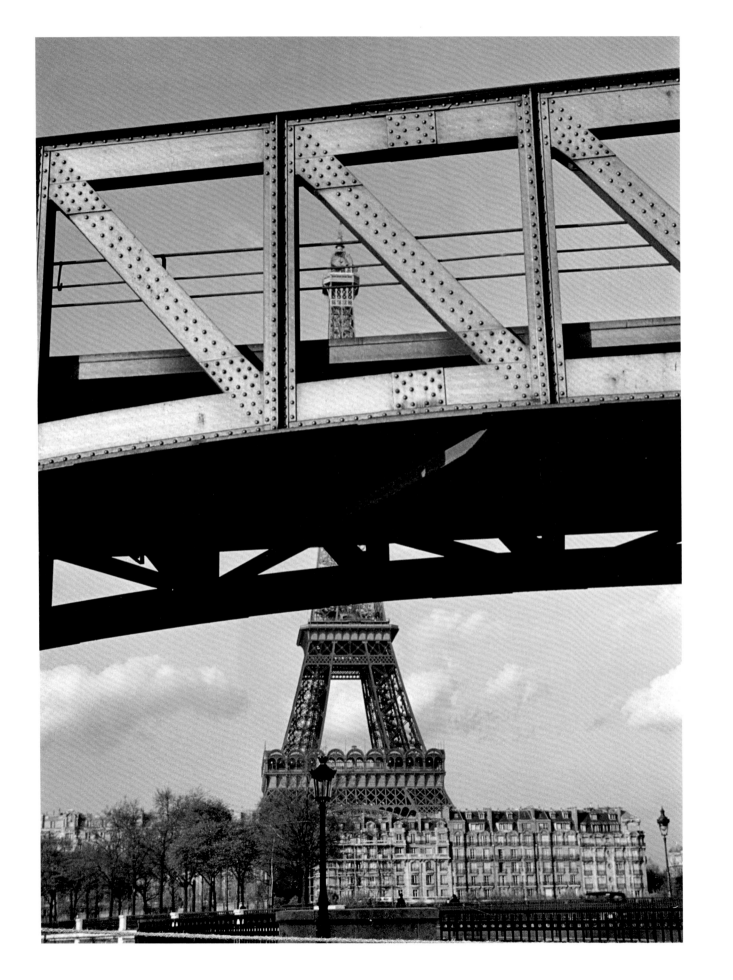

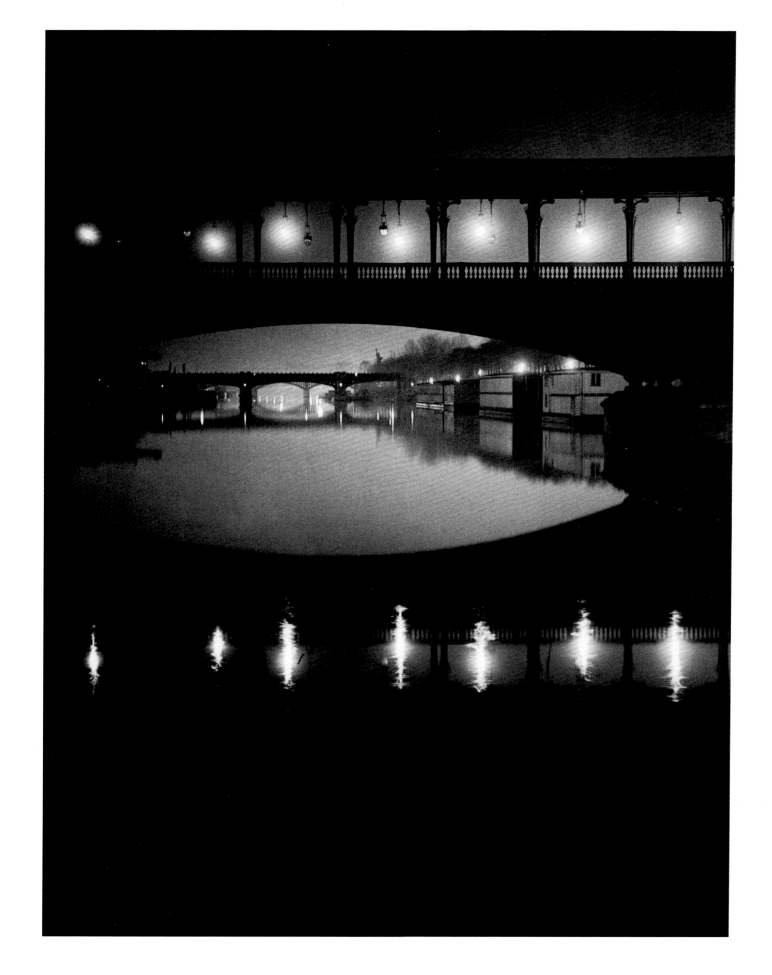

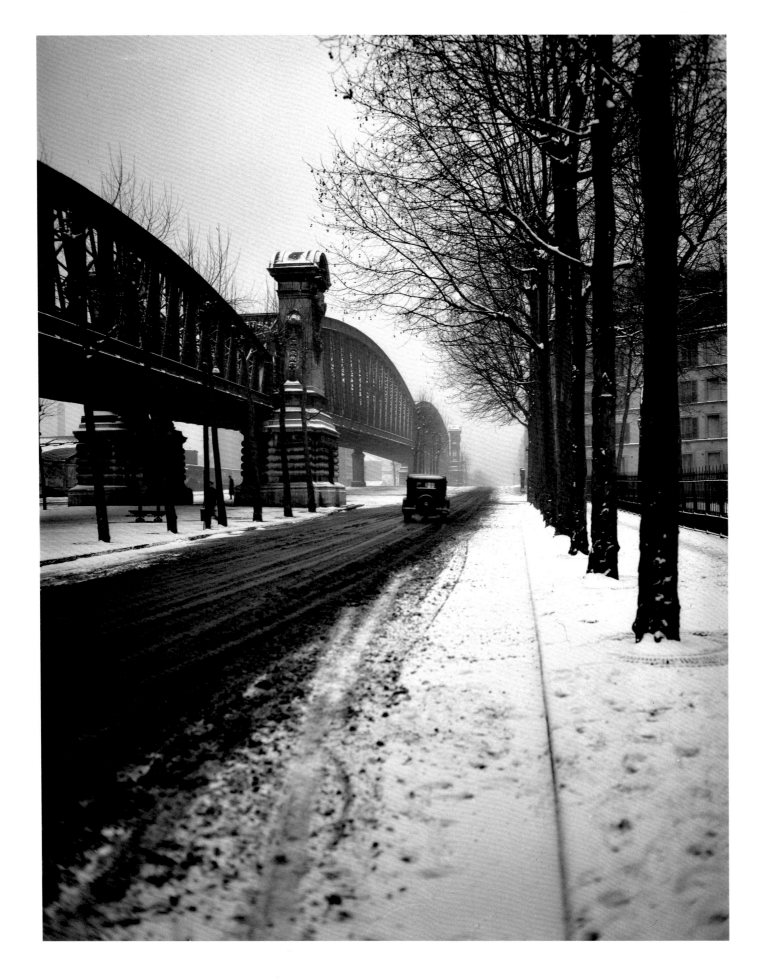

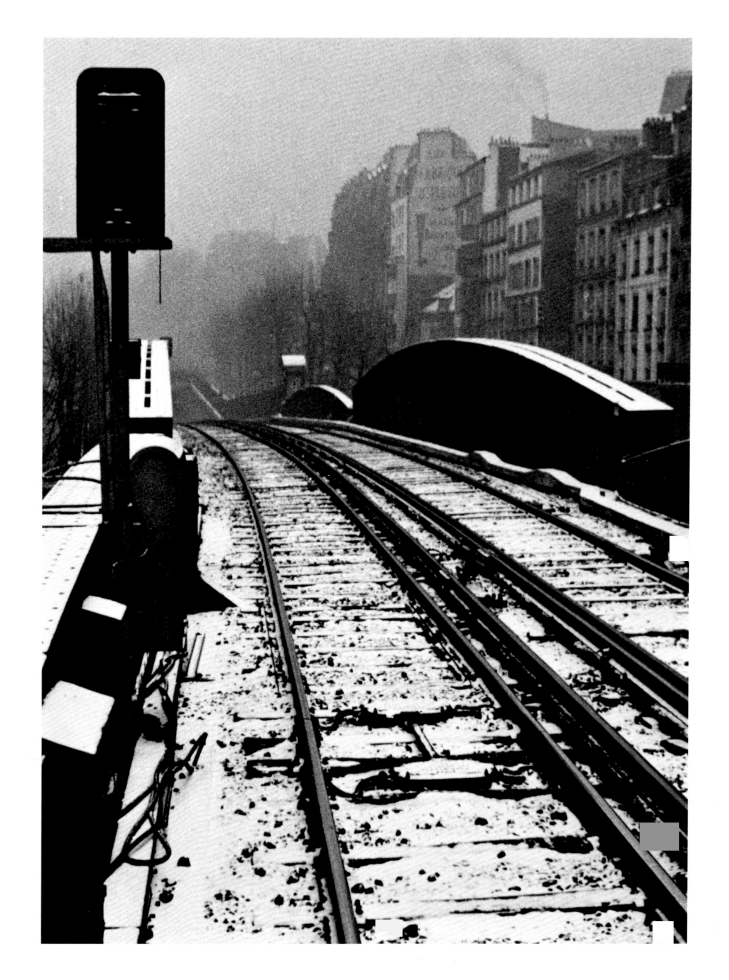

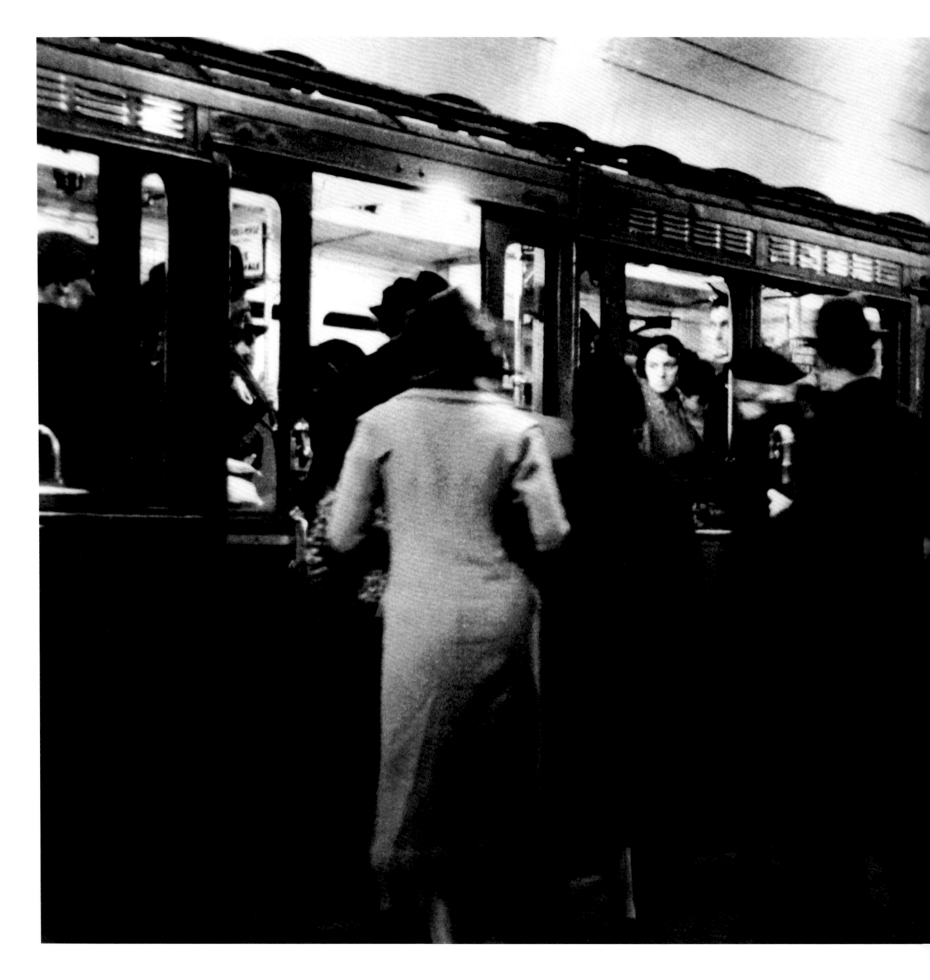

Preceding pages:

Left: RENÉ-JACQUES - *Boulevard de la Chapelle on a snowy day,* 1937

Right: RENÉ-JACQUES - *"Enchantment of Paris,"* 1937

KEYSTONE AGENCY (PARIS) - *Train standing at the platform,* 1936

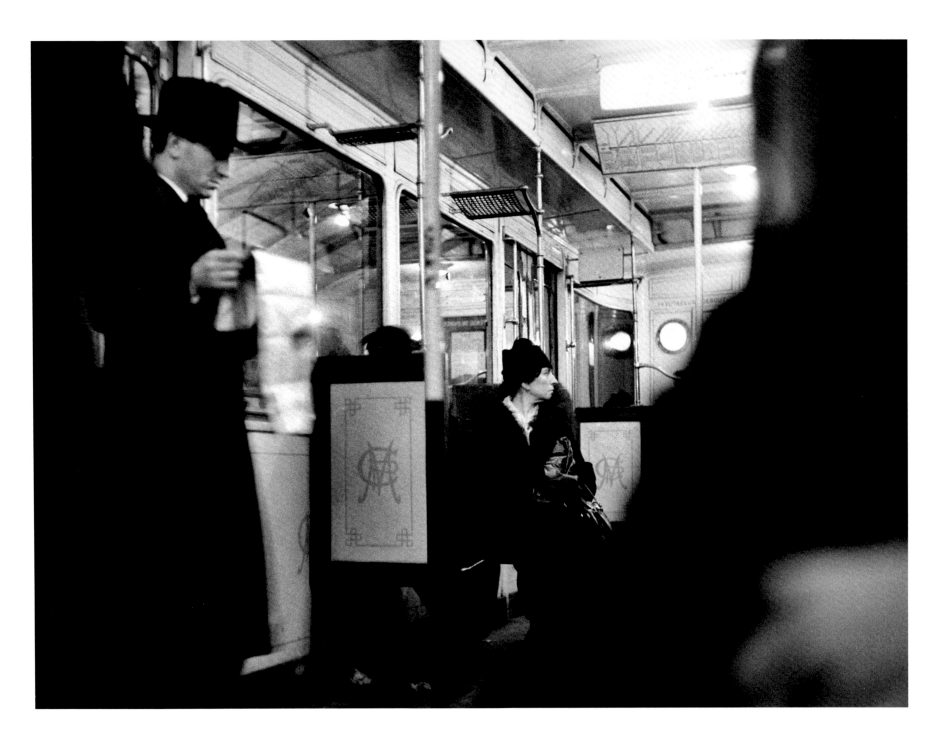

Above: PIERRE JAHAN - *Métro at night*, 1930s

Opposite: GASTON PARIS - *Passengers on a Métro train crossing the Seine*, 1930s

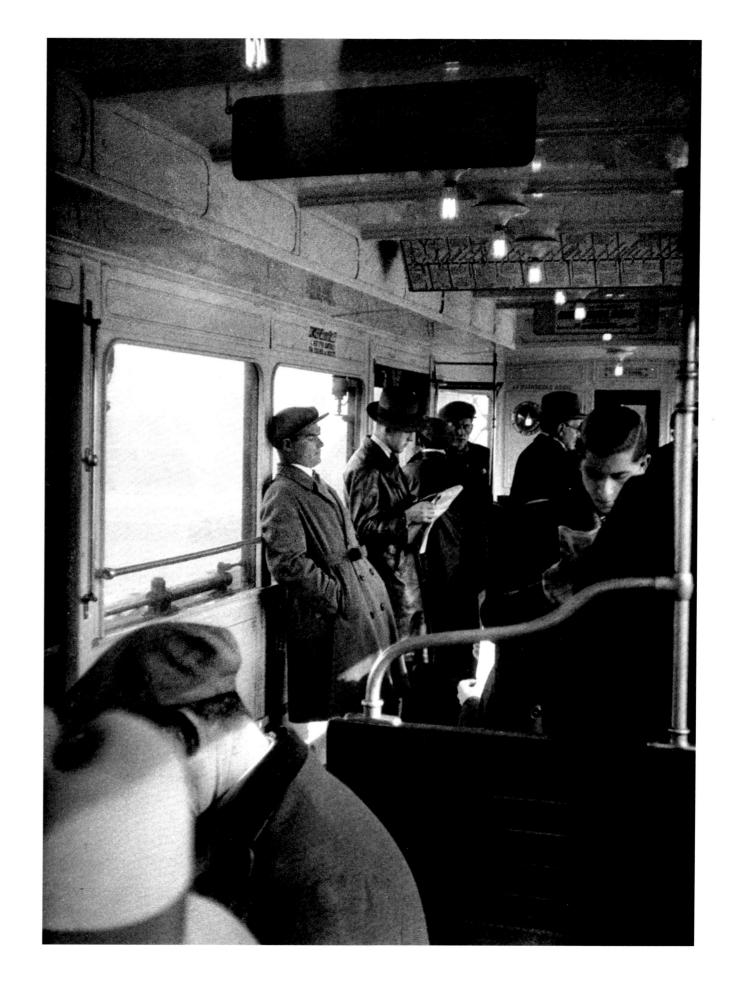

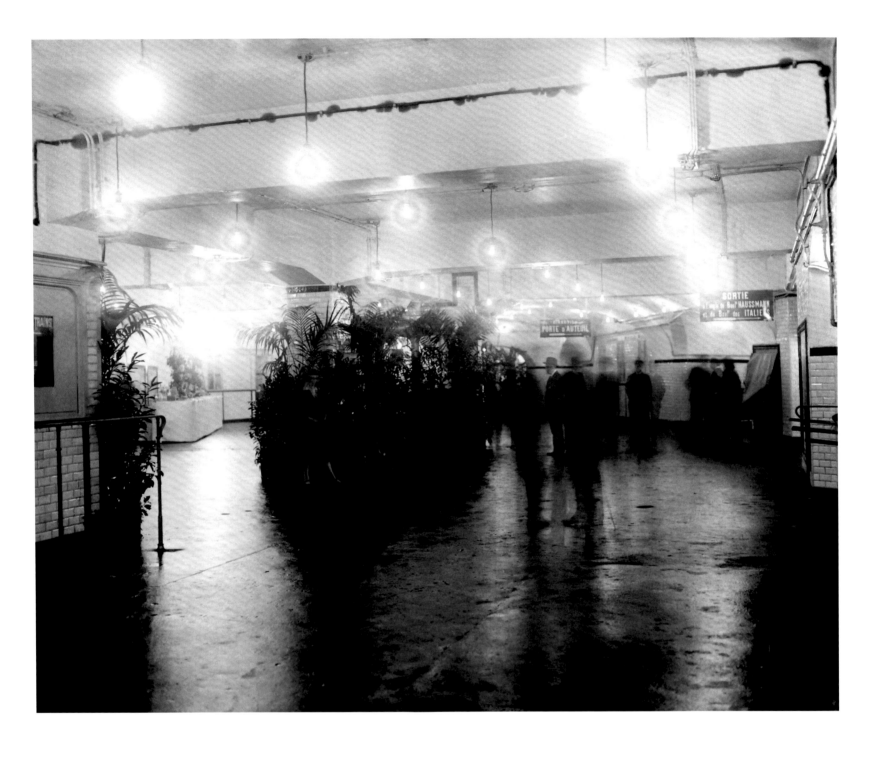

KEYSTONE AGENCY (PARIS) - *Opening ceremony at the Richelieu-Drouot station*, 1931

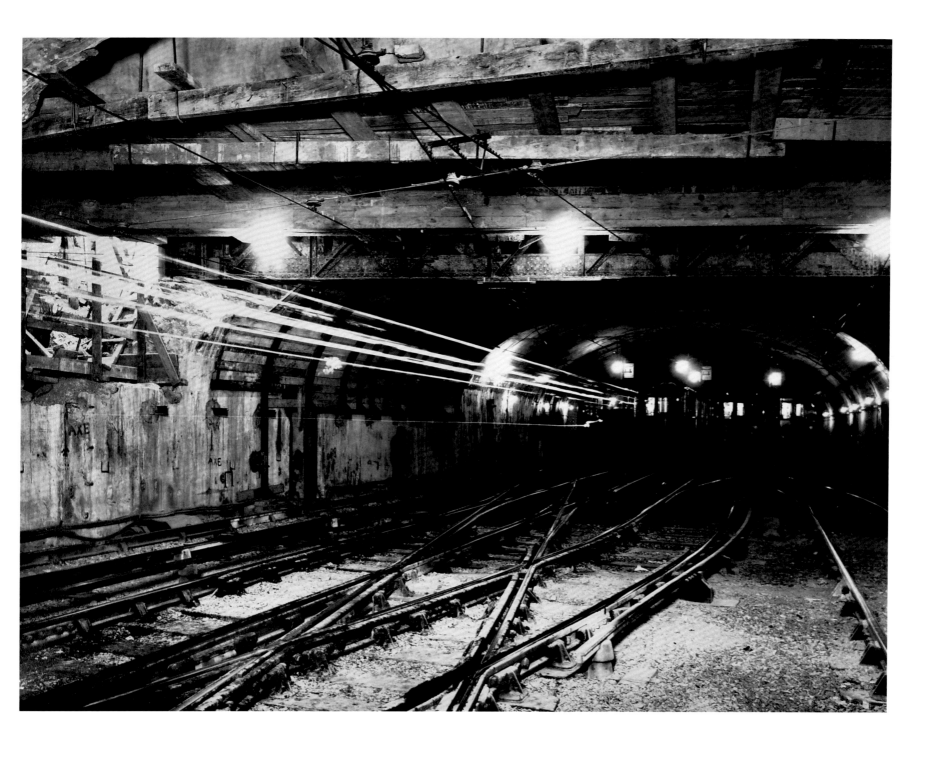

DIRECTION DES TRAVAUX DE PARIS. LABORATOIRE D'ESSAIS DE MATÉRIAUX (PARIS PUBLIC WORKS DEPARTMENT. MATERIAL TESTING LABORATORY) -
Construction of Line A of the Nord-Sud: "Third phase of the covered trench; taken inside the underpass, under beam 6, looking towards the current depot,"
January 25, 1929

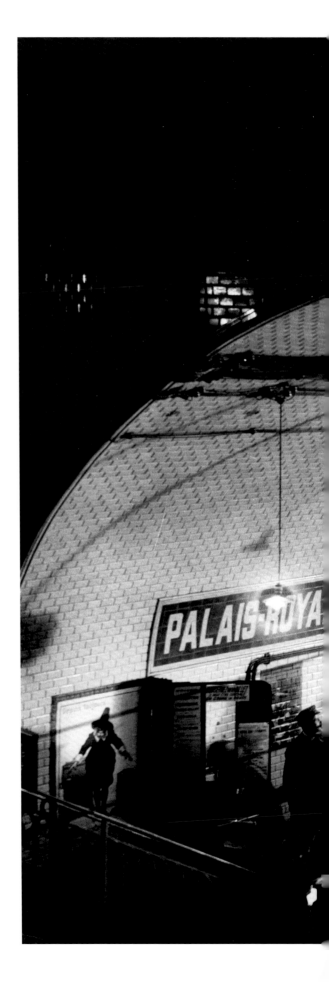

UNIDENTIFIED PHOTOGRAPHER (RATP COLLECTION) - *Crowd on the platform at the Palais-Royal station*, March 14, 1934

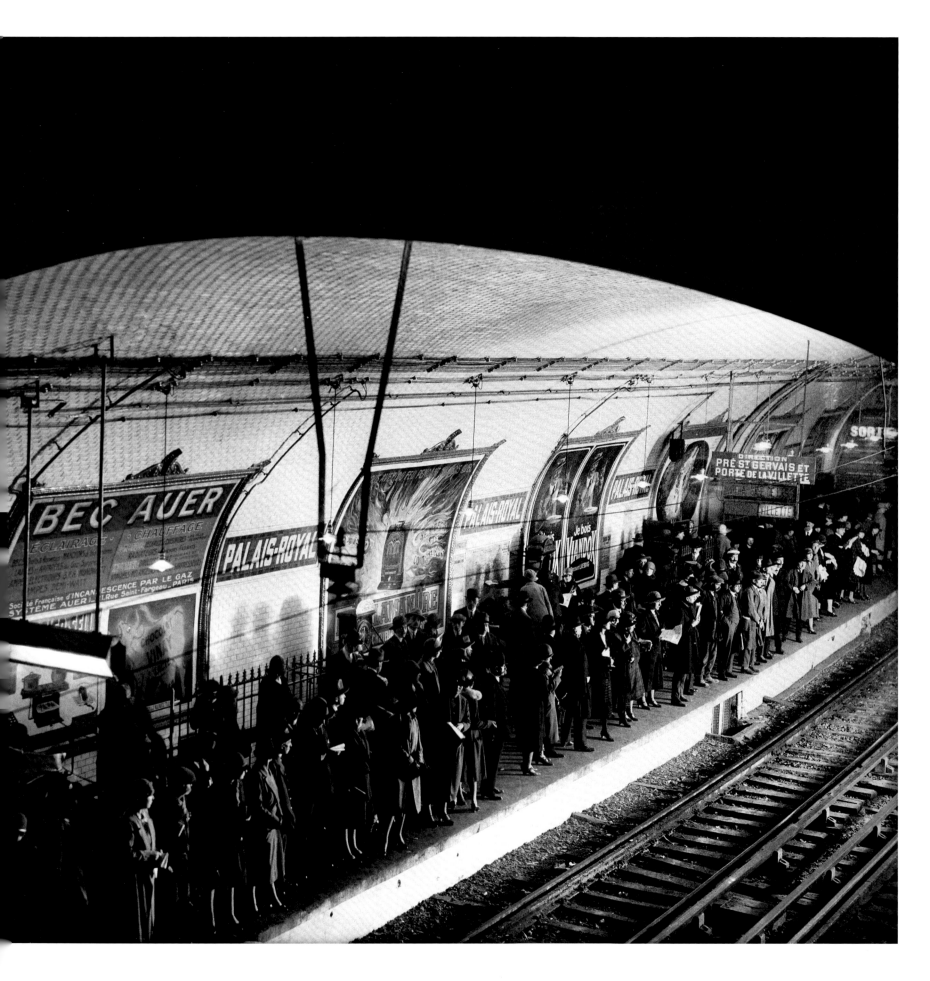

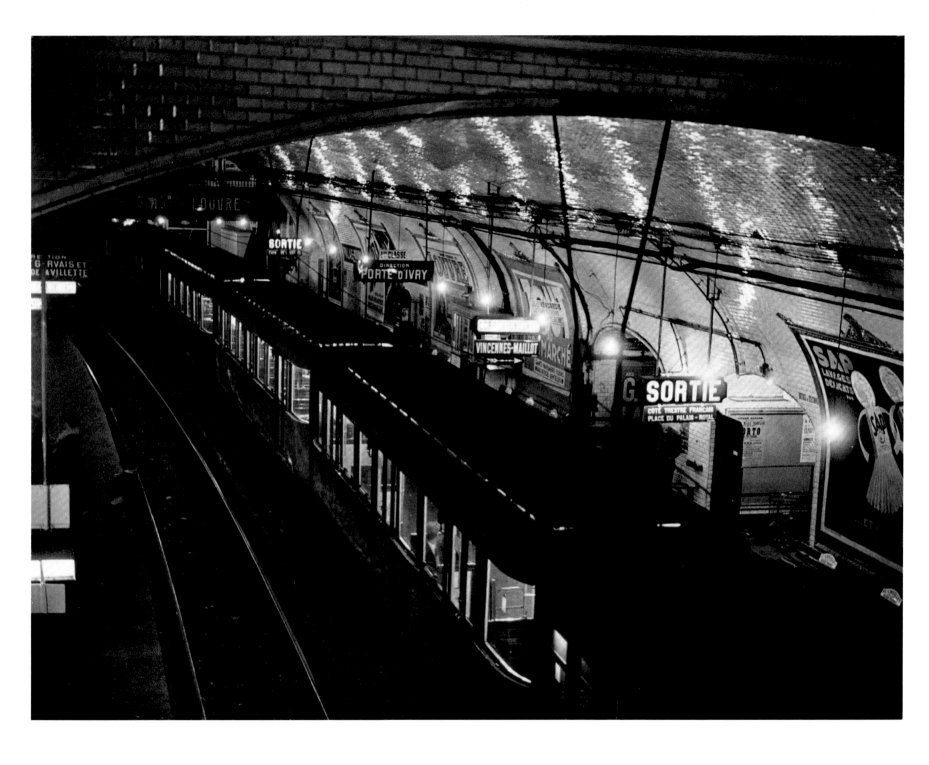

Above: BRASSAÏ - *"At 1.1 AM the 'last train out', the impecunious nightbird's last resort, enters the Palais-Royal station,"* 1930-1932

Opposite: GERMAINE KRULL - *"Métro, Station,"* 1928

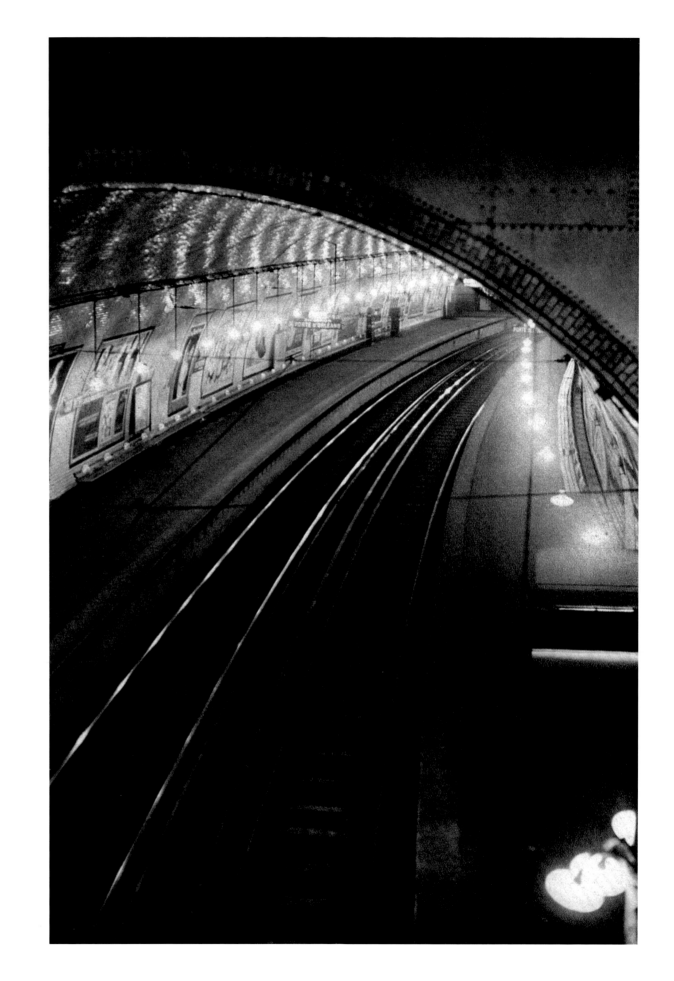

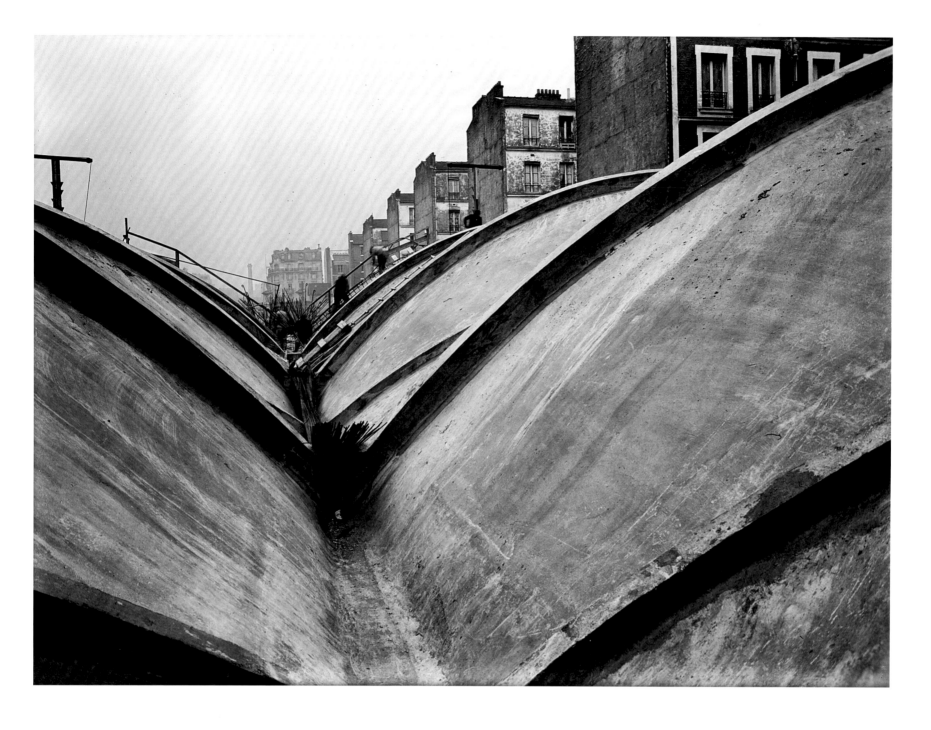

UNIDENTIFIED PHOTOGRAPHER (RATP COLLECTION) - *Construction site of the Javel maintenance yards*, 1936

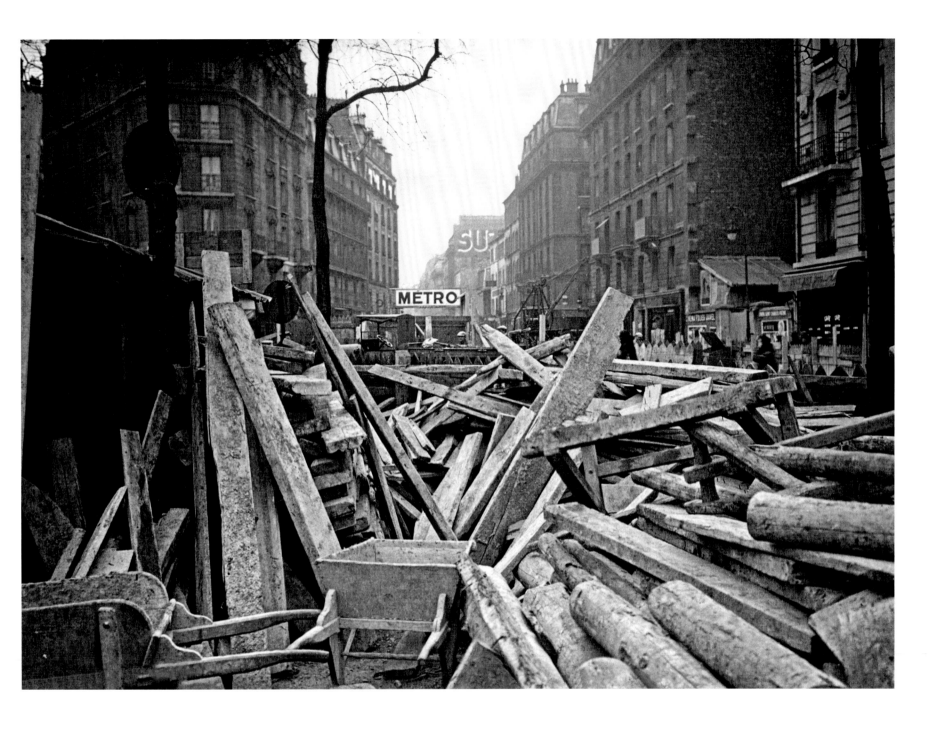

MONDIAL AGENCY - *Métro construction on the Place Beaugrenelle*, 1932

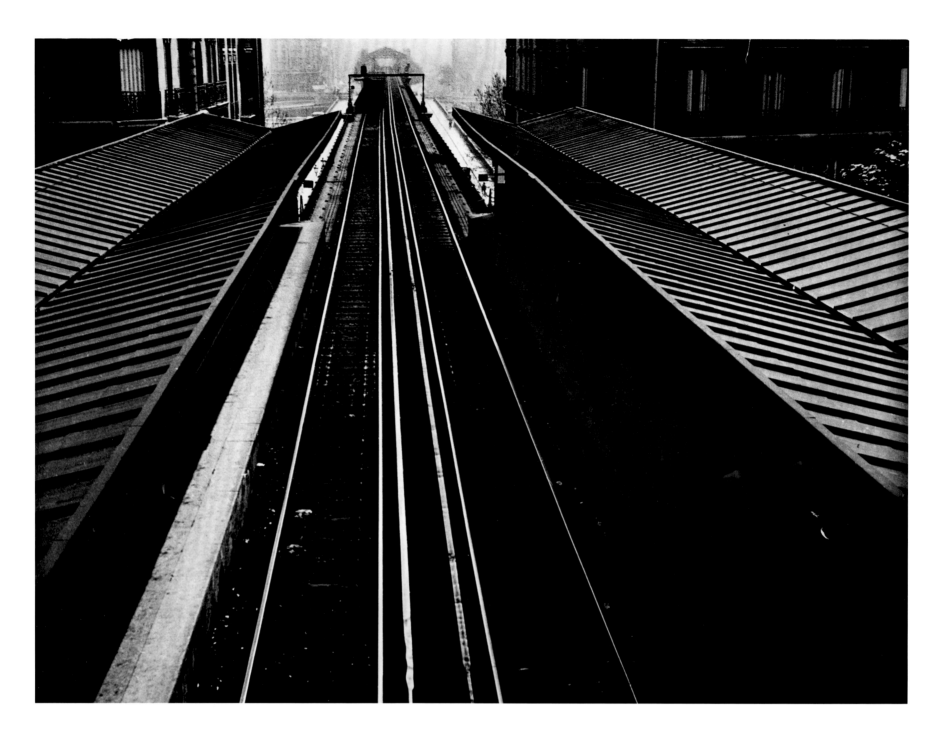

Above: ERGY LANDAU - *Passy station,* 1929

Opposite: GASTON PARIS - *Moving walkway in a Métro station,* circa 1935

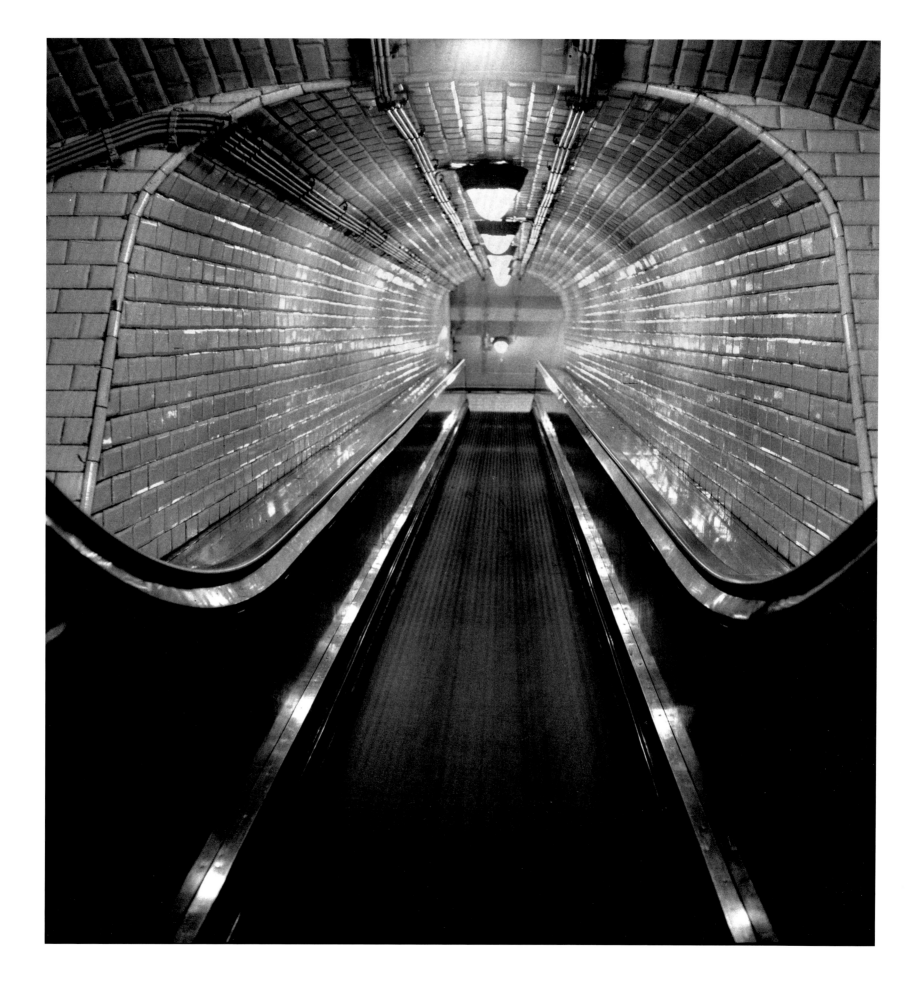

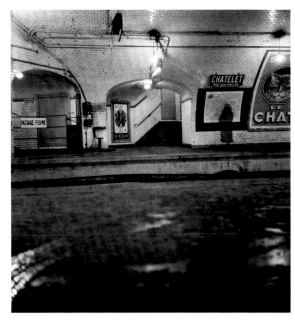

ROGER PARRY - *From top to bottom, left to right:*
Platform, Châtelet station, December 1939
Train standing at the platform, December 1939
Platform, Solférino station, December 1939
Métro corridor, December 1939

Opposite:
ROGER PARRY - *Transfer corridor*, December 1939

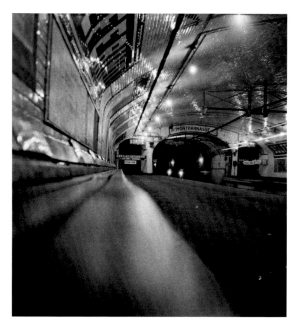

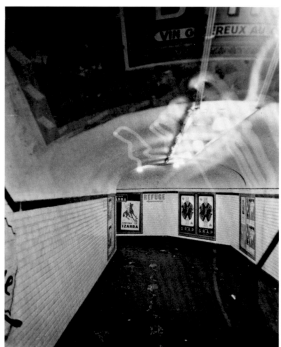

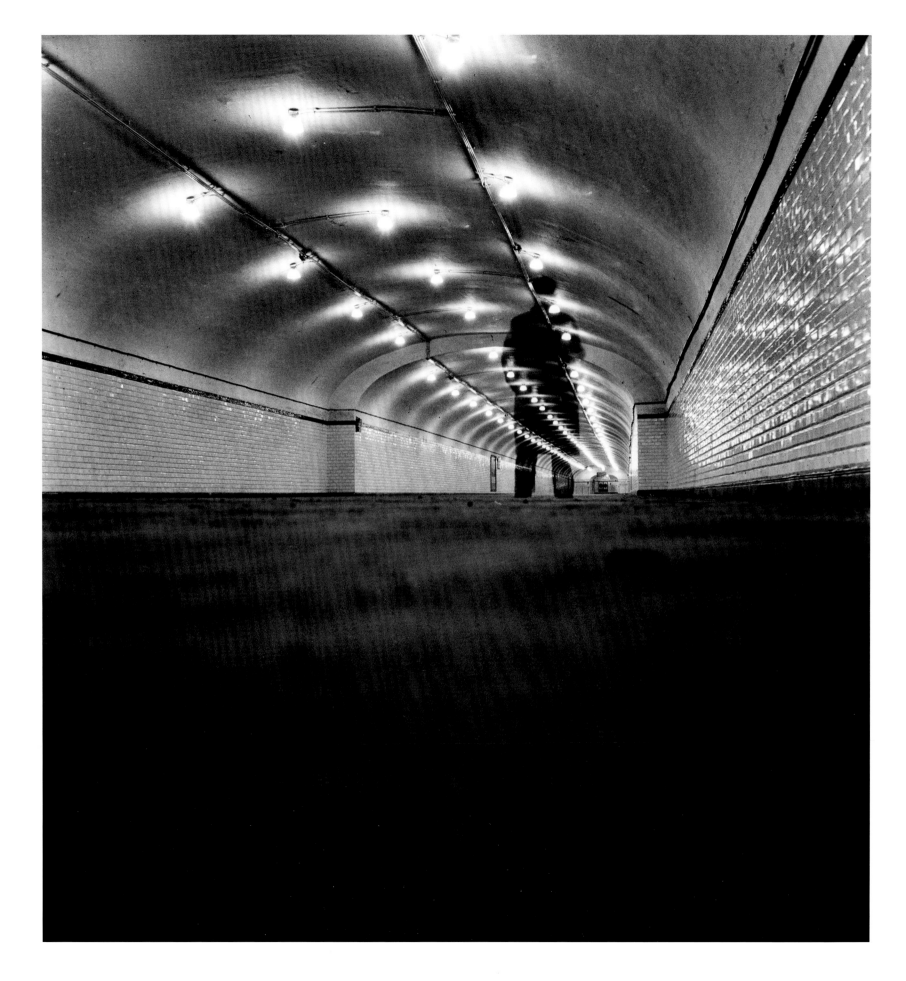

During the Second World War, the Métro became not just a means of transportation for Parisians, but also a refuge. Between 1939 and 1945, its external manifestations as well as its underground labyrinth continued to inspire photographers despite—or because of—the situation (pp. 148-149). While some, like André Zucca, took the occupiers' point of view,[1] others made themselves witnesses to the suffering and struggles of the French. This is true for Robert Doisneau, the author of some remarkable snapshots of the Liberation of Paris, like that barricade at the Belleville station whose map guide served the Resistance fighter on guard both as a rampart and as a position to shoot from (p. 153). I also responsible for a remarkable series on civilians taking refuge in the corridors and on the platforms of the Lamarck station during an air raid alert (p. 151). Weariness can be read on their faces while, on the tiled walls, an already tattered poster advises: "Remain calm until the end of the alert" (p. 150).

After the war, little by little life returned to normal. The poetization of the Métro, which had started in the 1930s, reasserted itself, and photographers directed a tender, gentle gaze on what had once and for all become an unquestioned symbol of the Parisian way of life. This is especially perceptible through the delicate atmospheric effects one finds in photographers of varying backgrounds, from photographers for the LAPI (Les Actualités Photographiques Internationales) press agency (p. 183) to Gisèle Freund (pp. 186-187), Ed Clark (p. 182), Maurice Tabard (p. 184), Elliott Erwitt (pp. 180-181) and Édouard Boubat (p. 185).

The 1950s marked the flourishing of a photographic style that was called "humanist," a simplistic designation for the work linked to its photographers, but a label that still has the merit of emphasizing the centrality accorded to all that is human in their work. Photographers who are world-famous today—Robert Doisneau, Willy Ronis, Édouard Boubat, Izis—placed anonymous people at the heart of their work and in the center of their lens: "little people," whose everyday ordinariness takes on an iconic, universal dimension under the photographers' compassionate gaze. Hence the little round lady with the questioning look immortalized by Inge Morath (p. 166), or the cleaning lady, the doorkeeper at the public toilets, shown napping by Willy Ronis (p. 163). Hence those laughing children captured in mad flight by the tender eye of Sabine Weiss (p. 144) or that subway-car driver concentrating on his task whose portrait Robert Doisneau gives us, through a clever play of reflections (p. 205). So, too, those three Fates

1940-1960

JULIEN FAURE-CONORTON

1.
A photographer working for the press, André Zucca was requisitioned in 1941 to provide photographs for the German propaganda magazine *Signal*. This position gave him access to a commodity rare at the time: Agfacolor photographic film, which allowed him to photograph the French capital in color.

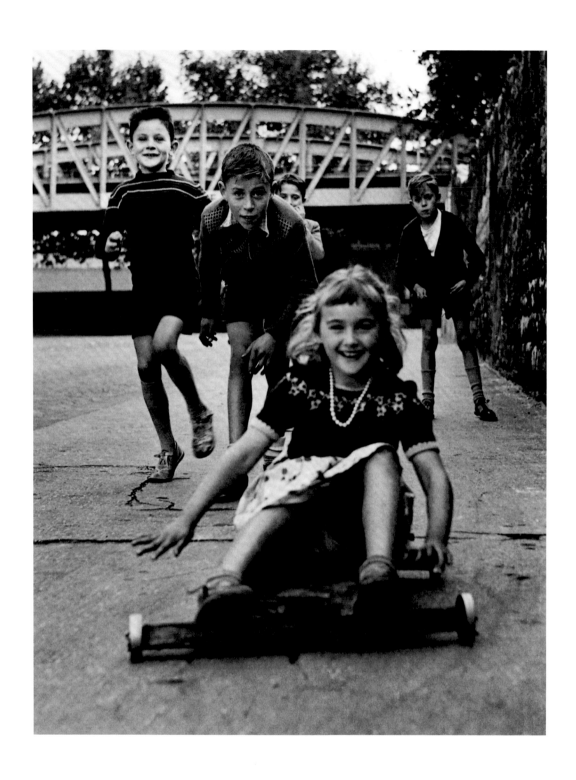

staring intensely at Jean Marquis's lens; in 1955, this *Rue du Petit-Musc* (p. 167) would appear in the monumental, groundbreaking exhibit *The Family of Man*, curated at the Museum of Modern Art in New York by Edward Steichen. And

then, of course, there are those pairs of lovers whose spontaneity we now know is feigned, but whose eternal happiness under the skies of Paris we still want to believe in, despite everything. Belonging to the same series as the legendary *Baiser de l'Hôtel de Ville (The Kiss, Hôtel de Ville)*, *Le Baiser de l'Opéra* (p. 214), of which at least two versions exist,[2] was taken by Doisneau in 1950 for an article about lovers in Paris commissioned by *LIFE* magazine.[3]

An article also gave rise to the creation of *Le Muguet du métro (The Lily-of-the-Valley of the Métro*, p. 196), another photograph emblematic of the humanist vein, taken with the complicity of a couple (Marc and Christiane Chevalier) who posed frequently for Doisneau. The delicate white bells of the bouquet's flowers are answered by the halo of the electric lightbulbs hanging from the station ceiling; the bulbs' reflection on the tiled roof forms a kind of starry sky above the two lovers.

The social realism tinged with poetry characteristic of "humanist" photographs confers a stylistic unity on them that makes them immediately identifiable. The results obtained, however, vary greatly. Thus, Doisneau and Boubat drew, from an identical subject, either a composition with an amusing symmetry emphasized by a mischievous, somewhat irreverent title, *Sèvres et Babylone, 1953* (p. 162) —or an atmospheric, fleeting, melancholic vision—*Sèvres-Babylone, 1952* (p. 185).

During this entire period, it was through the press and photography books that this humanist aesthetic was spread; its literary dimension came to the fore via frequent collaboration between photographers and writers (Robert Doisneau/Blaise Cendrars, Willy Ronis/Pierre Mac Orlan, etc.).[4] Paris is at the heart of all the attention, and the publications devoted to it at the time are countless.[5] One of the finest examples of this trend is *Paris des rêves (Paris of Dreams)*, published in 1950, a collection of photographs by Izis superbly printed in photogravure with commentary by a number of novelists and poets (André Breton, Francis Carco, Blaise Cendrars, Jean Cocteau, Paul Éluard, Henry Miller, Francis Ponge, Jules Supervielle, etc.). The writers' texts are reproduced not with typographical characters, but in the form of facsimiles of their manuscripts. Symbol of the French capital, the Métro appears many times and in various forms in *Paris des rêves*. Izis's gaze delivers poetic visions of Paris that inhabit two worlds, wavering between the borders of the real and the imaginary, in a Paris where dreams are made of shadow and light (pp. 193 and 204). The most striking example of this very personal gaze is undoubtedly *Le Métro Mirabeau, 6 heures du matin (Mirabeau Station, 6 AM*, p. 171).

2.
Taken with a relatively short exposure time, the first version shows the couple in the midst of passersby entering and exiting the Métro. Thanks to a much longer exposure, the second version—which is the one reproduced here—transforms the passersby into ghosts, thereby producing the illusion that the couple, absorbed in their embrace, is outside of the world and of time. It is this vision that *LIFE* would choose as the centerpiece for its article.

3.
"Speaking of Pictures," *LIFE*, June 12, 1950, pp. 16-17. Illustrated with six photographs by Robert Doisneau, the article is captioned: "In Paris young lovers kiss wherever they want and nobody seems to care."

4.
Cf. R. Doisneau and B. Cendrars, *La Banlieue de Paris (The Suburbs of Paris)*, Paris: P. Seghers, 1949; W. Ronis and P. Mac Orlan, *Belleville, Ménilmontant*, Grenoble: Arthaud, 1954.

5.
Cf. C. Bouqueret, *Paris, les livres de photographie: des années 1920 aux années 1950 (Paris, Photography Books: From the 1920s to the 1950s)*, Paris: Gründ, 2012.

This composition owes its phantasmagorical, grandiose quality to the backlit effect combined with a lower viewpoint that monumentalizes the Guimard architecture. Taken in 1949, the year the RATP was created, it inspired these lines by the publisher René Rougerie:

The way blocked… two tentacles above the "Métro" monster…
and the man, a shapeless spot on the sky, sets off, indifferent, on a new journey.[6]

Photographic representations of the Paris Métro dating from the 1940s and '50s show a marked interest in two aesthetic aspects of the subject: the graphic image and the Métro sign. Thus, a number of photographs are constructed around the expressive power of the guiding lines of the composition—Izis (pp. 203 and 204), André Kertész (p. 176), Eva Besnyö (p. 215), Édouard Boubat (p. 211), Jean Marquis (p. 202). Others play on the impact of the intrusion of text into image (whether it's the "Métro" sign itself or other signs), text whose graphic radiance is amplified by the night—Agence France-Presse (p. 158), Izis (p. 171), Marcel Bovis (p. 189), Janine Niépce (p. 207), Frank Horvat (pp. 208-209), William Klein (p. 219) and others. Although these two focuses are not unique to this period, they were particularly marked at the time. Though shared by a number of photographers, graphic emphasis produced extremely varied results. Two photographs especially bear witness to this, one by Willy Ronis, the other by Frank Horvat; although they represent exactly the same subject (a Métro train going over the Passy bridge with the Eiffel Tower in the background), they could not be more different (pp. 200-201). The unreal, disorienting result obtained by Frank Horvat comes from the use of a telephoto lens that, because it radically reduces the distance between the different planes of composition, distorts the perspective, producing a complete topographic/photographic illusion.

Photos from this period reveal a number of other aspects that deserve attention. As shown by photographs taken on set by Raymond Voinquel during the filming of Marcel Carné's 1946 movie *Les Portes de la nuit (Gates of the Night)*, cinema entered the Métro and gave a glamorized vision of it, thanks to the lighting resources available to filmmaking (pp. 173 and 190-191). Fashion, too, emerged

6.
Caption by René Rougerie for the photograph *Métro Mirabeau, 6 heures du matin* in: Izis, *Paris des rêves*, Lausanne: La Guilde du livre, 1950, p. 128.

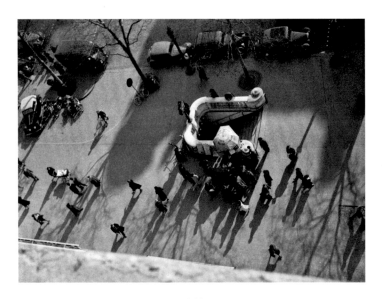

LUCIEN HERVÉ - *Métro entrance*, 1948

from the couture houses to go out onto the streets, using the Métro as background. The difference between the two worlds is so great that the result functions wonderfully under the lens of Mark Shaw (p. 213), Frank Horvat (pp. 216-217) and William Klein (p. 219). The striking effect Klein achieved in 1957 in *Marie-Hélène + Raphaël* (the result of using a telephoto lens) exemplifies the singularity of photographic vision, in the sense that such an image can exist only in photography. Fascination with the possible aesthetic of bedazzlement (whether from natural or electric lighting) is also especially noticeable in those years, whether in Kees Scherer (p. 174), George Zimbel (p. 176) or Sabine Weiss (p. 221), whose *À la sortie du métro* (*Métro Exit*, 1955) is a brilliant demonstration of the ability of photography to capture the ephemeral (of a movement, a light, an impression). Finally, the 1940s and '50s mark the progressive emergence of color—less timeless than black and white—anchoring the subject more clearly in its time (Jean-Philippe Charbonnier, p. 210). But color is also what constructs the image, takes part in its rhythm and its chromatic harmony, as in Mark Shaw (p. 213), Ernst Haas (p. 197) or Willy Ronis. Ronis's *Le Métro Opéra en hiver* (*Opéra Station in Winter*, p. 164) is an admirably constructed work where color, with infinite delicacy, perfectly conveys the winter atmosphere. This photograph also emphasizes a particularity of underground journeys: exiting the Métro, walking up the steps leading you to the open air, is to see suddenly appear before you a world you had left for the time of a journey.

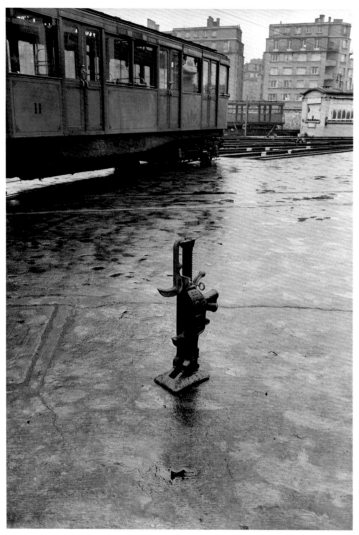

UNIDENTIFIED PHOTOGRAPHER (RATP COLLECTION) - *Simplex Jack (to lift trains after derailing)*, February 7, 1944

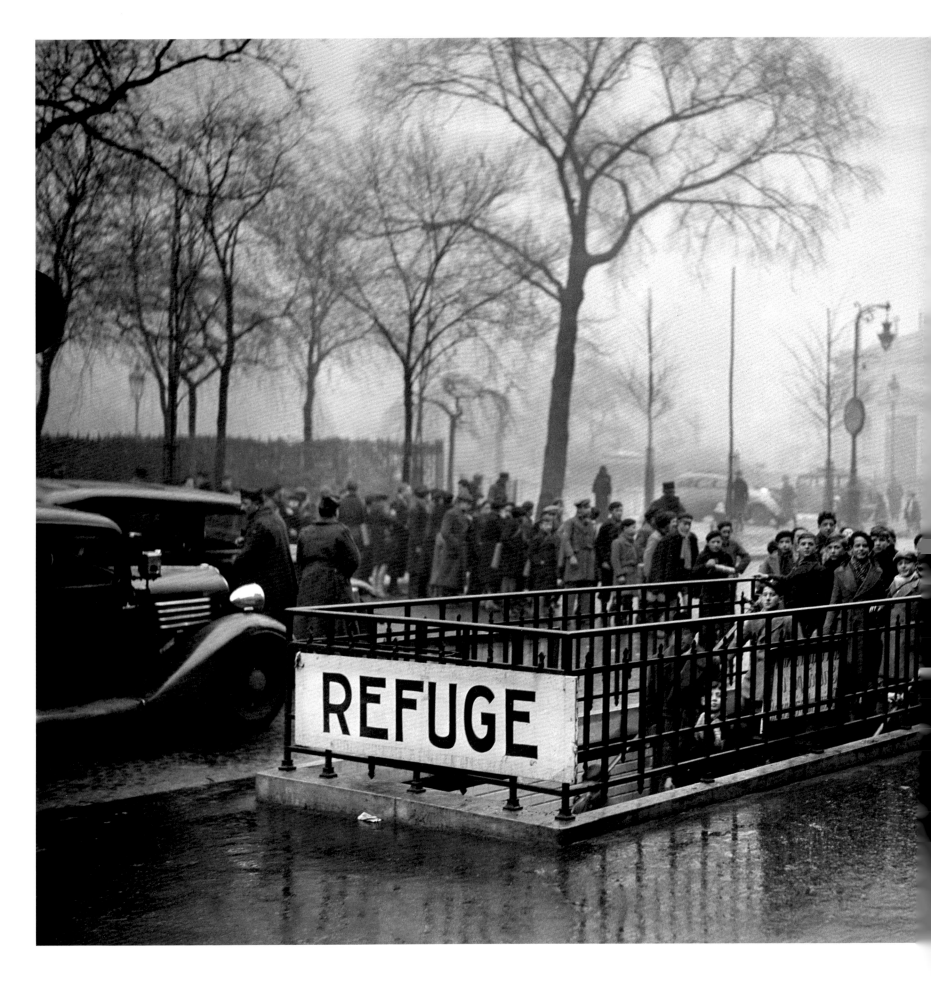

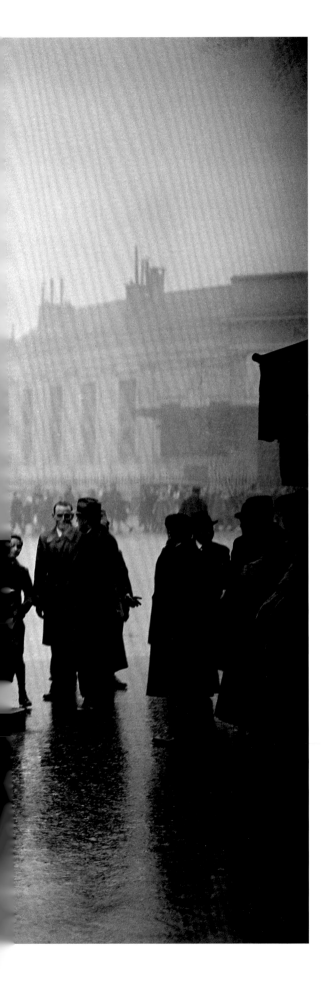

EXCELSIOR NEWSPAPER - *Group of children entering a shelter during an air raid exercise,* January 6, 1940

Next pages:

Left and right: ROBERT DOISNEAU - *Parisians taking shelter on the platforms of the Lamarck station during an alert,* circa 1942-1944

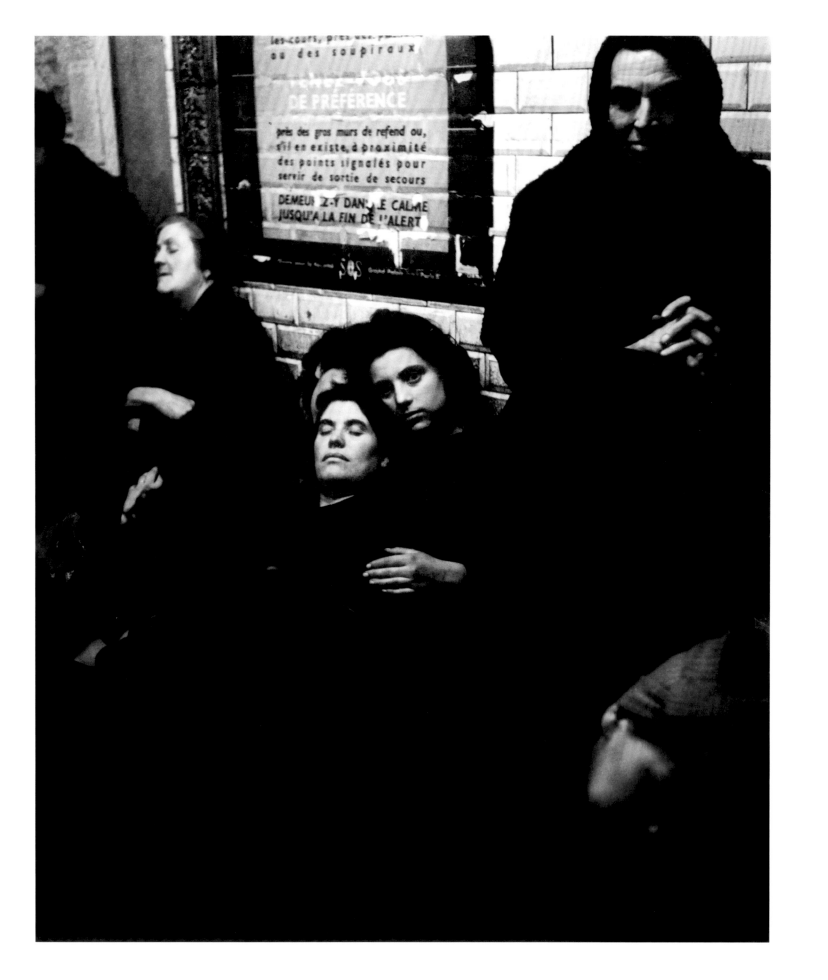

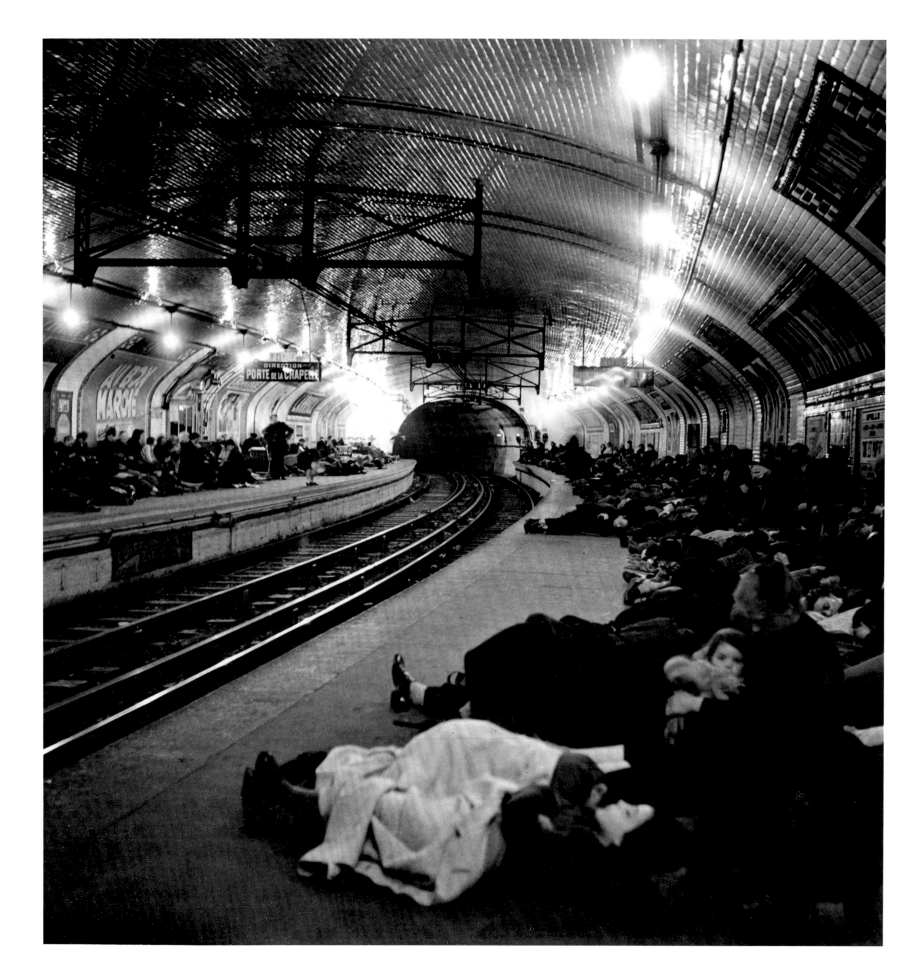

ROBERT DOISNEAU - *"To your weapons now, time for honor"* (*Resistance fighter on guard behind a barricade at the Belleville station*), August 22, 1944

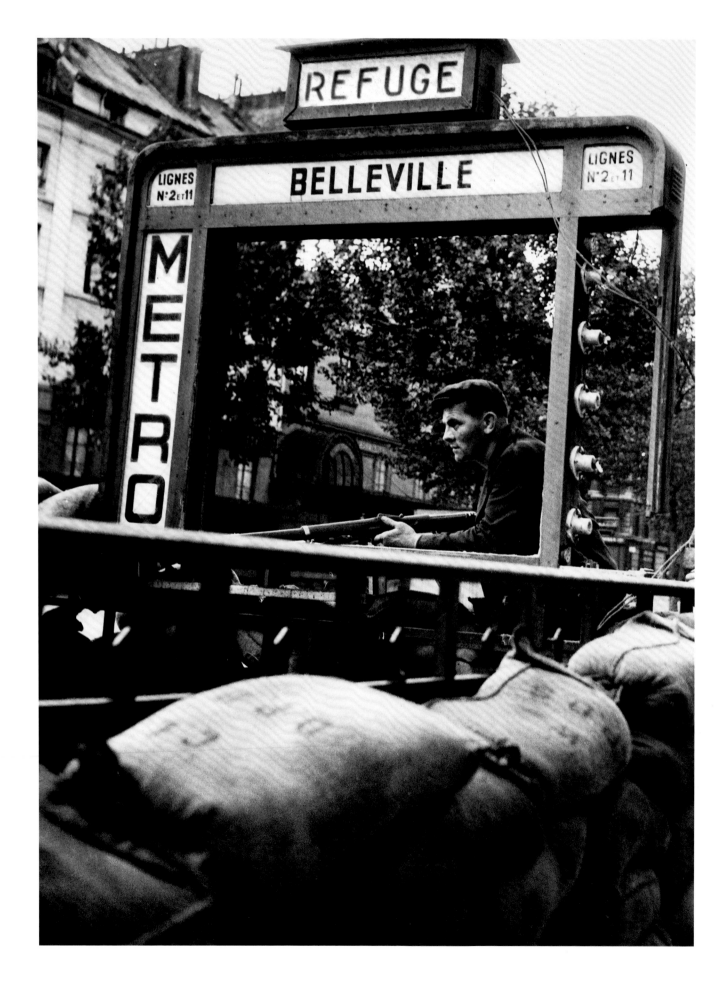

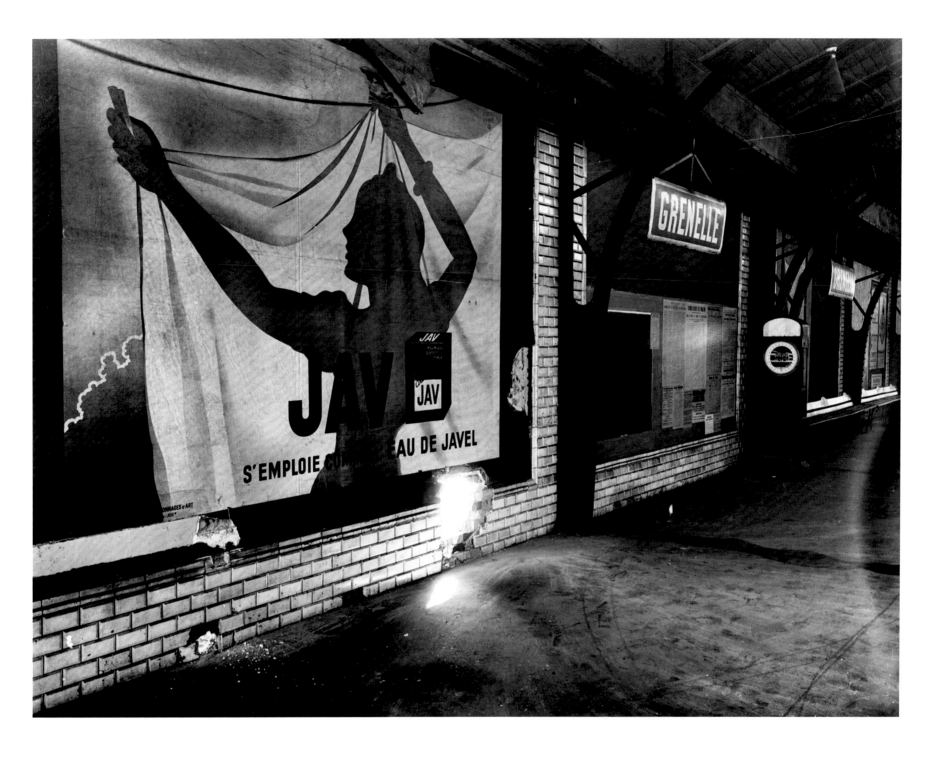

UNIDENTIFIED PHOTOGRAPHER (RATP COLLECTION) - *War damage at the Grenelle station*, August 30, 1944

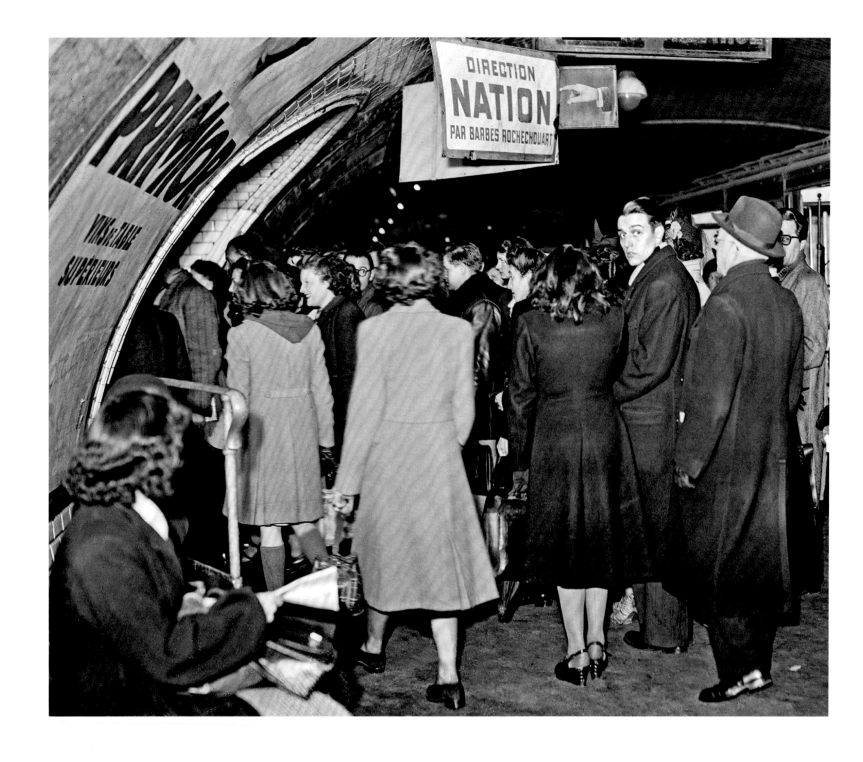

UNIDENTIFIED PHOTOGRAPHER (RATP COLLECTION) - *Rush hour at the Étoile station*, February 9, 1949

ANONYMOUS - *The trip to Paris*, circa 1945

Next pages:

Left: A.F.P. (AGENCE FRANCE PRESSE) - *"Métro out of order: a sign informs users that trains are suspended due to an electrical outage,"* December 1, 1947

Right: HENRI CARTIER-BRESSON - *"Paris,"* 1952

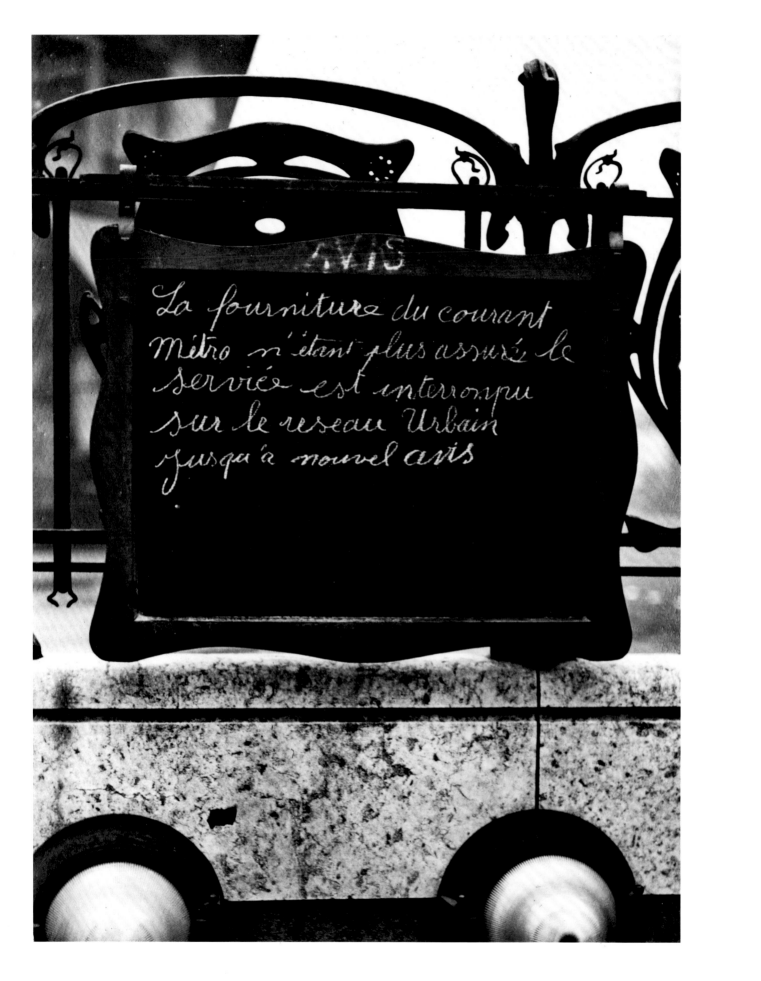

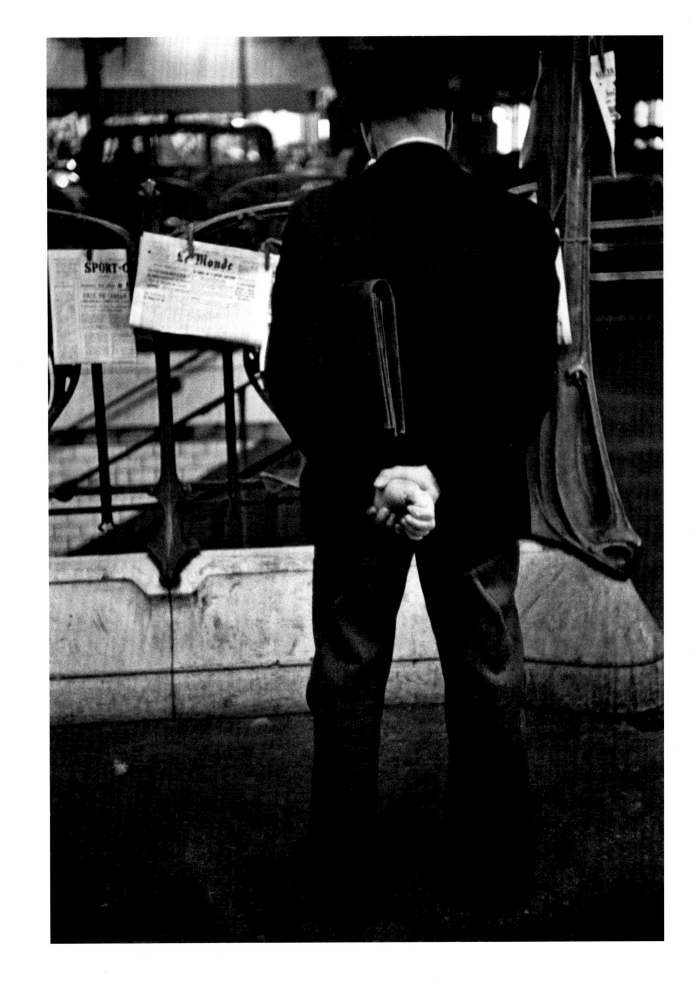

ROBERT DOISNEAU - *Place de l'Hôtel de Ville*, 1950

Next pages:

Left: ROBERT DOISNEAU - *"Sèvres and Babylone,"* 1953

Right: WILLY RONIS - *Lavatory*, 1951

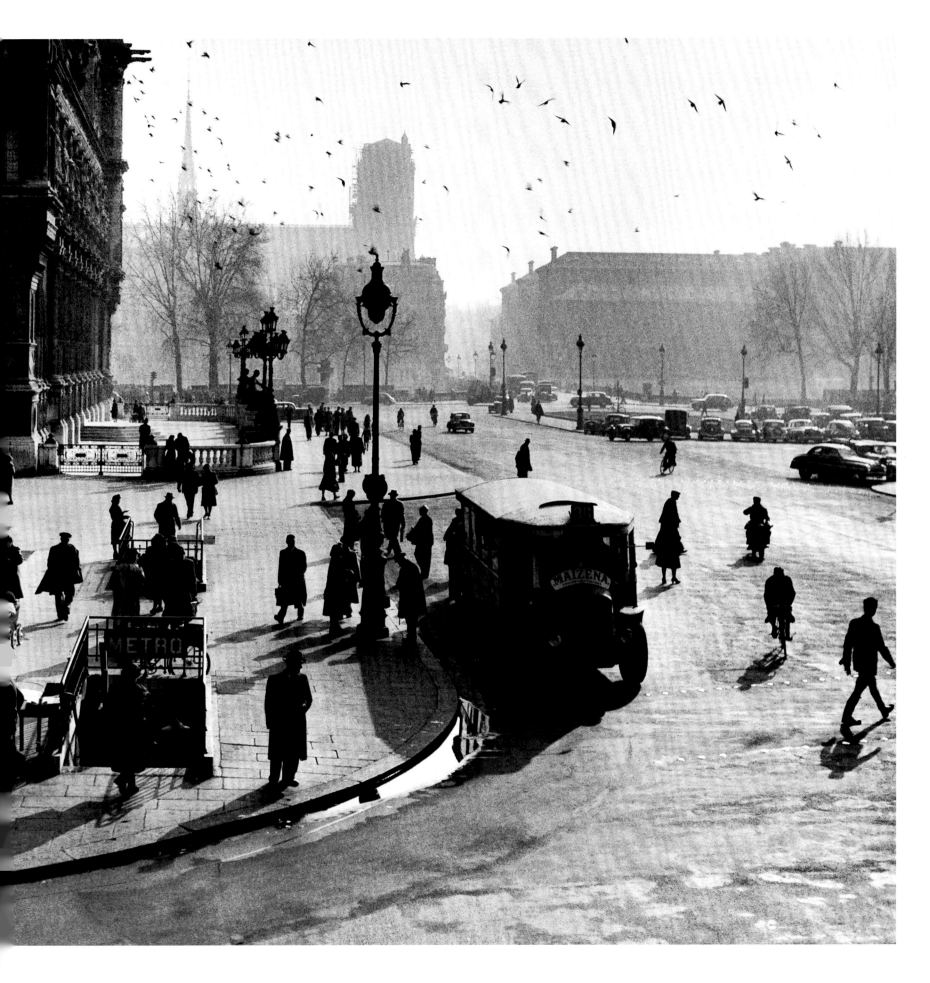

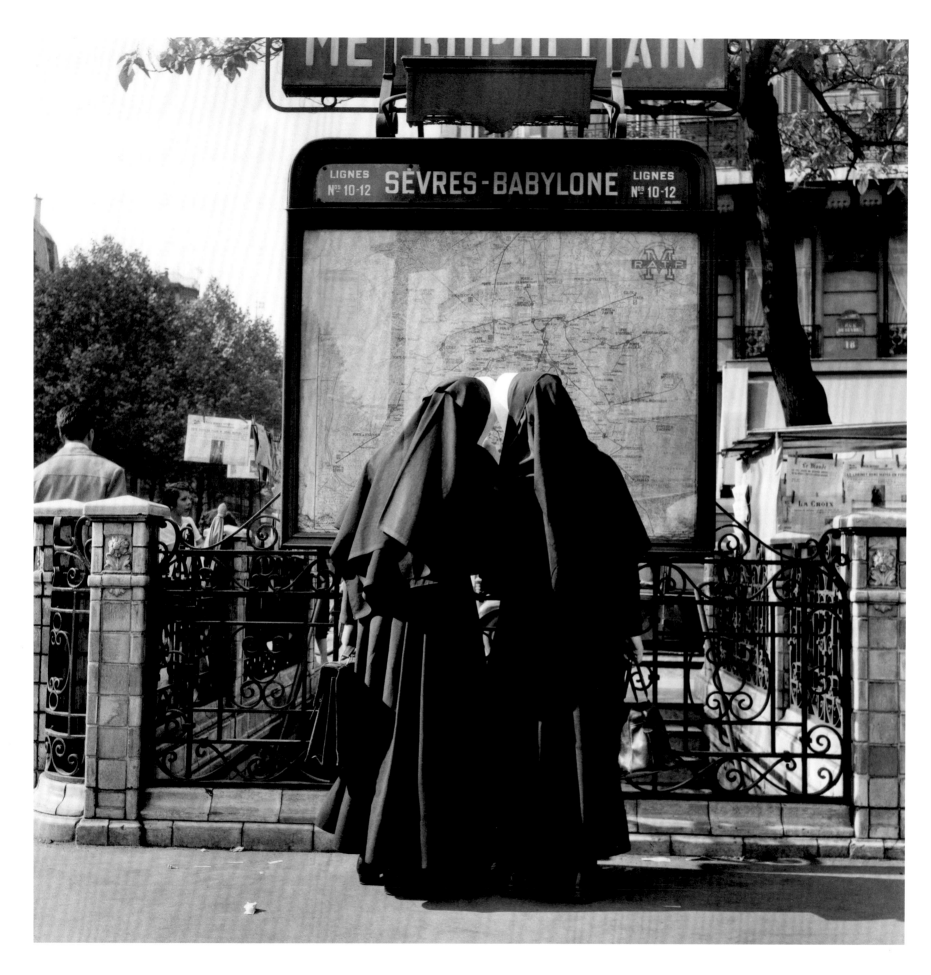

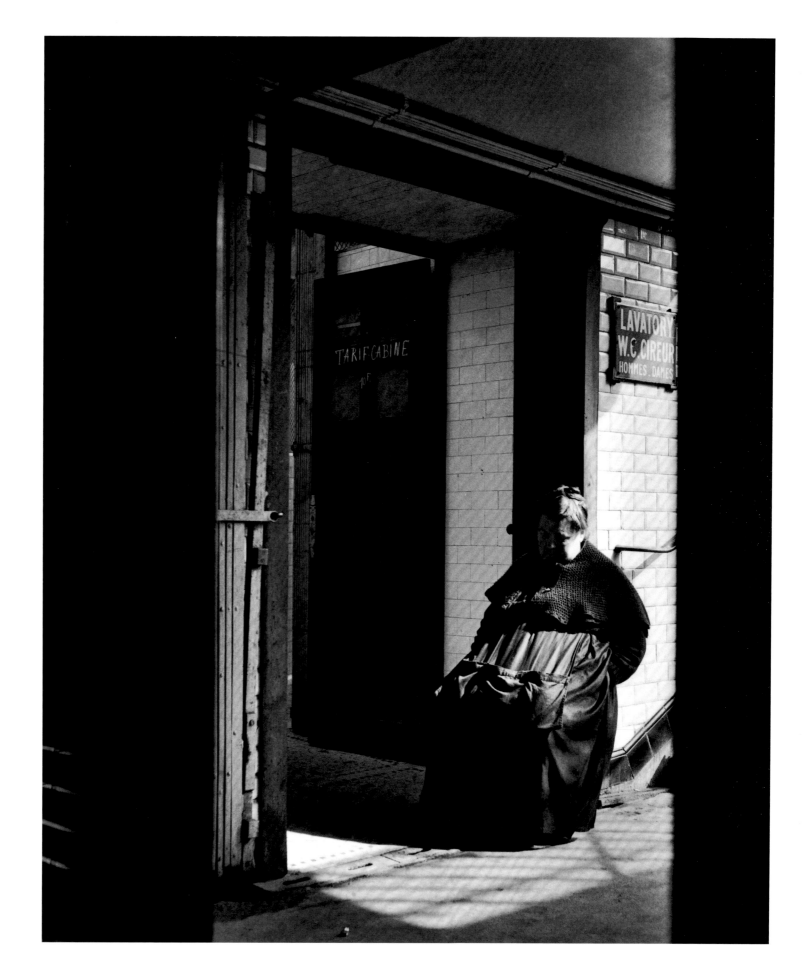

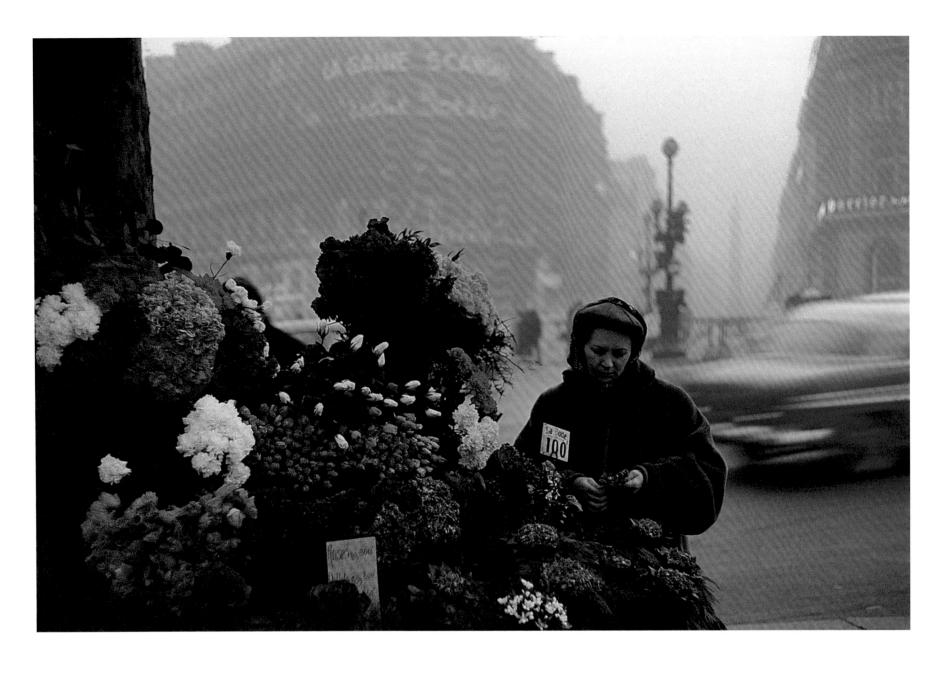

Above: WILLY RONIS - *Opéra Station in Winter (from the "Paris in Color" series)*, 1955

Opposite: MARCEL LOUCHET - *"Bird and Flower Market,"* 1950s

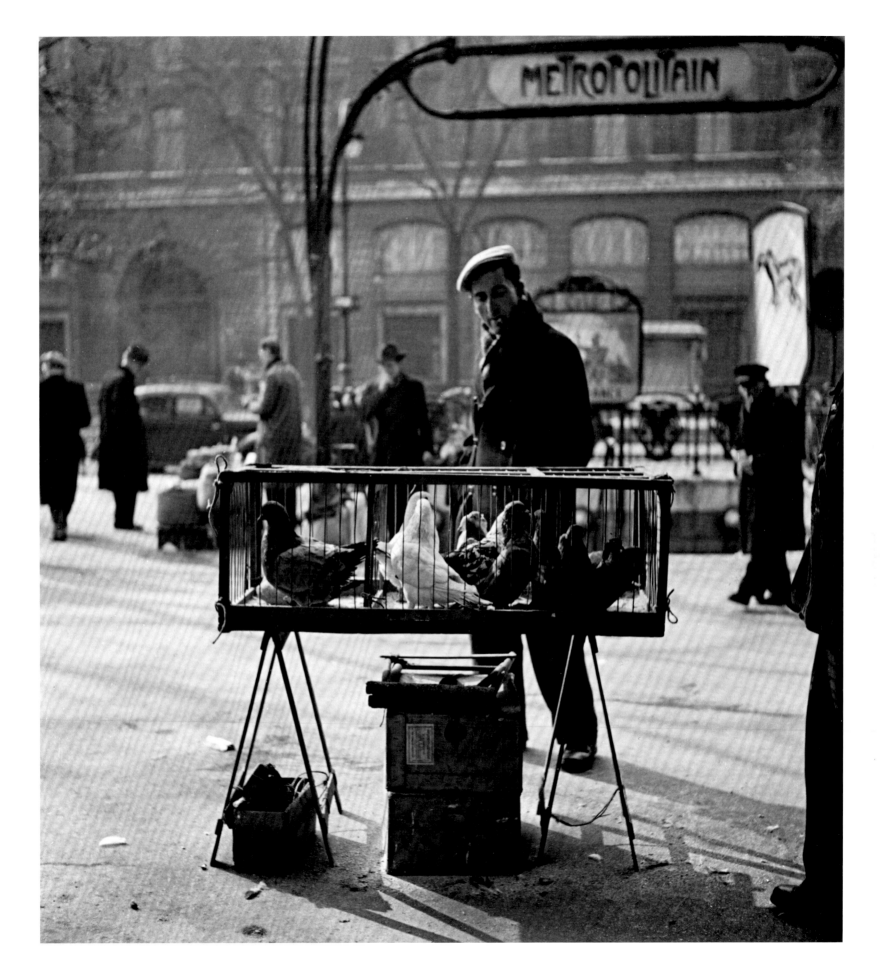

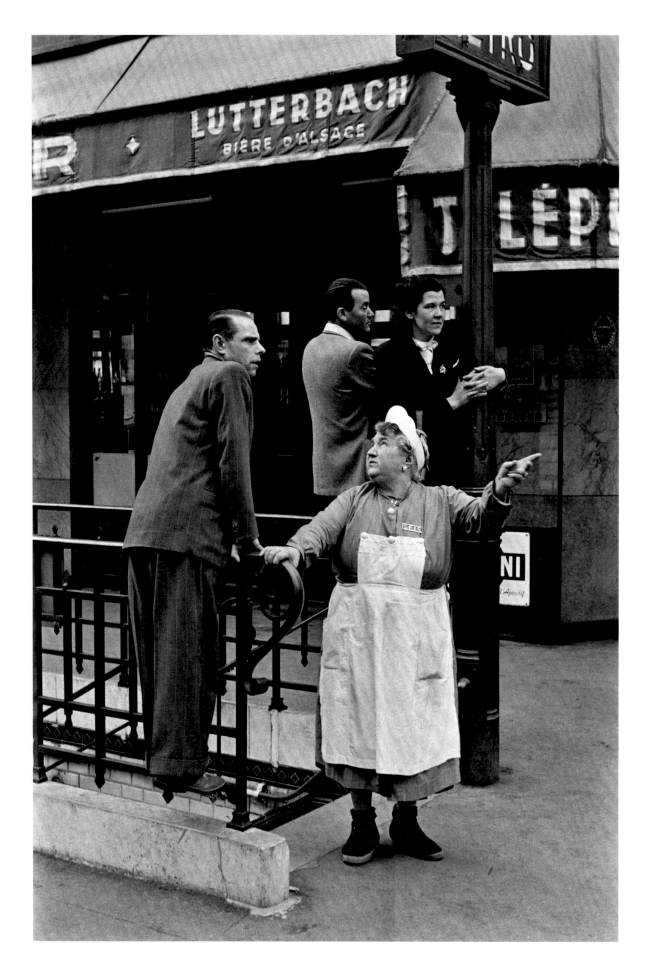

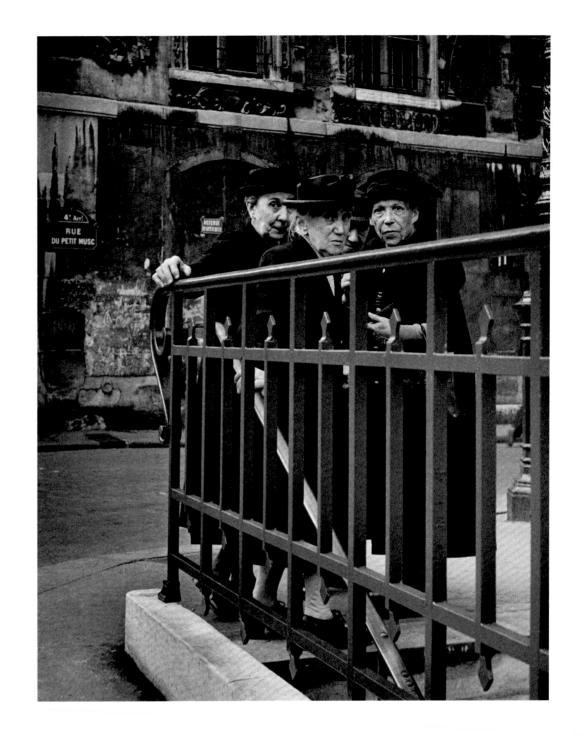

Opposite: INGE MORATH - *Near the Place de la Bastille,* 1953

Above: JEAN MARQUIS - *Rue du Petit-Musc,* 1951

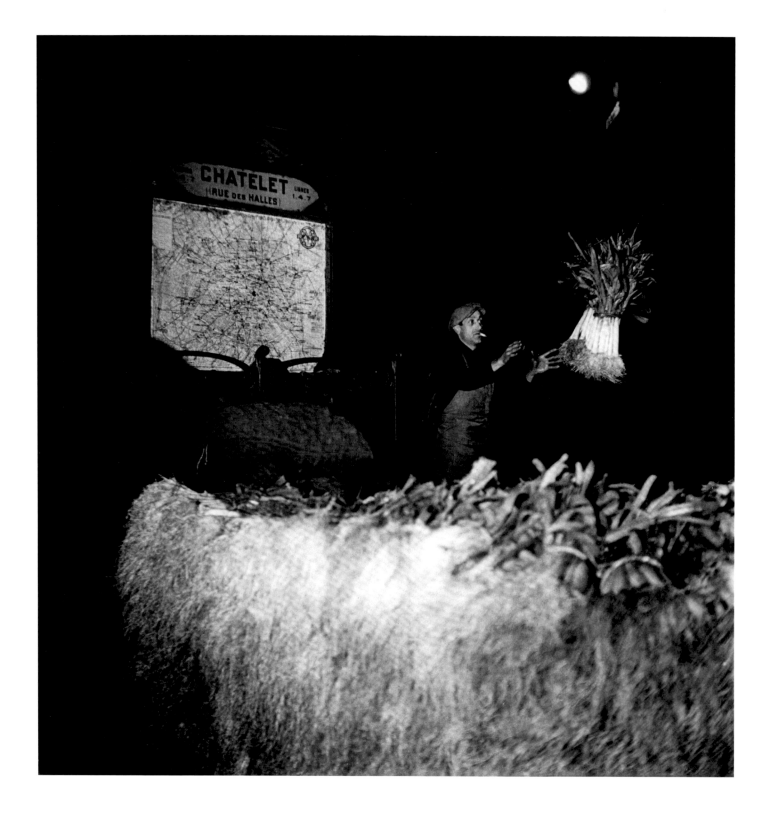

Above: PAUL ALMASY - *Les Halles*, 1955

Opposite: ROBERT DOISNEAU - *Punching tickets on the Métro platform*, 1957

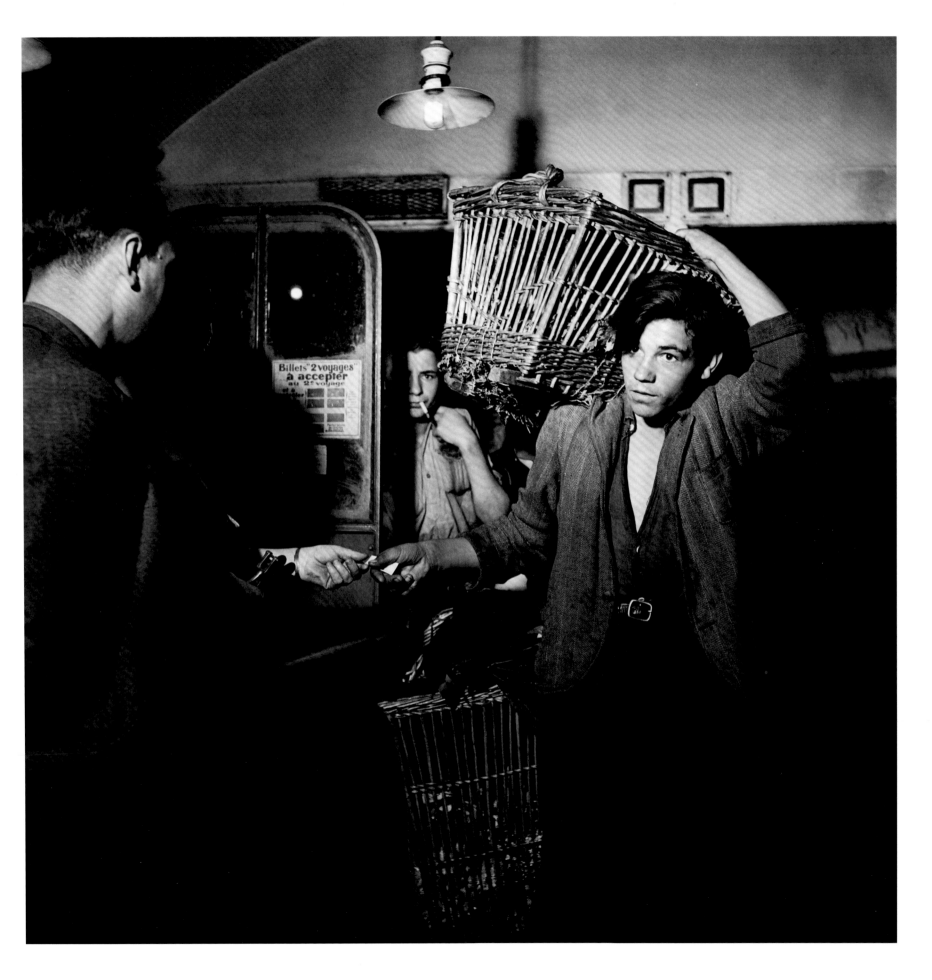

IZIS - *"Mirabeau Station, 6 AM,"* 1949

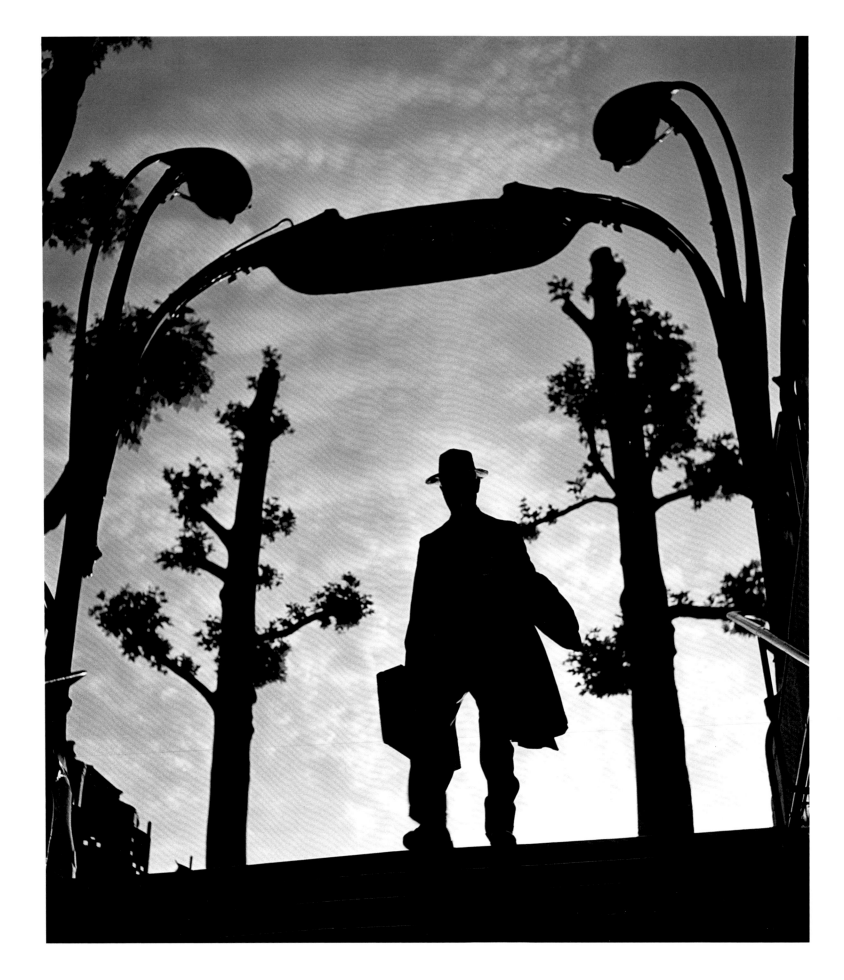

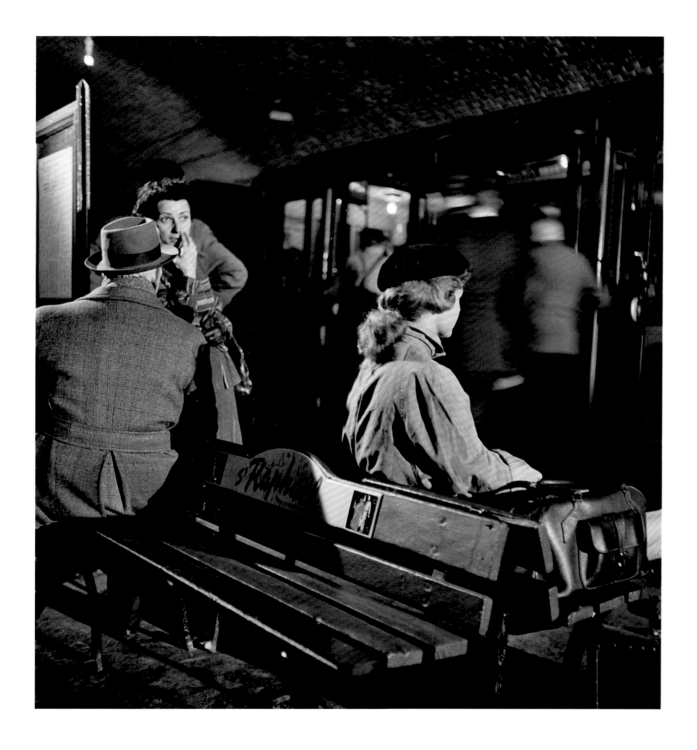

JACQUES HENRI LARTIGUE - *"Métro,"* 1954

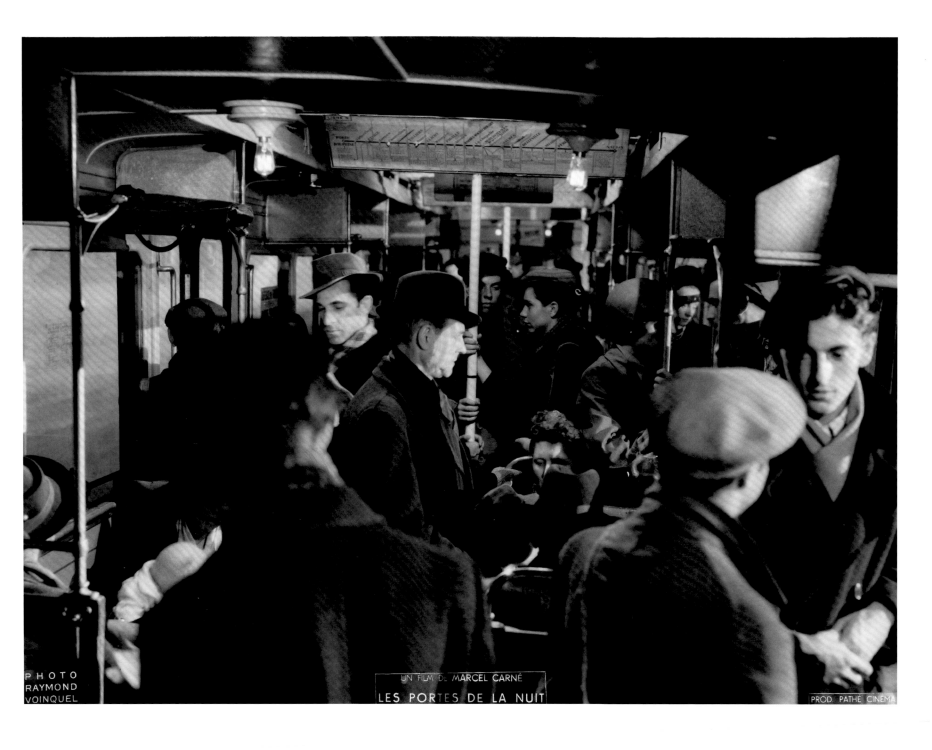

RAYMOND VOINQUEL - *Filming Marcel Carné's movie* Gates of the Night, 1946

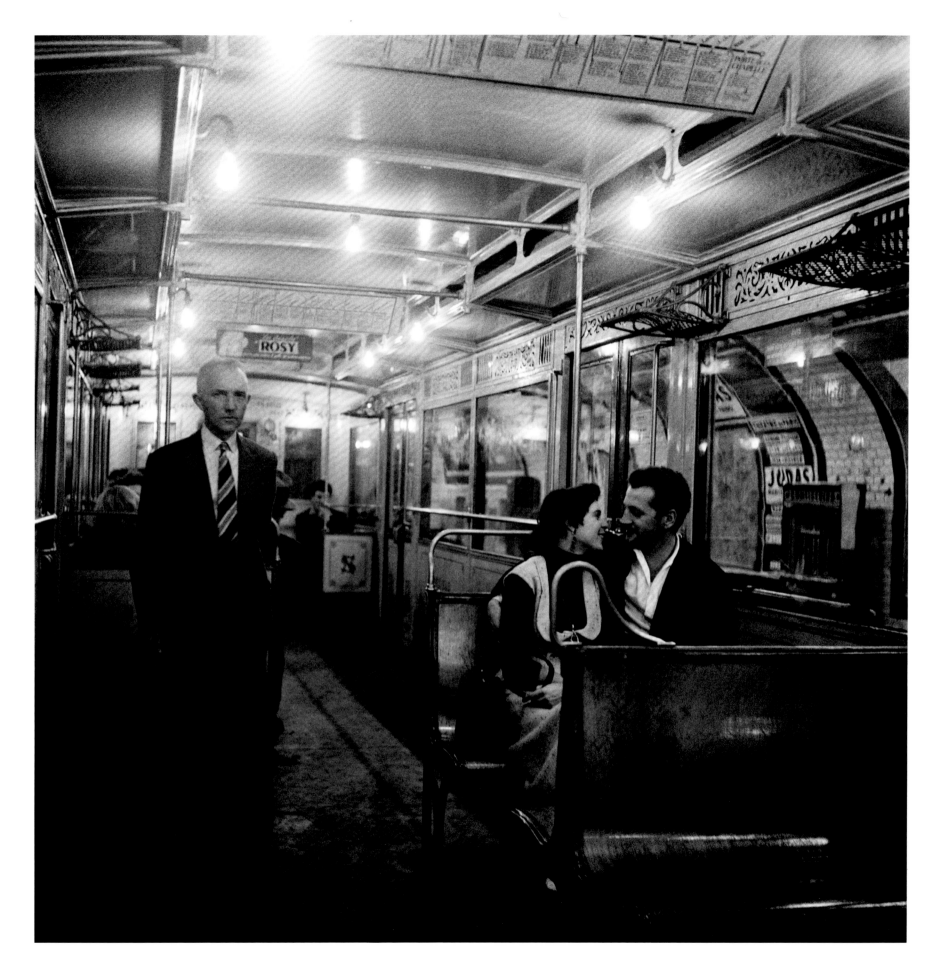

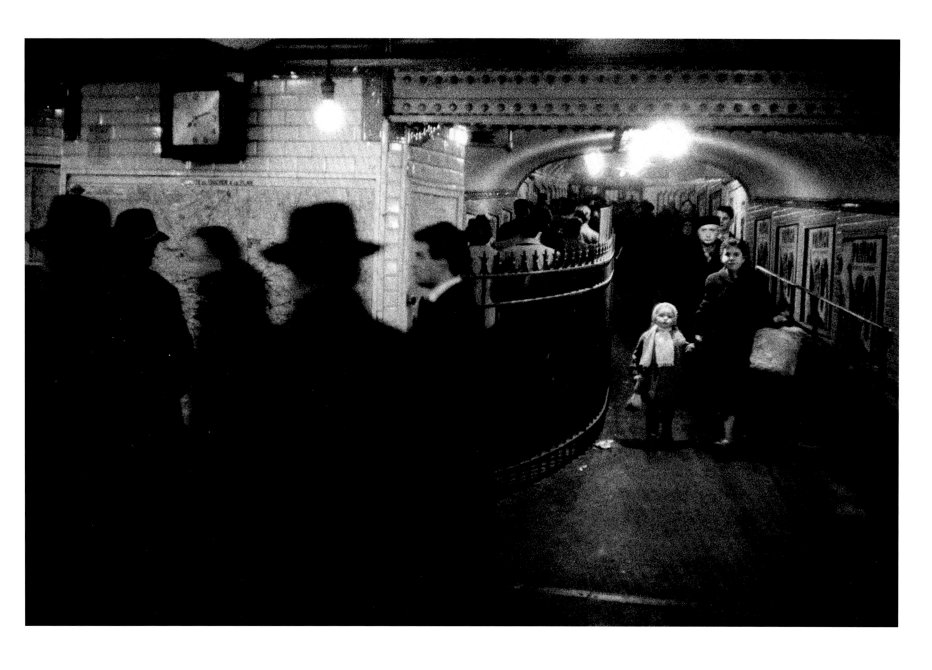

Opposite: KEES SCHERER - *Couple in the Métro*, 1955

Above: JOHAN VAN DER KEUKEN - *"Gare de Lyon, Paris,"* 1957

Next pages:

Left, top: GEORGE S. ZIMBEL - *Métro corridor*, 1951

Left, bottom: ANDRÉ KERTÉSZ - *Men with underground cables (Père-Lachaise station)*, 1950

Right: UNIDENTIFIED PHOTOGRAPHER (RATP COLLECTION) - *Repairing the girders at the Montmartre station*, December 23, 1949

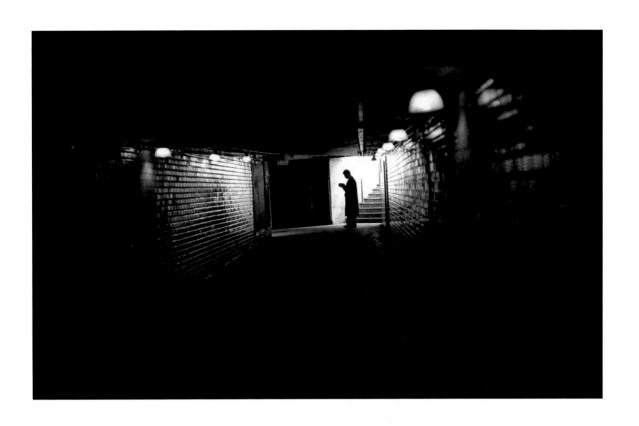

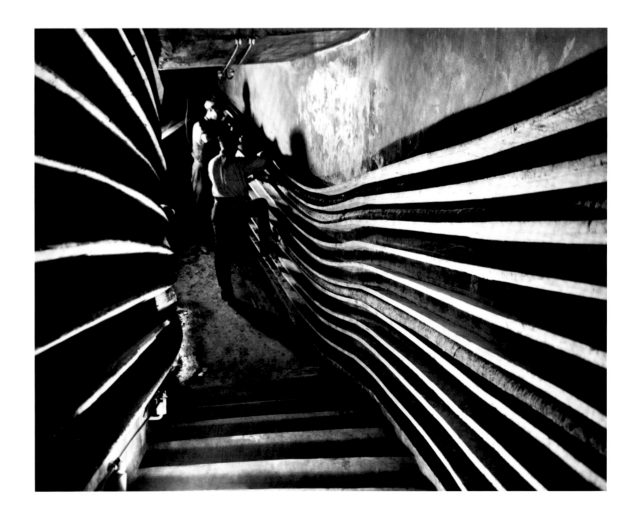

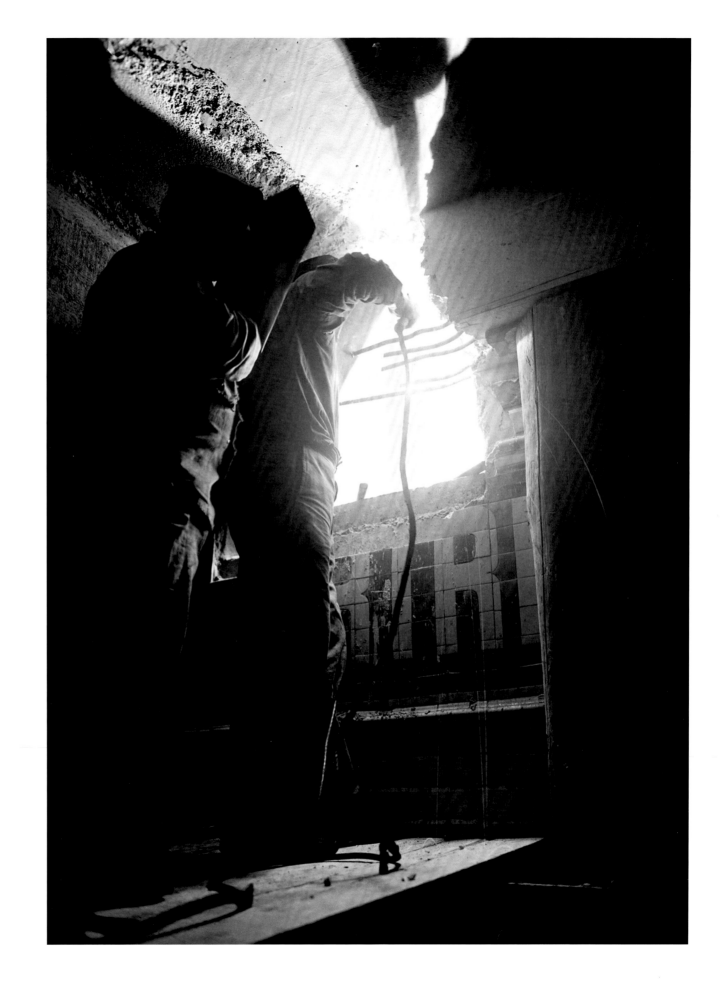

ED VAN DER ELSKEN - *At the Métro entrance*, circa 1950-1954

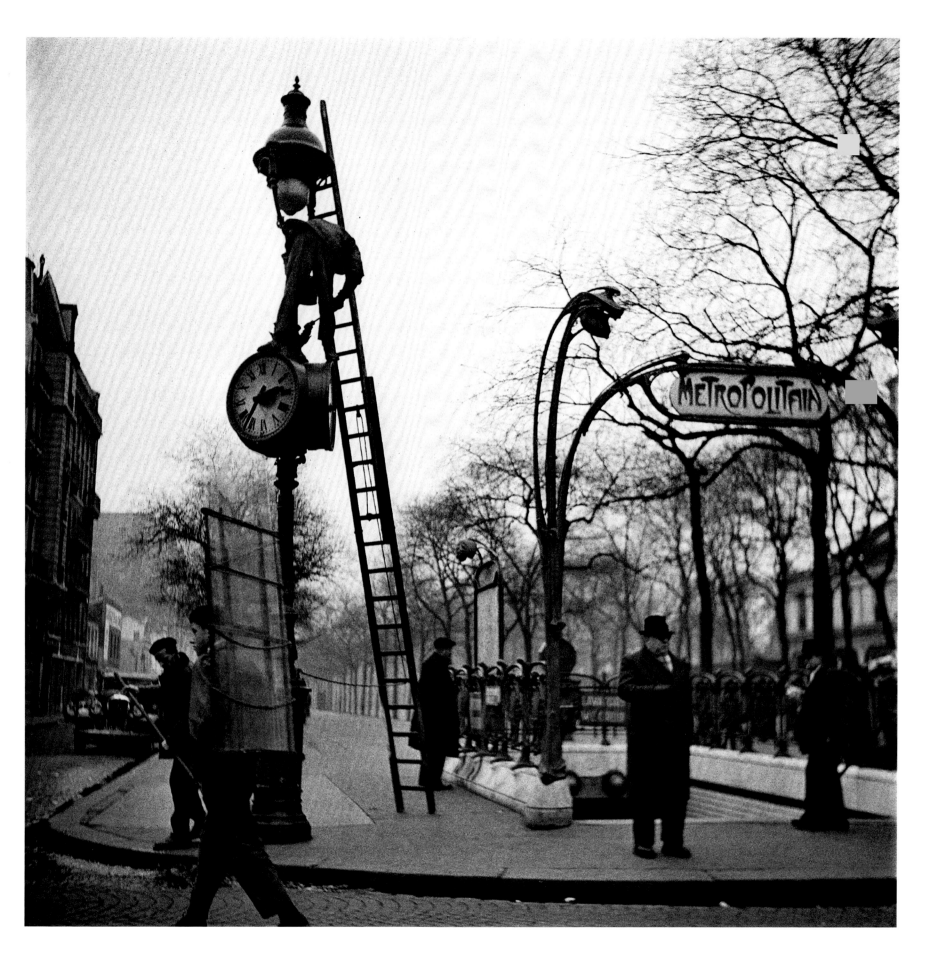

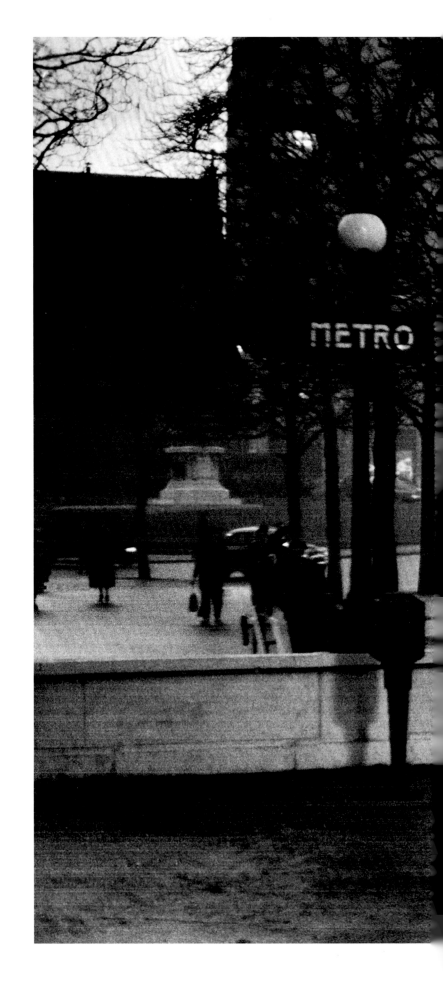

ELLIOTT ERWITT - *"Paris,"* 1951

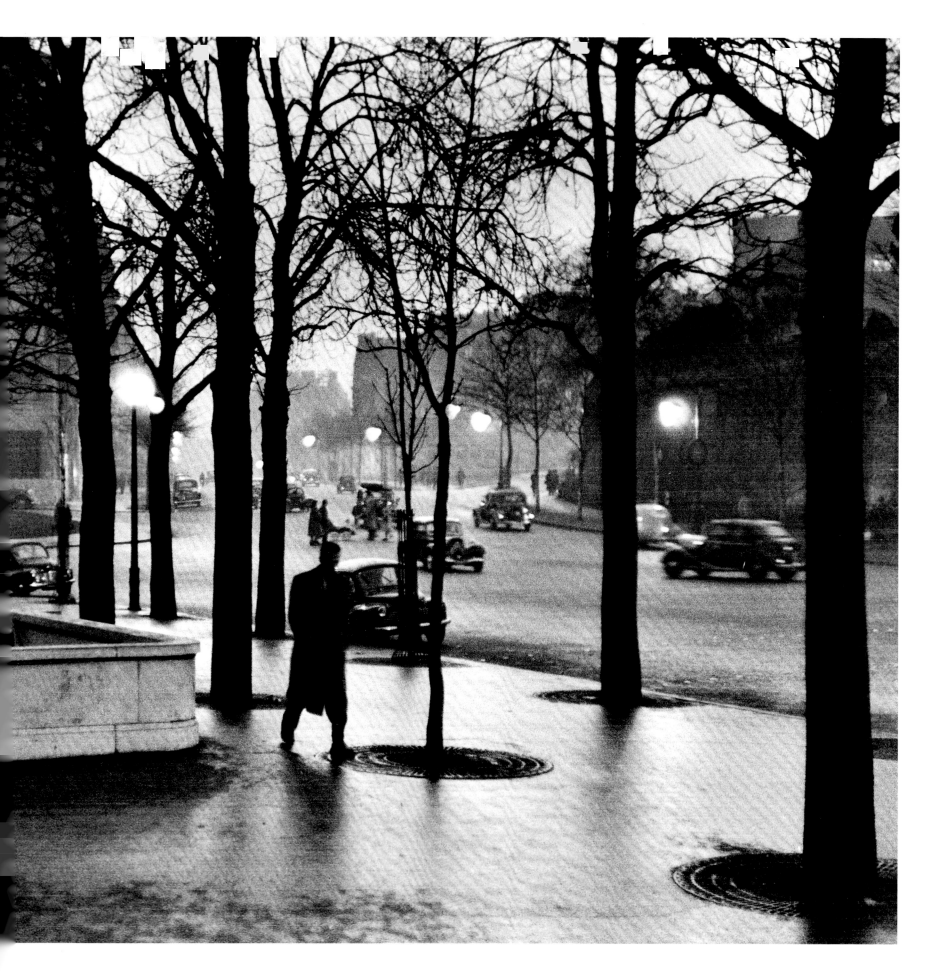

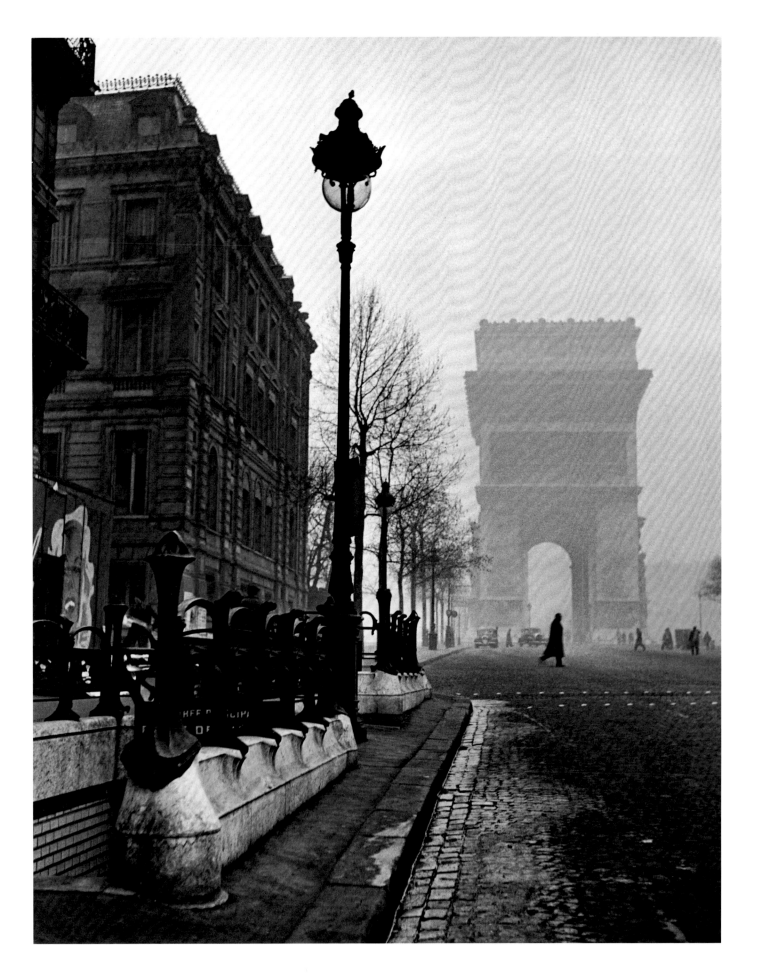

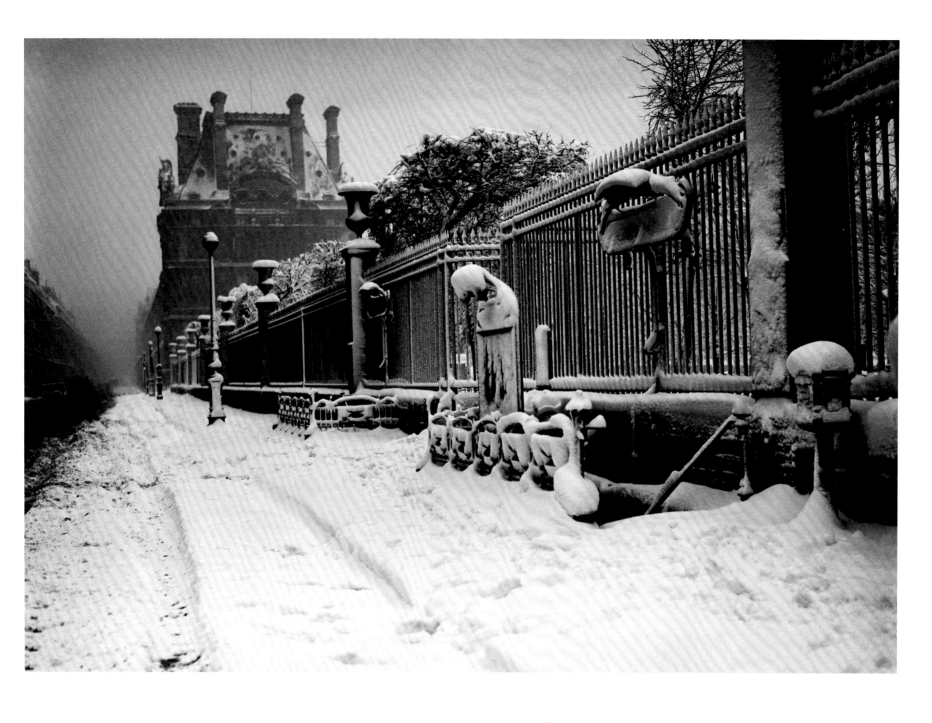

Opposite: ED CLARK - *The Arc de Triomphe*, 1946

Above: LAPI AGENCY (LES ACTUALITÉS PHOTOGRAPHIQUES INTERNATIONALES) - *Snow, Rue de Rivoli*, 1946

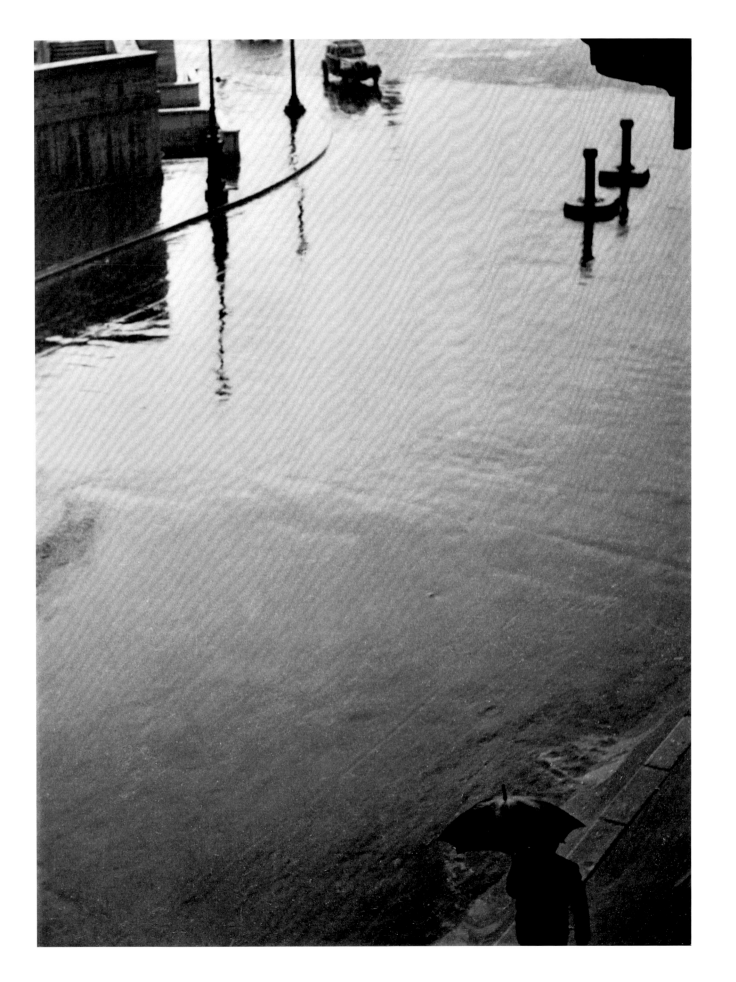

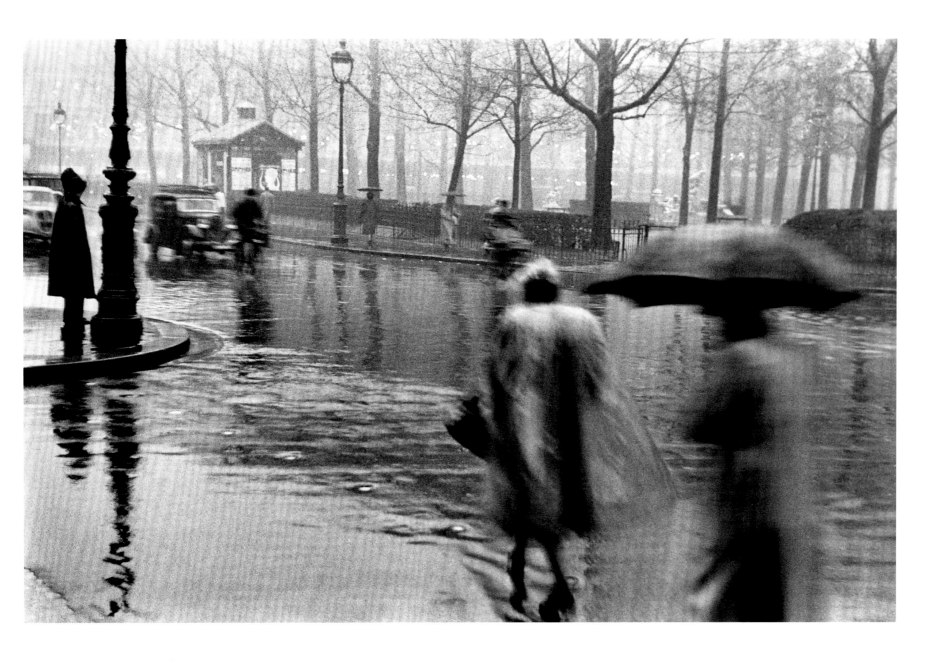

Opposite: MAURICE TABARD - *Rain, Rue de Rivoli,* 1948

Above: ÉDOUARD BOUBAT - *"Sèvres-Babylone,"* 1952

GISÈLE FREUND - *Snow at Sèvres-Babylone station*, 1958

Next pages:

Left: RENÉ-JACQUES - *Havre-Caumartin station*, 1947

Right: MARCEL BOVIS - *Gaîté station (at night, Avenue du Maine)*, circa 1950

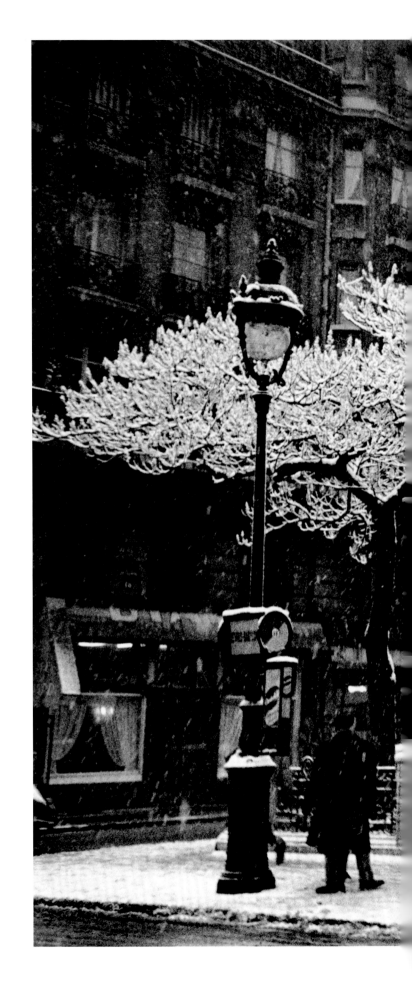

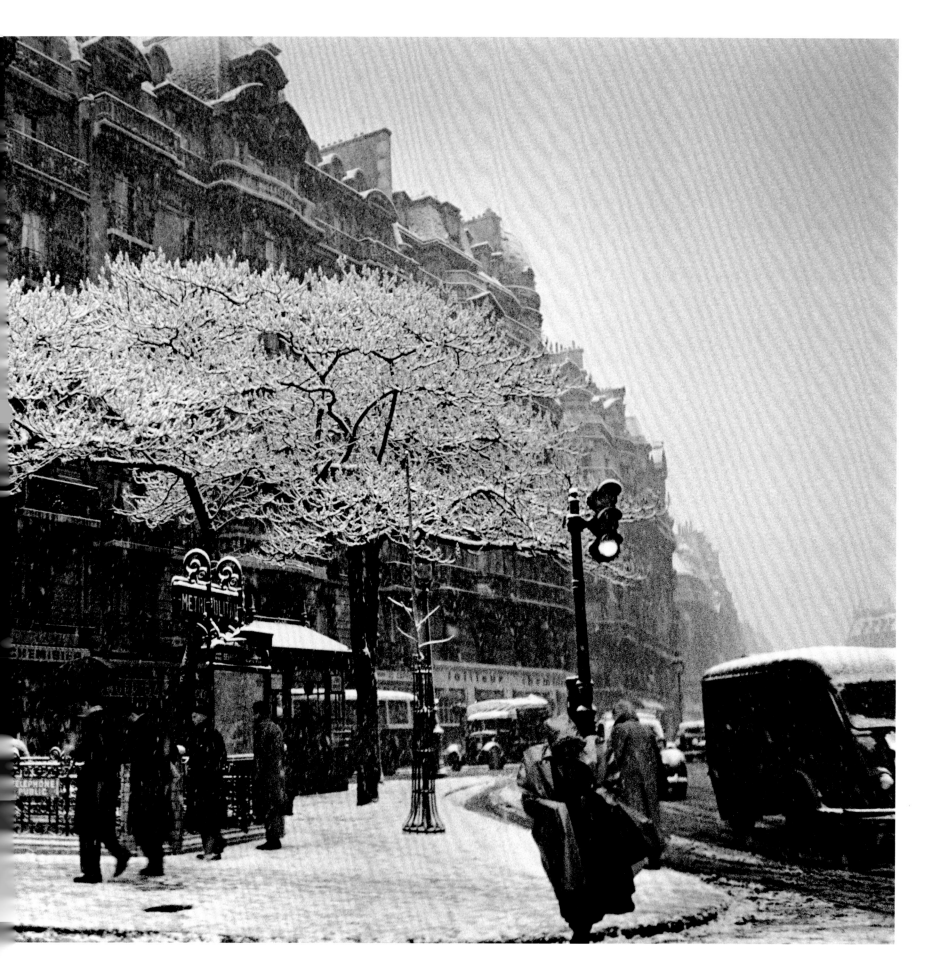

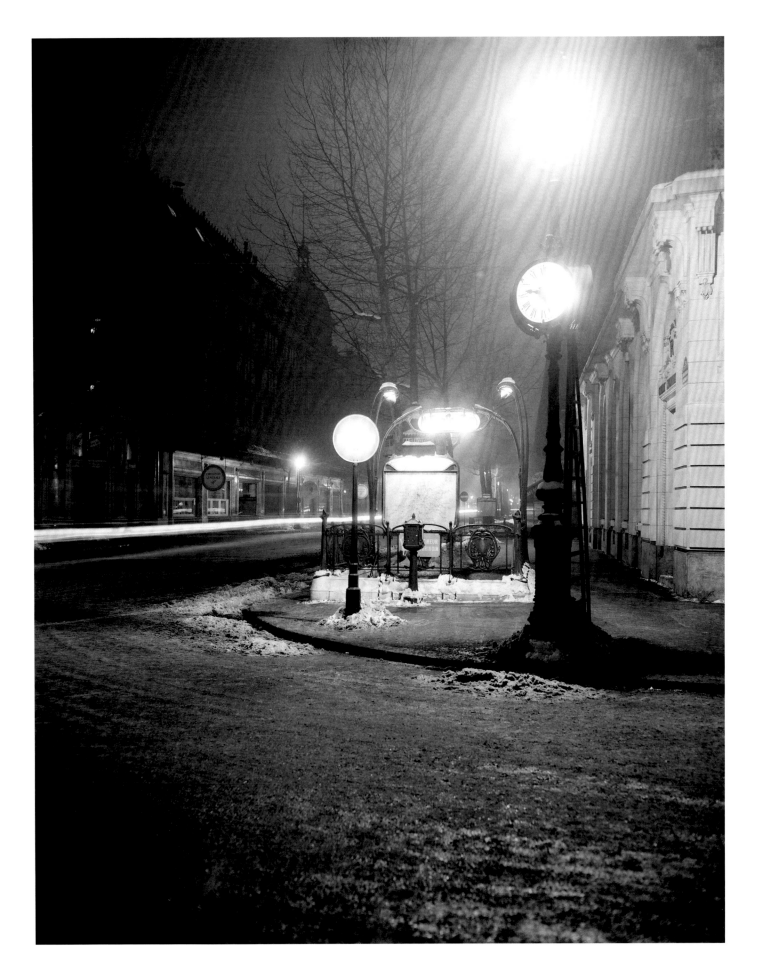

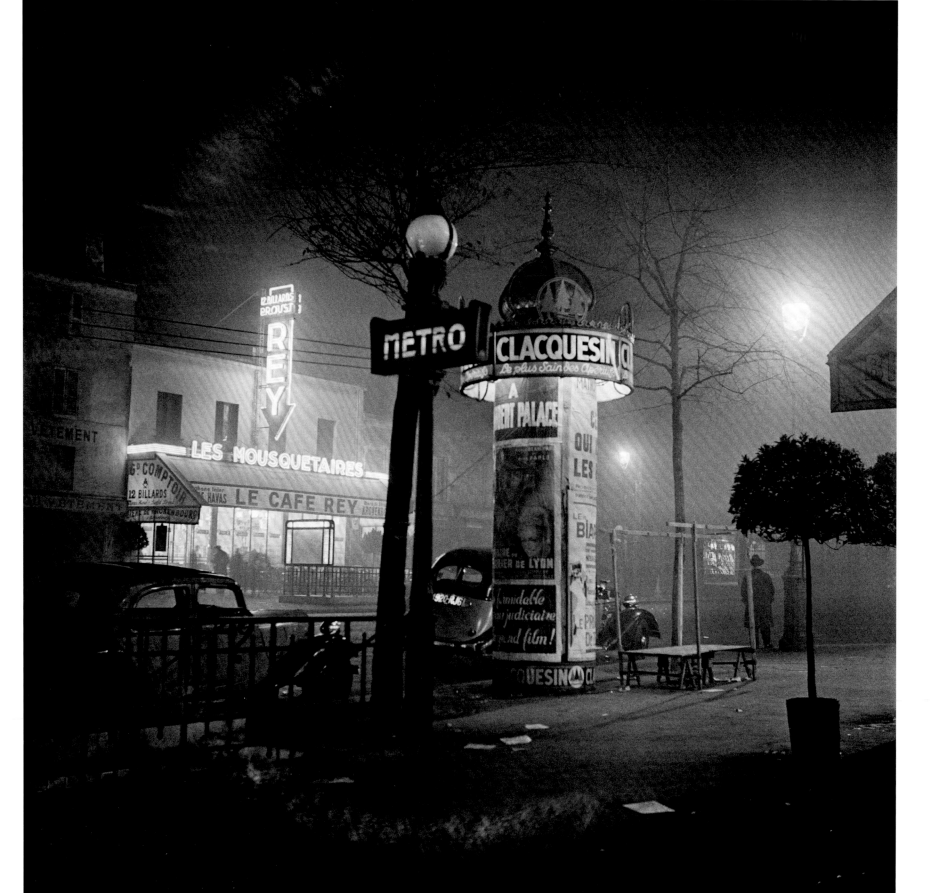

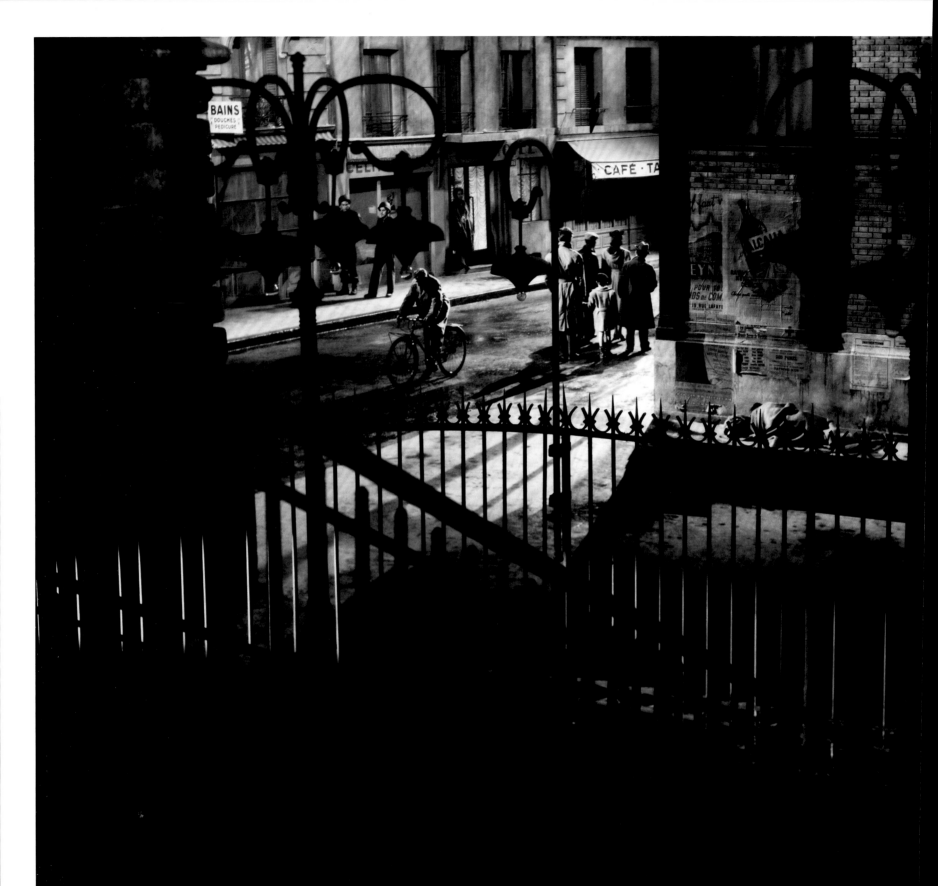

UN FILM DE **MARCEL CARNÉ**

LES PORTES DE LA NUIT

RAYMOND VOINQUEL - *Filming Marcel Carné's movie* Gates of the Night, 1946

IZIS - *"Pont de Grenelle,"* 1948

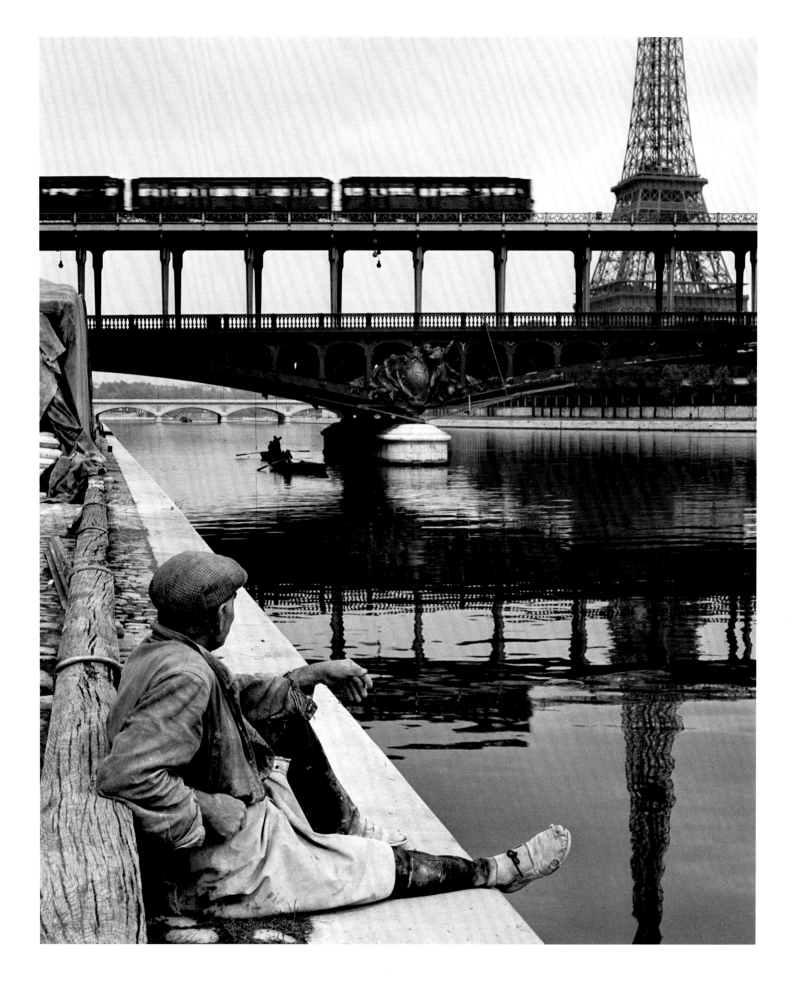

Above: ÉDOUARD BOUBAT - *The French writer Raymond Queneau (author of* Zazie in the Métro*), 1956*

Opposite: ROBERT DOISNEAU - *"In the Métro" (Maurice Baquet and his cello)*, 1958

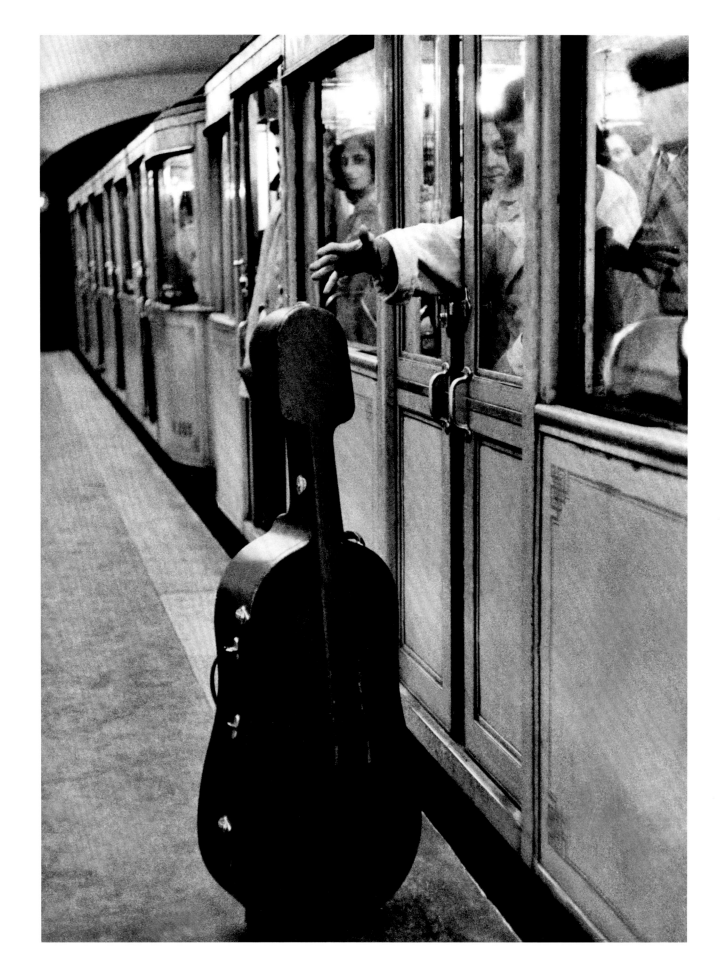

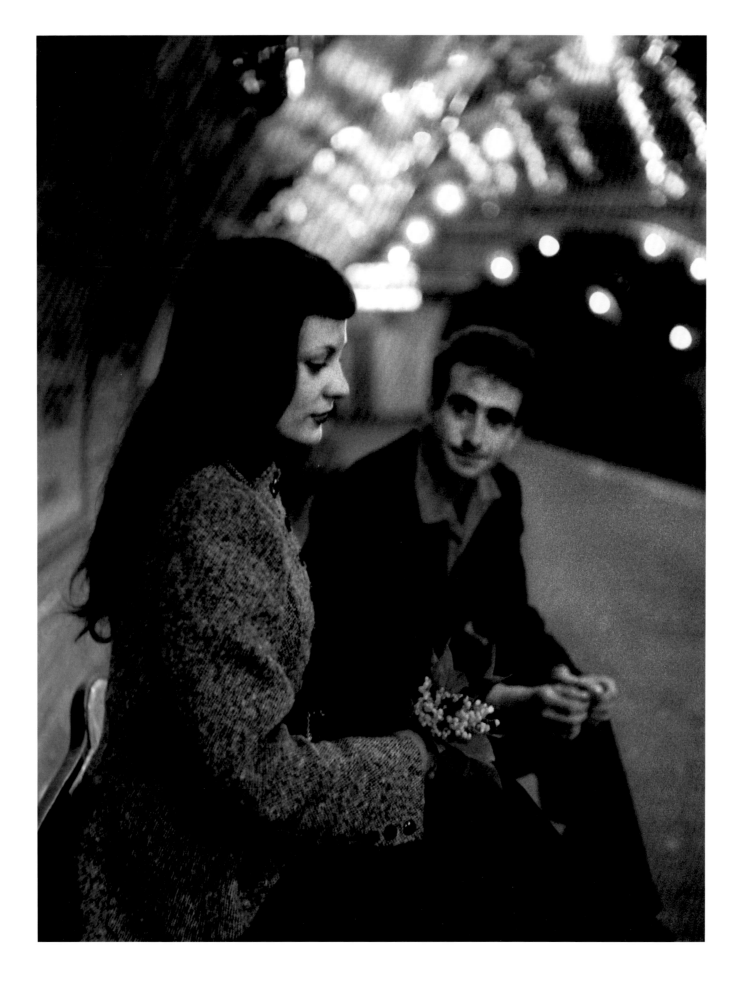

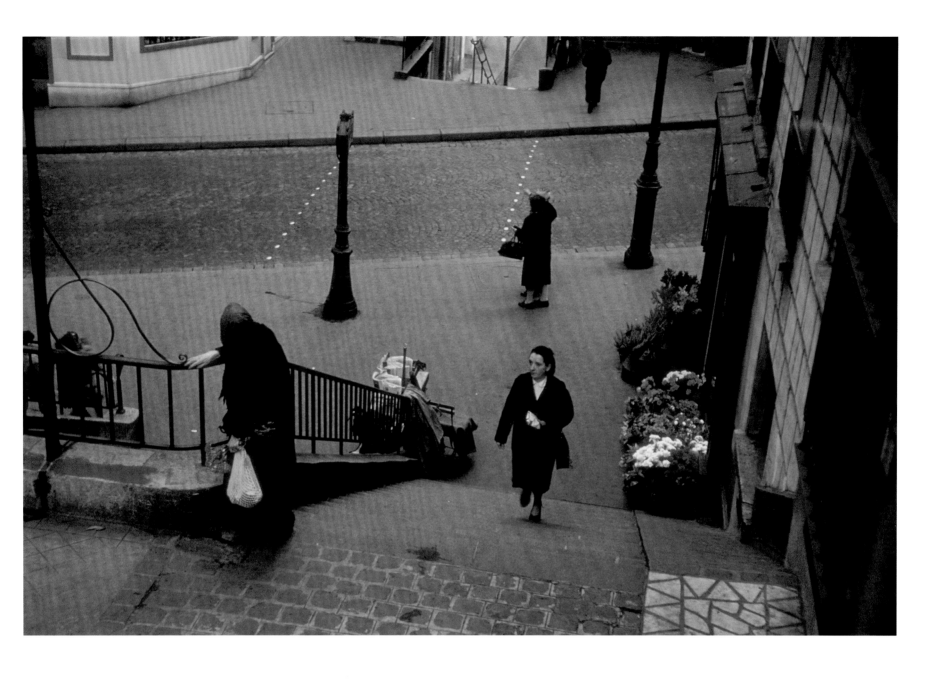

Opposite: ROBERT DOISNEAU - *"The Lily-of-the-Valley of the Métro,"* 1953

Above: ERNST HAAS - *Flowers at the Lamarck-Caulaincourt station,* 1954

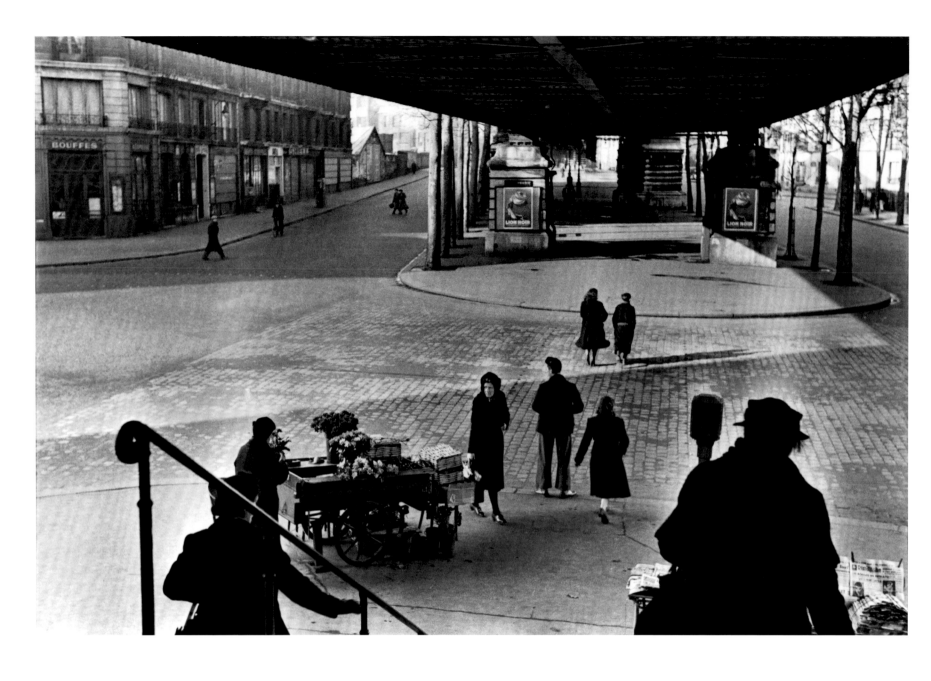

Above: HENRI CARTIER-BRESSON - *"Boulevard de la Chapelle,"* 1951

Opposite: WILLY RONIS - *Under the elevated Métro at Barbès-Rochechouart,* 1939

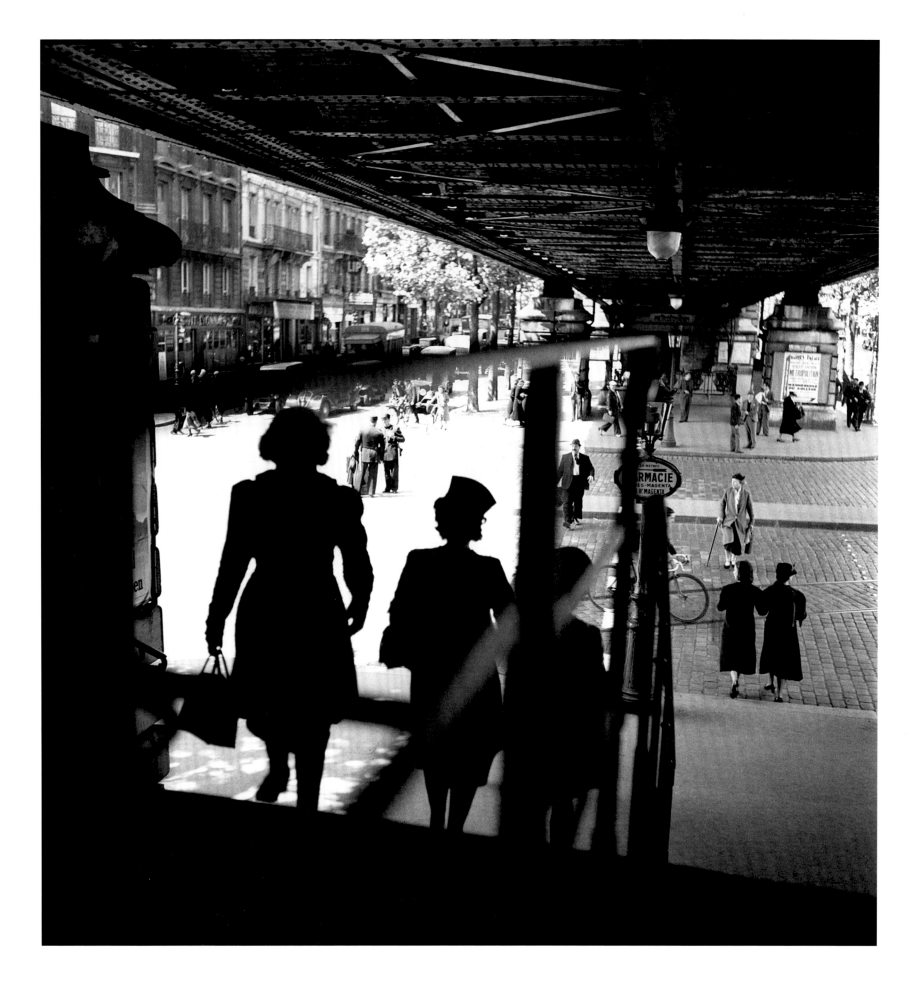

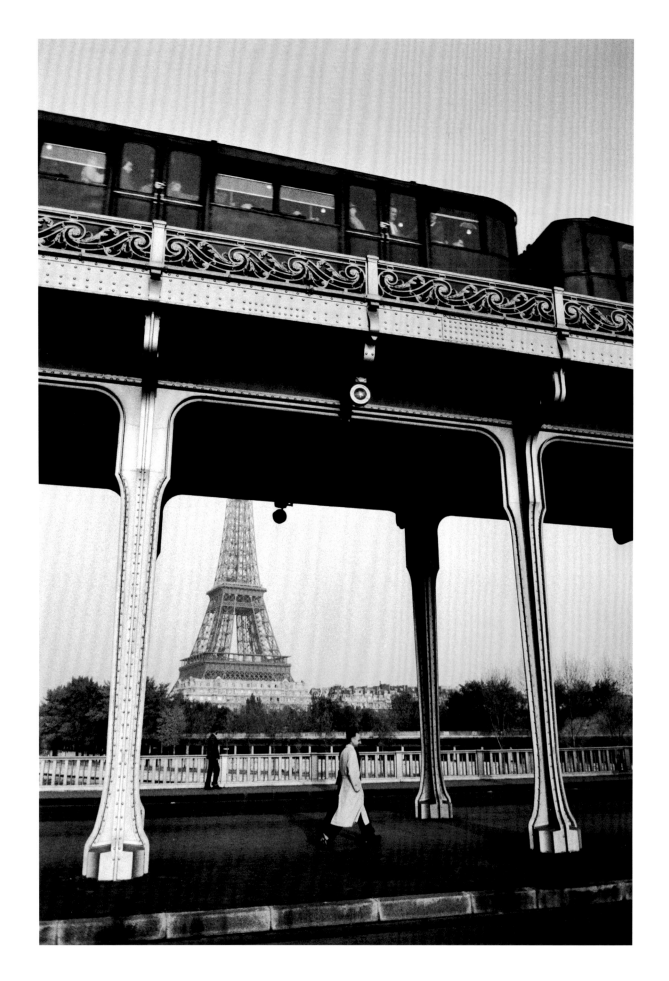

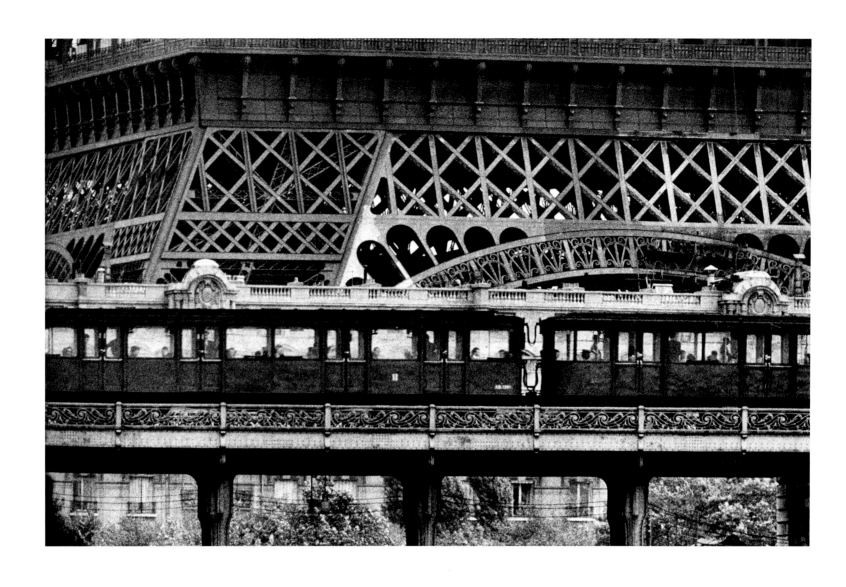

Opposite: WILLY RONIS - *Métro and Eiffel Tower*, 1958

Above: FRANK HORVAT - *Eiffel Tower and Métro*, 1956

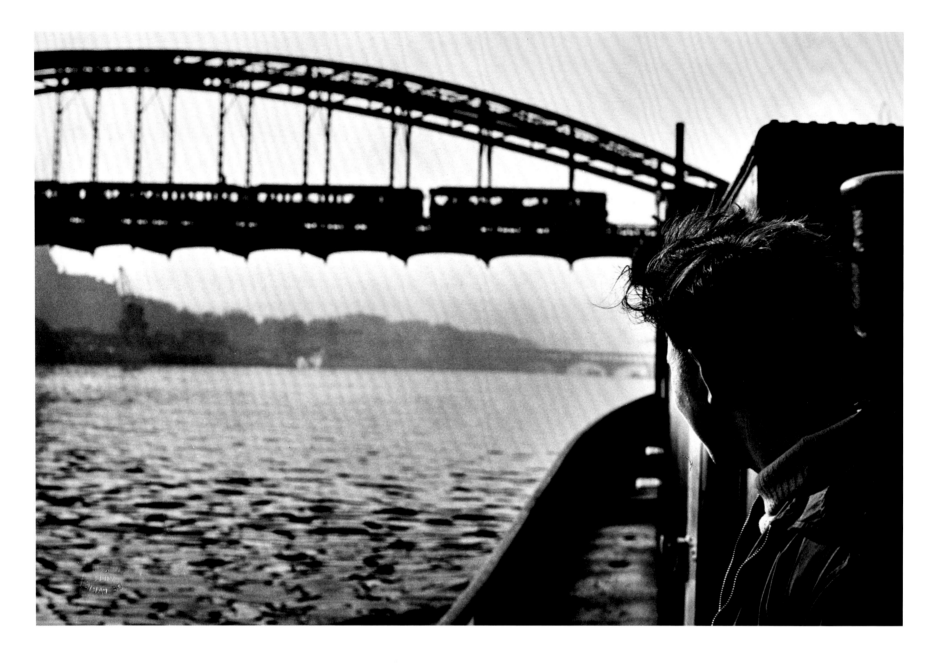

Above: JEAN MARQUIS - *Pont d'Austerlitz (photo published in 1964 in Louis Aragon's book of selected poems called* Il ne m'est Paris que d'Elsa*)*, 1953

Opposite: IZIS - *Boulevard Rochechouart*, circa 1950

Next pages:

Left: IZIS - *"Quai de la Gare,"* 1947

Right: ROBERT DOISNEAU - *Train driver*, 1955

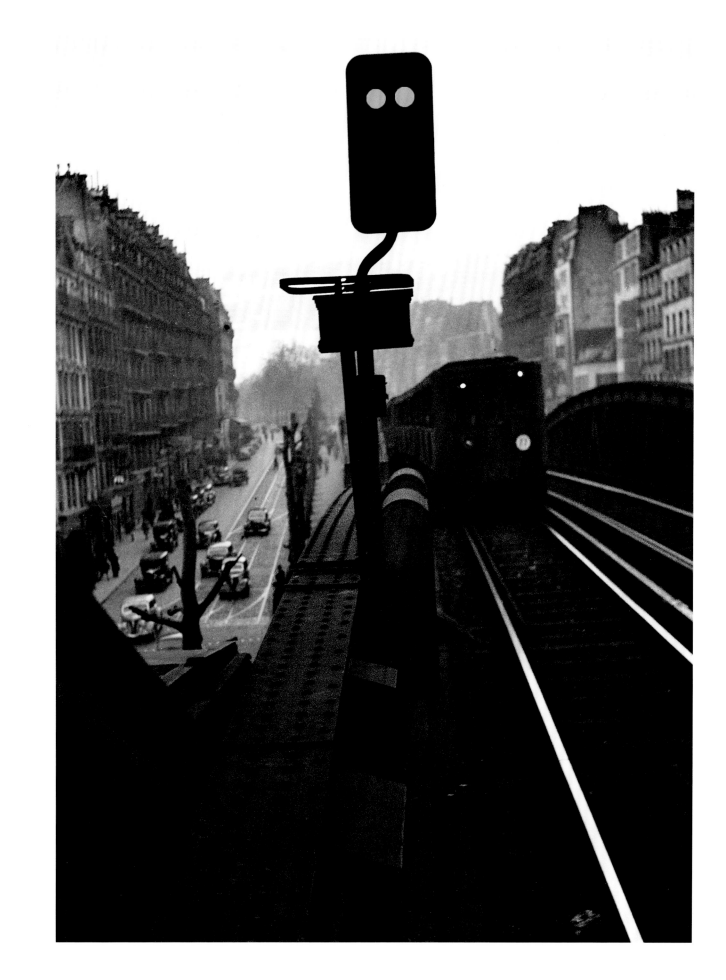

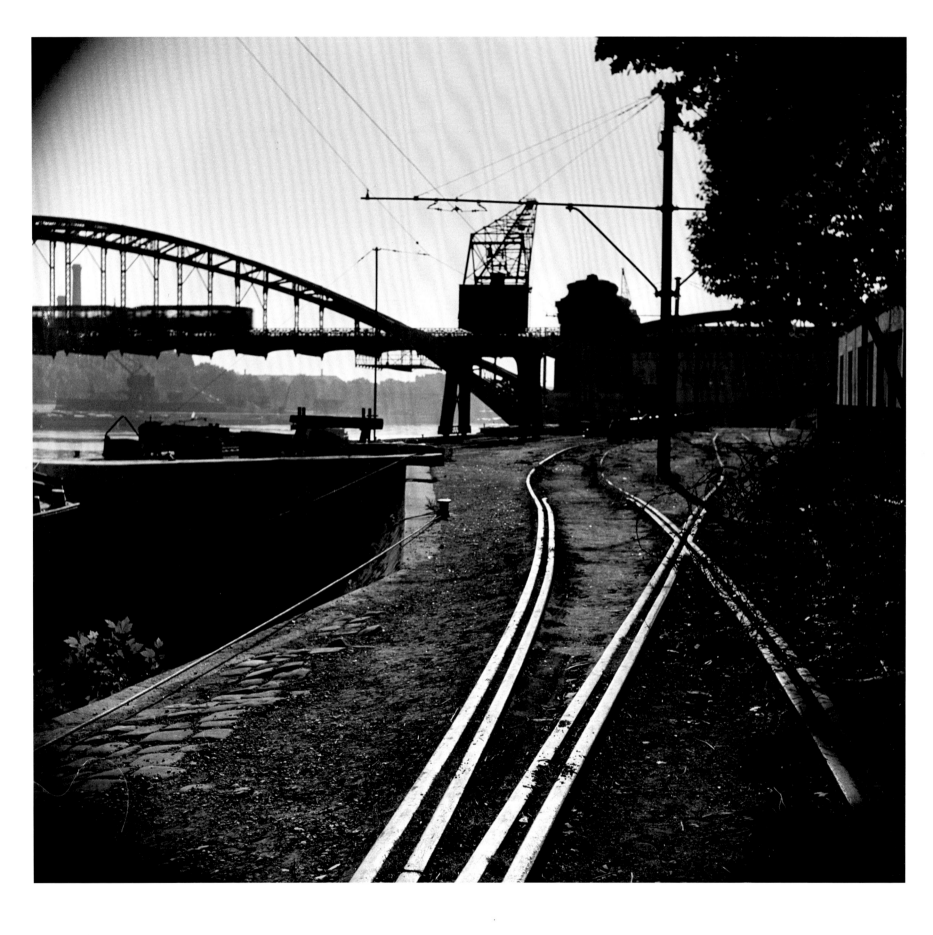

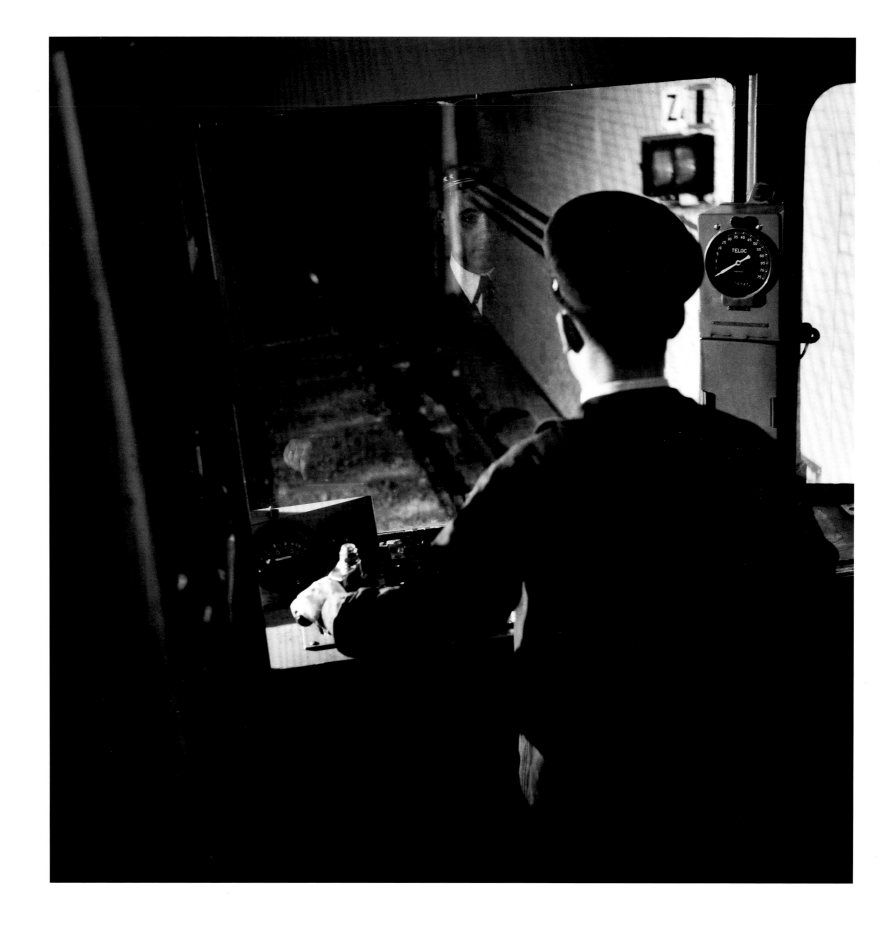

JANINE NIÉPCE - *Exit (Chaussée-d'Antin)*, 1955

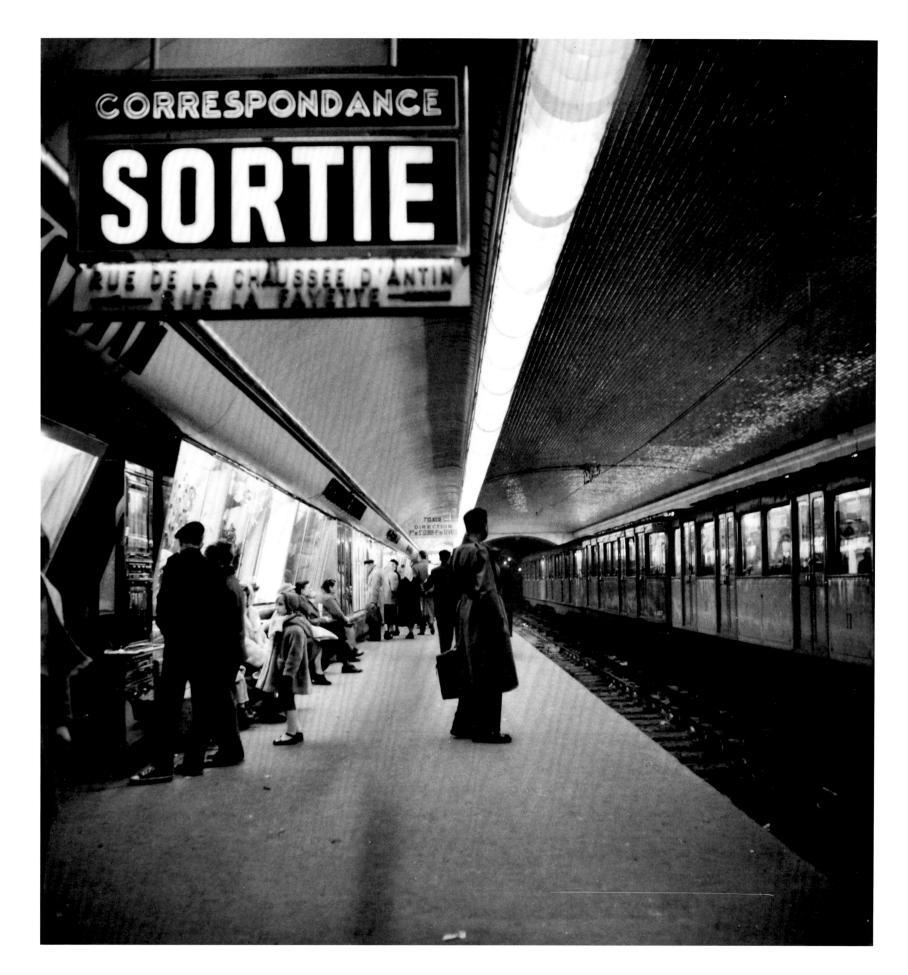

FRANK HORVAT - *Strasbourg-Saint-Denis station*, 1956

Next pages:

Left: JEAN-PHILIPPE CHARBONNIER - *Havre-Caumartin station (the department store crowd)*, 1950s

Right: ÉDOUARD BOUBAT - *Place de l'Opéra*, 1953

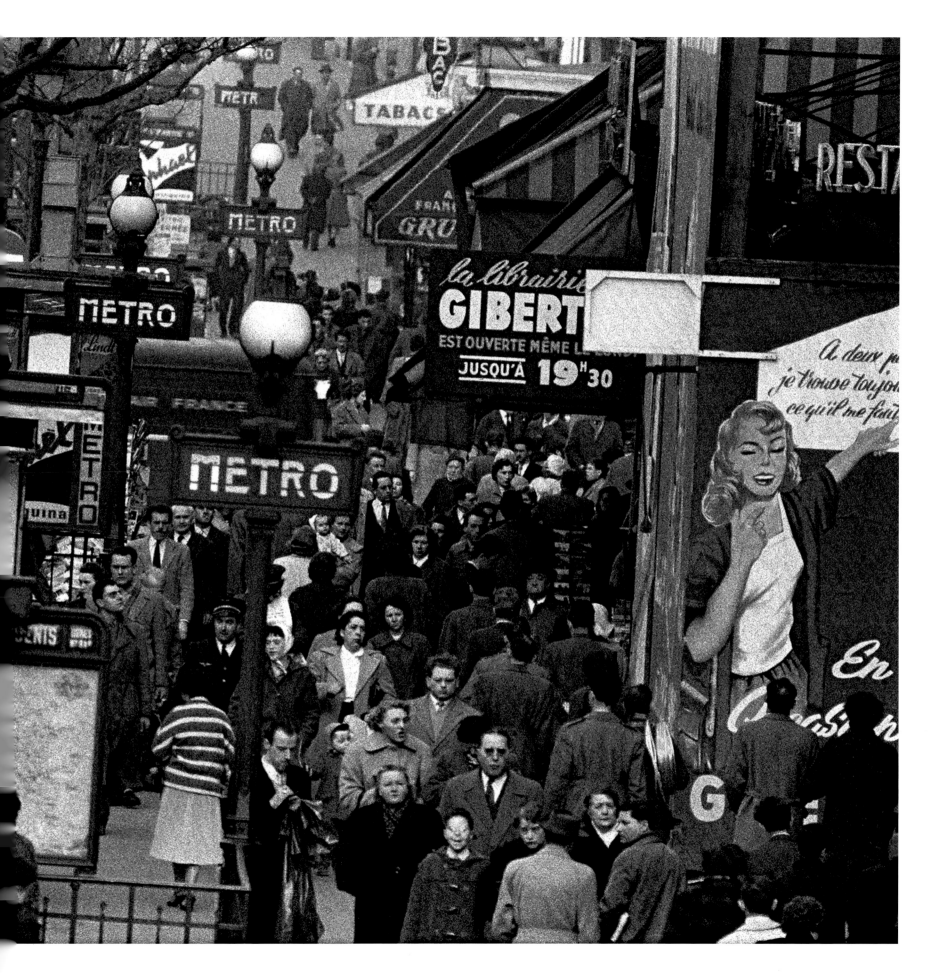

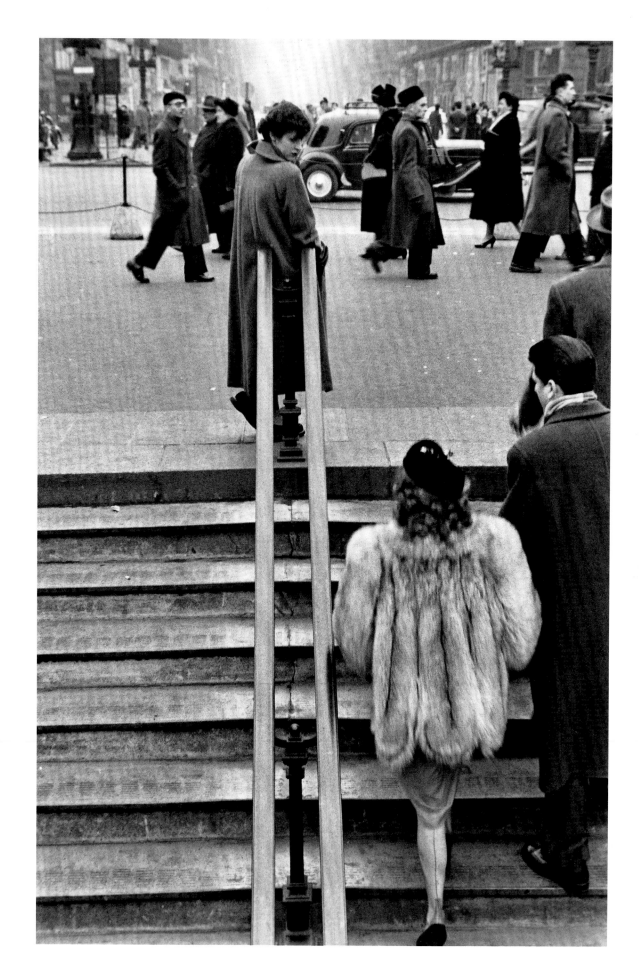

MARK SHAW - *"Palais de Glace" dress (Dior)*, 1957

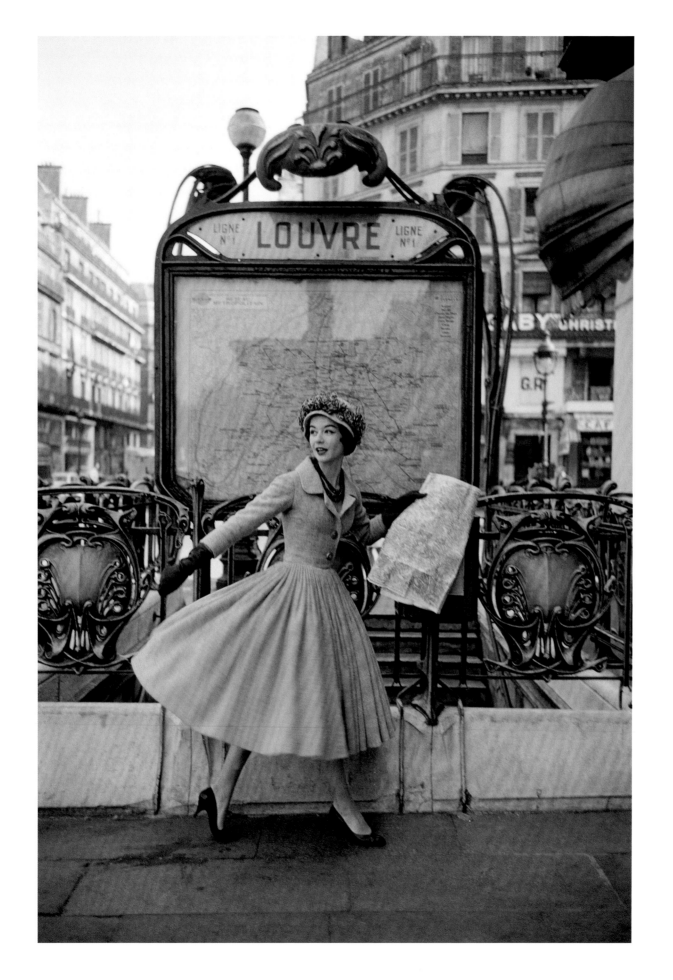

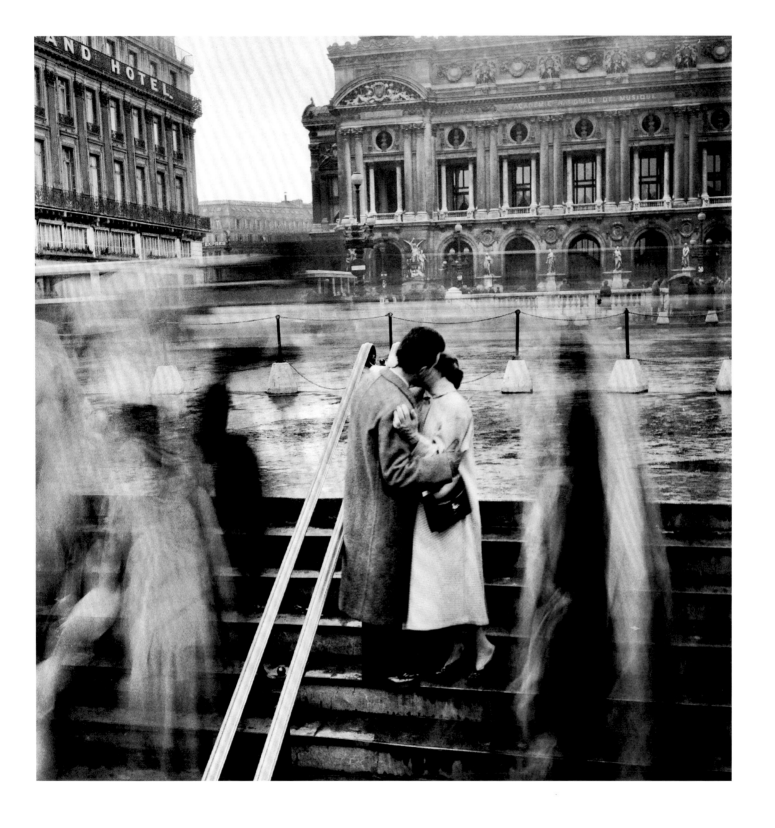

Above: ROBERT DOISNEAU - *"The Kiss, Opéra Station,"* 1950

Opposite: EVA BESNYÖ - *Rue de Rivoli,* 1952

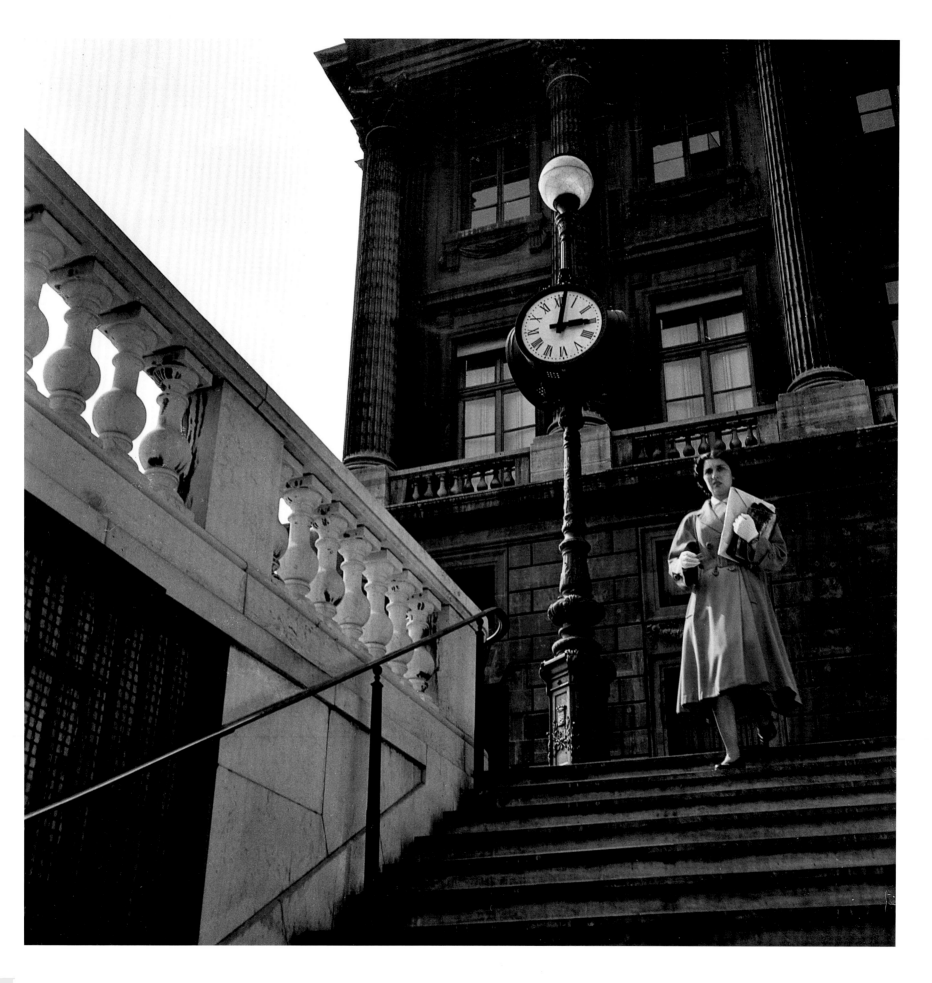

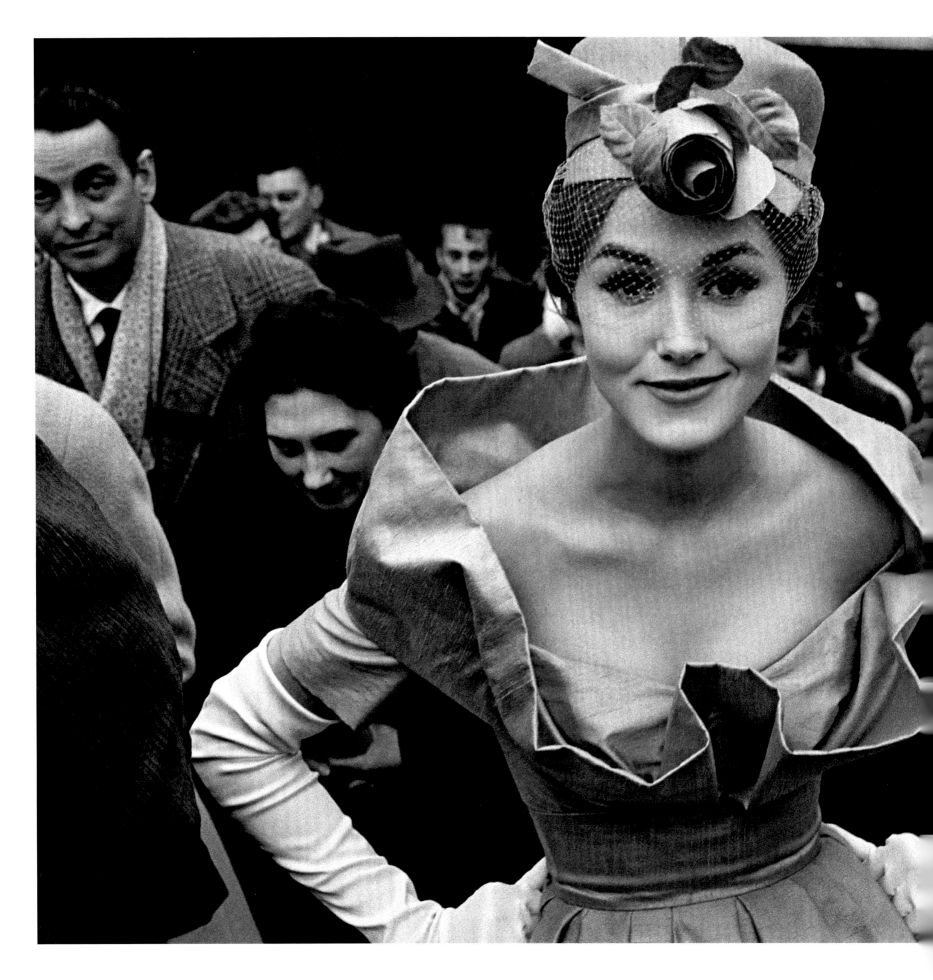

FRANK HORVAT - *Métro exit (Monique Dutto for* Jours de France), 1959

WILLIAM KLEIN - *"Marie-Hélène + Raphaël, Paris"* (Vogue), 1957

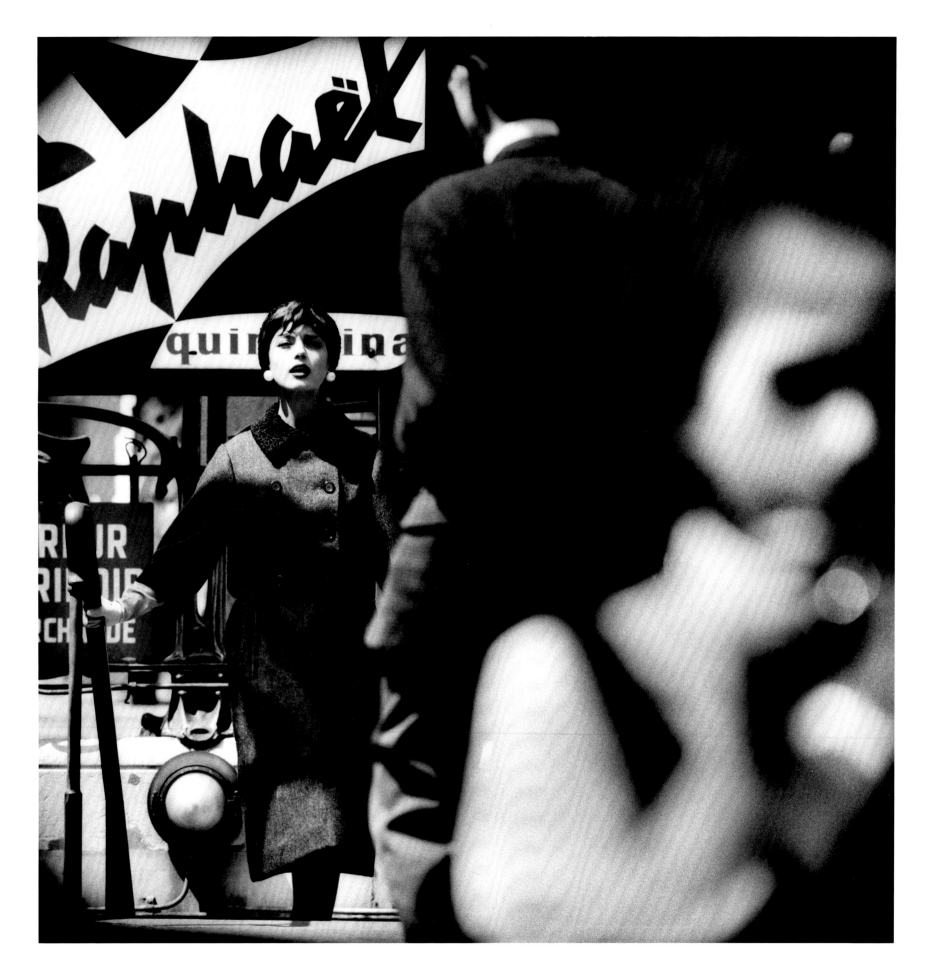

SABINE WEISS - *Métro Exit*, 1955

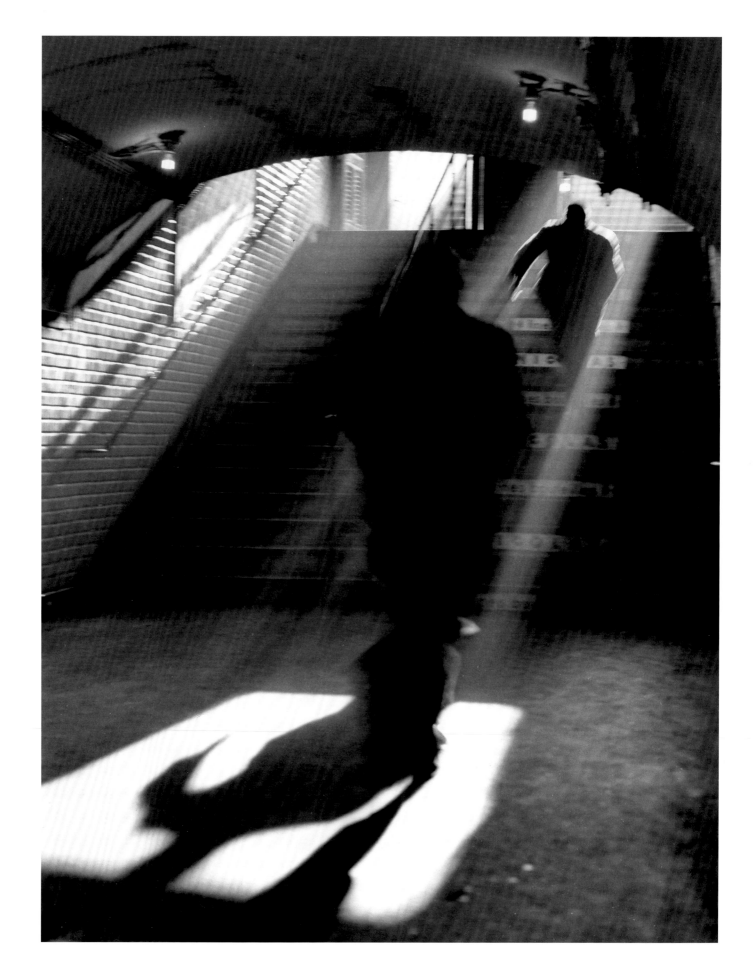

Ten years separate them: same point of view, same station (Rambuteau), same streetlight, same peeling façades, same letters on the walls. And yet, these two photographs—one by Elliot Erwitt, the other by Ervin Marton—could not be more different (pp. 240-241). While Erwitt's emphasizes line, juxtaposition of blacks, greys and whites, the joyful jumble of geometric shapes (windows, signs, billboards, cobblestones) and typically French typographic symbols ("PMU," "Gerflex," "Beaubourg," "Brasserie," "Plat du Jour," "Triperie," "Restaurant," "Métro"), Marton's lives by color, mosaic of colorful fragments, blue of the sky, grey of the asphalt, red of the *tabac* and the Métro. The range of photographic possibilities is striking here, whether the author expresses himself in black-and-white or in color.

In the 1960s and '70s, the aesthetic tendencies of the previous period continued to flourish. Humanism pursued its exploration of a social reality poetized by the nostalgia of the lens, as with that young magazine seller by Édouard Boubat (p. 249) or that little boy on his way to school by Reporters Associés (pp. 246-247). The graphic image and the Métro sign still fascinated photographers just as much, as a number of prints show, from photoreports by the Keystone agency (p. 243) to the admirable *Jambes du métro (Métro Legs)* by Robert Doisneau (p. 230), along with splitting the image by the superimposition of bars—Joël Thibaut (p. 262), Bruno Réquillart (p. 263)—or the typographical saturation of the nighttime space (Georges Kelaïditès, p. 229). The Métro continued to flirt with the world of fashion, as in the famous composition by William Klein, *Isabella + Opera + Blank Faces* (pp. 236-237) or in the lesser-known photo by Helmut Newton (pp. 232-233), both taken for *Vogue*. In both cases, the photographer confronts the environment of the Métro while using artifices to isolate the subject within the charged setting where the subject is placed. While Klein plays on the model's hieratic character and the impression of schematic strangeness created by the obliteration of faces in the crowd, Newton makes use of a long exposure, which reduces the flow of travelers to an undulating fog and transforms the escalators into three huge slides. In this mechanical setting, a long-legged model stands, a modern caryatid who seems to be holding up the tunnel's ceiling. By de-centering his subject (to place the model out of the passengers' way), Newton amplifies the contrast between the elegance of the tuxedo-wearing model and the coldness of the world of transfer corridors. The result is a photograph both sober and powerful, which reaches its target directly.

With the use of color becoming more widespread, some photographers applied themselves to exploring color's possibilities in the underground world of the Métro. In this field, the photographs by Léon-Claude Vénézia are some of the most remarkable.

1960-1980

JULIEN FAURE-CONORTON

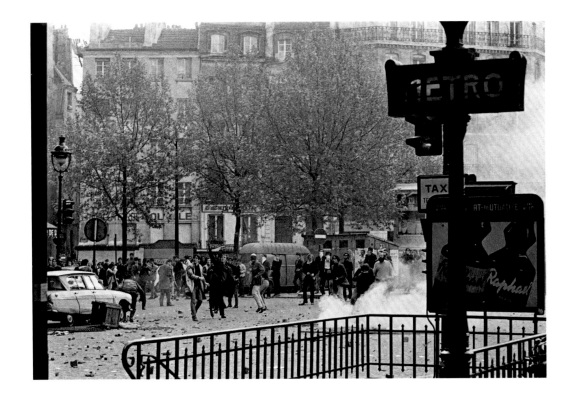

MANUEL BIDERMANAS - *Clashes between students and police at the Maubert-Mutualité station*, May 6, 1968

Indeed, his choice of subject was based on its chromatic potential; his shot of an old Nord-Sud train car (pp. 276-277) offers a harmonious contrast between warm and cold tints, and the car's colors (white, blue, brown) echo those of the tiled walls visible in the background. Another photograph presents the same chromatic characteristics (p. 225), this one animated by the movements of the passengers entering and exiting the cars (the partial blurriness of the passengers stems from the long exposure time, indispensable because of the weakness of the light). Bathed in a soft, warm ambiance, these two photos offer an engaging, even reassuring vision of the Métro, far from stereotypes. Color also allows for the capture of attractive, multicolored abstract compositions (René Minoli, pp. 260-261), allegories of locomotion and speed that, while not new (cf. p. 131), are magnified in full color. Not as timeless as black and white, color reflects its era more directly, as in that photograph by Jean-Marie Carrier with the typical colors of the 1970s (p. 278). Métro and color also join above ground, from Giancarlo Botti (p. 235) to Willy Ronis (p. 242) and Joel Meyerowitz (pp. 238-239). An adept of street photography and a pioneer of color, the American Meyerowitz here delivers a work whose force comes from soft colors and complex lines combined with the subject's strangeness, which inevitably arouses questioning. For Meyerowitz, this typically Parisian (largely due to the presence of the Métro) snapshot constitutes one of his greatest successes.[1]

1.
Cf. Joel Meyerowitz: Taking My Time, New York: Phaidon, 2012.

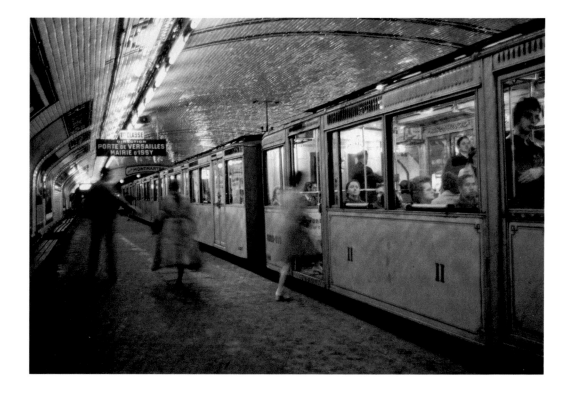

Still mostly predominant, black-and-white draws its effects from other resources. The disappearance of color in fact leads the viewer to think about—and read— the image in a different way; it partly detaches the image from contingencies of time and place, and focuses attention on values, lines, contrasts, light. This is true for that remarkable portrait of the beautiful *Nana* (p. 231) from the series called "Ladies of the Place Blanche," a pioneering work by the Swedish photographer Christer Strömholm on the lives of transsexuals in Paris in the 1960s.[2] This is also true for that striking composition by Jean-Louis Swiners (pp. 250-251), painting-like in many respects, from its triptych-style format to its inquisitive gazes straight out of a canvas by the Le Nain brothers. In many cases, black-and-white augments the expressive power of the photographic image, whether the image's aesthetic stems from the choice of a point of view (Gauthier, p. 259), from a rhythm (Keystone, p. 268) or from a focal point (Ferdinando Scianna, p. 272); or whether it's that instant of intimacy of a couple exposed to the harsh lights of the train and glimpsed by Jacques Henri Lartigue (p. 273) or that dozing homeless man whose dreams of happiness Henri Cartier-Bresson seems to be projecting (p. 274). The inexhaustible resources of the monochrome image are also obvious in those amusingly poetic photographs marked with the seal of the absurd (Martine Franck, p. 269), which could also be found in

2.
This immersion in a community that fully adopted him gave rise to the publication of a book: C. Strömholm, *Vännerna Från Place Blanche*, Stockholm: AB Tiprod, 1983.

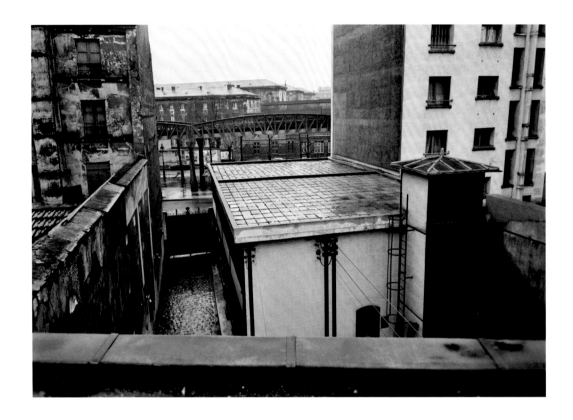

the previous periods (cf. Jacques Boyer, p. 52; Roger Parry, p. 104; Robert Doisneau, p. 195).

Just as the Paris Métro had been a witness to previous historic events, it was there during the clashes of May 1968. Gilles Caron, a great war reporter, remained close to the action, plunging us into the heart of the riot-police charge on the Boulevard Saint-Germain, near the Maubert-Mutualité station (pp. 256 and 257). More distanced, the gaze of Manuel Bidermanas (p. 224)—also a photojournalist—reveals the reverse shot of that police charge, the clusters of angry students and the ground littered with cobblestones, while in the foreground the Métro station, cleverly framed, both gives structure to the composition and locates the confrontation. Then there is that image—astounding in many respects—by Jean Marquis, a photographer whose concerns were close to those of the humanist school (pp. 254-255). By the simple fact of a clever lower viewpoint, Marquis spontaneously makes a brilliant typographical photomontage appear; it invades the image and predicts the "total liquidation ... of modern man."

The 1960s and '70s also marked the affirmation of a socially conscious photography that aimed to show, without voyeurism or pathos, the fringes of humanity, made invisible by ignorance or indifference: marginalization, exclusion, poverty (pp. 231, 253, 264, 266-267, 272, 274, 275). While the images resulting

from such a procedure are often disturbing, even harsh, an unusual strength emerges from them that stems largely from the delicacy and decency with which their author approached them. Thus, that photograph by Jean Gaumy (pp. 266-267) where the very identity of the homeless man keeping guard over his sleeping companion in misfortune seems to dwindle into the desperately empty space opening up behind him. Thus, too, that fugitive instant captured by Ferdinando Scianna (p. 272) in which it's easy to see the symbol of the tenuous border that separates those who are on the train from those who have fallen off. And, finally, there is that masterpiece by Jane Evelyn Atwood (p. 275), a marvel of humanity and restraint, admirably served by the gentleness of a nighttime moon that makes a particularly harsh subject bearable. Like Rodin's *Cathedral*, sculpted by shadow and light, the clenched hand—probably folded over a few imaginary coins—expresses better than anything the desolation and destitution of those who have lost everything. Each in its own way, these three works give rise to a strange impression of erasure, disappearance, oblivion.

Finally—and the three previous photographs testify to this—the 1960s and '70s see the development of a marked taste for tightly cropped framing, offering a more direct, intimate confrontation with the subjects, which are isolated from the whole for aesthetic reasons. This immersive tendency is obvious in Christer Strömholm (p. 231), Peter Turnley (p. 272), Hervé Gloaguen (p. 248), Jean Gaumy (p. 252) and Ferdinando Scianna (pp. 270-271). The gaze often plays a decisive role here. Whether melancholy (pp. 280-281), mischievous (p. 231) or concentrated (p. 248), fixed on us (pp. 270-271) or averted (p. 272), even obliterated (p. 253), the gaze determines the tone of the image, and its irresistible power of attraction magnetizes our own eyes.

GEORGES KELAÏDITÈS - *Pigalle*, 1960

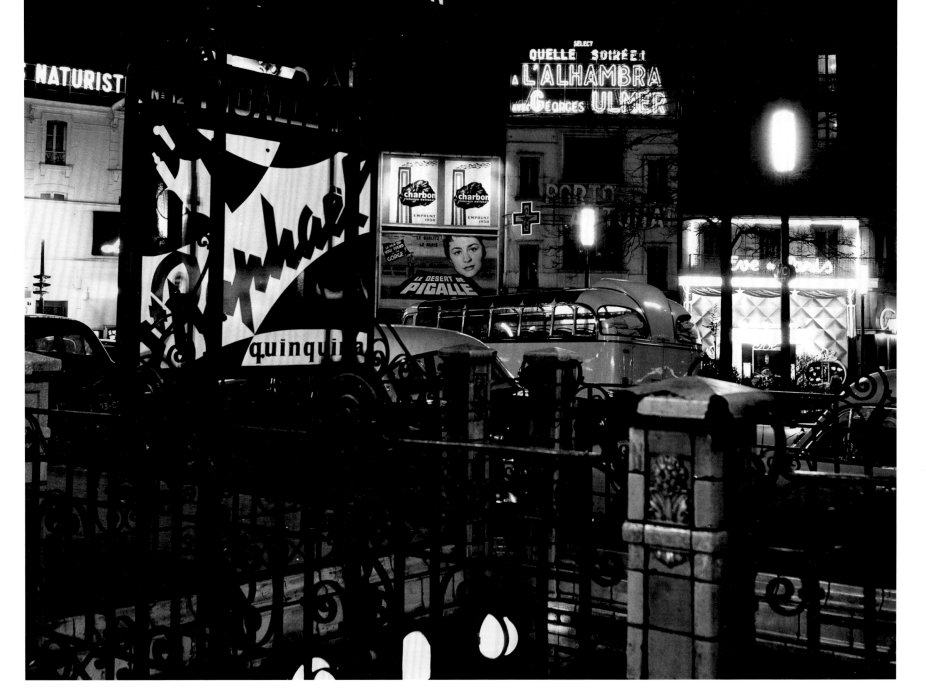

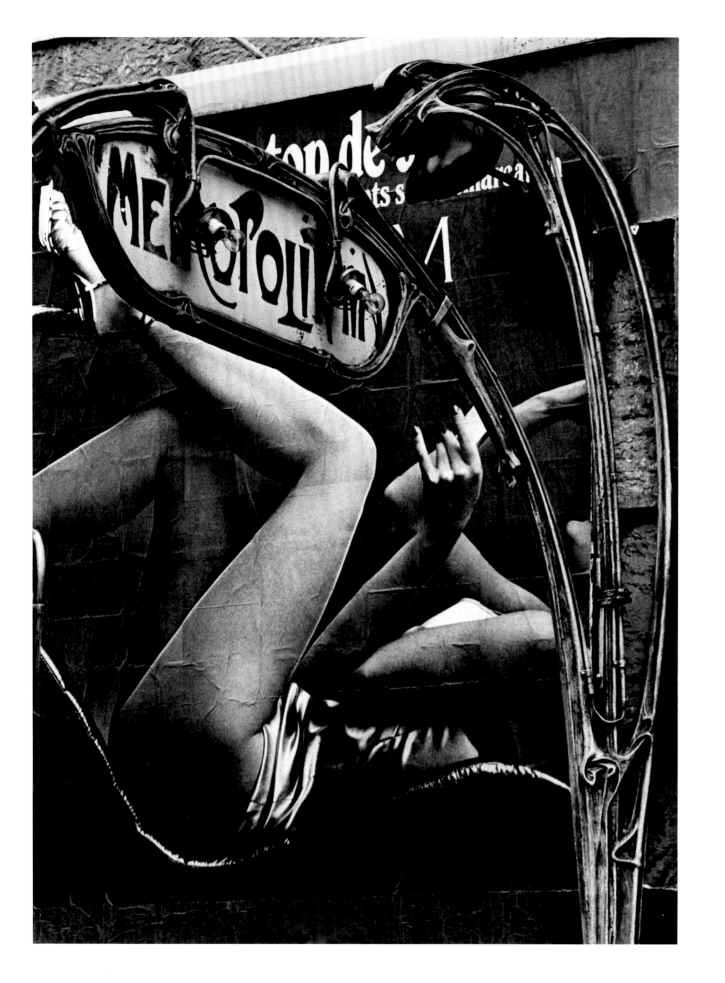

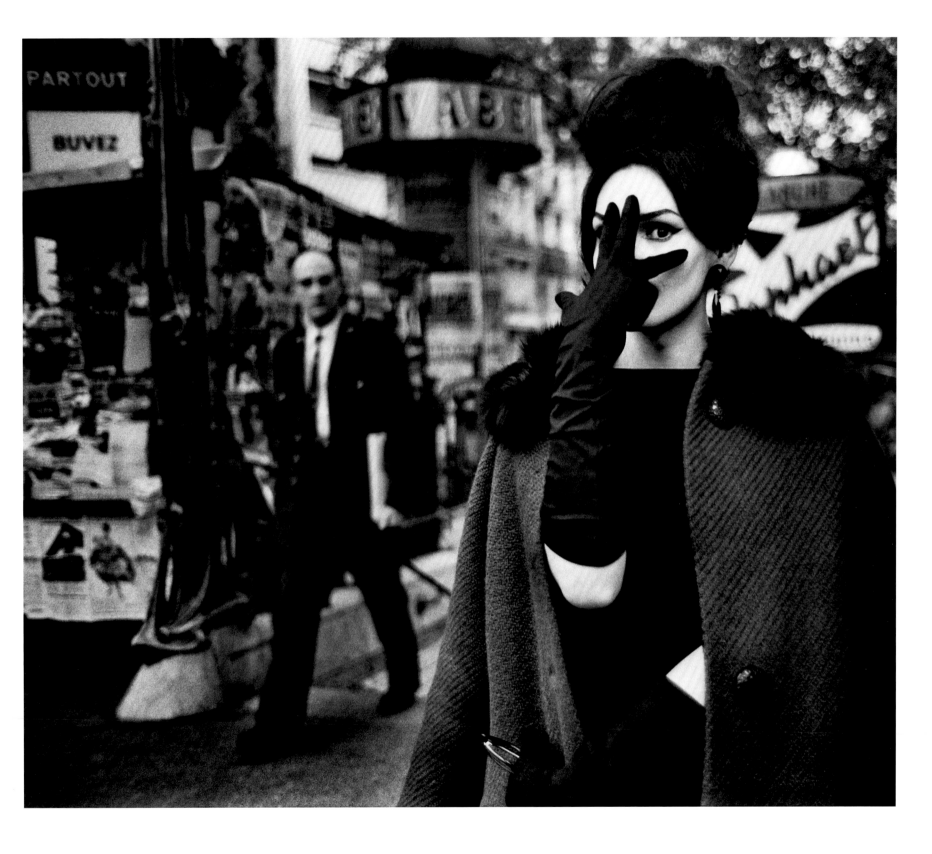

Opposite: ROBERT DOISNEAU - *"Métro Legs,"* 1971

Above: CHRISTER STRÖMHOLM - *Nana, Place Blanche,* 1961

HELMUT NEWTON - *Paris Métro* (Vogue), 1975
© Helmut Newton Estate / Maconochie Photography

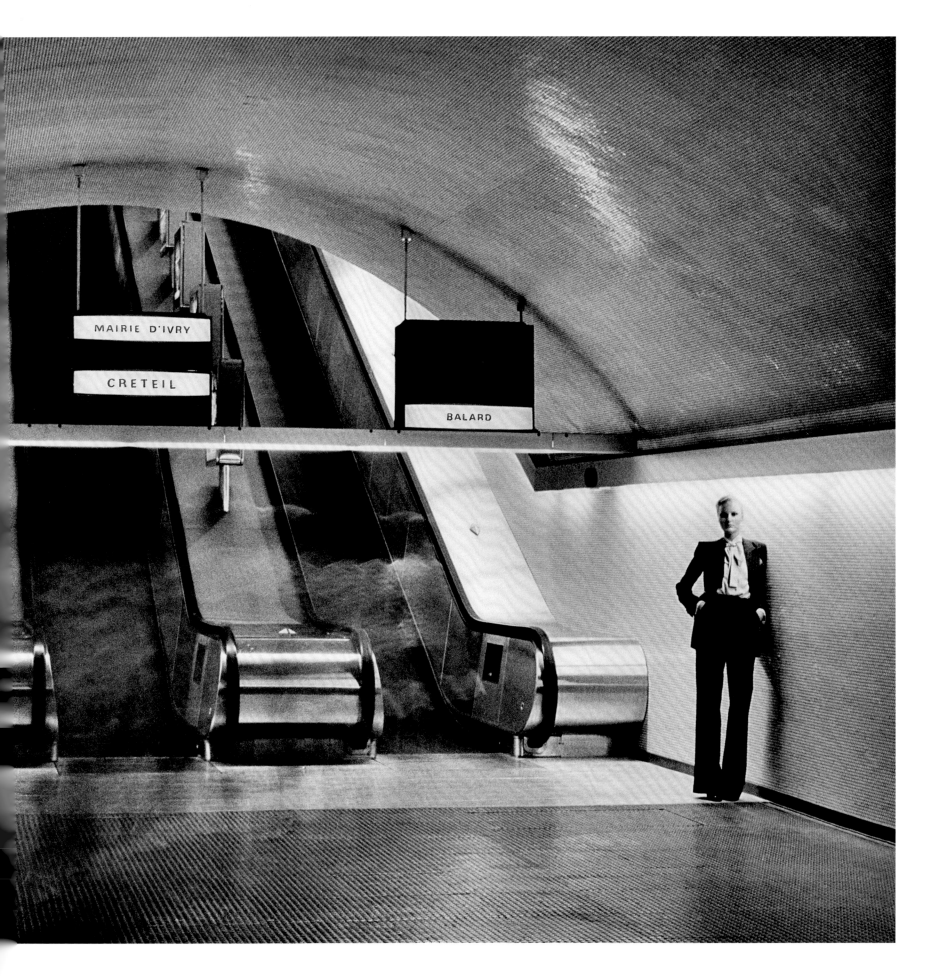

GIANCARLO BOTTI - *Place de l'Opéra*, circa 1960

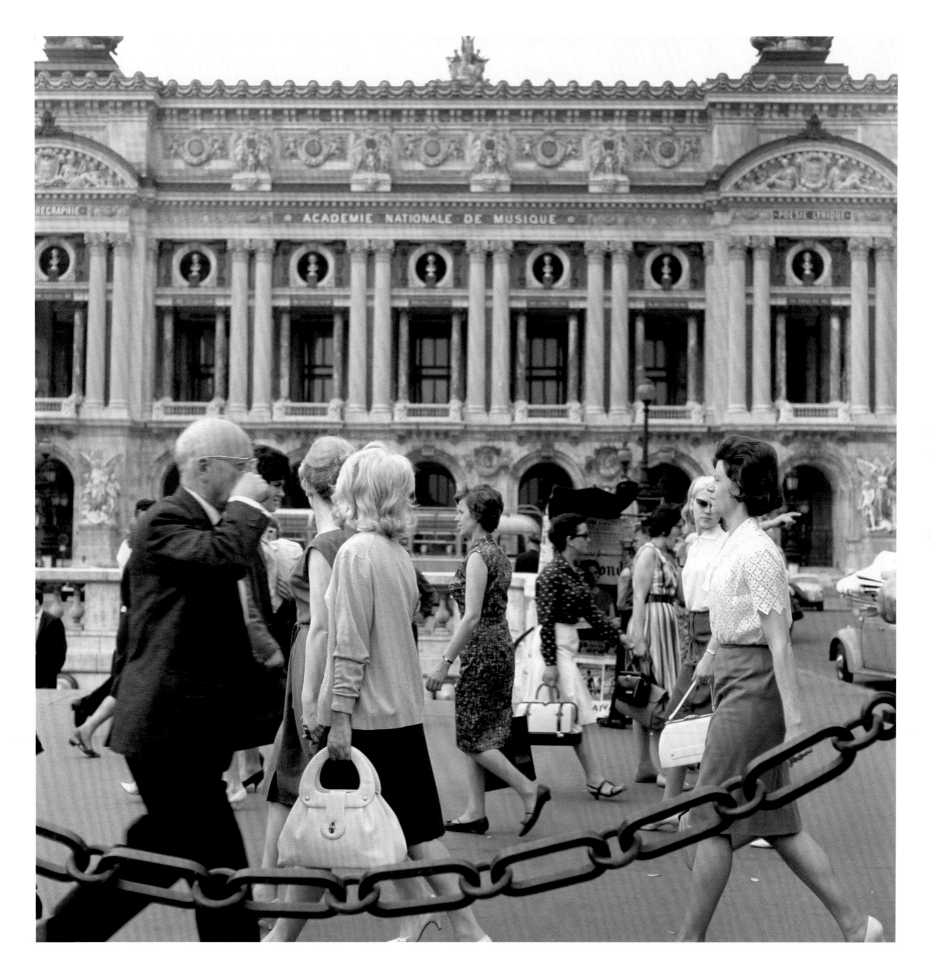

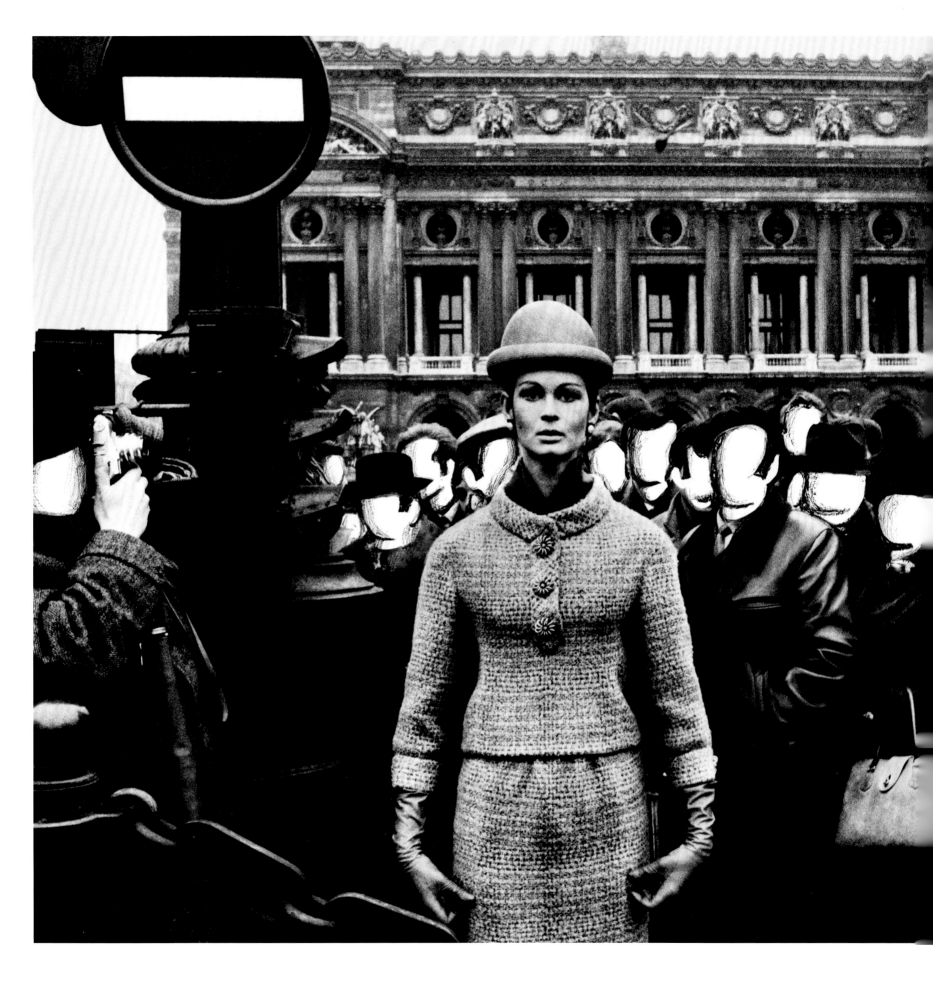

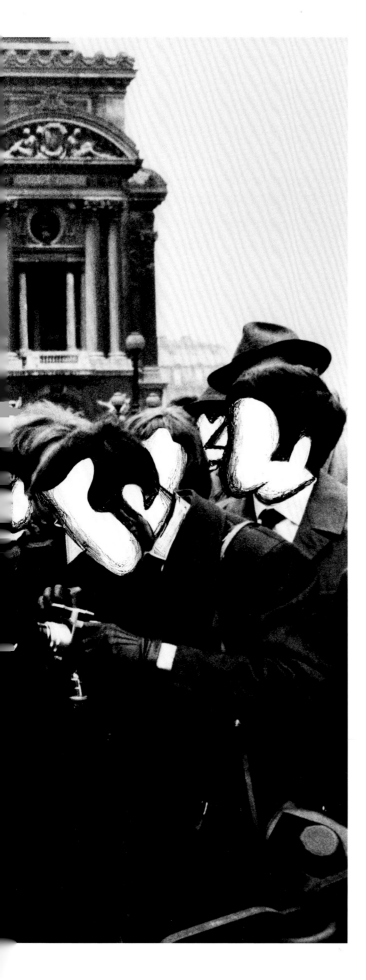

WILLIAM KLEIN - *"Isabella + Opera + Blank Faces, Paris"* (Vogue), 1963

JOEL MEYEROWITZ - *"Paris, France,"* 1967

Next pages:

Left: ELLIOTT ERWITT - *Rambuteau station*, 1970

Right: ERVIN MARTON - *Rambuteau station*, 1960

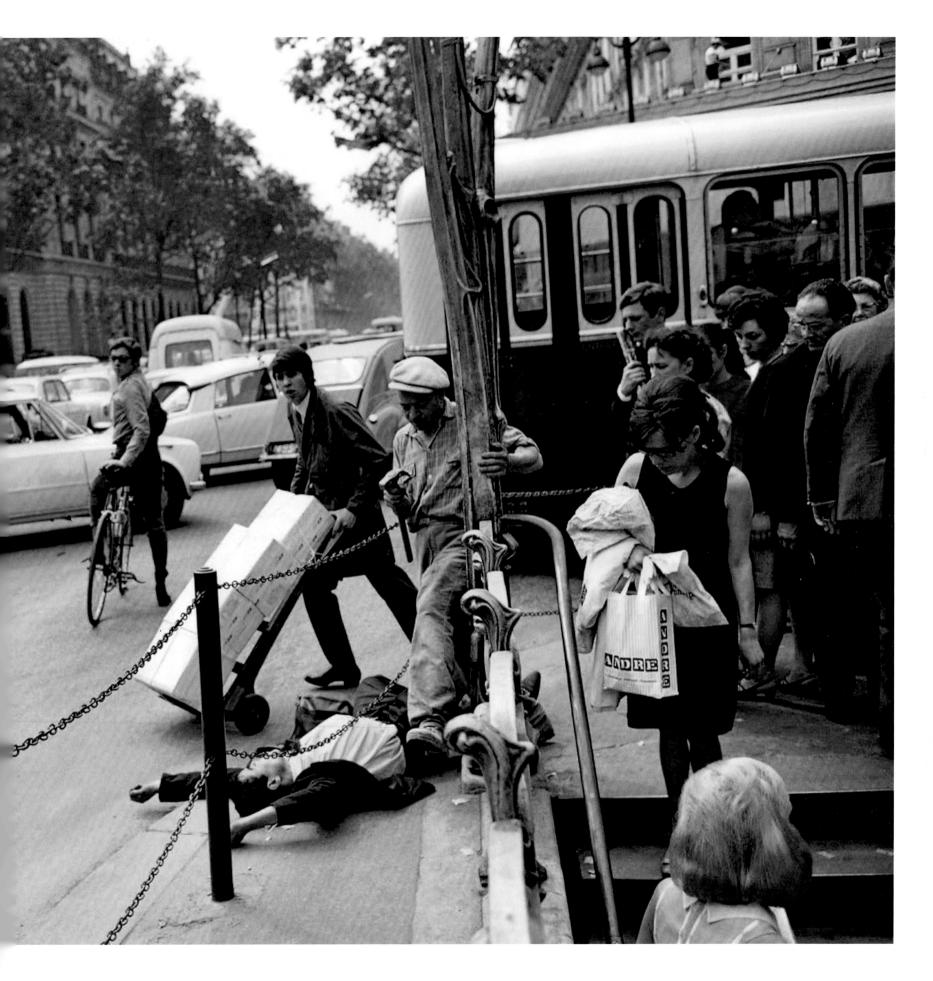

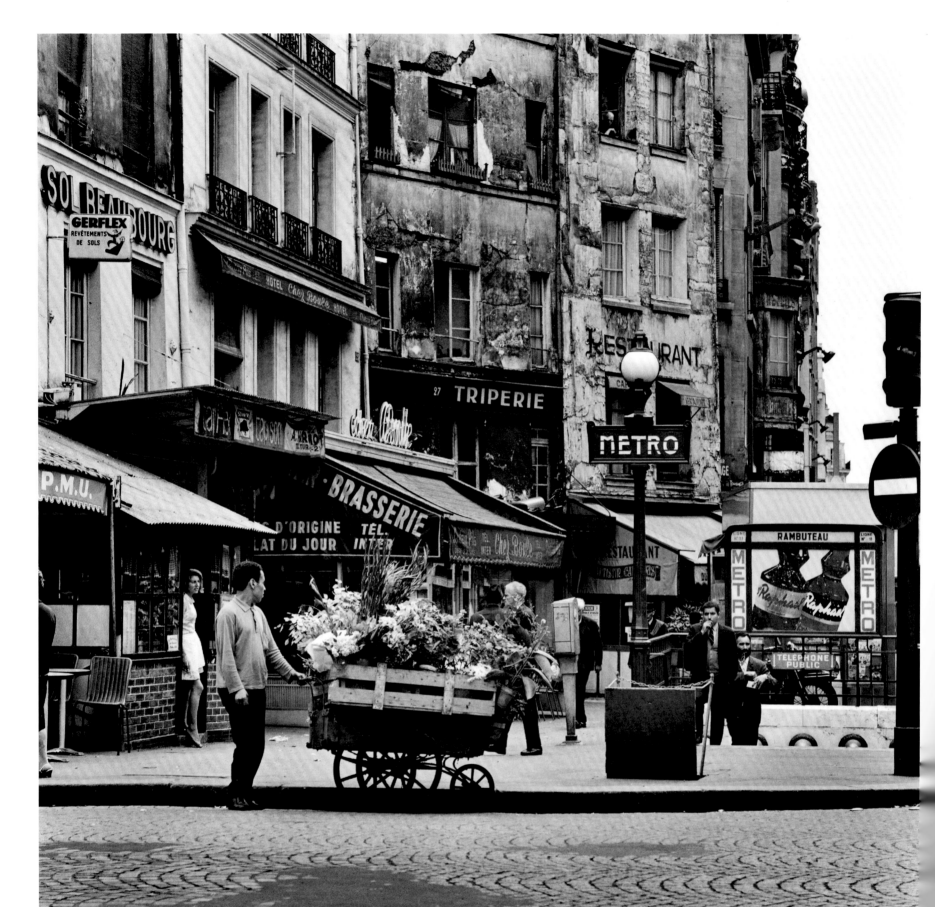

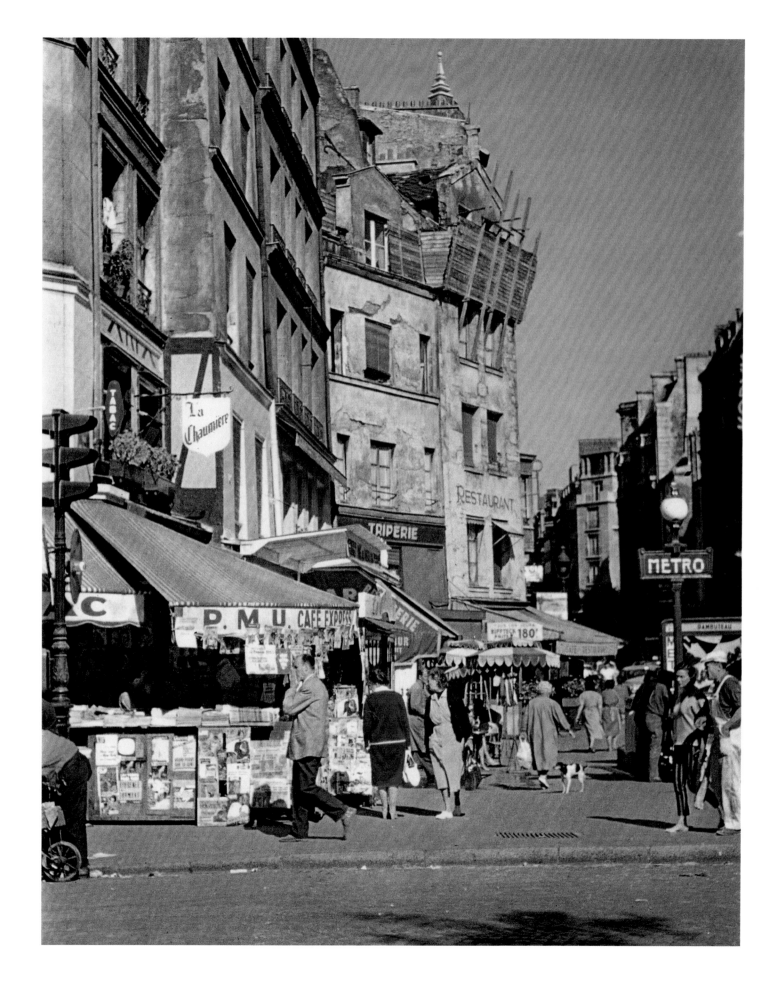

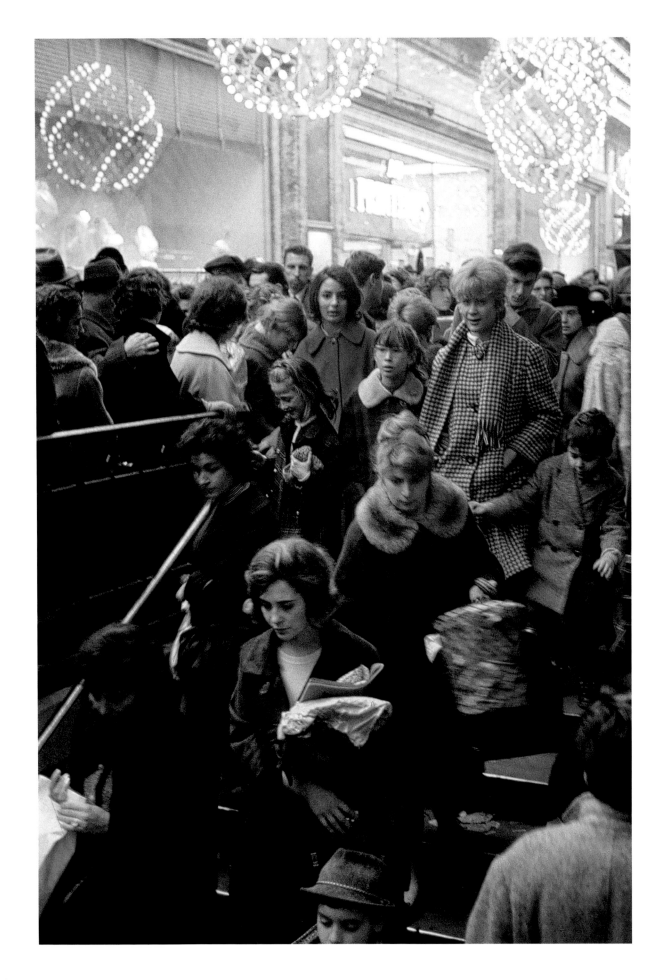

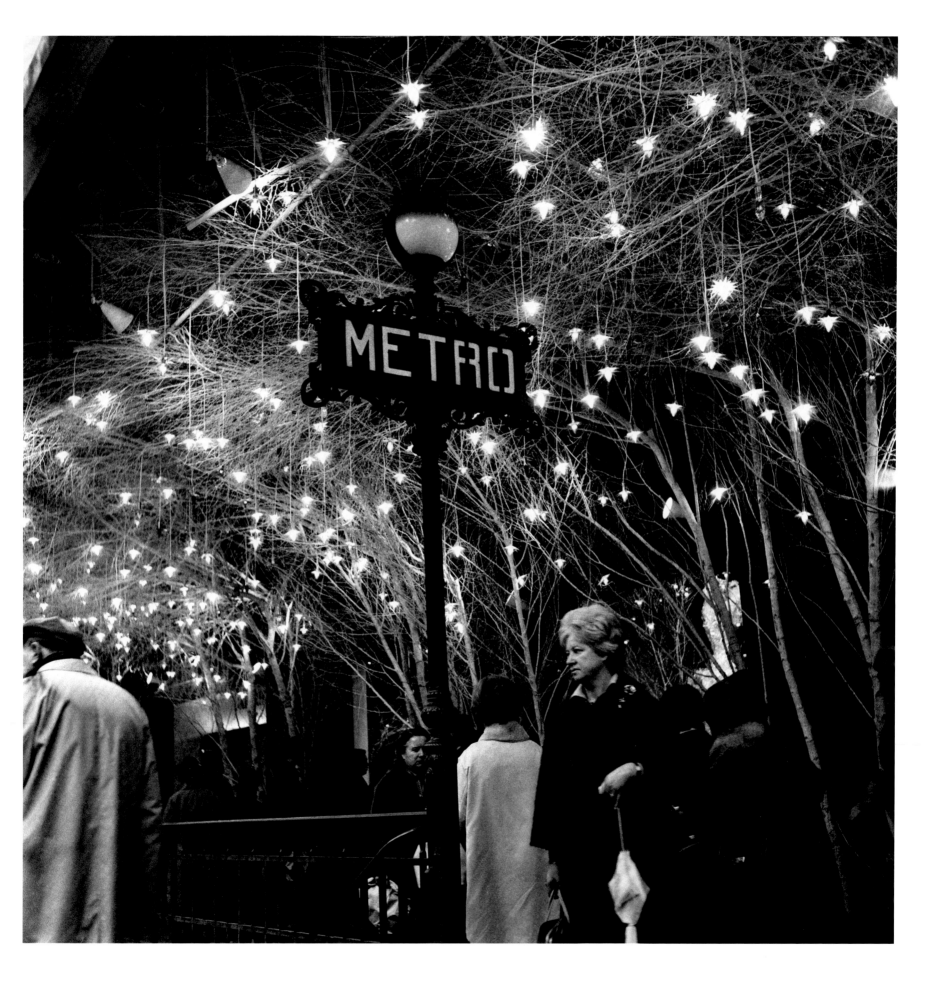

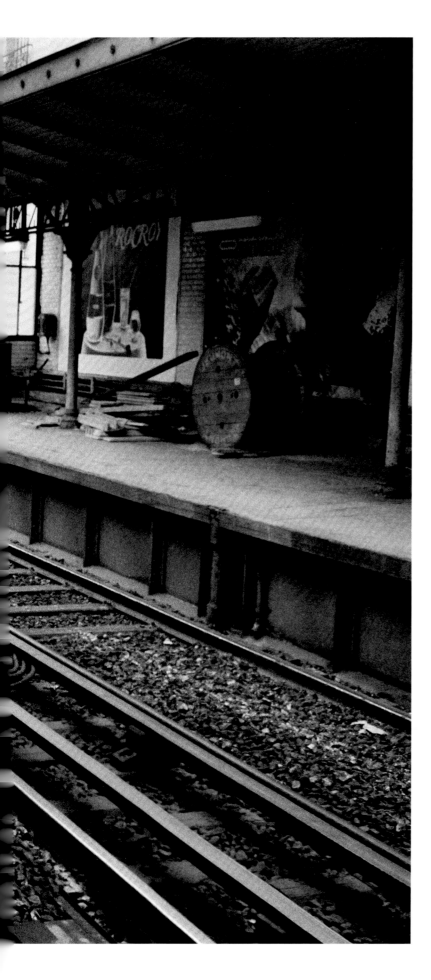

REPORTERS ASSOCIÉS - *Daily life of a schoolboy*, 1964

Opposite: HERVÉ GLOAGUEN - *RATP technology school,* 1970s

Above: ÉDOUARD BOUBAT - *Young magazine seller,* 1961

JEAN-LOUIS SWINERS - *Shared transport*, 1964

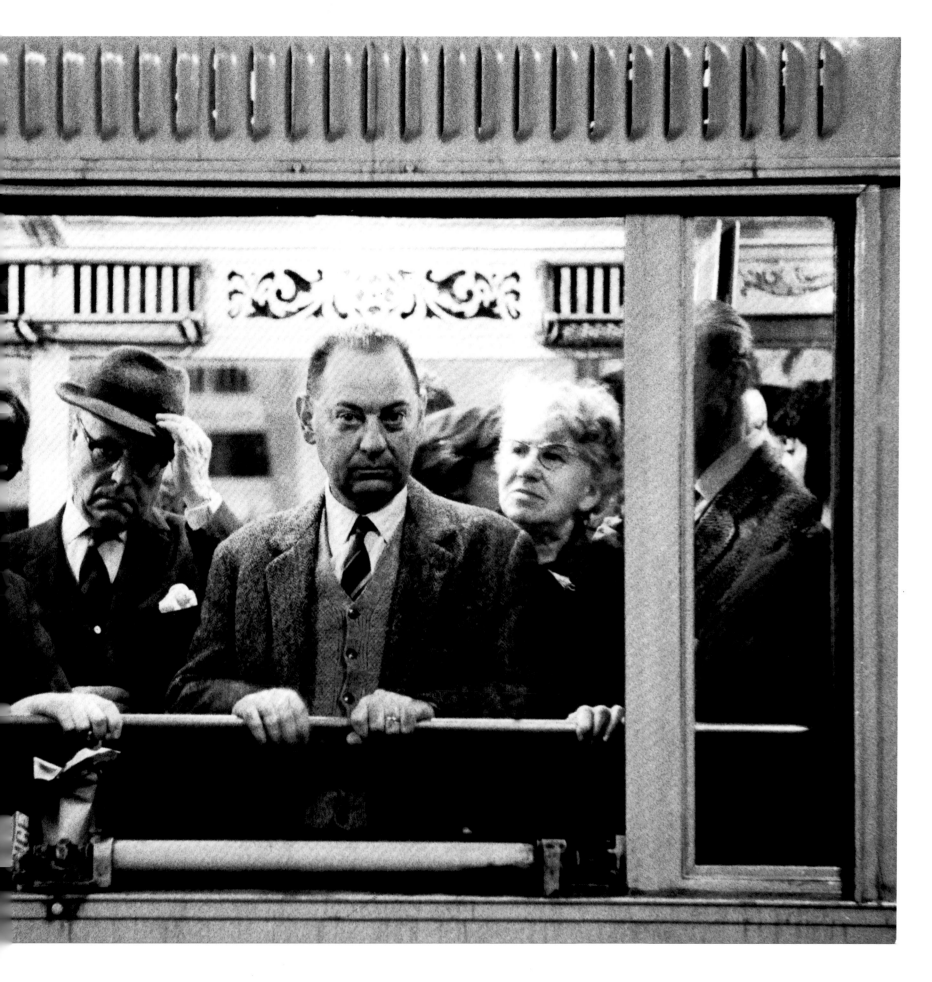

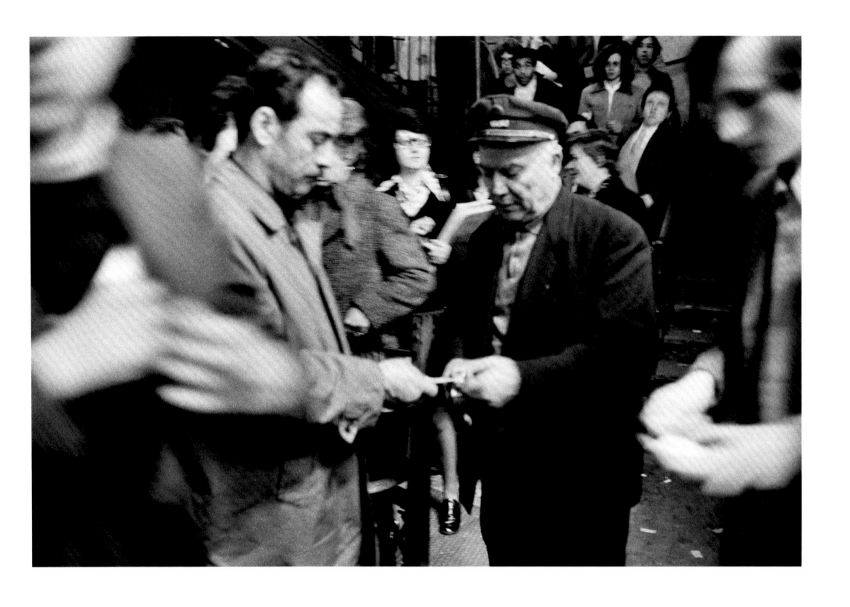

Above: JEAN GAUMY - *Ticket-puncher*, 1973

Opposite: MARTIN MONESTIER - *Pigalle*, circa 1970

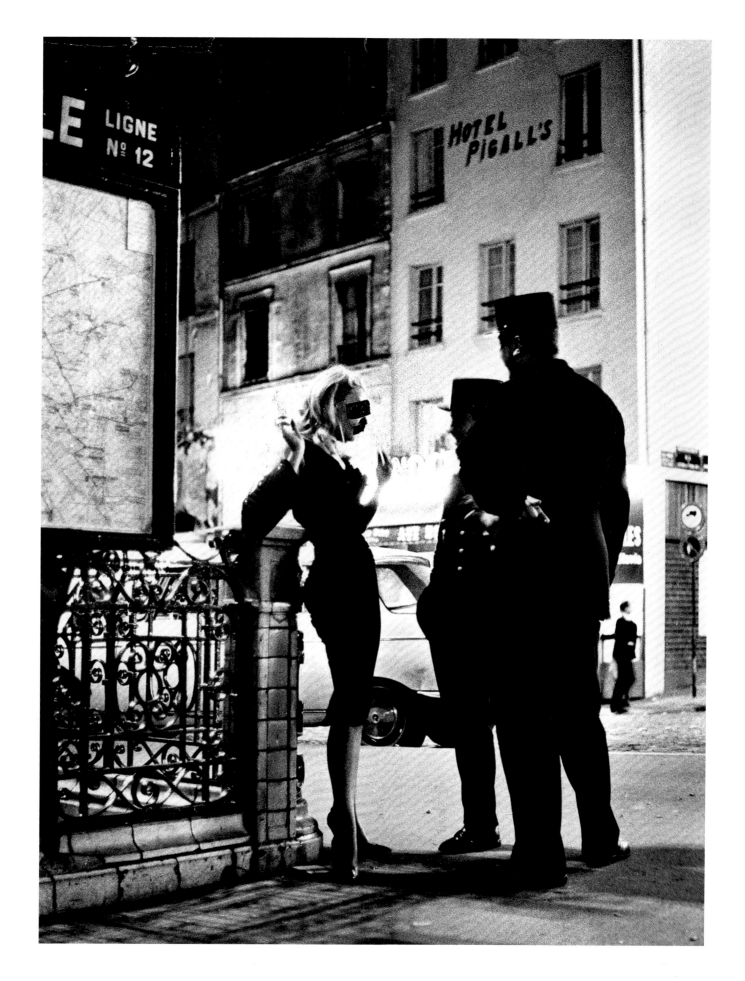

JEAN MARQUIS - *Total liquidation … of modern man (demonstration at the Gare Saint-Lazare)*, May 1968

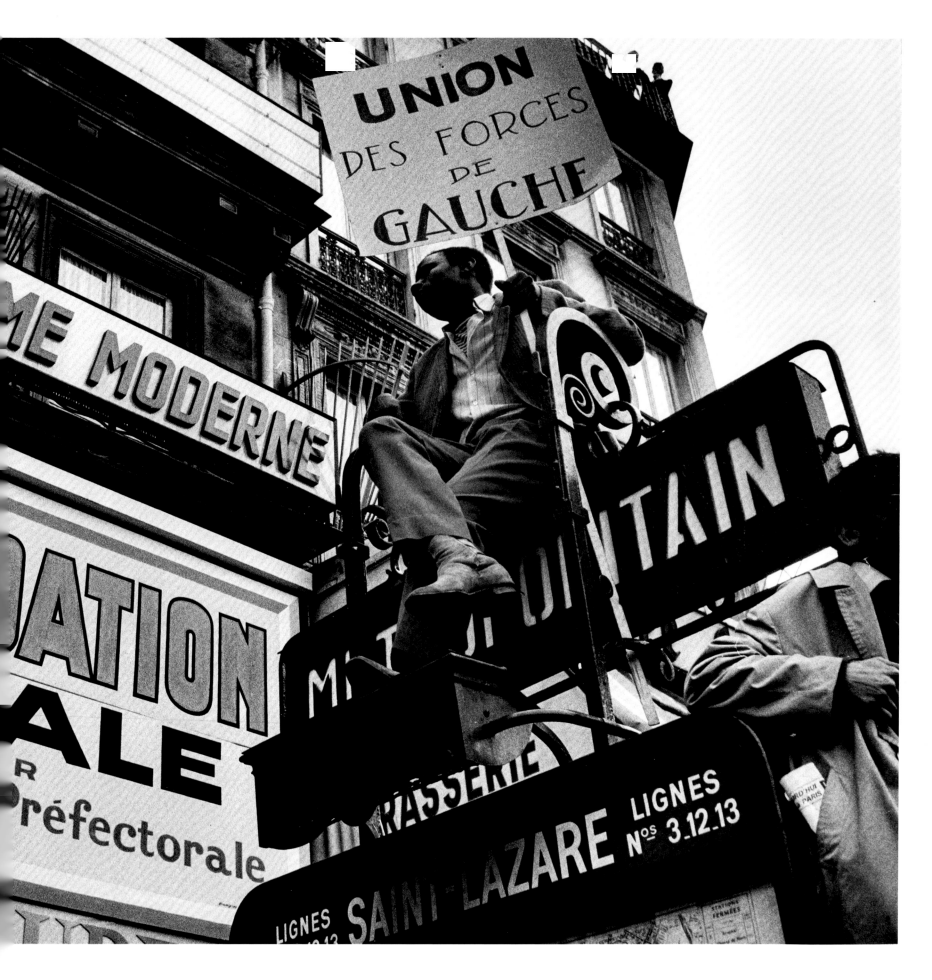

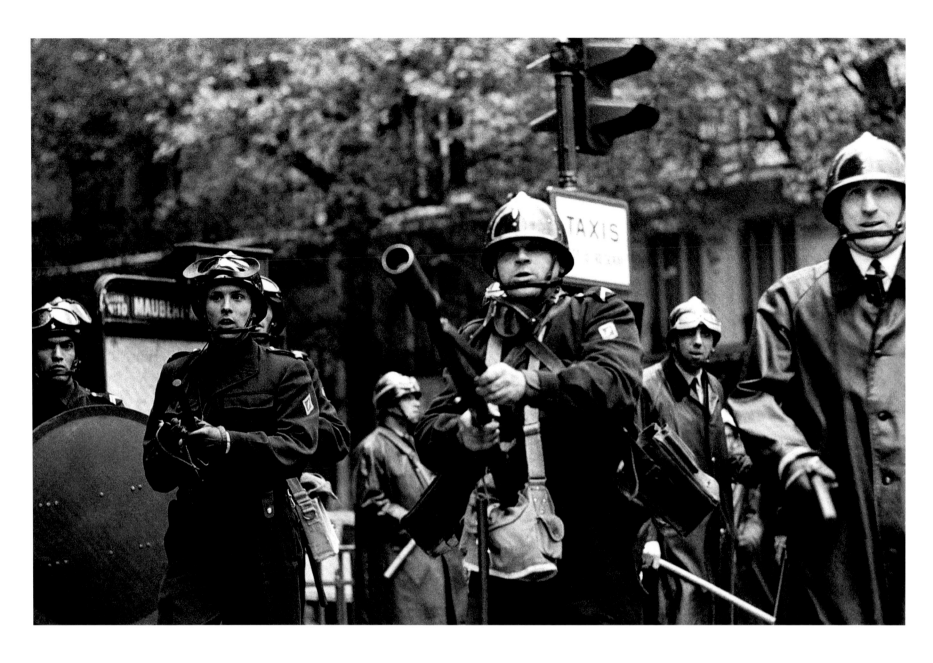

GILLES CARON - *Riot police at Place Maubert*, May 6, 1968

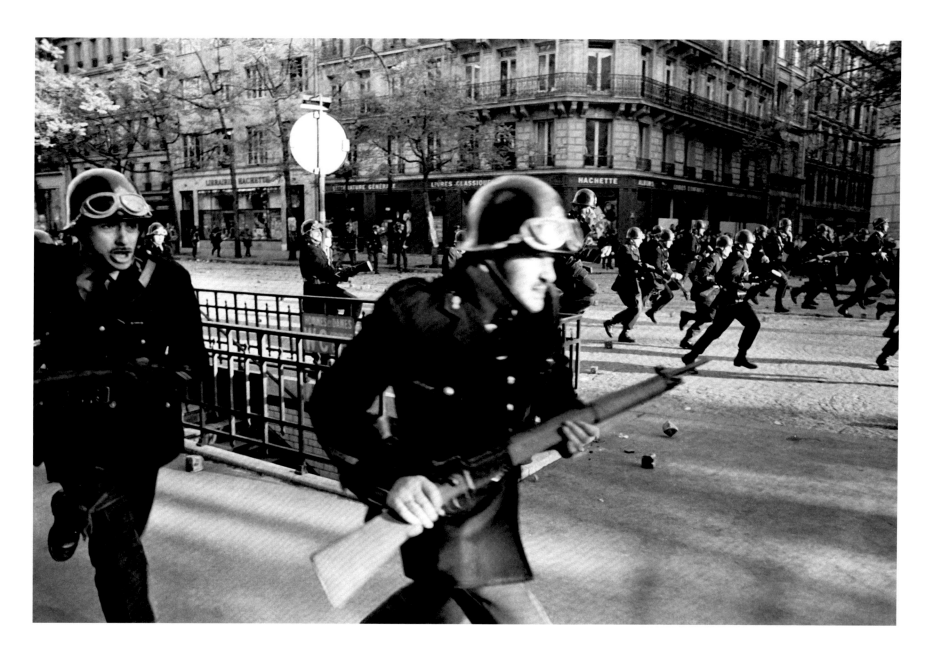

GILLES CARON - *Riot police charging at Saint-Germain-des-Prés*, May 6, 1968

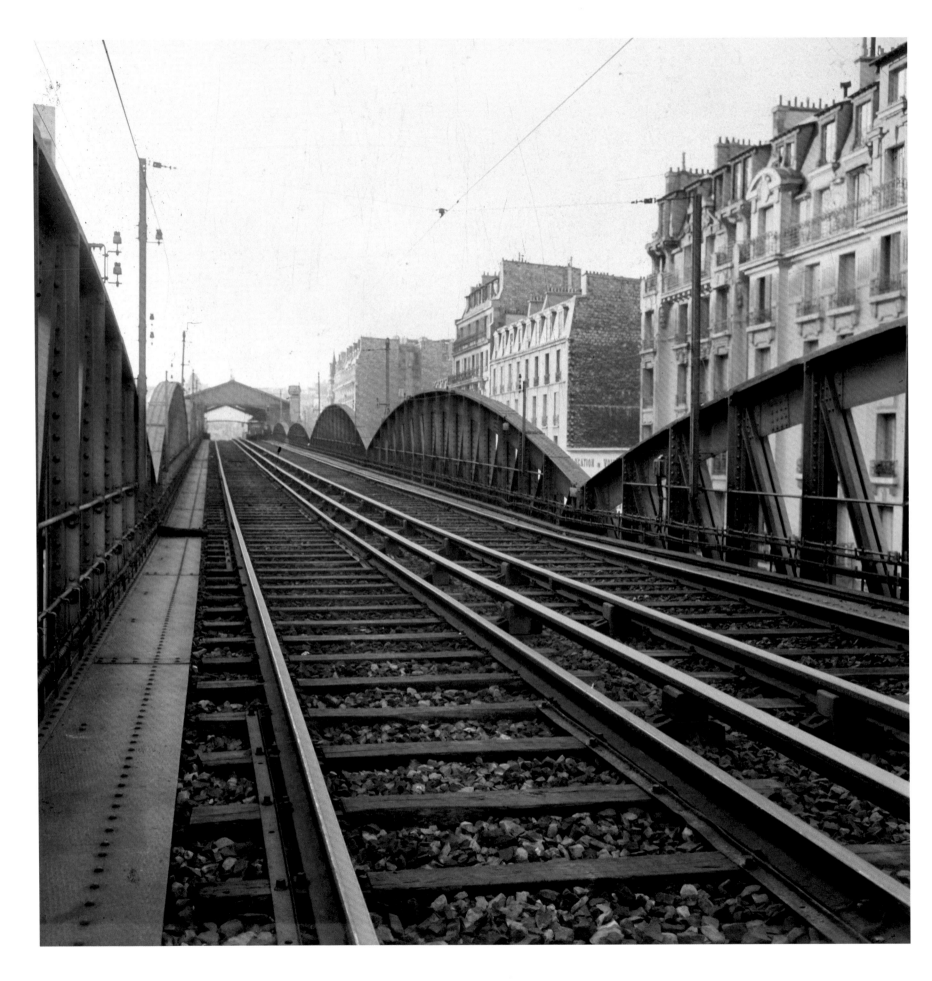

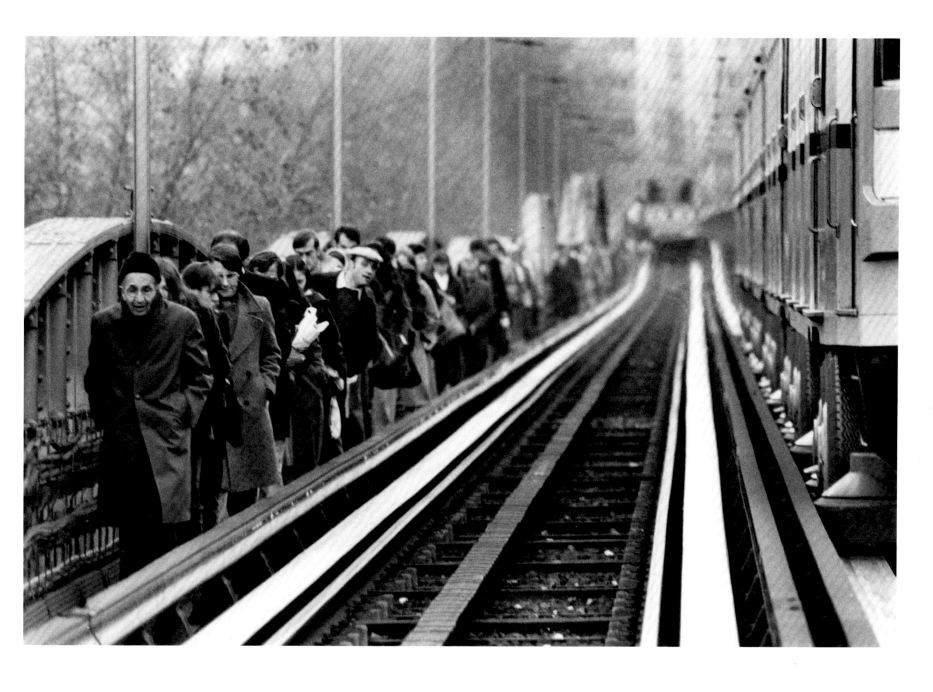

Opposite: GEORGES AZENSTARCK - *Métro employee strike,* May 1968

Above: GAUTHIER - *"The entire French territory was deprived of electricity this morning due to a glitch in the national power grid,"*
December 19, 1978

RENÉ MINOLI (RATP) - *Trains moving through a tunnel*, August 4, 1975

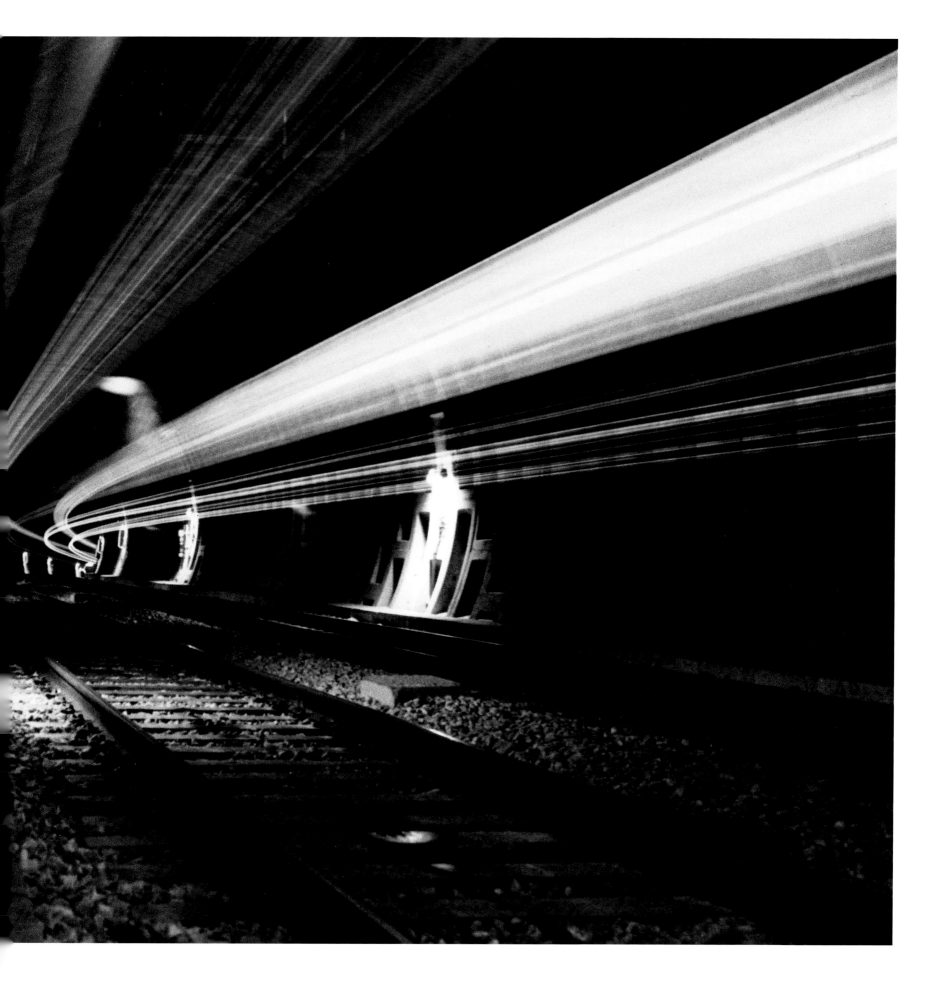

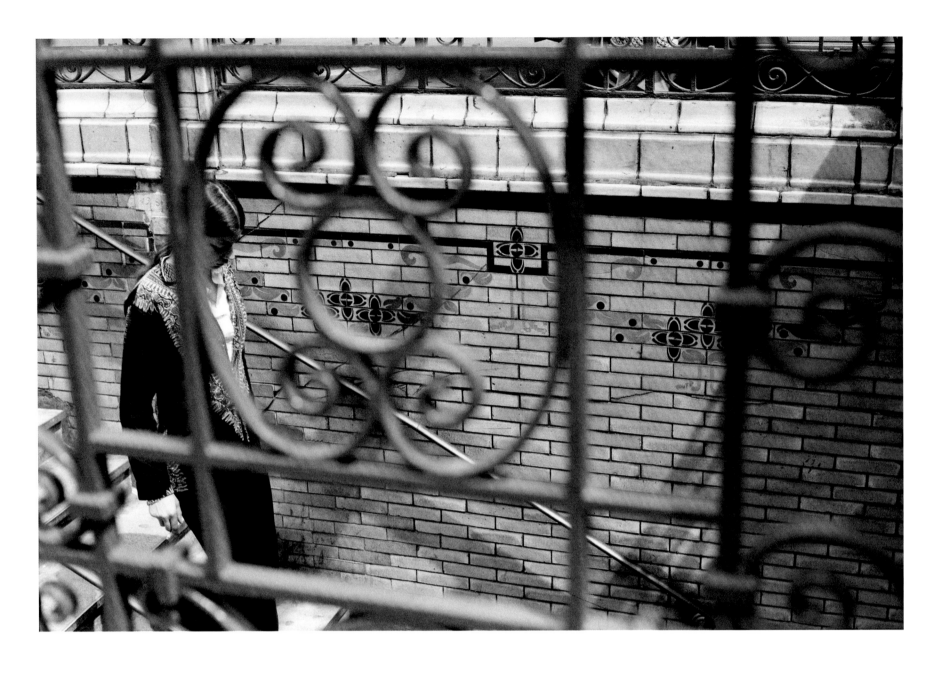

JOËL THIBAUT (RATP) - *Ceramic tiles and cast iron (entrance to a Nord-Sud line)*, June 19, 1975

BRUNO RÉQUILLART - *The tracks*, 1979

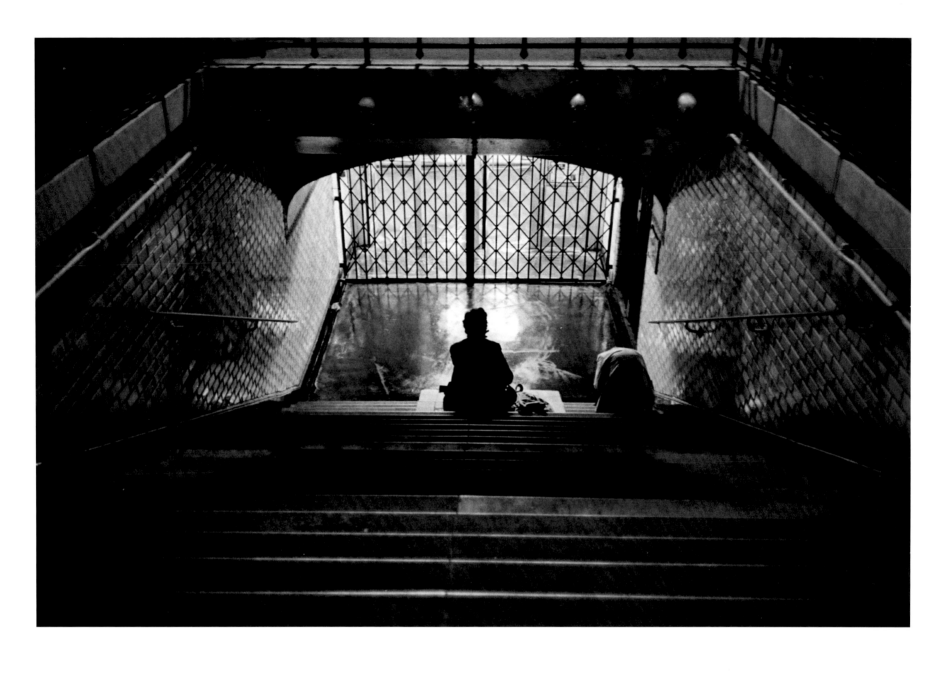

JANE EVELYN ATWOOD - *Homeless, waiting for the Châtelet station to open (from the "Poverty" series)*, 1976

CHRISTER STRÖMHOLM - *"Old Paris,"* 1960

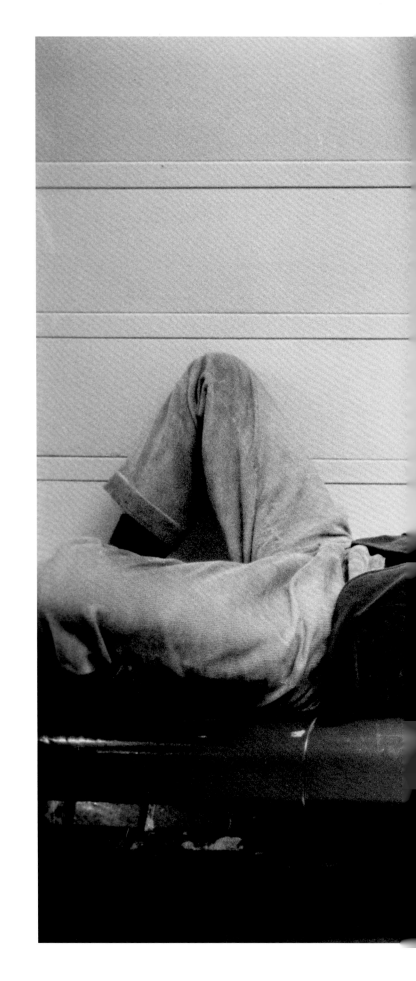

JEAN GAUMY - *Homeless in the Métro*, 1977

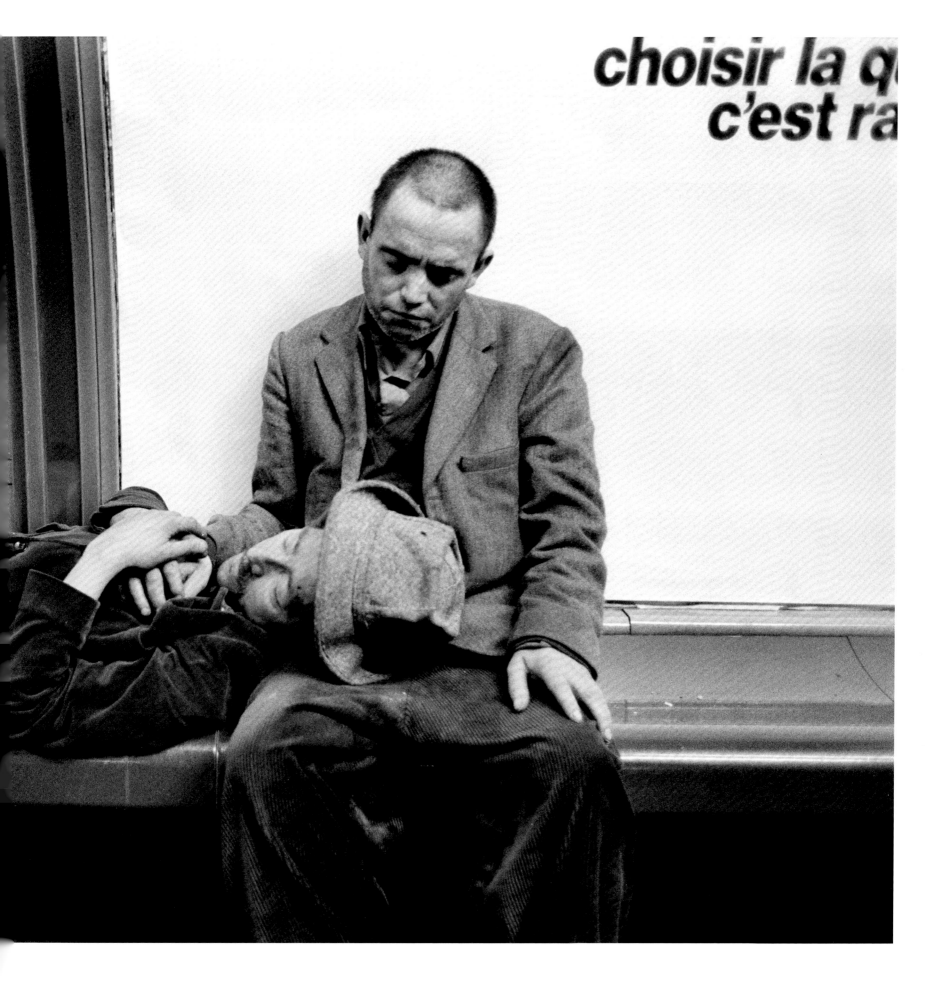

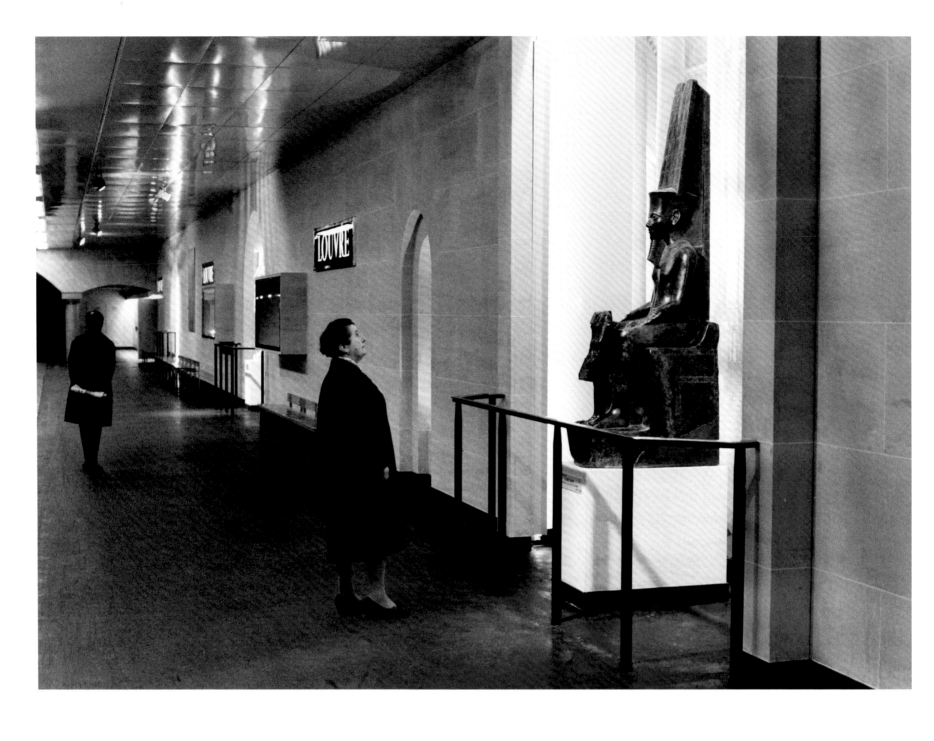

Above: KEYSTONE AGENCY (PARIS) - *"The Louvre station becomes a museum,"* September 28, 1968

Opposite: MARTINE FRANCK - *Tuileries station,* 1977

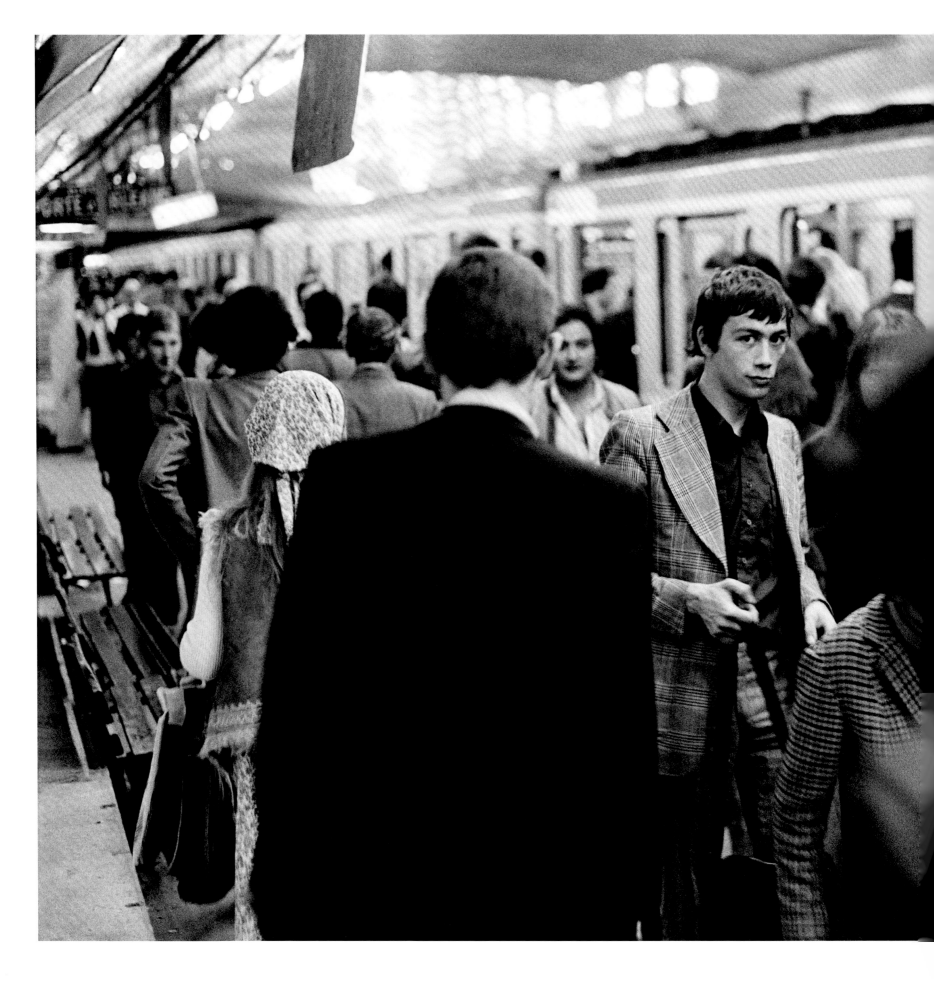

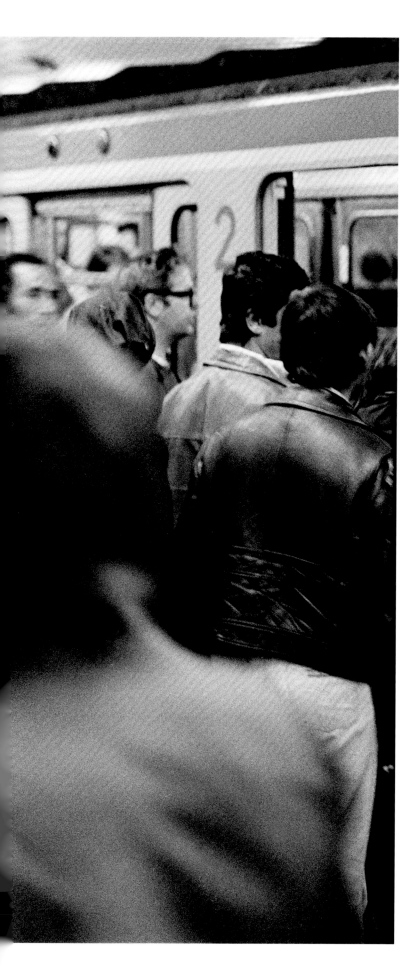

FERDINANDO SCIANNA - *Crowd in the Métro*, 1977

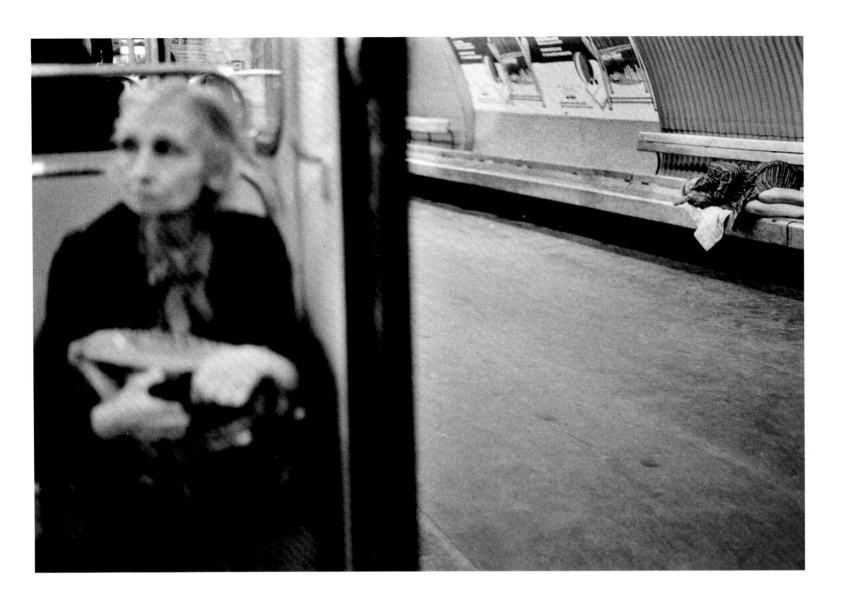

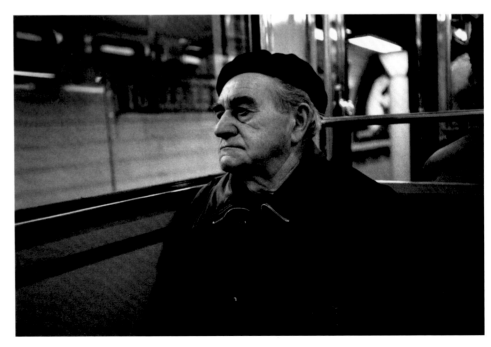

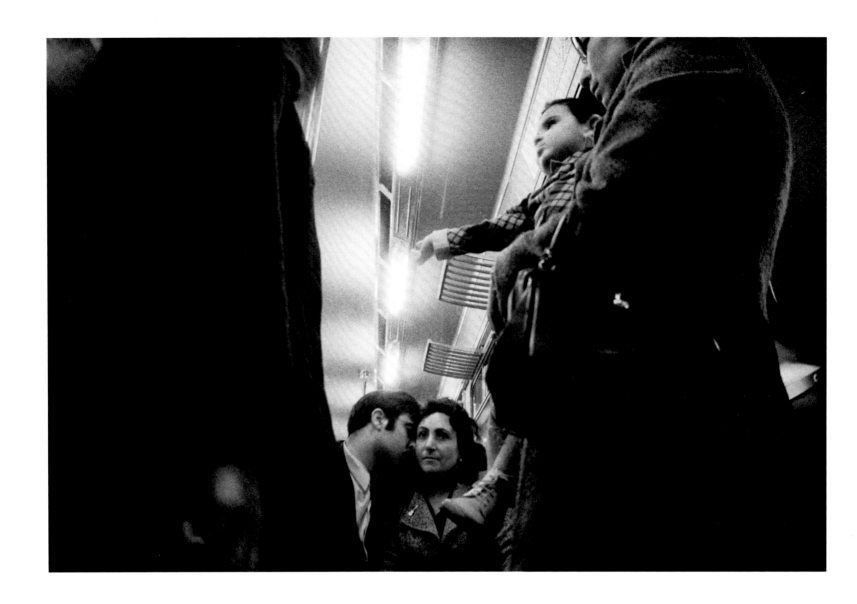

Opposite:

Top: FERDINANDO SCIANNA - *In the Métro*, 1978

Bottom: PETER TURNLEY - *Tuileries station*, 1978-1984

Above:

JACQUES HENRI LARTIGUE - *Couple in the Métro*, 1968

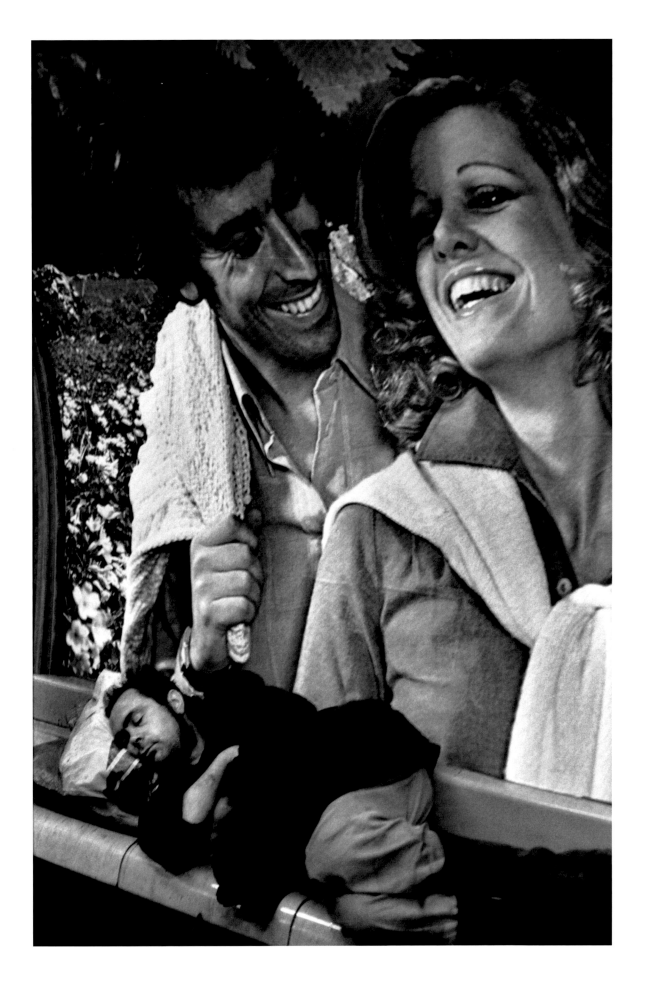

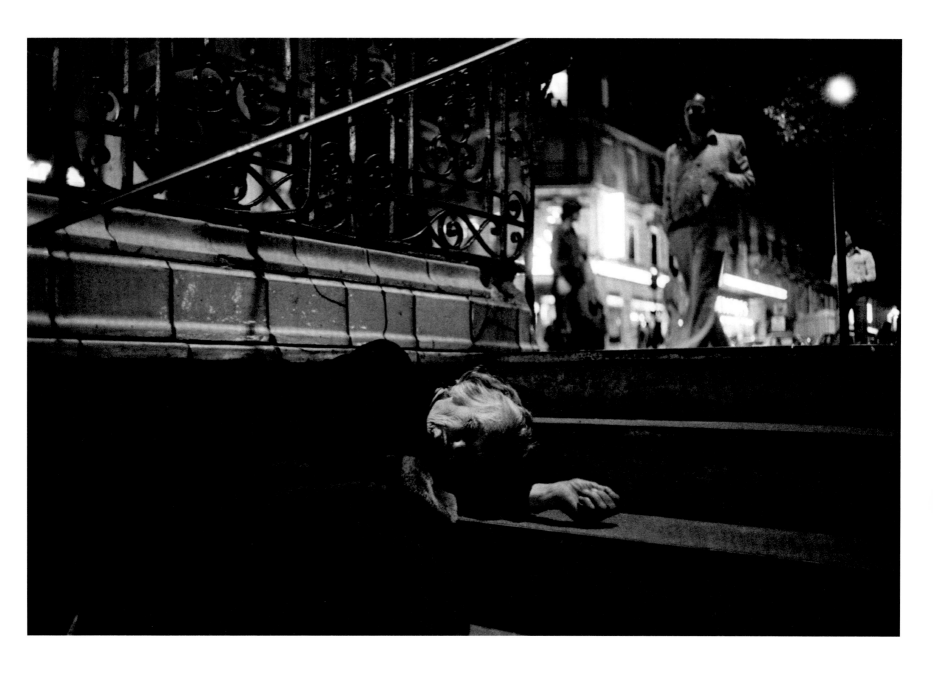

Opposite: HENRI CARTIER-BRESSON - *"Métro, Paris,"* 1976

Above: JANE EVELYN ATWOOD - *Homeless woman on the steps of the Pigalle station (from the "Poverty" series)*, 1979

LÉON-CLAUDE VÉNÉZIA - *Nord-Sud train at Solférino station*, circa 1970

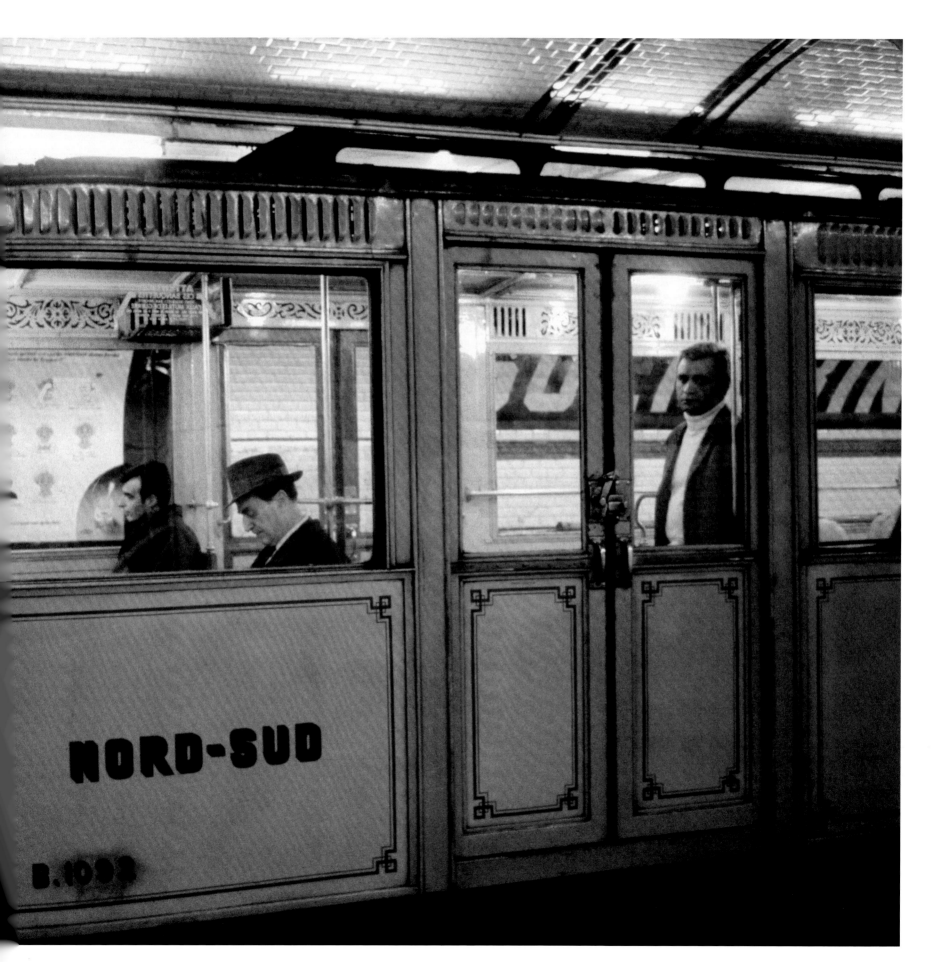

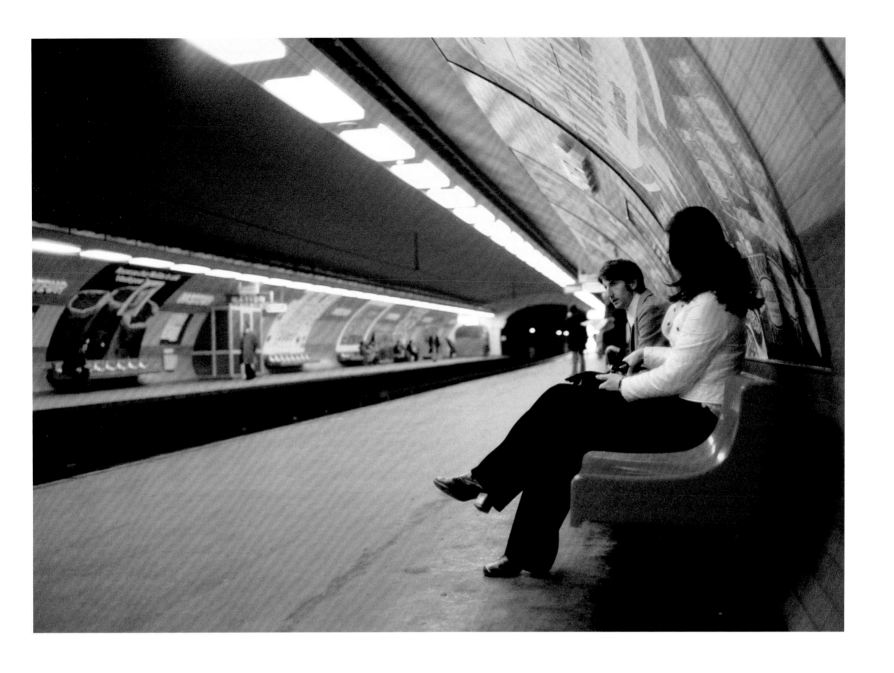

JEAN-MARIE CARRIER (RATP) - *Renovated Pasteur station*, January 14, 1975

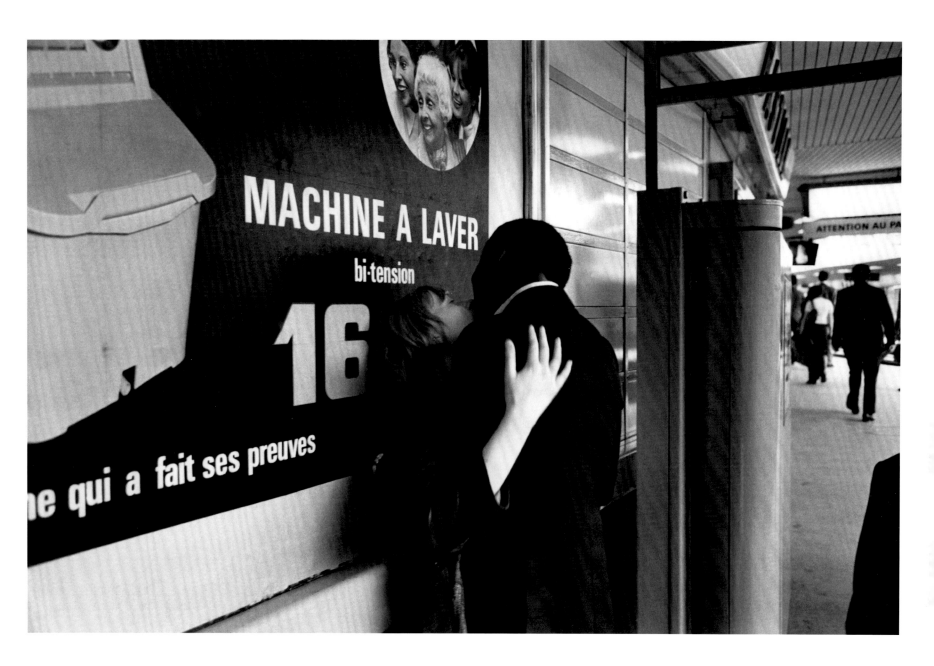

HENRI CARTIER-BRESSON - *"Paris,"* 1971

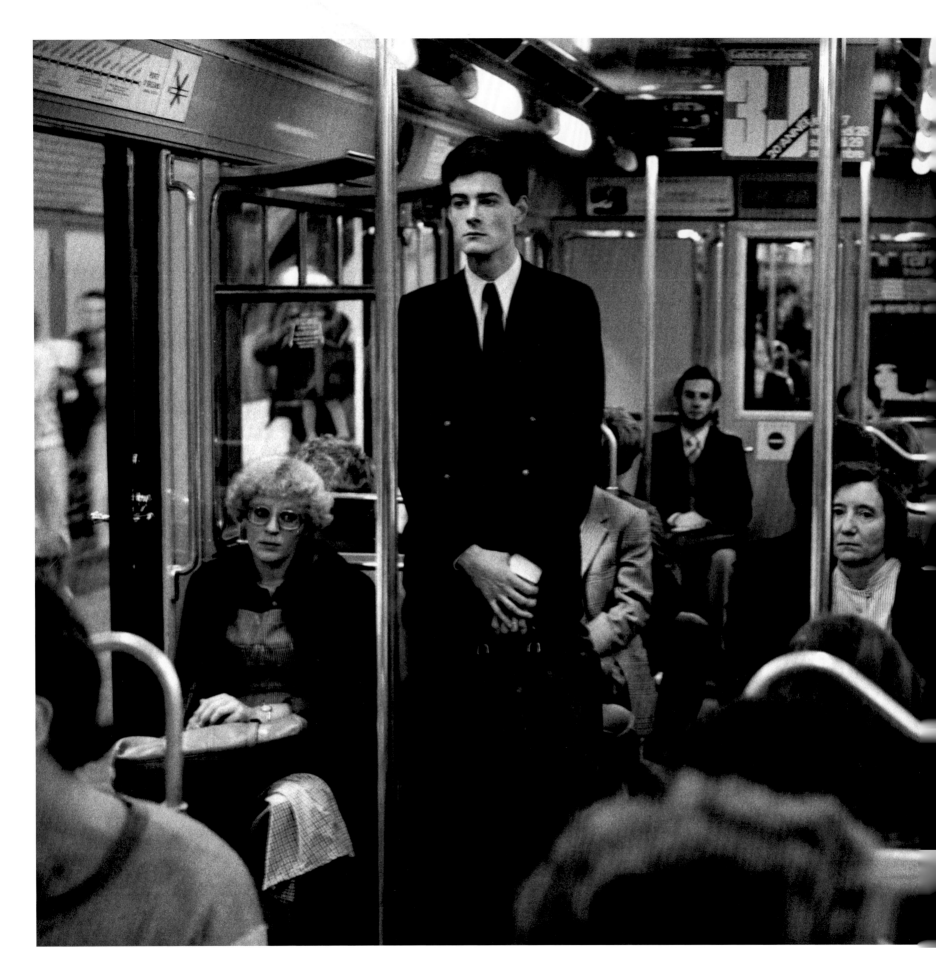

PETER TURNLEY - *Passengers*, 1979

Covering a period ranging from the ad campaign (now a cult classic) called "Ticket chic, ticket choc"[1] (1983) to the inauguration of Line 14 (1998), the 1980s and '90s are marked by ever more numerous and varied photographic realizations. One of the most notable aesthetic tendencies of those two decades is the multiplication of Métro images playing on blurred, out-of-focus effects, better to convey the notion of perpetual motion inherent to the subject. These blurred effects occur in several different ways. In the work of Raymond Depardon (pp. 308-309), it's a combination of the blur from a shaky camera (caused by the simultaneous movements of the train and the car from which the photographer is taking the picture) and the condensation and raindrops on the windshield. In Krzysztof Pruszkowski (p. 329), the blurred effect stems from the procedure followed by the photographer and results from the superimposition of a large number of shots. In Bernard Plossu, it's a blurred focus (p. 298), sometimes combined with the blur from camera movement (p. 297). In the underground labyrinth of connecting corridors, Plossu, a great lover of the desert, invokes a supernatural subway where forms dissolve, as if the picture were taken in a sandstorm. Many other photographers take advantage of the potential aestheticism and symbolism of the out-of-focus, whether they express themselves in black-and-white or color. We will cite especially Michaël Zumstein's somber *Métro, Boulot, Dodo* (*Daily Grind*, p. 312), to which the out-of-focus, combined with backlighting and a lower viewpoint, confers a sinister, unsettling aspect, or the incredible *Metro-Chien* by Terence Ford (p. 311), as fascinating as it is incomprehensible. The works of Éric Barrielle rely on the power of color, as their titles imply: *Femme à l'écharpe violette* (*Woman With Purple Scarf*, p. 294), *Escalier orange* (*Orange Stairway*, p. 295). Here, the blurred effect, by suppressing details and simplifying forms, concentrates attention on the color harmonies. We find the out-of-focus at the service of color again in certain works—always of great formal rigor—by the Italian Ferdinando Scianna (pp. 324-325) or in those of Dolorès Marat (p. 326), who, starting in 1983, made the Paris Métro one of her favorite subjects (p. 332). All these works project an impression of transience that has as much to do with the nature of the subject dealt with as it does with the medium used, since the photographic image is, in its essence, the representation of a minuscule instant of time that has irremediably passed.

An inexhaustible source of wonder for the attentive eye, the Métro, in its various manifestations, continues to inspire photographers, giving rise to multiple

1980-2000

JULIEN FAURE-CONORTON

1.
Cf. Quand la pub nous transporte: 65 ans de publicité de la RATP (When Publicity Transports Us: 65 Years of Publicity by the RATP), Paris: Le Cherche Midi, 2014, pp. 120-133.

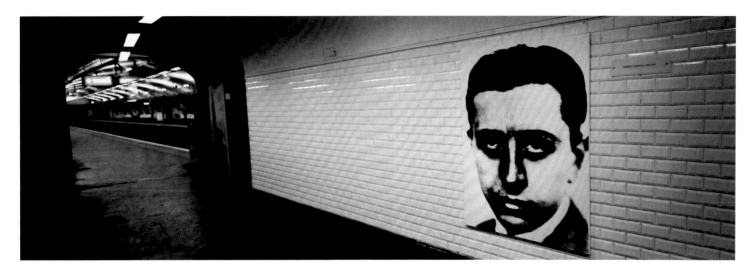

JOSEF KOUDELKA - *Robert Desnos,*
Saint-Germain-des-Prés station,
1986

graphic experimentations. These rely especially on the Métro's architecture, different aspects of which are emphasized: its labyrinthine nature (François Le Diascorn, p. 290), its geometry or its gigantic size (Jean-Pierre Couderc, author in 1980 of a series on the elevated Métro that superbly conveys the elegance, nobility and majesty of the Métro's architecture, pp. 285 and 291). This produces the most varied results, from that dizzying flight of stairs by Philippe Lopparelli (p. 293), a veritable architectural whimsy straight out of Piranesi's *Prisons*, to those gleaming tracks rushing towards the roofs of Paris in the sober, pure style typical of the works of Michael Kenna (p. 319). Here, light reigns supreme; on the negative, its imprint transforms the subject, sculpts its shape, magnifies its symmetry, amplifies the equilibrium of masses and the harmony of lines.

The graphic experiments to which photographers devoted themselves during this period frequently relied on the strong contrast between shadow and light. The results offered by such propositions are striking, whether it's a question of violent backlighting (Michaël Zumstein, p. 312, and Philippe Lopparelli, p. 316), an elegantly projected shadow (Serge Sautereau, p. 313), or a bright gleam emanating from the darkness of a tunnel under construction (Lily Franey, p. 330). Night is also propitious for this kind of effects, to which it adds a share of mystery, as in the portrait by Mat Jacob (p. 292) where the model is nothing but a silhouette, an outline, graffiti on the wall. There is shadow and light, again, in those two photographs by Peter Turnley (p. 303) and Jean-Pierre Couderc (p. 315), strangely similar even though one is the embodiment of a uniquely photographic sense of the ephemeral, while the other hints at immutability. As in the past, graphic experiments also take advantage of the posters on the platforms and near the station entrances. The American Richard Kalvar offers two variations, one with almost Surrealist accents (p. 304), the other more serious, encouraging

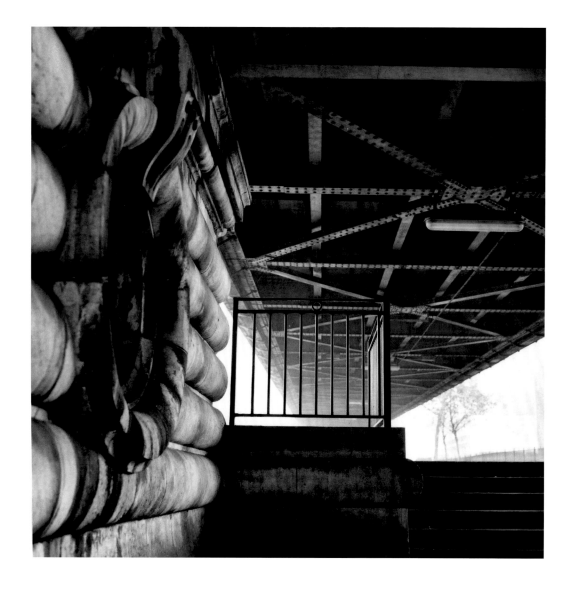

JEAN-PIERRE COUDERC -
*Boulevard de la Chapelle (from the
"Elevated Métro" series)*, 1980

reflection (p. 336). In 1982, however, Jean-Philippe Charbonnier takes the stance opposite to this overabundance of information imposed by advertising posters; he aims his lens at the void, the abstract, silence, which constitute for him *La Revanche du panneau vierge* (*The Revenge of the Blank Board*, p. 328).

Color becomes more and more present in the realm of photographs of the Paris Métro, especially during the 1980s, a colorful period if ever there was one. Lively palettes and bold associations mingle and clash, sometimes offering unexpected results of a surprising harmony. Thus that woman with the red coat (Bertrand Chabrol, p. 289) or that carpet of yellow tickets during the 1983 exhibit *Ticket chic, ticket choc* (Armand Borlant, p. 333). For others, specialists in the genre and colorists in their very souls, the Métro is only a pretext, with the essential thing

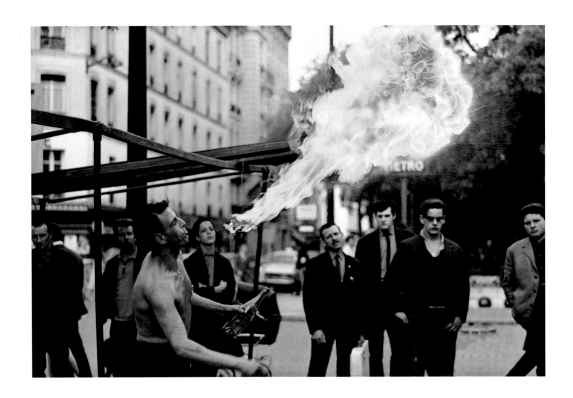

lying in the power of color, bright and saturated. This is the case for Joel Meyerowitz's *Street Busker* (p. 286) or Harry Gruyaert's *Boulevard Haussmann* (p. 305). Color also gleefully explores the power of typographic designs—the Métro sign, already mentioned in the previous periods—as in that photograph by Christian Sappa (pp. 306-307), a harmonious superimposition of textual and graphic elements. Finally, we note in color photography an admirable use of black, whether in the backlighting of that Métro exit by Gueorgui Pinkhassov (pp. 320-321) or in the tunnel of the *Raspail station* by Patrick Zachmann (p. 322).

Faced with these full-color expressions, black-and-white remains predominant, despite everything. If photographers privileged it, this was, of course, out of personal taste but also out of tradition; another reason, certainly, was the fact that in the period that saw the growth of institutional recognition of photography in France, black-and-white remained more prestigious than color. The filter it affixes adorns reality with an unquestionable aura and, often, with a timeless quality. This is true for the portrait of the American saxophonist Archie Shepp (p. 317), taken in 1983 by Guy Le Querrec in a little street in the 10th arrondissement, but which looks as if it came straight out of New York in the 1950s.

Among other characteristics of the 1980s and '90s, one can cite the abiding interest in isolated figures, which often seem to give rise to questions, like that young boy with the lost look (Jean-Philippe Charbonnier, p. 300) or that alert-looking cat (Jane Evelyn Atwood, p. 301). Elements rarely dealt with in the world of the

Métro are ennobled by the gaze the photographer directs at them: a forsaken photo booth (Raymond Depardon, p. 334), or tickets negligently dropped on the ground (Richard Kalvar, p. 331). Sometimes, the originality lies not in the choice of subject, but in the means used to represent it. Josef Koudelka is one of the first to photograph the Paris Métro with the help of a panoramic camera, a format that was surprisingly rarely used, since it did such a good job of magnifying the physiognomy of that underground world, going along with its perspectives and accentuating its implacable horizontality (pp. 284 and 296). We can also witness the birth, during this period, of an aesthetic of reflections that would clearly assert itself during the 2000s and 2010s. In 1991, it is magisterially expressed by Stéphane Burlot in an infinitely rich image that summarizes all by itself the very essence of the photographic (p. 318).

2.
Cf. K. Pruszkowski, *Pruszkowski-Fotosynteza, 1975-1988,* Lausanne: Musée de l'Élysée, 1989.

3.
A mixture of photographic recreation and ethnographic fantasy, the *portrait-type* gave rise in 1887 to the publication by Arthur Batut (1846-1918) of a booklet entitled *La Photographie appliquée à la production du type d'une famille, d'une tribu ou d'une race (Photography Applied to Producing the Type of a Family, Tribe or Race).*

4.
L. Delahaye, *L'Autre,* London: Phaidon, 1999 (with commentary by Jean Baudrillard).

Finally, the period between 1980 and 2000 saw the emergence of elaborate artistic projects that took the Métro as sole or occasional subject. These projects are developed as a series and are characterized by respect for a specific method, often strict and immutable, that confers a scientific rigor on the process and an aesthetic unity on the photographs. In 1985, Krzysztof Pruszkowski took portraits of Métro passengers for the newspaper *Libération* according to a procedure he called "photosynthesis," which he had been using for a dozen or so years (p. 329).[2] Inspired by experiments carried out at the end of the nineteenth century by Arthur Batut on the *portrait-type*,[3] this process consists of superimposing a number of portraits of individuals taken in similar conditions; this results in accumulating shared traits and canceling out individual traits. With the diptych on which he has fastened his Métro tickets—attesting to the occurrence of the experiment—Pruszkowski took the *portrait-type* of passengers in 1st and 2nd class, a photosynthesis of sixty individuals encountered over the course of his two hours of travel on Lines 1 and 4. Ten years later, Luc Delahaye undertook a study mixing Métro, portrait and strict application of a method (p. 335). For three years, with the camera around his neck and the remote hidden in his pocket, he photographed the passengers opposite him, without their realizing it. The striking portraits resulting from this exemplify the aesthetic unity produced by the rigorous use of a predetermined, fixed procedure (distance, framing, light, focus). Their strength lies in the dichotomy between these faces, very present to the camera lens, and these souls that, projected elsewhere, entirely escape photographic capture. In this respect, the series conveys remarkably well the ability of travel to give rise to mental voyage. In the Métro, as the stations fly by, thoughts drift away and head elsewhere. It is that other self, who lives in each of us, that Delahaye's photos capture. In 1999, a book presented this ambitious enterprise. Its title: *L'Autre (The Other)*.[4]

BERTRAND CHABROL (RATP) - *Woman in red, Boulogne - Jean-Jaurès station*, October 7, 1980

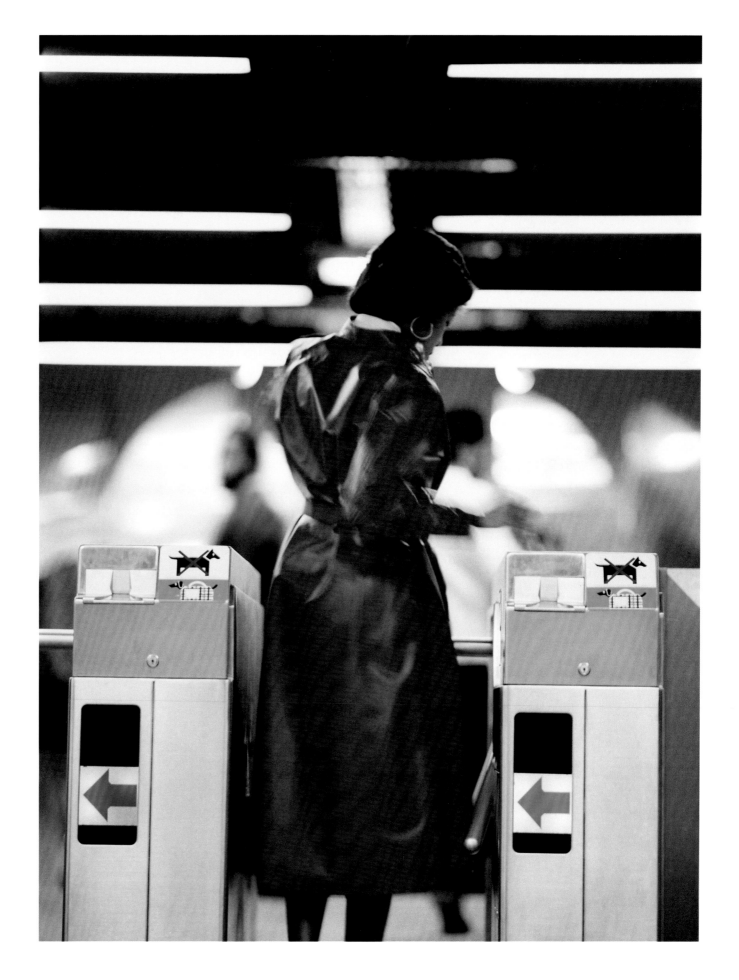

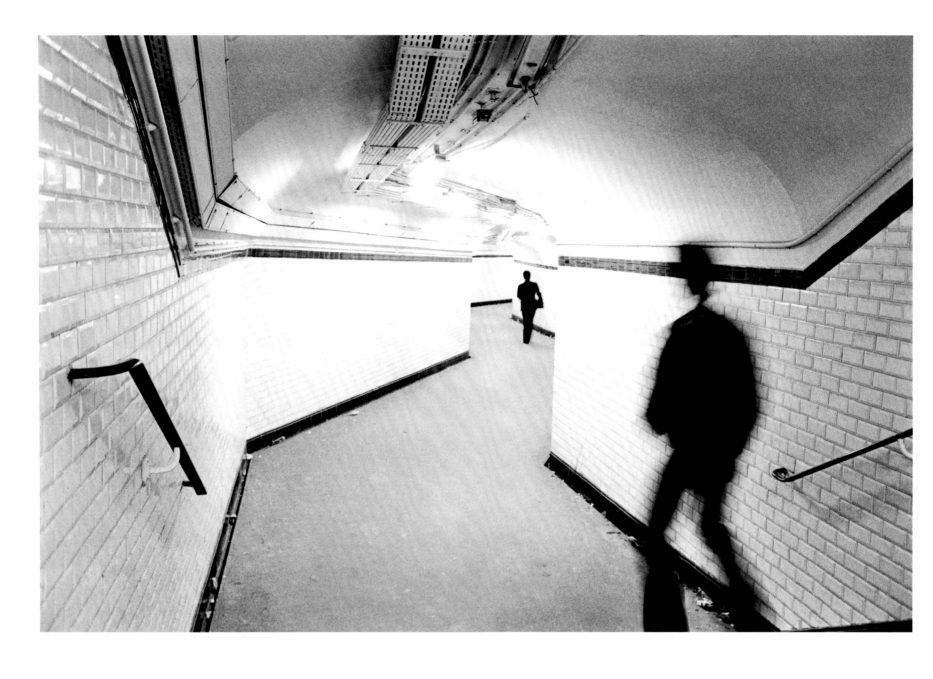

Above: FRANÇOIS LE DIASCORN - *In the Métro corridors (from the "Mysterious Paris" series)*, 1990s

Opposite: JEAN-PIERRE COUDERC - *Stairways (from the "Elevated Métro" series)*, 1980

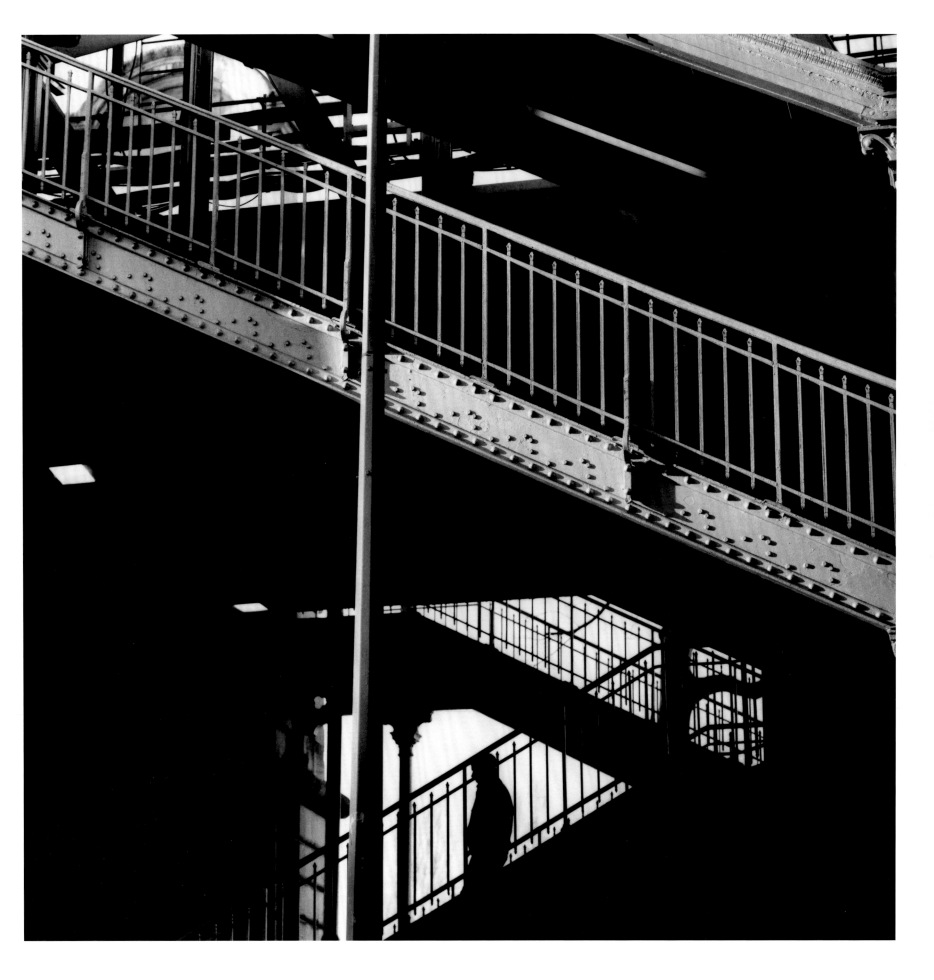

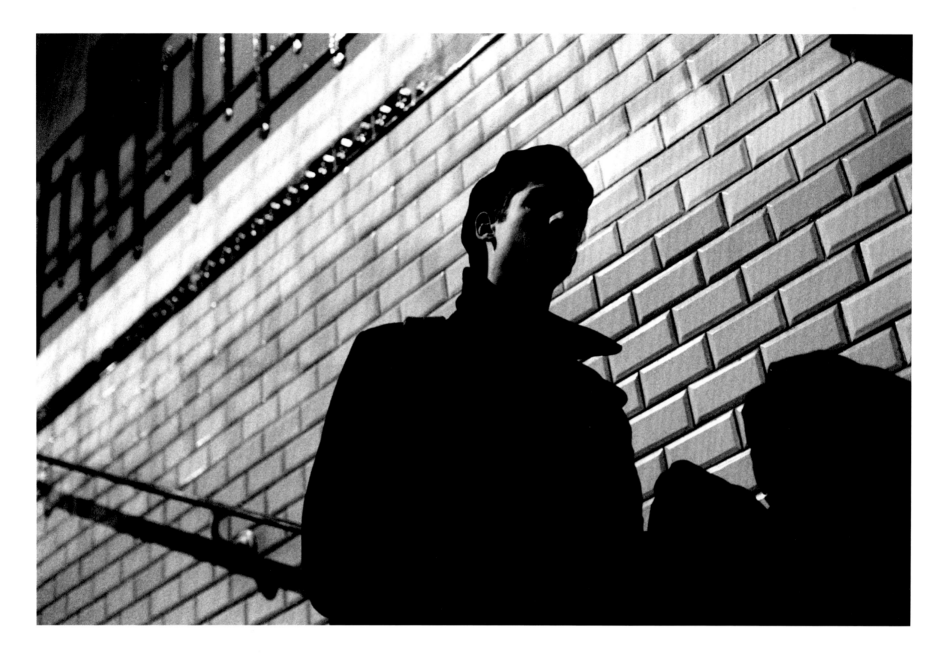

Above: MAT JACOB - *André, Métro at night, Paris,* 1991

Opposite: PHILIPPE LOPPARELLI - *The stairs,* 1994

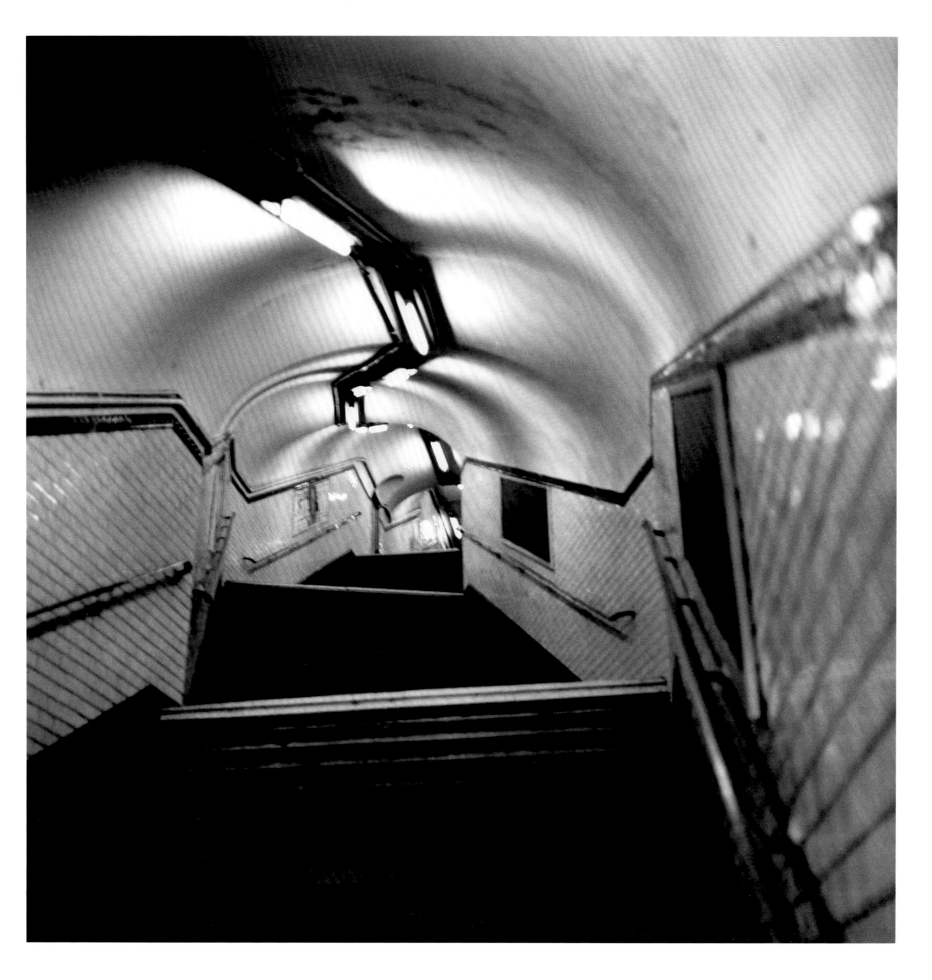

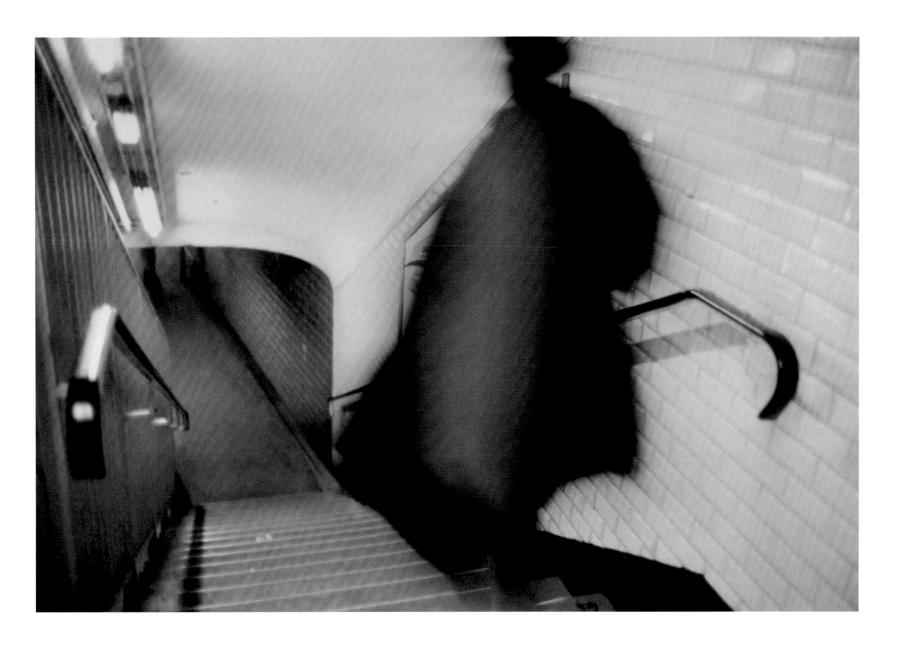

ÉRIC BARRIELLE - *Woman With Purple Scarf*, 1988

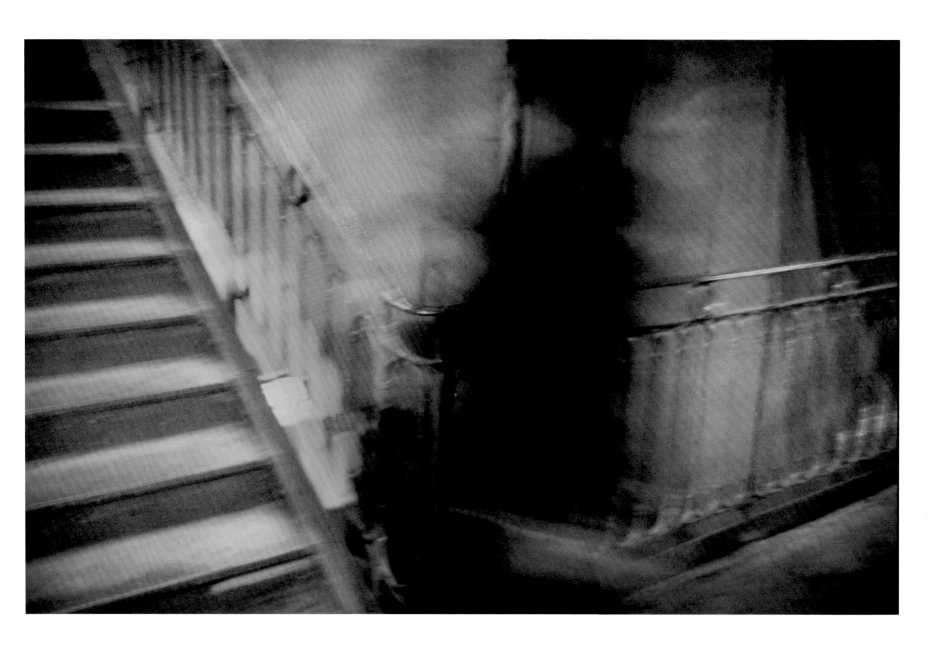

ÉRIC BARRIELLE - *Orange Stairway*, 1988

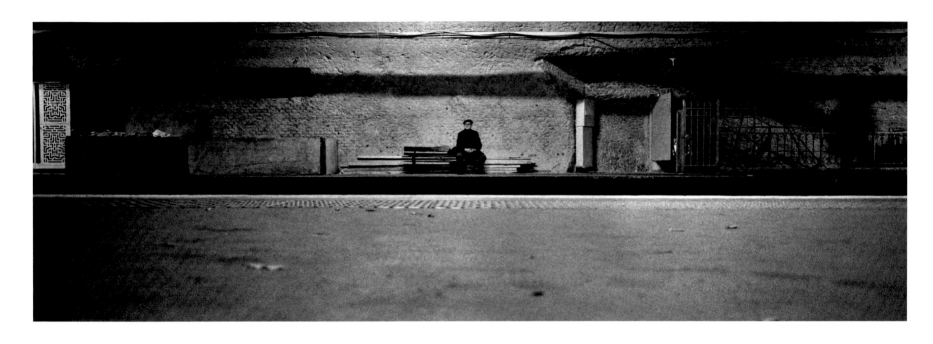

Above: JOSEF KOUDELKA - *Montparnasse-Bienvenüe station*, 1988

Opposite: BERNARD PLOSSU - *"Métro, Paris,"* 1989

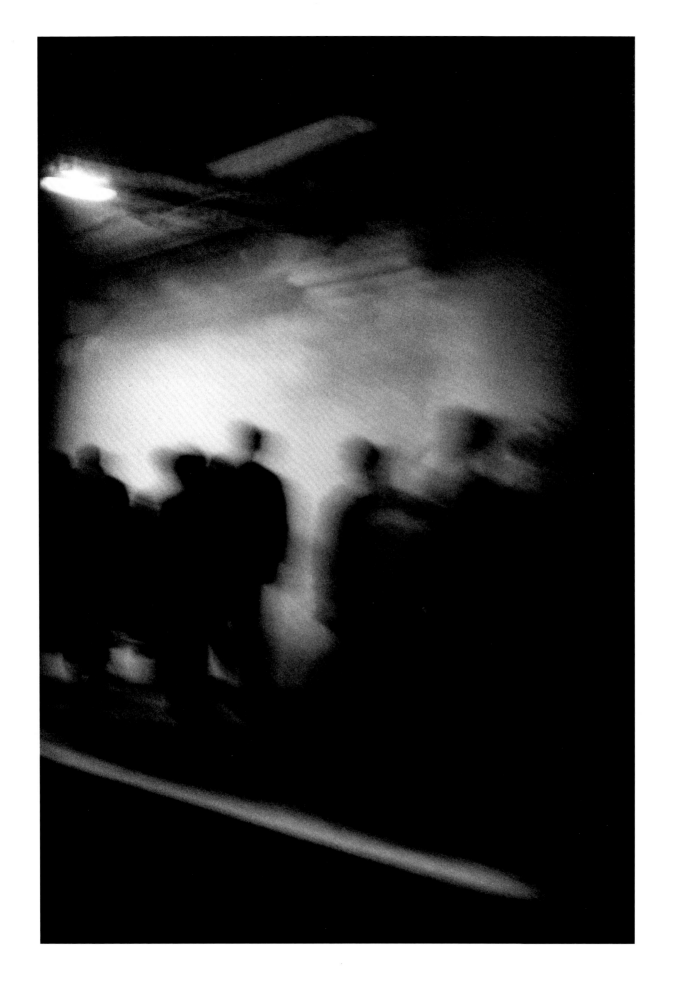

BERNARD PLOSSU - *"Paris,"* 1985

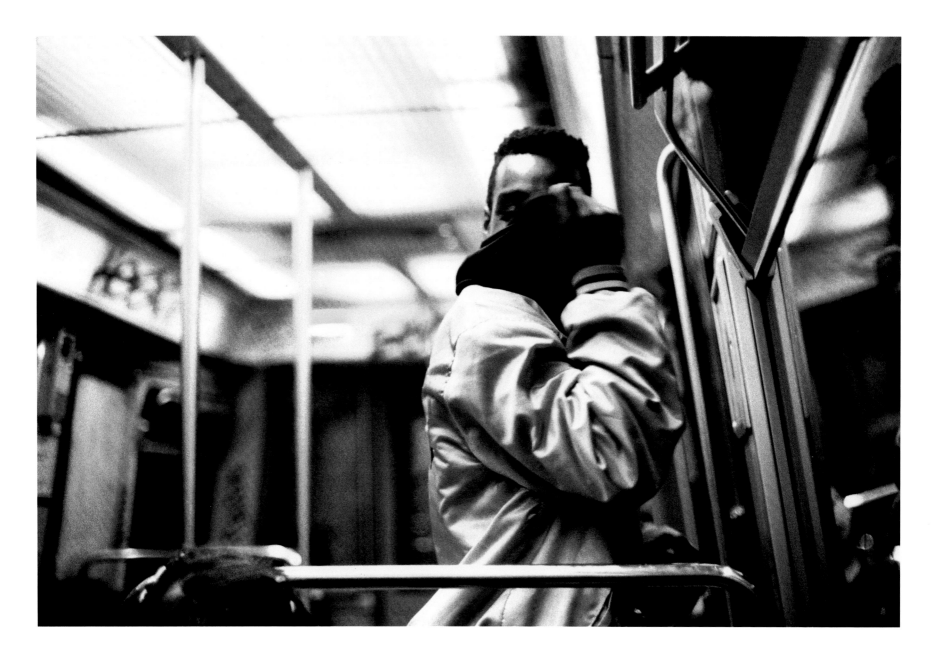

MAT JACOB - *In the Métro*, 1990

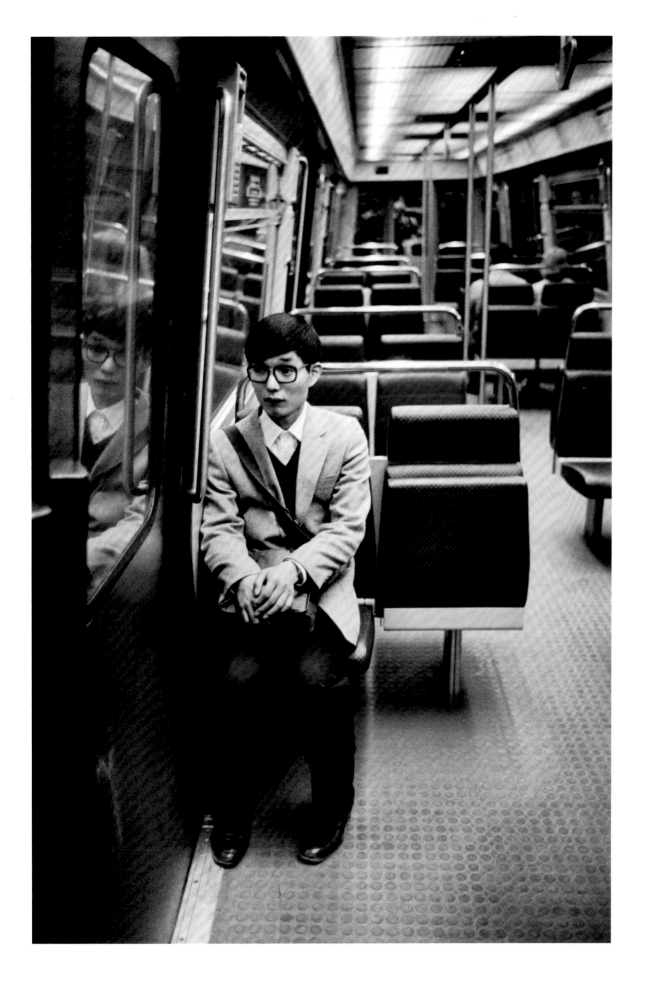

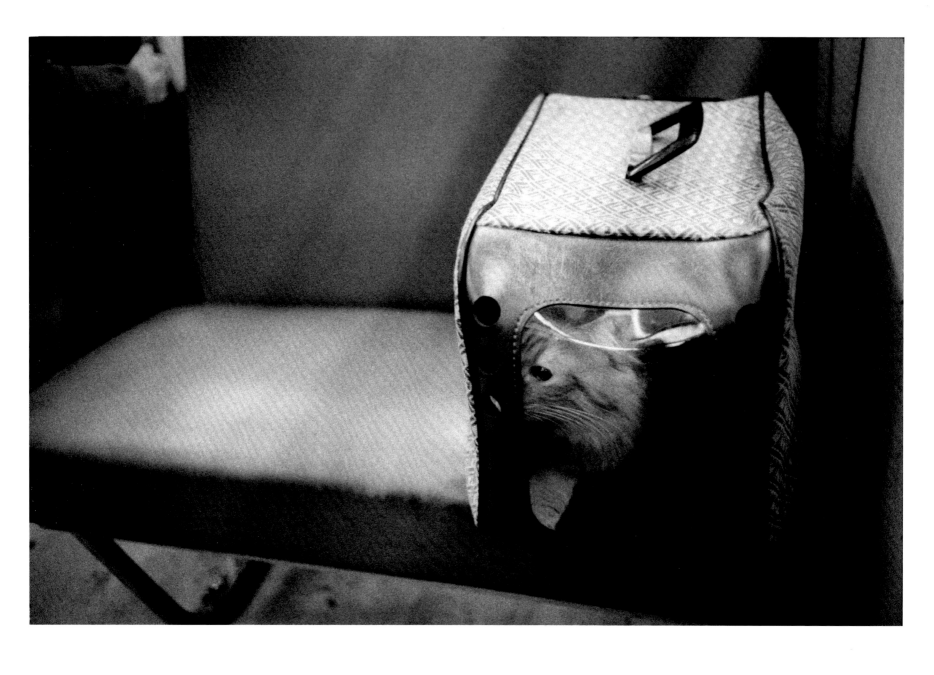

Opposite: JEAN-PHILIPPE CHARBONNIER - *Young boy in the Métro,* 1980

Above: JANE EVELYN ATWOOD - *"Romeo in the Métro,"* 1982

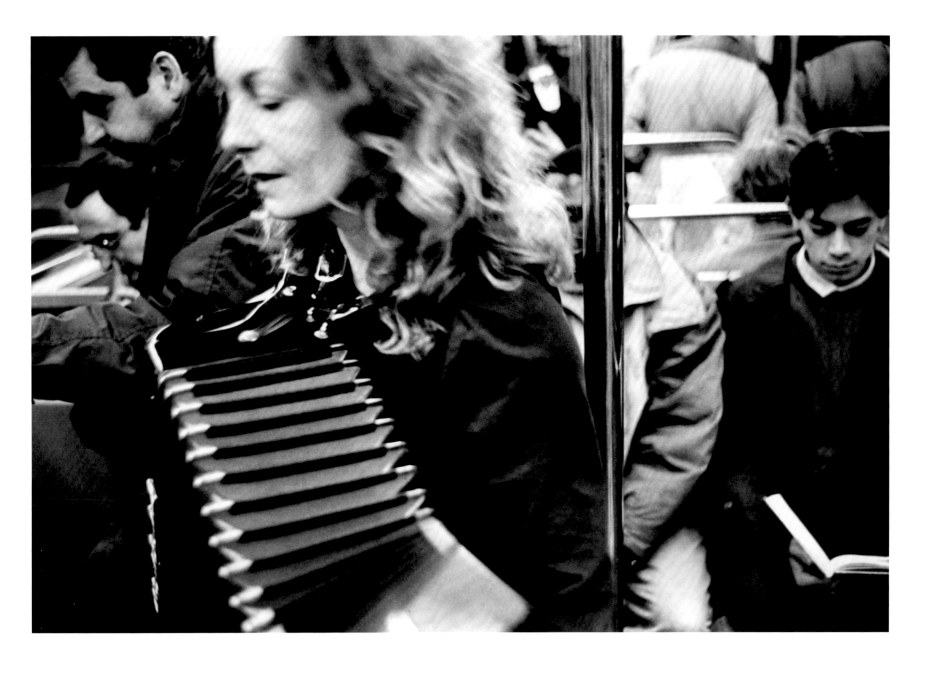

PASCAL AIMAR - *Musicians in the Métro*, 1994

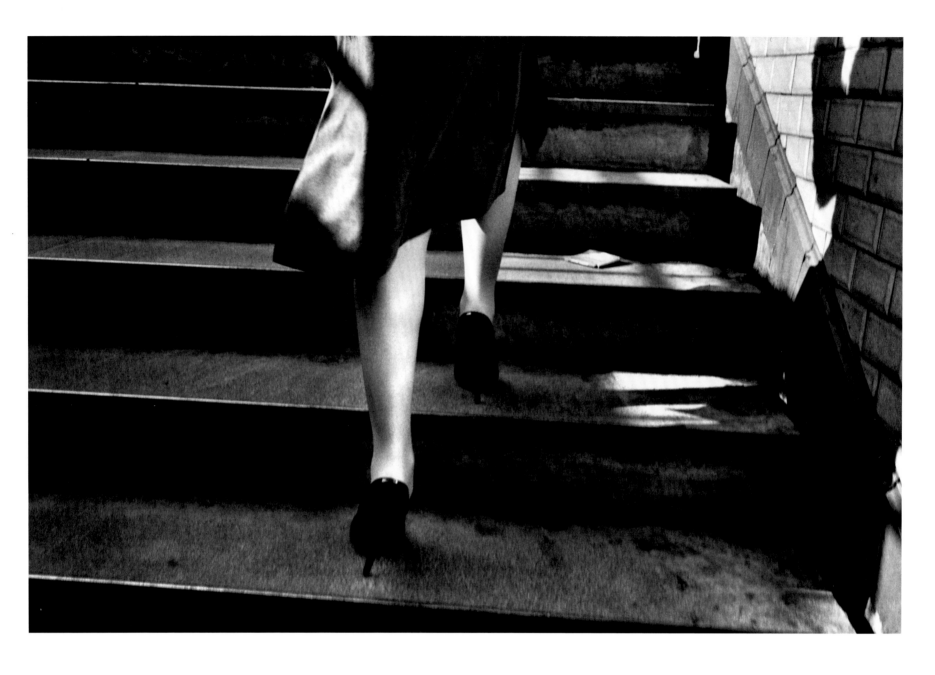

PETER TURNLEY - *"Paris,"* 1980

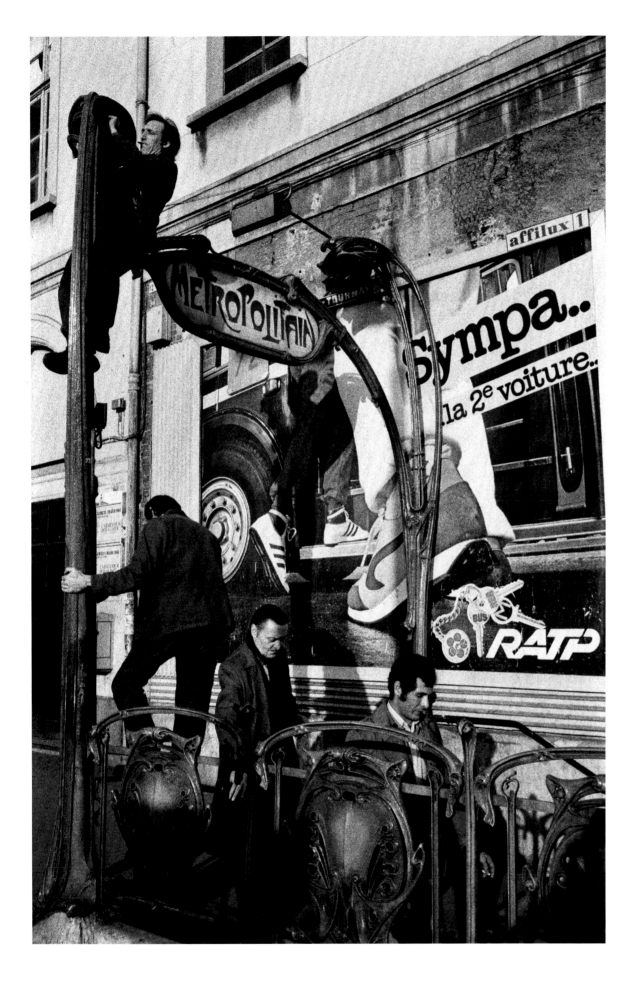

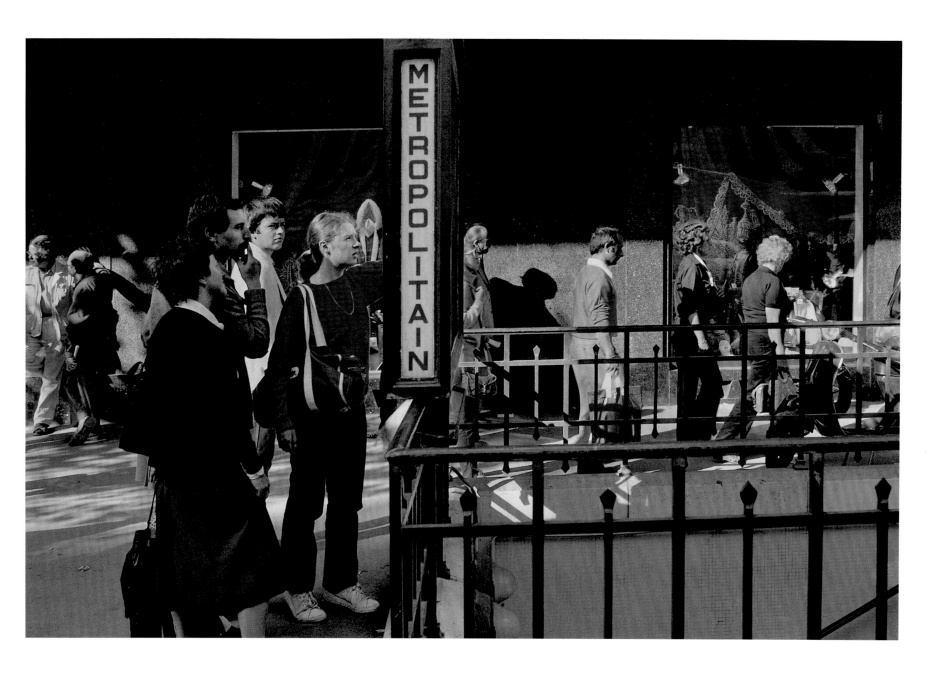

Opposite: RICHARD KALVAR - *Station entrance,* 1980

Above: HARRY GRUYAERT - *"Boulevard Haussmann,"* 1985

CHRISTIAN SAPPA - *Moulin Rouge and Métro*, 1995

RAYMOND DEPARDON - *Paris, 16th arrondissement*, 1982

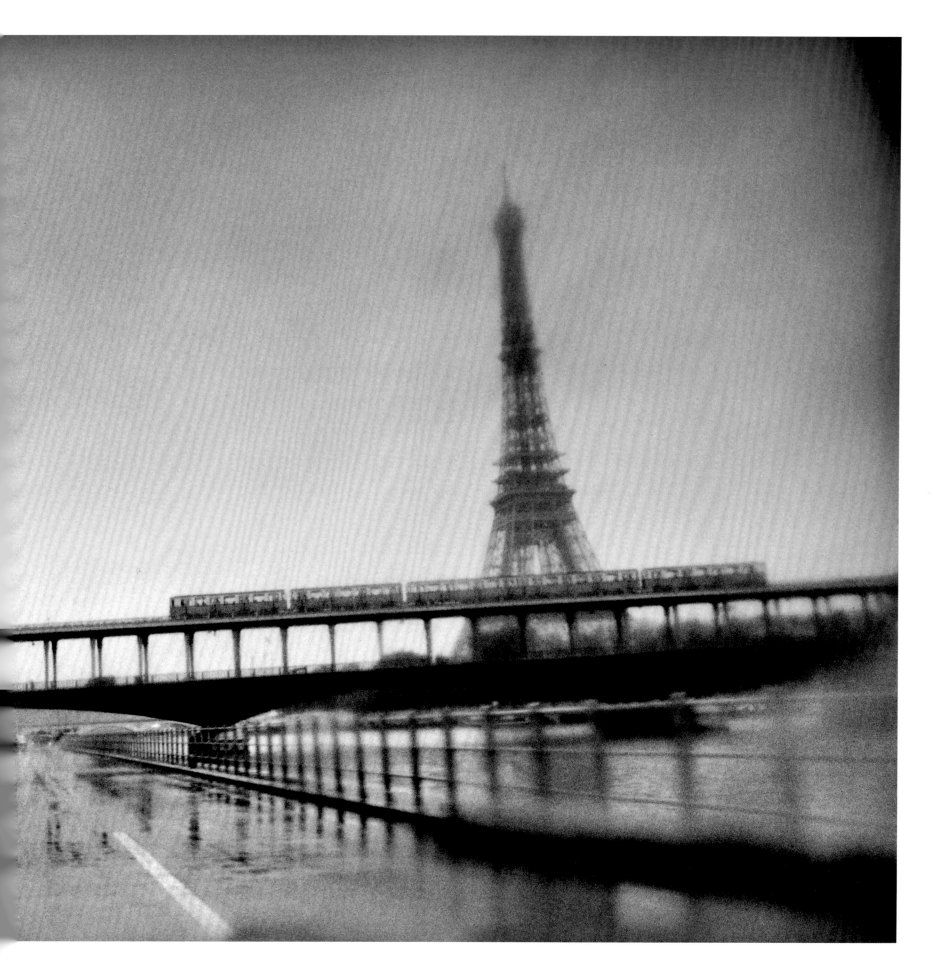

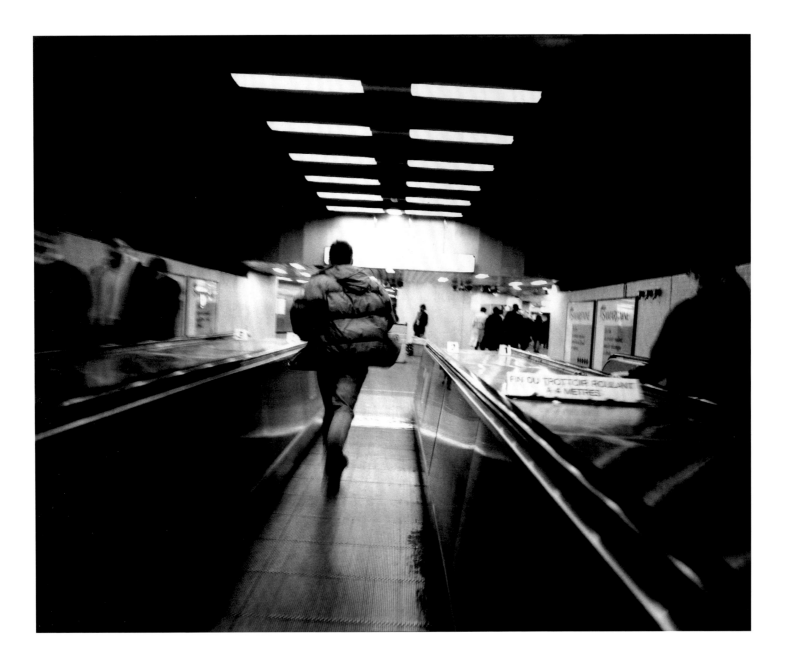

RAYMOND DEPARDON - *Châtelet - Les Halles*, 1991

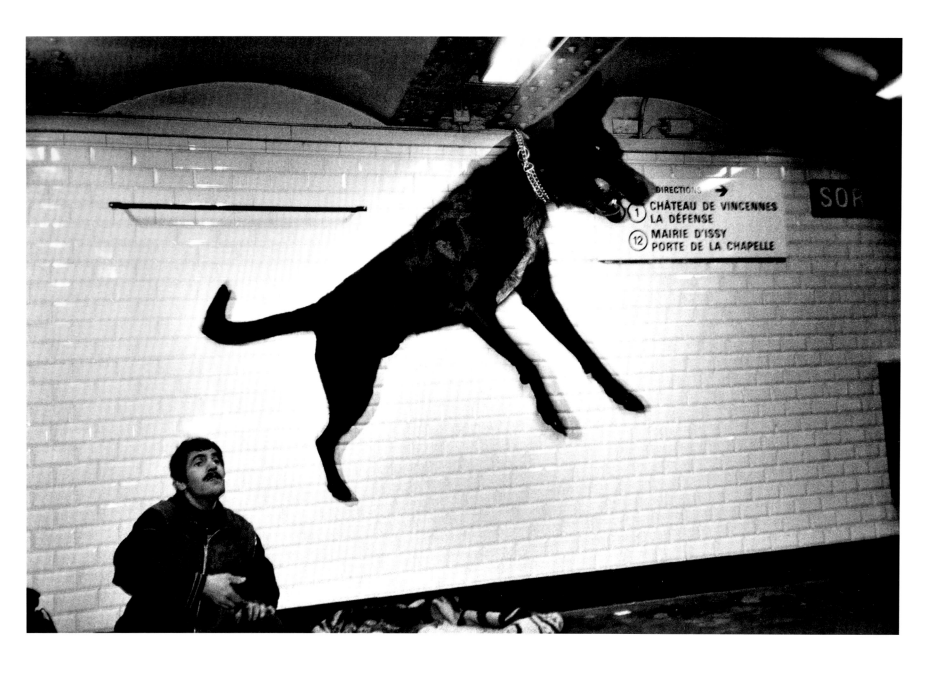

TERENCE FORD - *"Metro-Chien,"* 1991

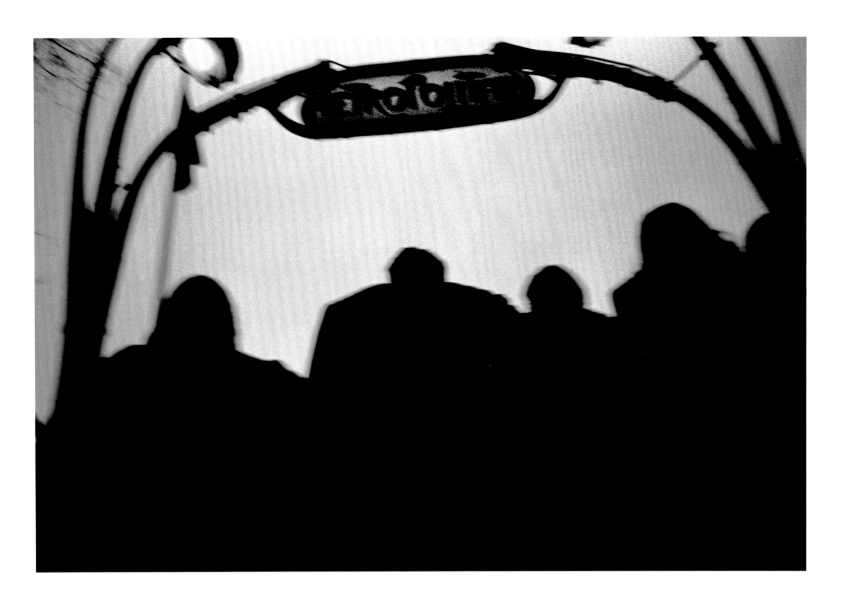

Above: MICHAEL ZUMSTEIN - *"Métro, Boulot, Dodo" (Daily Grind)*, 1999

Opposite: SERGE SAUTEREAU - *Châtelet station, Rue de Rivoli*, 1985

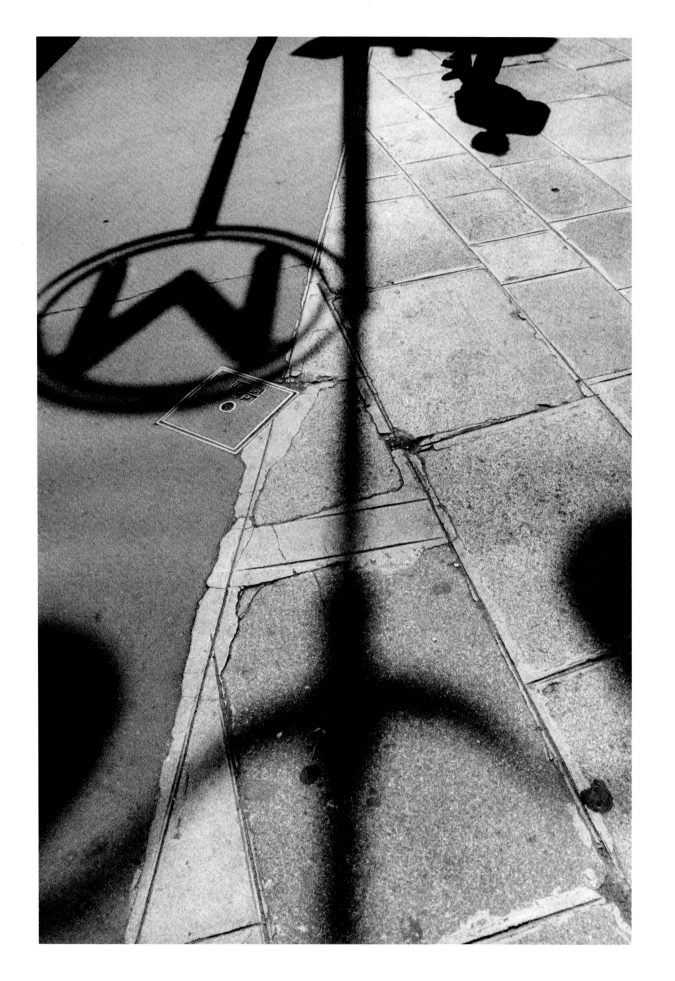

JEAN-PIERRE COUDERC - *Rue de l'Alboni (from the "Elevated Métro" series)*, 1980

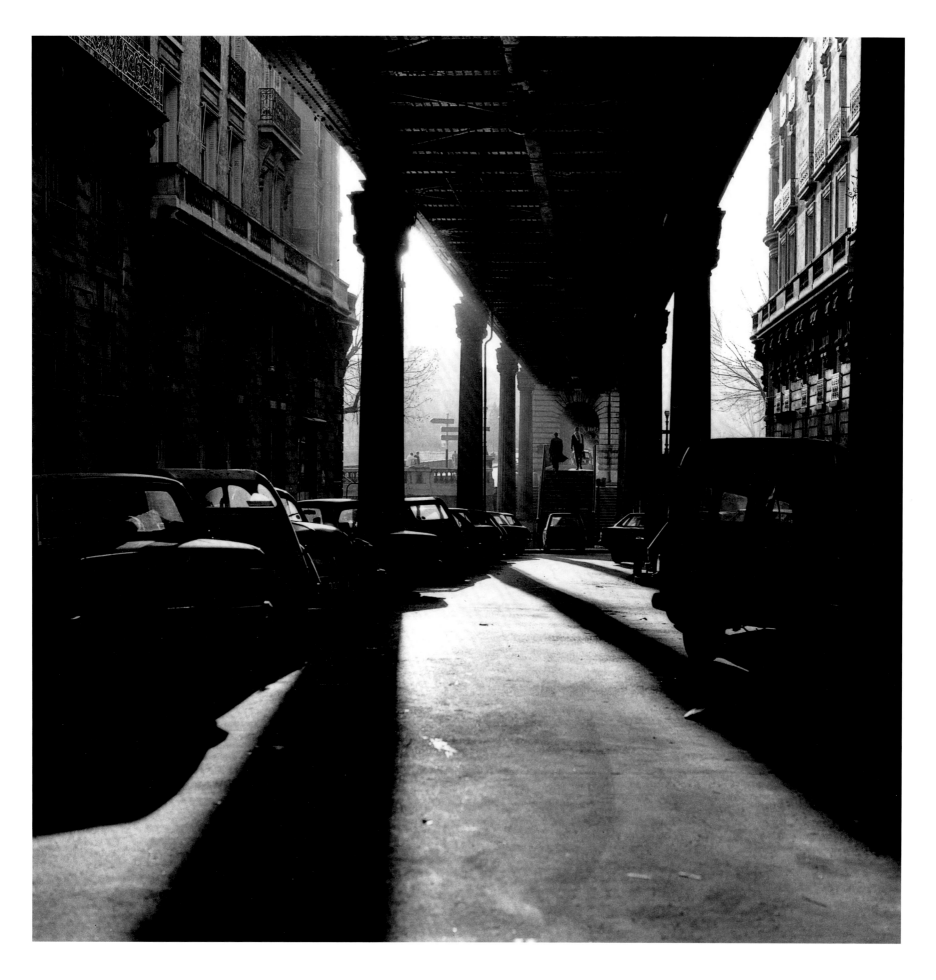

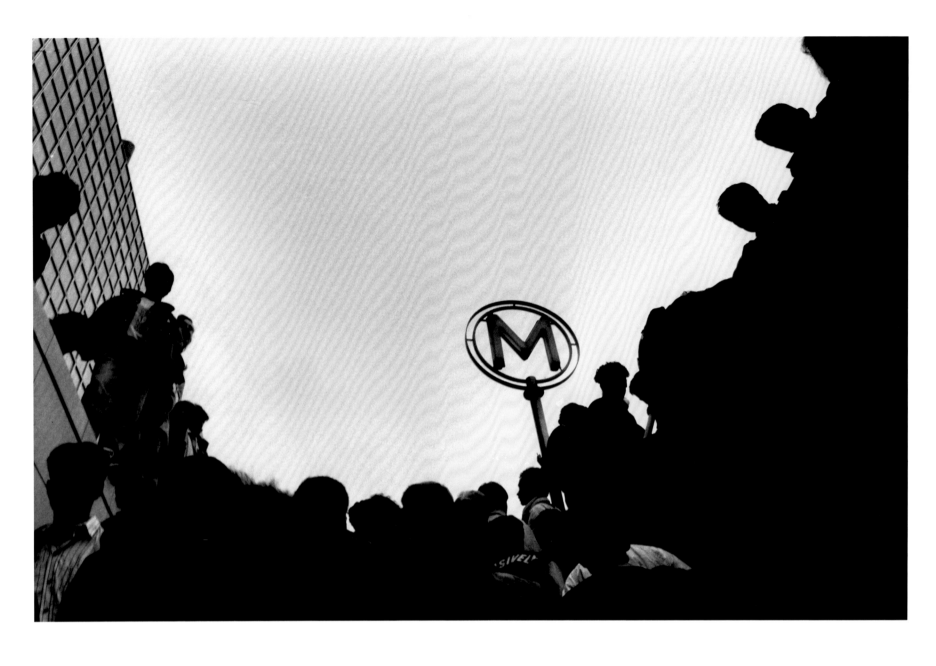

PHILIPPE LOPPARELLI - *High school students demonstrating at the Place de la Bastille*, November 12, 1990

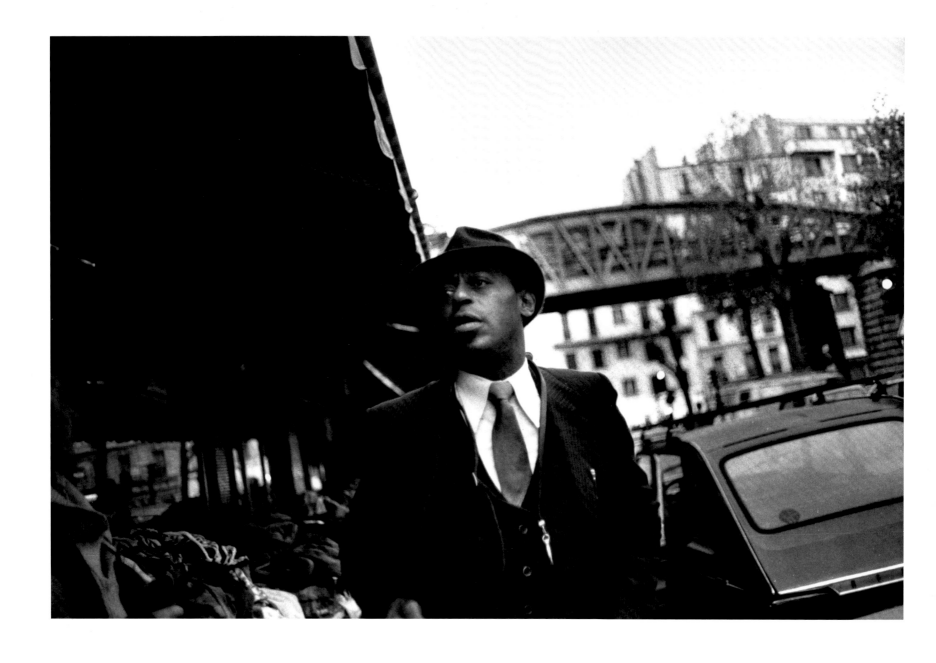

GUY LE QUERREC - *Archie Shepp, Rue Guy Patin*, November 9, 1983

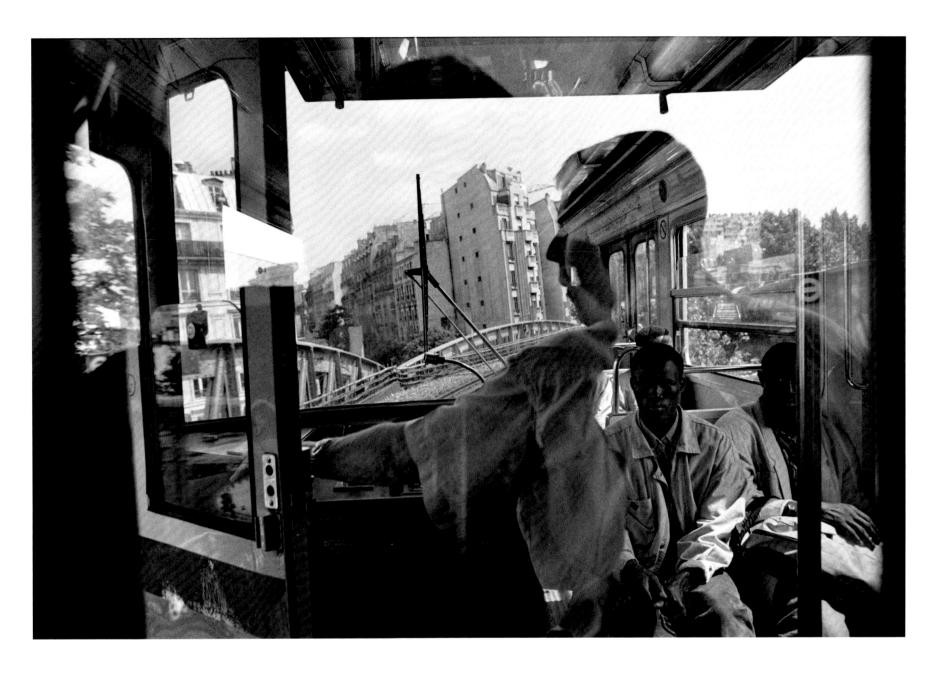

Above: STÉPHANE BURLOT - *Paris (from the "Métro-Burlot-Dodo" series)*, 1991

Opposite: MICHAEL KENNA - *"Passy, Métro, France,"* 1991

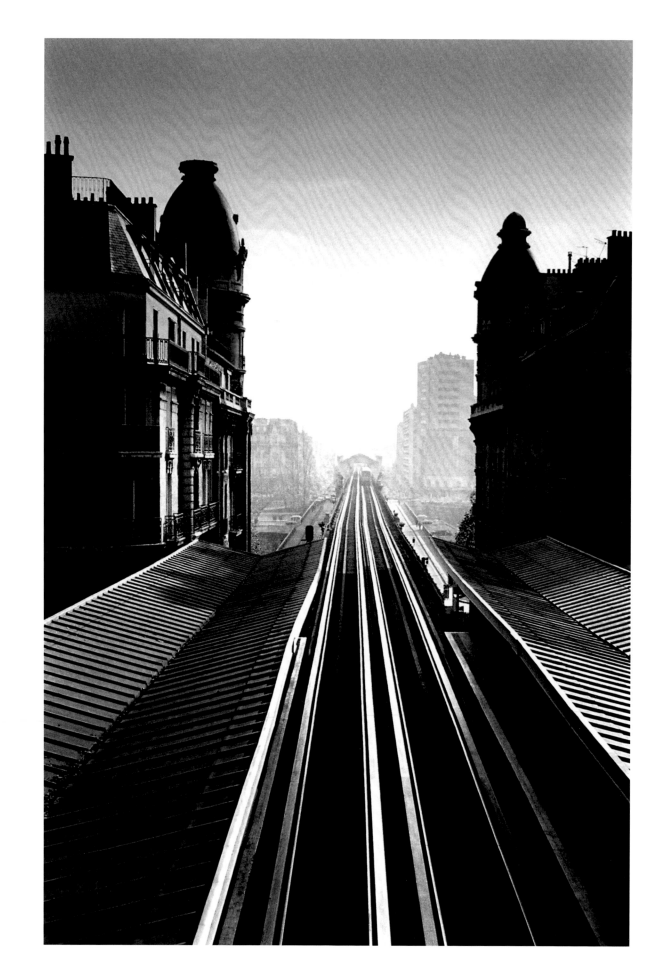

GUEORGUI PINKHASSOV - *"Paris,"* 1997

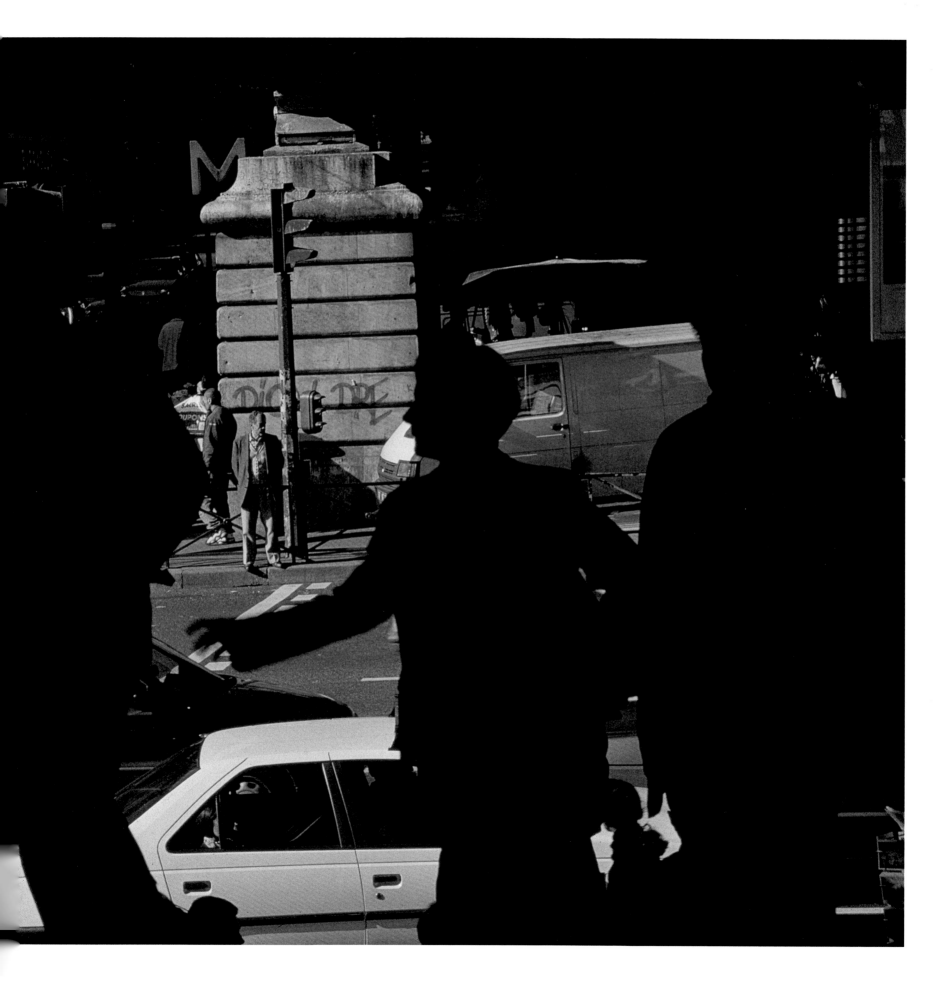

PATRICK ZACHMANN - *Raspail station*, 1997

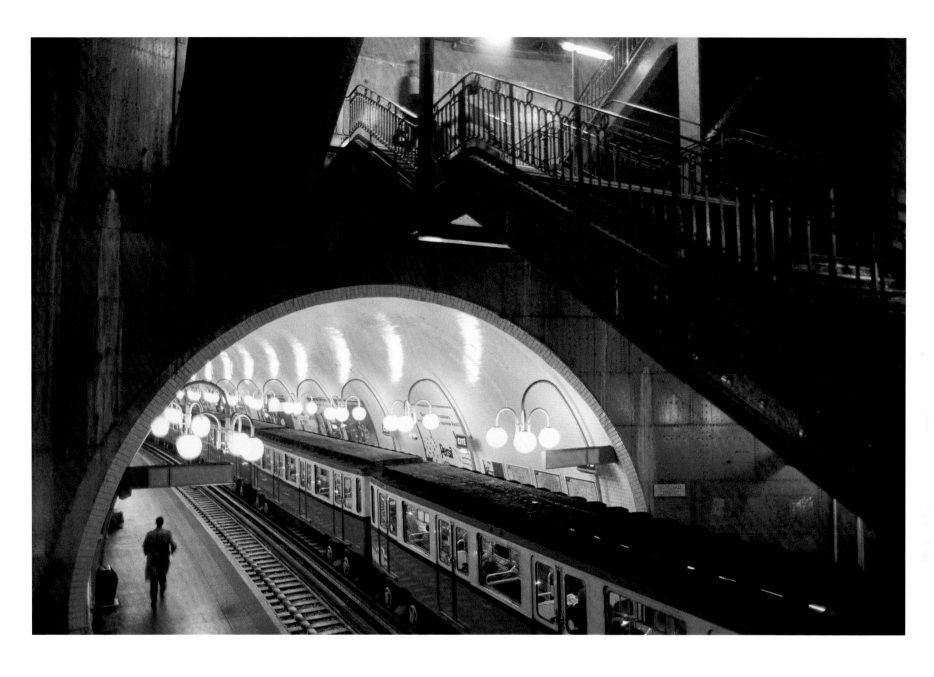

DENIS SUTTON (RATP) - *MP59 train standing at the platform*, March 3, 1992

FERDINANDO SCIANNA - *Concorde station*, 1981

Opposite: DOLORÈS MARAT - *Sleeping man, Arts et Métiers station,* 1997

Above: OLIVIER CULMANN - *Call point (from the "Minox" series),* 1999

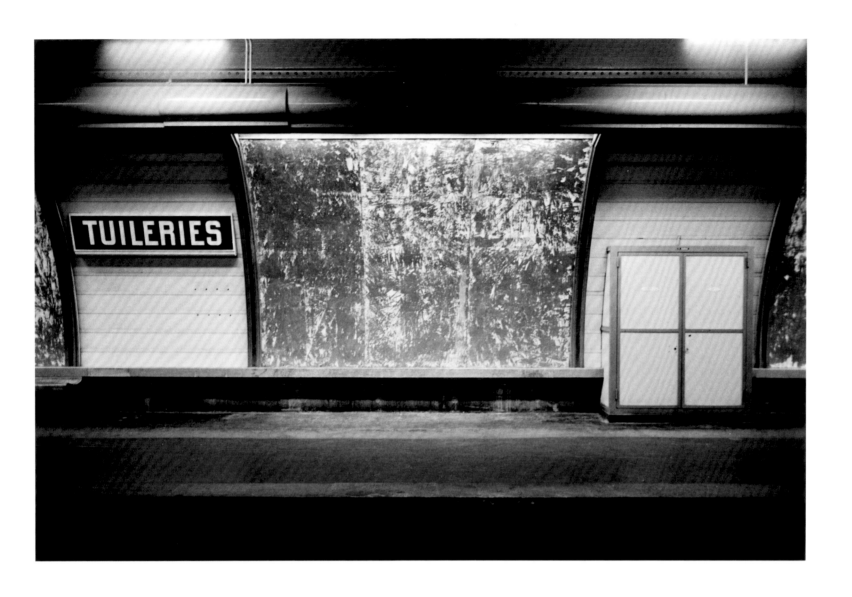

JEAN-PHILIPPE CHARBONNIER - *"The Revenge of the Blank Board,"* 1982

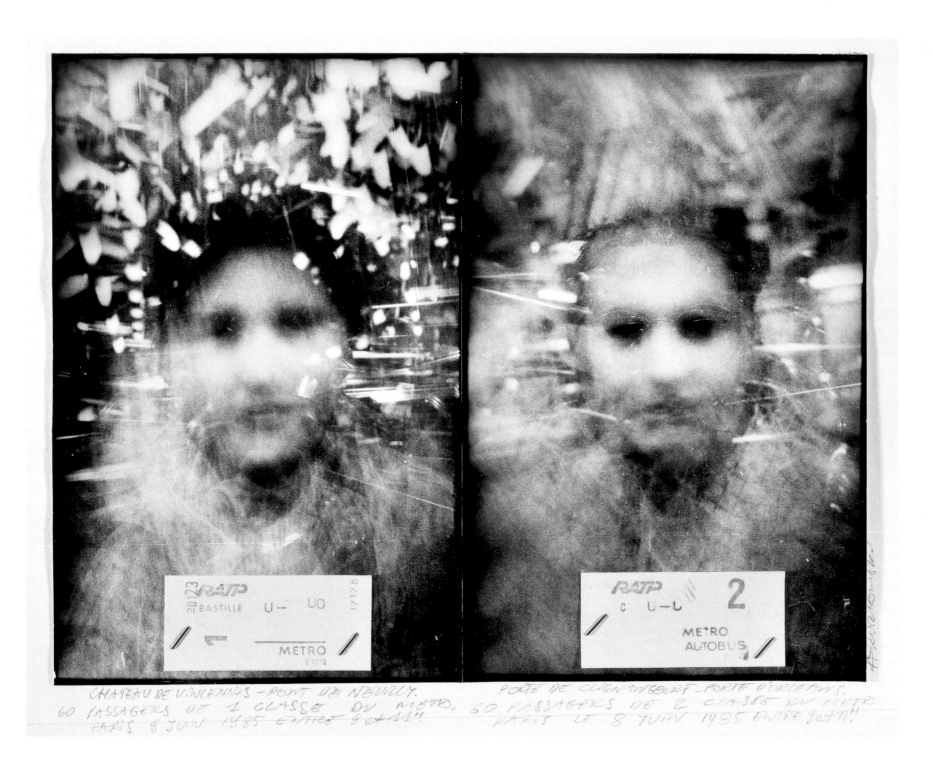

KRZYSZTOF PRUSZKOWSKI - *"60 Passengers, 1st Class" / "60 Passengers, 2nd Class" (Photosynthesis)*, 1985

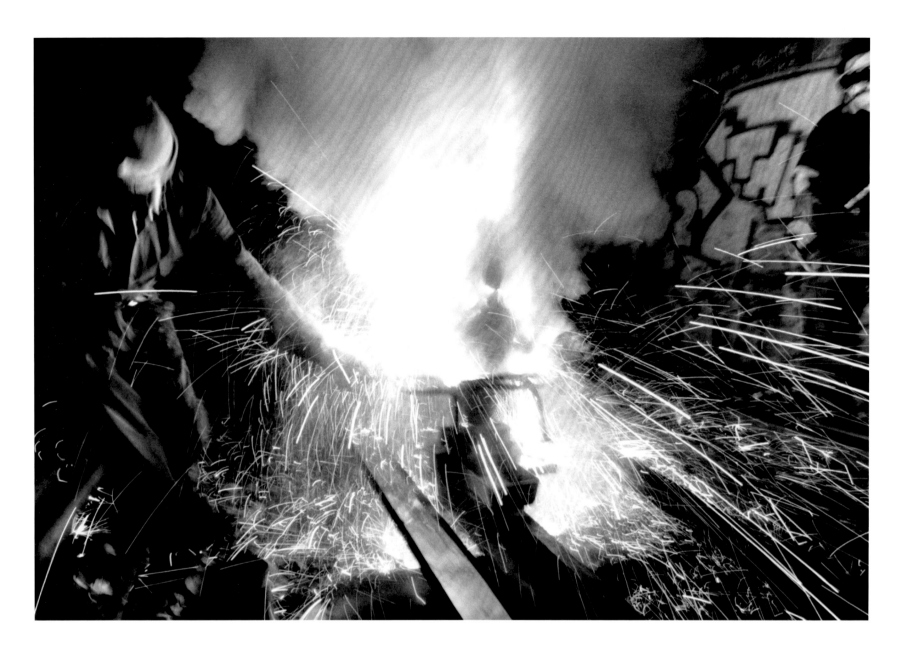

LILY FRANEY - *Tracklayer*, 1997

RICHARD KALVAR - *Tickets (during a cleaning service strike)*, 1980

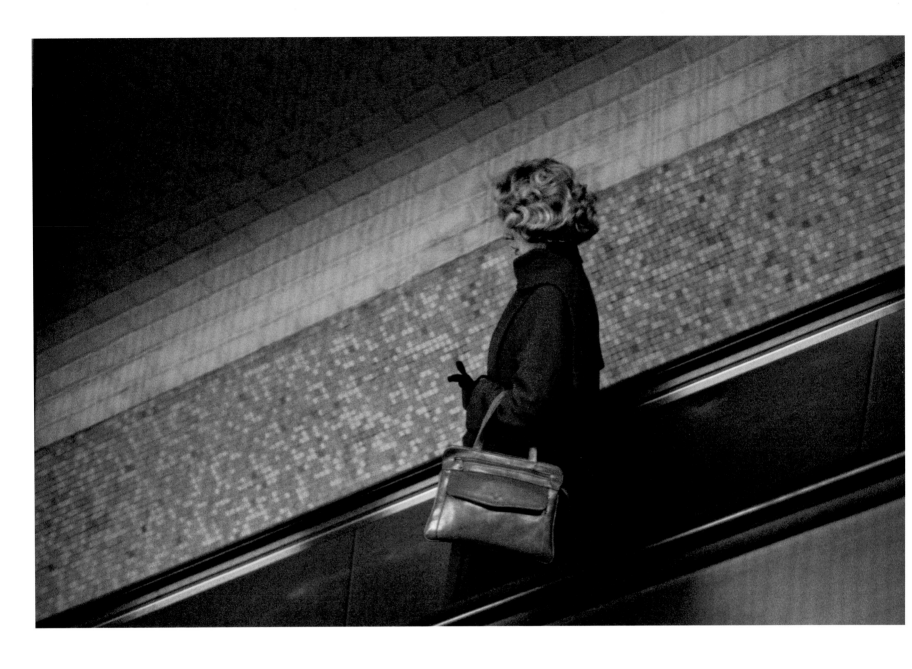

DOLORÈS MARAT - *Blue tiles, Monge station*, 1987

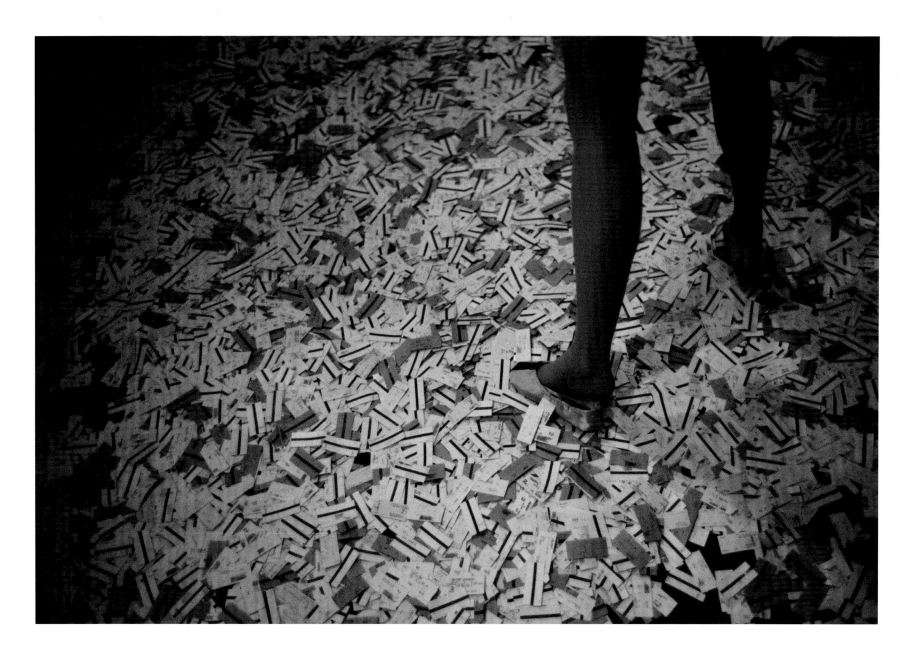

ARMAND BORLANT - *"Ticket chic, ticket choc" exhibit*, 1983

Next pages:

Left: RAYMOND DEPARDON - *Boulevard Saint-Michel*, 1986

Right: LUC DELAHAYE - *"L'Autre" (The Other)*, 1995-1997

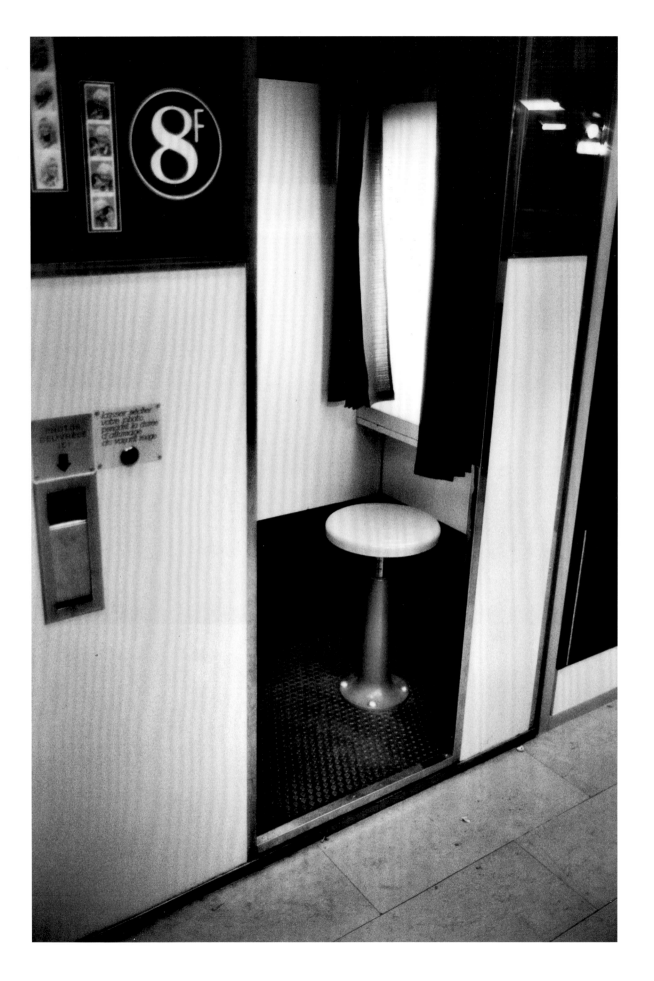

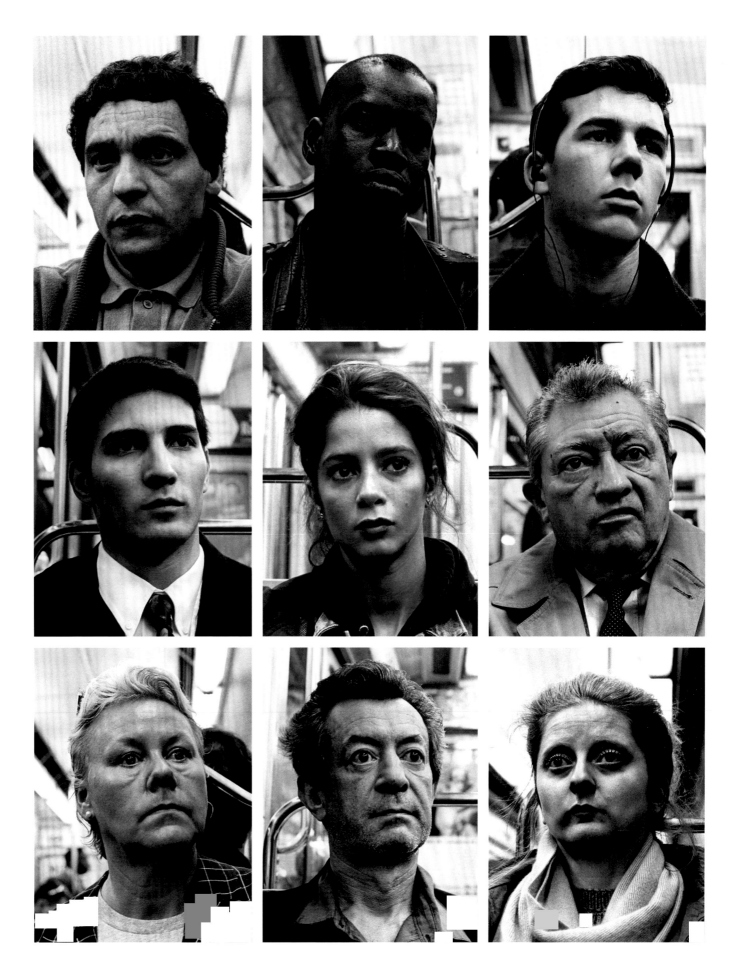

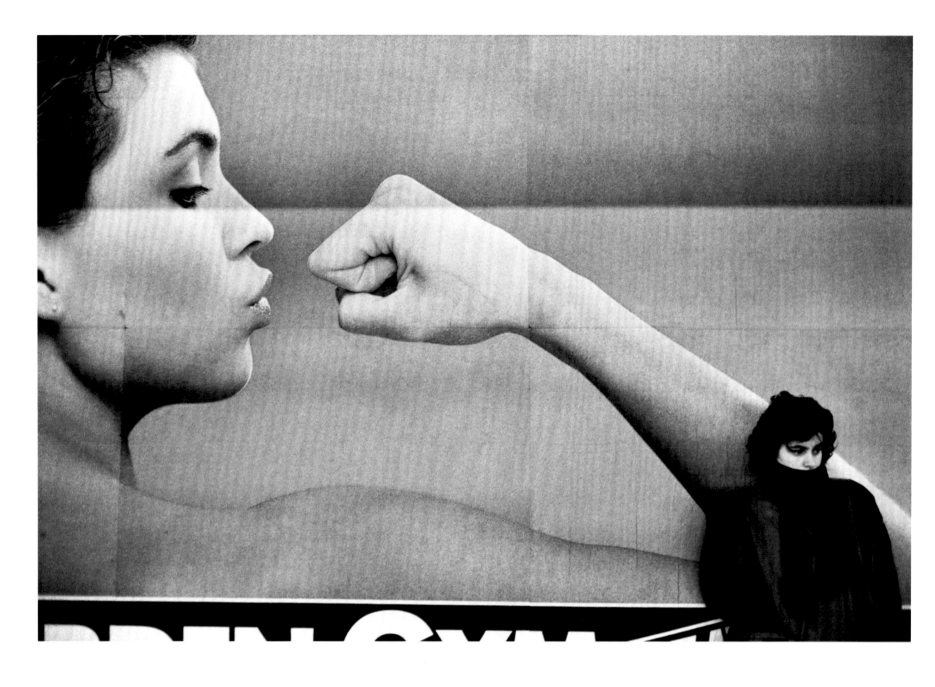

Above: RICHARD KALVAR - *Métro*, 1987

Opposite: OLIVIER CULMANN - *Woman with hat (from the "Minox" series)*, 1999

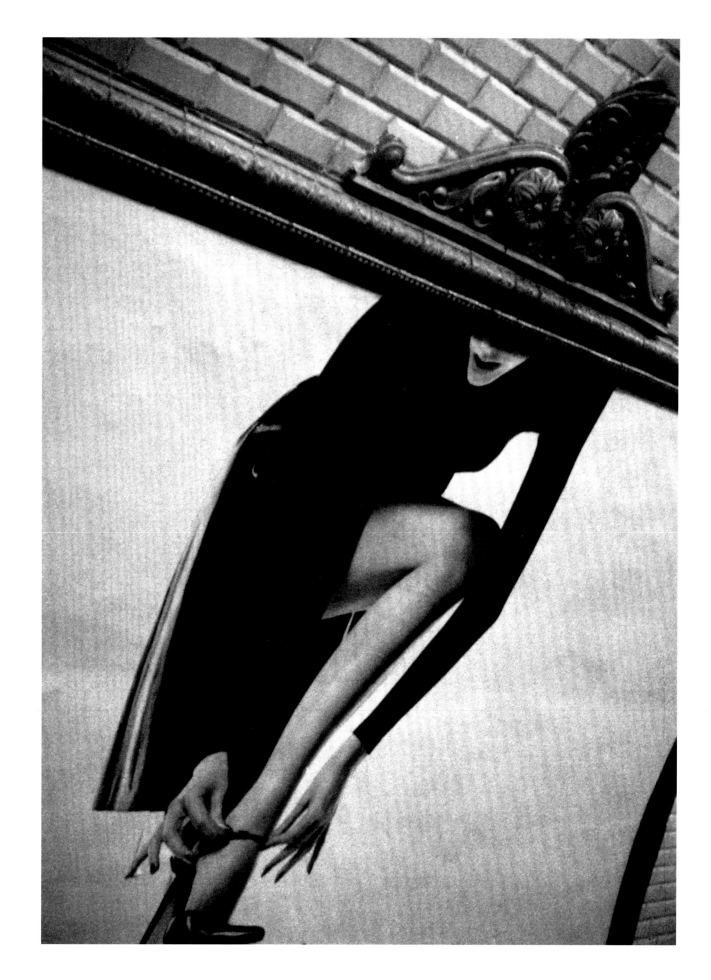

JEAN-BAPTISTE MONDINO - *"Peace on Earth" (from Nina Ricci's "L'Air du Temps" advertising campaign)*, 1998

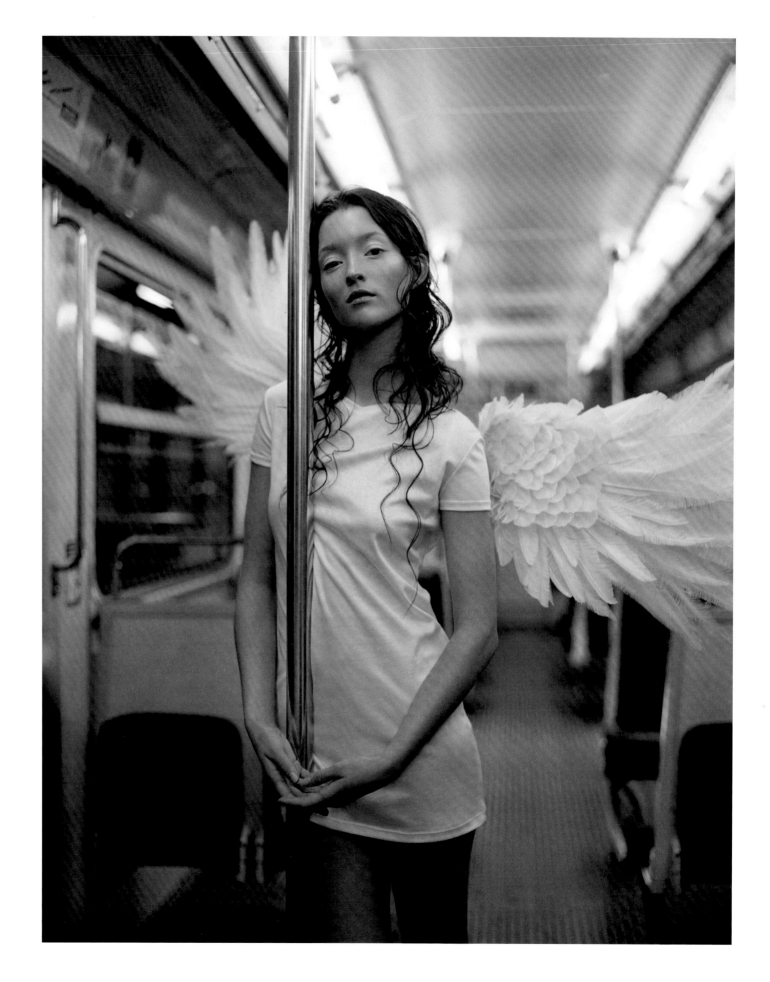

The beginning of a new century, the year 2000 also marks the centennial of the Paris Métro. Despite this respectable age, the Métro continues to be extended and transformed, but also to inspire photographers. While there is nothing surprising in that, since the Métro has long since become one of the iconic symbols of Parisian identity, one can't help but be surprised by the eternal renewal this subject offers, and by photographers' ability to find — without necessarily looking for it — new ways to represent it. Begun in the previous period, interest in artistic projects involving the Métro continued, sometimes in direct collaboration with the RATP. Thus, in 2002, twelve photographers from the Tendance Floue agency explored and revealed a little-known aspect of the world of the Métro: its maintenance workshops.[1] Among the photographers for this commission, Meyer and Olivier Culmann both favored a square format. While the former managed, with a great economy of means, to give rise to an unreal atmosphere verging on science fiction (p. 349), the latter tells a story, with a beginning, a middle and an end — a story with saturated settings and bright colors, where the power of suggestion of colorful harmonies triumphs (p. 360). Three spots of paint on brown paper are enough to make the familiar profile of a Métro train appear (p. 361). At the end of the 1990s, with his black-and-white series *Minox*, taken with the spy camera of that brand name, Culmann had already explored the world of the Métro, in a very different context and style (cf. pp. 327 and 337).

In recent years, wanting to broadcast its international presence, the RATP commissioned a series of photographs on the theme of urban mobility. For this, it called successively upon two masters of street photography, with immediately identifiable and radically different styles: Gueorgui Pinkhassov and Bruce Gilden, both members of Magnum.[2] Neither one waited for this "carte blanche" to direct their gaze at the Paris Métro. Living in Paris since 1985, Pinkhassov photographed it many times, as testified by the examples gathered in this book, taken between 1997 and 2015 (pp. 320, 354, 380 and 392-393). The vision he offers of it is that of a brightly colored but still somber world where — by the play of backlighting, shadows, transparency and reflections — another reality comes to light: the one you attain sometimes when, tired, your wandering eye gets lost in vagueness, then suddenly superimposes bodies and travels through them, revealing unsuspected beauty. Radically different, Bruce Gilden's photographs — erratic

2000-2016

JULIEN FAURE-CONORTON

1.
This commission gave rise to an exhibit and a book, *Ateliers: 12 photographes, 12 sites de la RATP (Workshops: 12 Photographers, 12 RATP Sites)*, Paris: Alternatives, 2002.

2.
These commissions each gave rise to an exhibit in various Paris Métro stations and to the publication of a book, *Gueorgui Pinkhassov: un nouveau regard sur la mobilité urbaine (Gueorgui Pinkhassov: A New Look at Urban Mobility)*, Paris: La Martinière, 2015; *Bruce Gilden: un nouveau regard sur la mobilité urbaine*, Paris: La Martinière, 2016.

framing, deep blacks, brilliant whites—are the very expression of the transience that characterizes urban mobility: fleeting expressions on the faces of those strangers taken on the fly (here at the exit to the Barbès-Rochechouart station); transience of the brief light produced by the flash Gilden uses to obtain this special effect; even the transience of the photographer's gesture as he walks around, on the lookout, before suddenly pouncing on his prey (pp. 372 and 373). Among the different artistic projects developed around the Métro, we will also cite the works of Paolo Verzone and Jérôme E. Conquy who, in 2007 and 2008, both became interested in found objects at the Paris police headquarters. Strange photographs result from this, with a rigorous method (isolated subject, neutral background, careful lighting)—veritable portraits of objects, sometimes amusing, sometimes unsettling (pp. 374-375). Finally, in other cases, the Métro is there only in the background, the setting and silent witness to each person's personal tragedies—Sophie Calle's *Douleur exquise* (*Exquisite Pain*, p. 376).

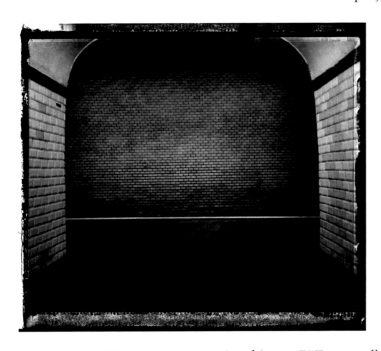

SERGE PICARD - *Métro station*,
2000

Already well established in the previous period, the out-of-focus aesthetic becomes dominant in the 2000s and 2010s. Whether it comes from focus, depth of field or movement (of the subject and/or the photographer), the blurred effect is omnipresent—in black-and-white (Francesco Acerbis, p. 357) as well as in color (Didier Goupy, p. 344), partially blurred (François Le Diascorn, p. 366) as well as completely out-of-focus (Arno Brignon, p. 391). This out-of-focus effect, which blurs the frontiers between fixed and animated image, seems to reflect not only the characteristics of the subject being treated, but also the tendencies of contemporary society: movement, circulation, rapidity, mobility. While the issue of image copyright certainly plays a part in the use of this stance by photographers who depend on the sale of their creations, it is not the only reason for this infatuation with the out-of-focus. It can be linked to several factors, with the emergence of digital photography and the global evolution of society seemingly the decisive ones. A veritable revolution in the history of photography, digital photography, the development of which happened at lightning speed—both technologically and commercially—is a new regime; one of its main characteristics is freedom from numerical contingents. While photographic film imposed a determined number of shots, leading the photographer to wonder, even for a fraction of a second, if he should press on the trigger, this barrier disappears with digital photography. No longer having to count shots, shooting becomes freer, more spontaneous, to the point that today the number of

photographs taken each year in the world can be counted in the hundreds of billions. This proliferation of images, without precedent in the history of humanity, of course decisively influences our apprehension of the photographic, which continues to evolve. What was not a photograph just twenty years ago is unquestionably so today. By its mode of functioning, digital photography authorizes—even encourages—error, allows for repenting, selection, choice, not to mention the possibilities offered by editing software (Photoshop, Lightroom, etc.). In parallel with this, the world has also evolved, very quickly, into a media-obsessed society where immediate distribution reigns, with images being re-posted through social networks (in 2016, 350 million photos were posted on Facebook every day). Translating these various phenomena into images, the blurred effect dear to contemporary photographers constitutes as much a stylistic as a cultural evolution of the medium.

Possessing a strong identity that makes it identifiable from its slightest details, the Paris Métro continues tirelessly to expose its aesthetic, in black-and-white (Lorenzo Castore, pp. 396-397) as well as in color (Christopher Morris, pp. 382-383). It also inspires hybrid creations, a mixture of photography and graphic art: *Le Métro* (pp. 398-399) by the cartoonist Nicolas Fructus, from his sci-fi book *Mémoire des mondes troubles (Memory of Disturbed Worlds)*.[3] Among other characteristics of Métro photos from the 2000s and 2010s, we can cite the exploration of the aesthetic resources of color, a tendency already perceptible in the works of Culmann and Pinkhassov, but which can also be felt in Jean-Claude Jaffre (p. 359) and Patrick Tourneboeuf (p. 358), as well as Bruno Marguerite (p. 365) and Jean-François Mauboussin (p. 348), both photographers for the RATP. Experiments with the graphic and colorful potential of torn posters are also recurrent, from Bertrand Meunier (p. 395) to Philippe Lopparelli (p. 394). They express an ever-renewed interest in the Métro sign, admirably expressed by the joyous "I should not write on the Métro" by Bertrand Meunier (pp. 402-403), joining an anti-conformist artistic expression[4] with a reference to a monument of pop culture (the opening credits for the animated TV serial *The Simpsons*).

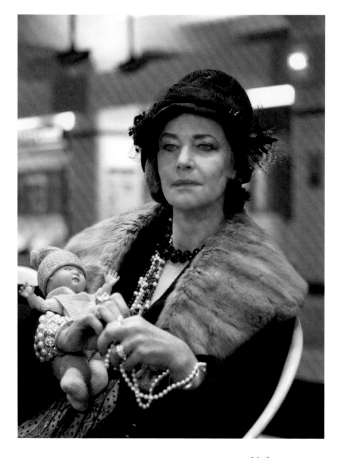

BETTINA RHEIMS - *Madame Jacquot (Charlotte Rampling), Porte de Saint Cloud station (from the "Rose, c'est Paris" series)*, 2009

3.
N. Fructus, *Mémoire des mondes troubles*, Paris: Un livre – Une image, 2008 (fifteen digital prints in a limited edition of twenty copies).

4.
On the history of graffiti in the Paris Métro, see K. Boukercha, *Descente interdite (No Entry)*, Paris: Alternatives, 2011.

DIDIER GOUPY -
"Metropolis: Faces of the Paris Métro," 2007

5.
Cf. Metro: Photographic Elevations of Selected Paris Metro Stations: Photography and Text by Larry Yust, Corte Madera, CA : Gingko Press, 2005.

Finally, we should say a few words about certain photographs that, through their very personal vision of the Métro, have managed to renew the genre in an unusual and surprising way. This is true of Larry Yust (pp. 388-389) and Adam Magyar (pp. 350-351). Following the tradition of Josef Koudelka's panorama photos (cf. pp. 284 and 296), both have adapted their photographs to the format of station platforms and Métro trains, Yust in color by assembling successive shots *(Photographic Elevations)*,[5] Magyar in black-and-white with the help of a digital slit-scan camera *(Stainless)*. Among the most notable creations of the 2000s and 2010s, we should also cite the delicate and poetic superimpositions by Jérémie Dru, leading irreconcilable worlds to collide: *Le Voyageur incertain (The Uncertain Traveler,* pp. 400 and 401); the magisterial series called *Paris Underground* by Tony Daoulas, who joined geometric purity of form with subtle lights and deep blacks (pp. 369, 384-385 and 387); instants of public intimacy captured by the benevolent eye of Stéphane Burlot (pp. 362 and 377); and finally, the fugitive visions of Johann Soussi from his series called *Aller-Retour (Round Trip)* (pp. 367, 368 and 386) to which *Demi-ton (Half-Tone)* belongs (p. 347), unarguably one of the most extraordinary Métro abstractions ever created. By their extreme originality, these works testify to the endless possibilities of a much-studied genre.

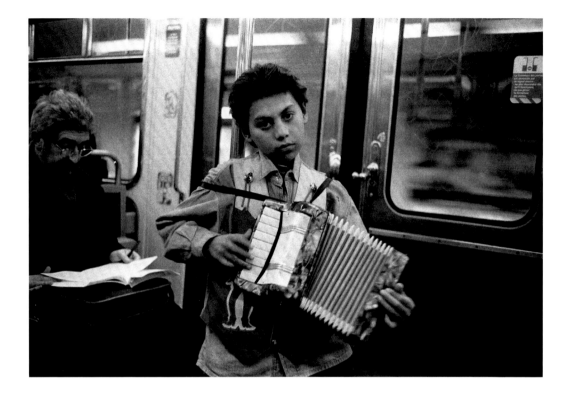

PHILIPPE LISSAC -
*The accordionist (from the "Child
Labor Throughout the World"
series)*, 2001

After traveling through these 300-some stations, after journeying on these different lines, after embracing these 116 years of history (of Paris, of the Métro and of photography), one can't help but be struck by the extraordinary fertility and inexhaustible richness of a subject that has become invisible, so familiar is it to Parisians. We need the eye of the photographer to remind us of its diversity and singularity, its graphic elegance and geometric rigor, its shadows and lights, its perpetual movement, reflections, joys, sufferings, tragedies, its violence, too, sometimes. Each period reveals a thousand different aspects, reflects its era, possesses its specificities, while at the same time foretelling certain trends and following others. From 1900 to 2016, shared traits come to light. Universal, they travel through the century, conveying a constant interest in certain aspects of the photographic, beyond schools, tendencies or fashions.

More than a century after its inauguration, it is undeniable that the Paris Métro has far from finished inspiring photographers. Between now and 2030, they should see the birth of four new lines over which they can let their eyes wander, solitary passengers on an eternal voyage.

JOHANN SOUSSI - *"Half-Tone" (from the "Round Trip" series)*, 2007-2010

Next pages:

Left: JEAN-FRANÇOIS MAUBOUSSIN (RATP) - *Arts et Métiers, Line 11*, April 9, 2010

Right: MEYER - *RATP service yards, Bobigny*, 2002

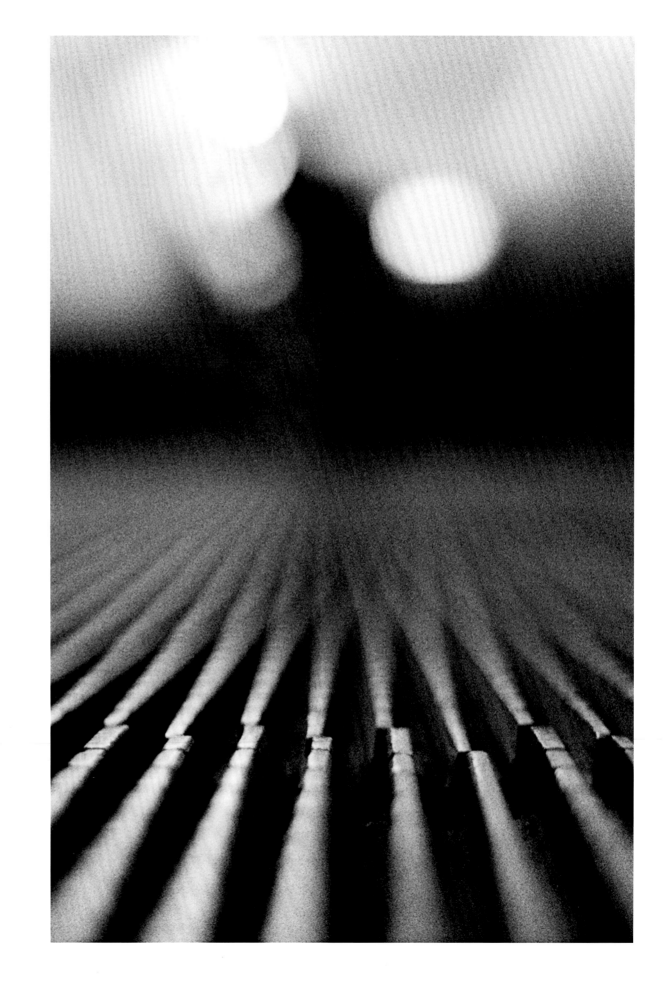

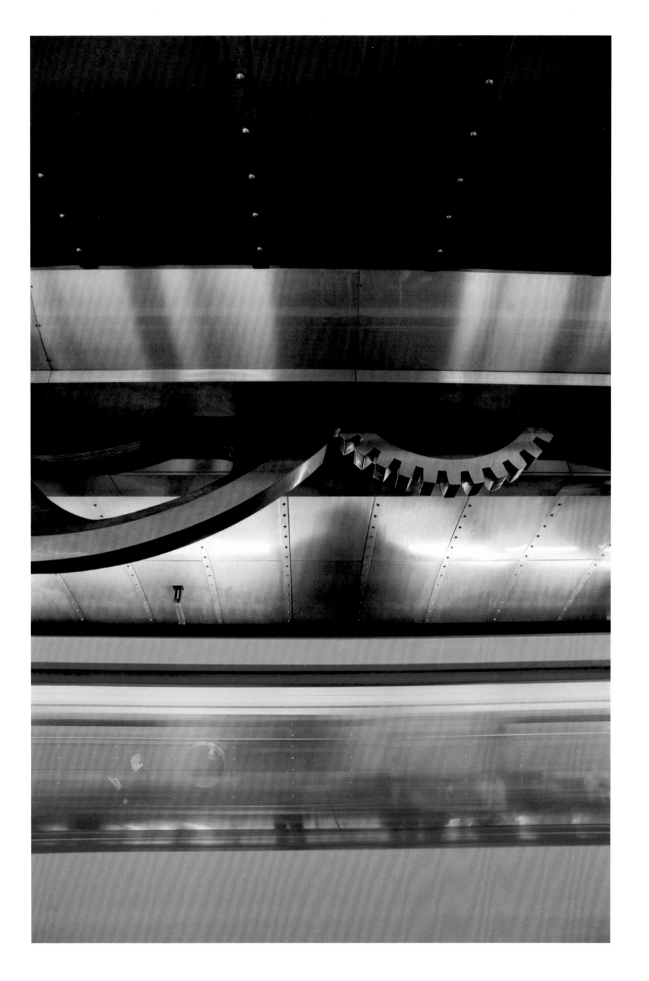

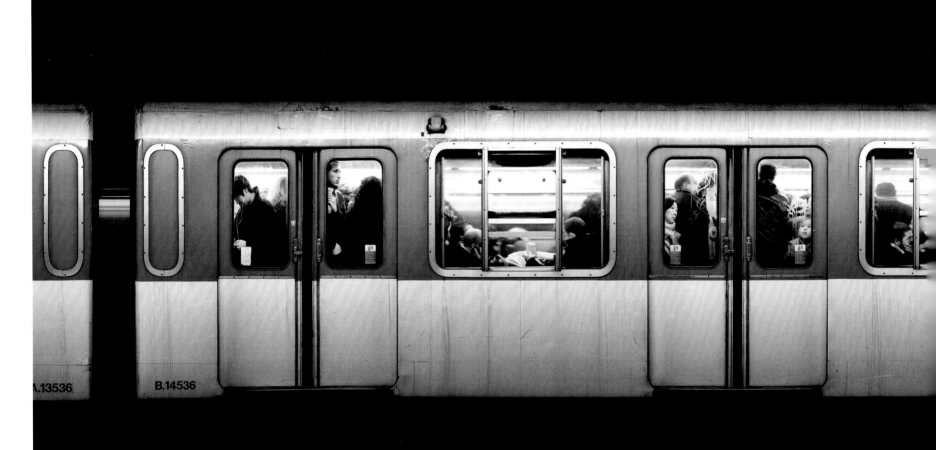

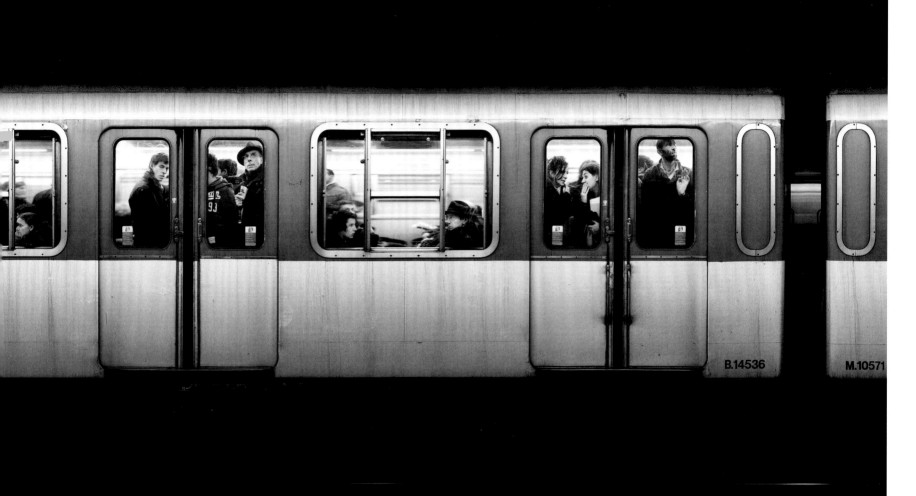

Preceding double page:

ADAM MAGYAR - *"Stainless #14536, Paris" (from the "Stainless" series)*, 2011

SCOTT STULBERG - *"Ghost Train,"* 2014

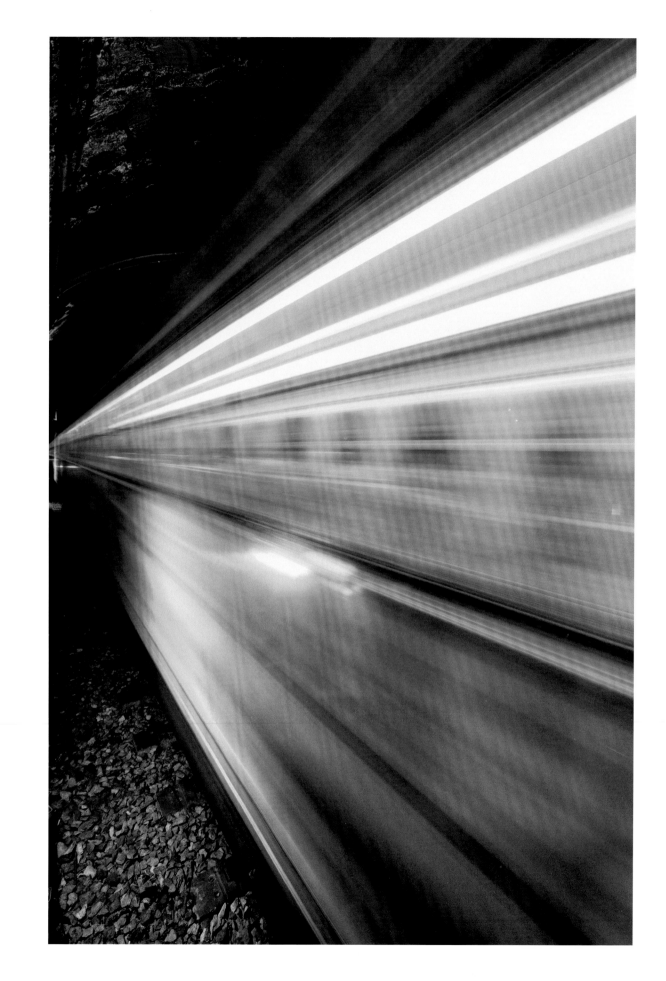

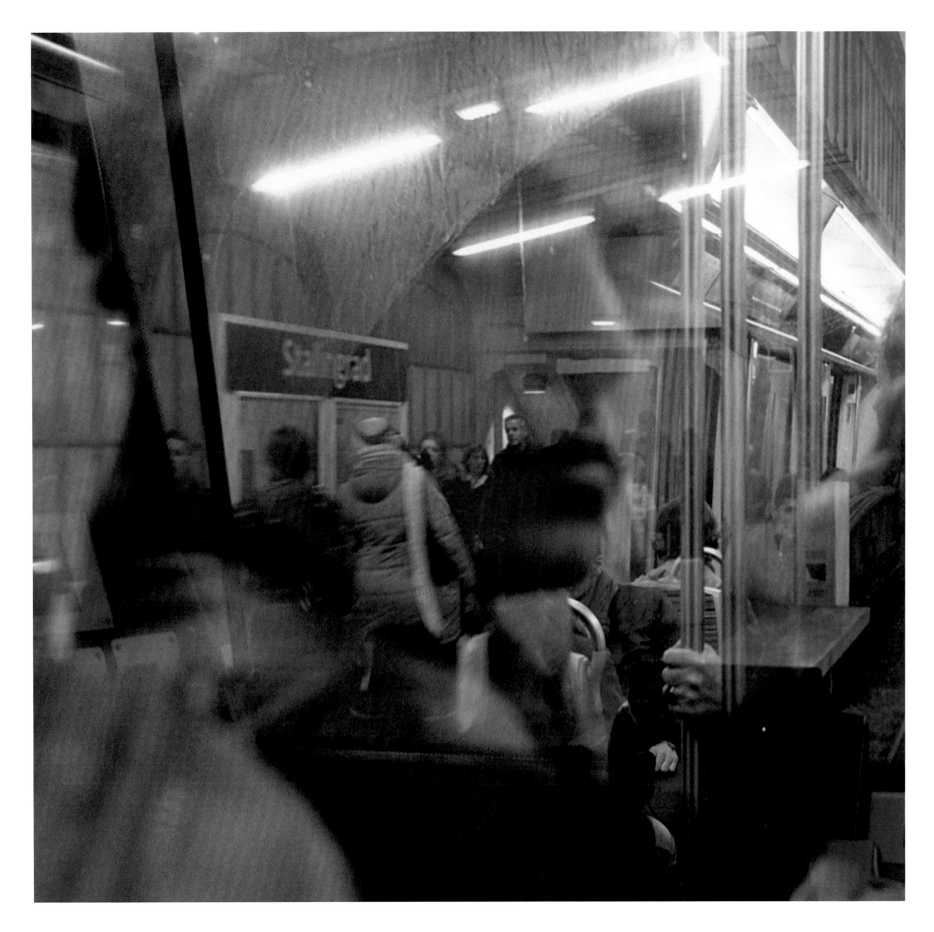

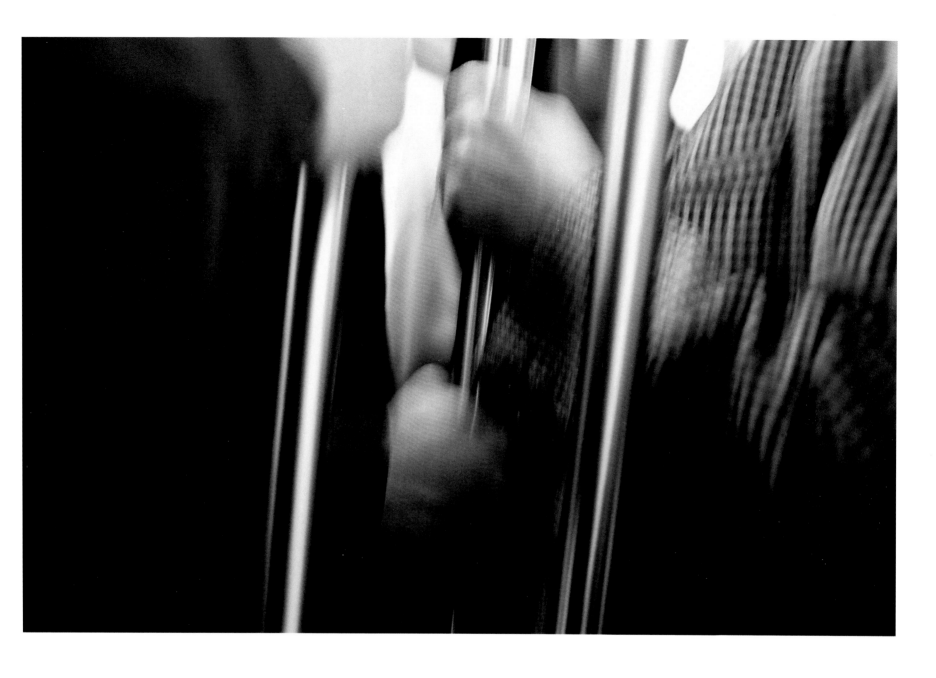

Opposite: GUEORGUI PINKHASSOV - *"Paris,"* 2014

Above: LUC CHOQUER - *"Holding on in the Métro,"* 2010

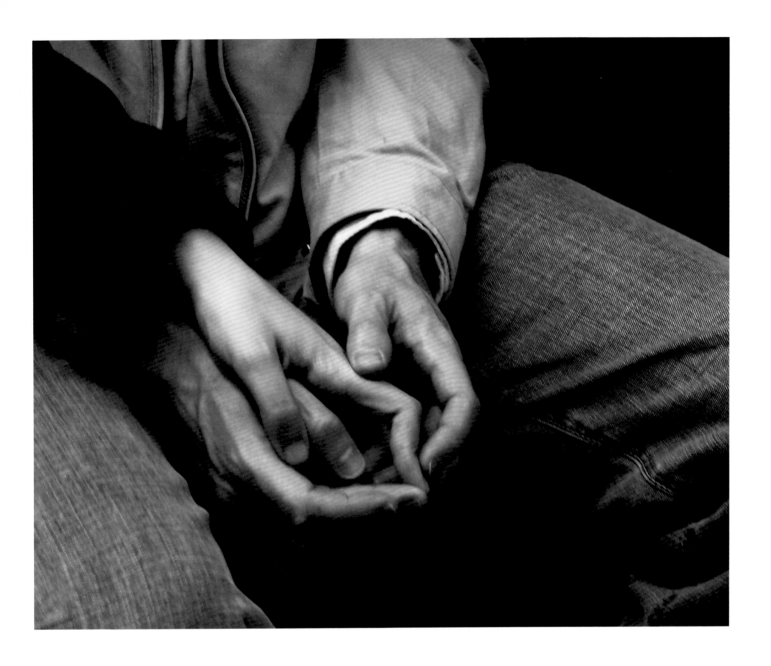

HORACIO VILLALOBOS - *Hands*, 2004

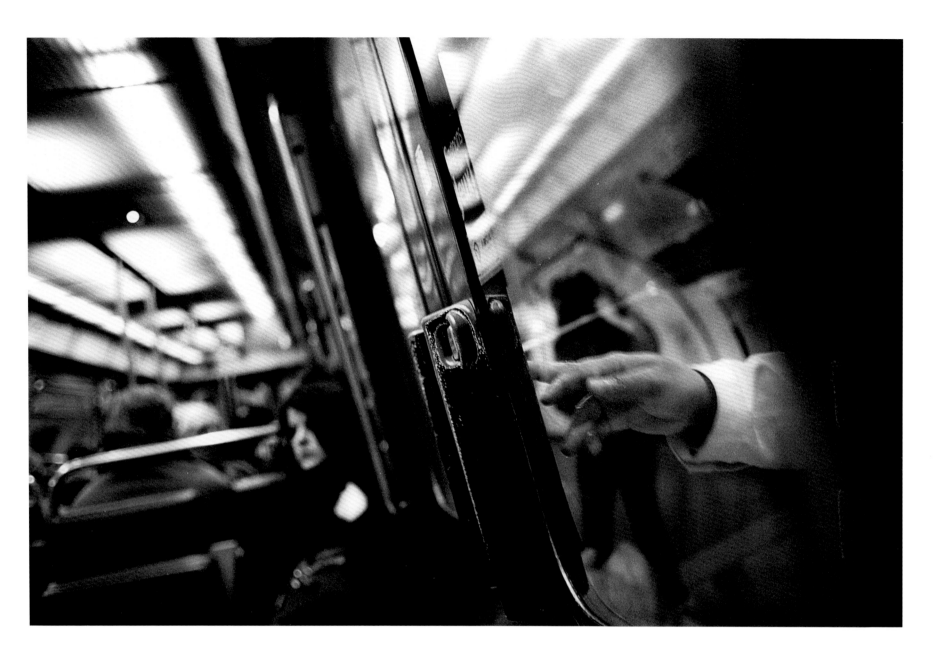

FRANCESCO ACERBIS - *Push to open*, 2005

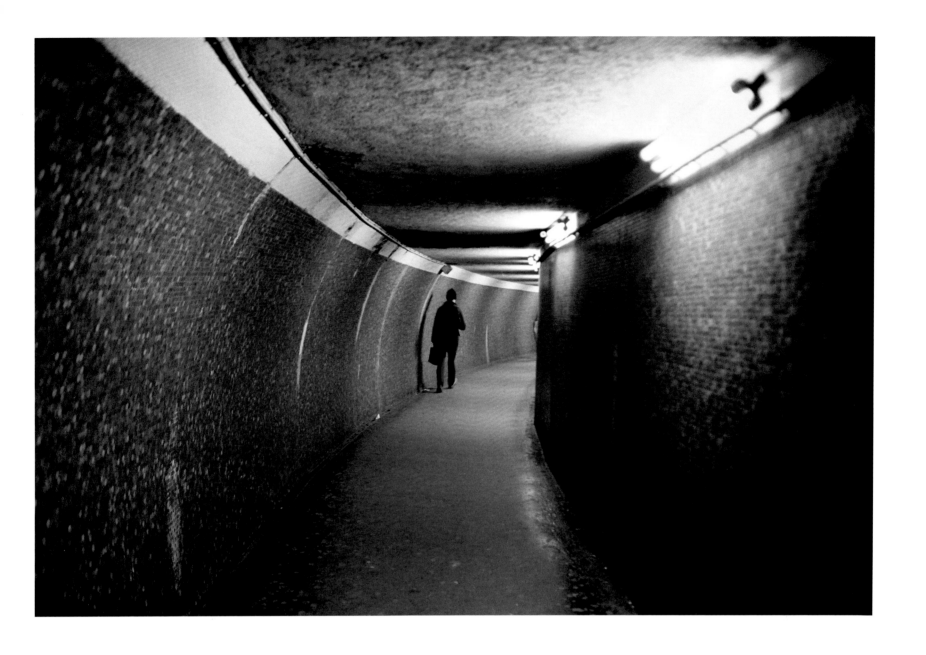

PATRICK TOURNEBŒUF - *The curve (from the "Vanished Memory" series)*, 2003

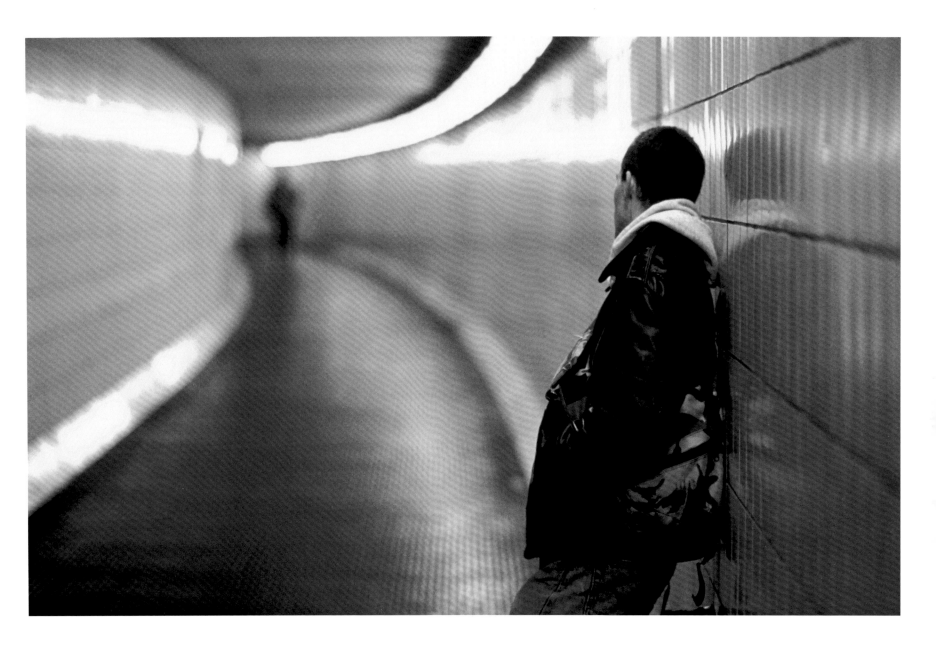

JEAN-CLAUDE JAFFRE - *Yellow corridor*, 2015

OLIVIER CULMANN - *Maintenance building for Line 1 Métro trains, Fontenay-sous-Bois*, 2002

STÉPHANE BURLOT - *Spirit of contradiction (from the "Métro-Burlot-Dodo" series)*, 2011

PETER MARLOW - *M, Stalingrad station*, 2008

BRUNO MARGUERITE (RATP) - *Daumesnil station, Line 8*, June 26, 2015

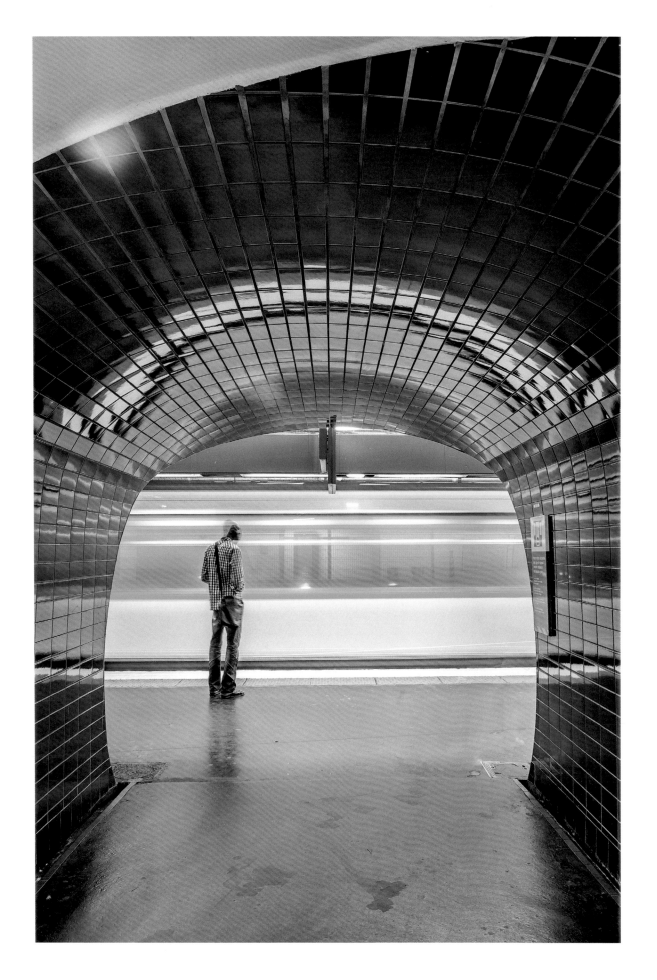

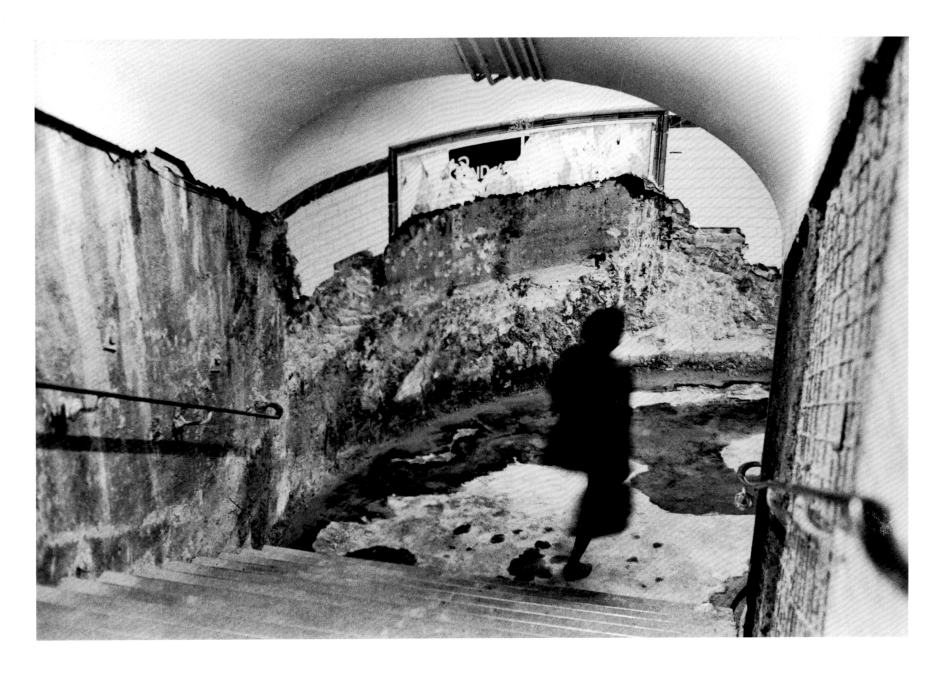

Above: FRANÇOIS LE DIASCORN - *The Paris Métro (from the "Mysterious Paris" series)*, 2004

Opposite: JOHANN SOUSSI - *"Stalingrad" (from the "Round Trip" series)*, 2007-2010

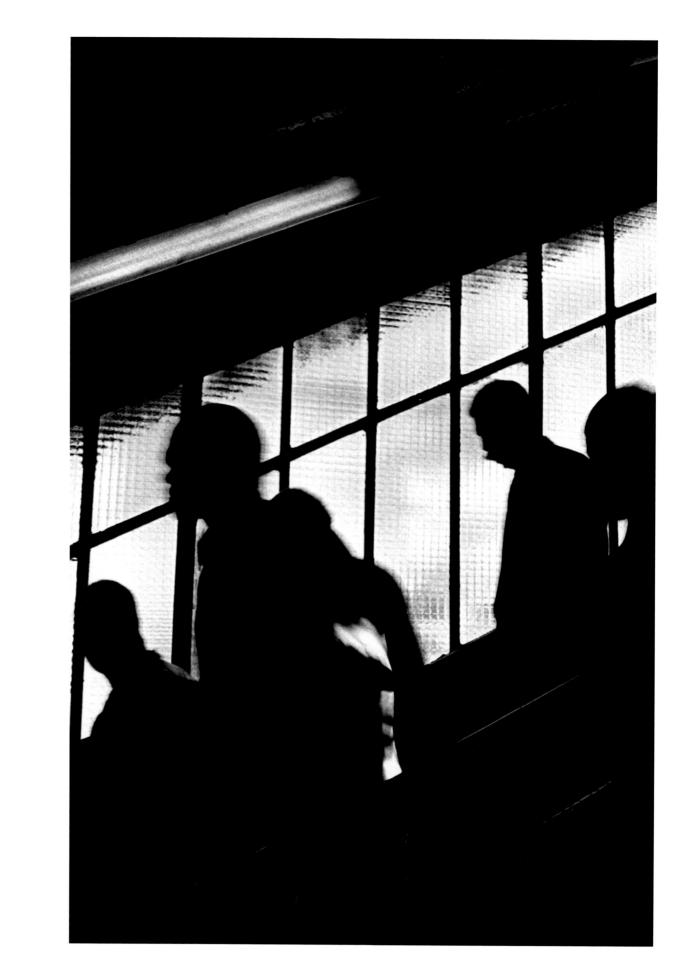

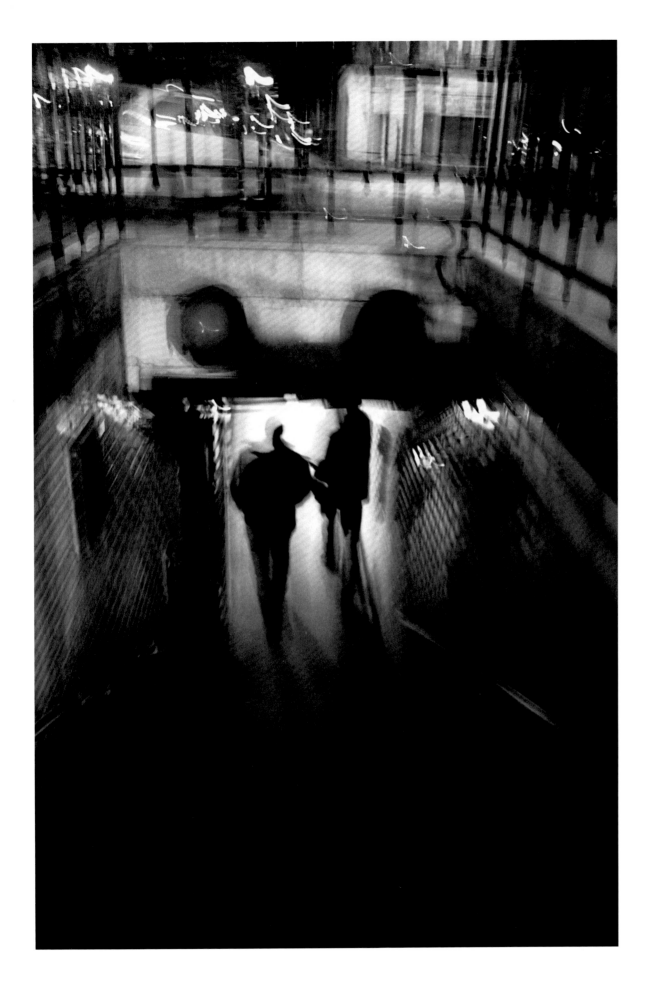

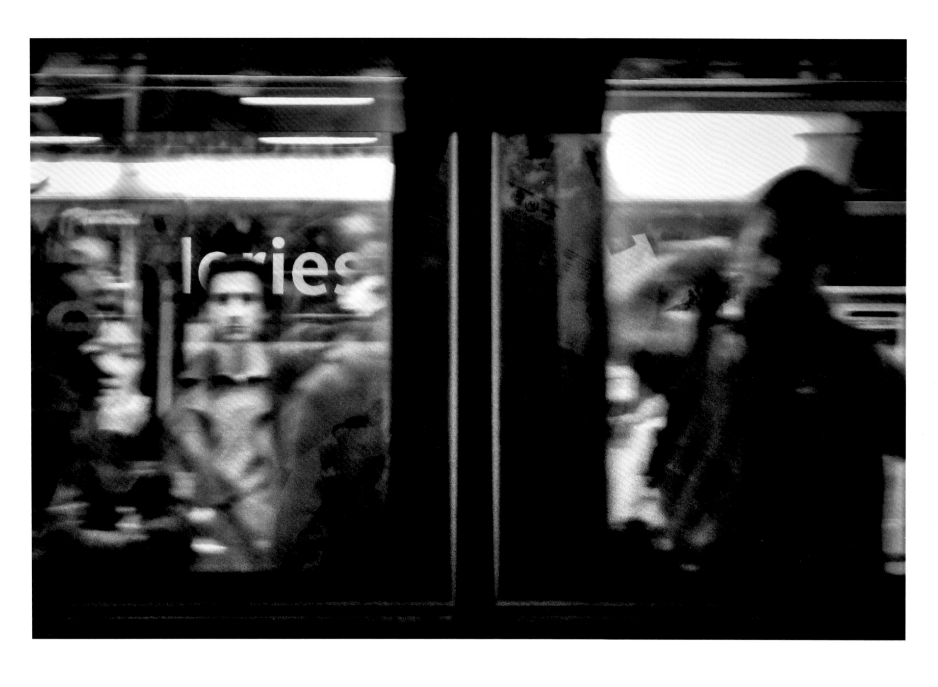

Opposite: JOHANN SOUSSI - *"Underground" (from the "Round Trip" series)*, 2007-2010

Above: TONY DAOULAS - *"Tuileries" (from the "Paris Underground" series)*, 2012

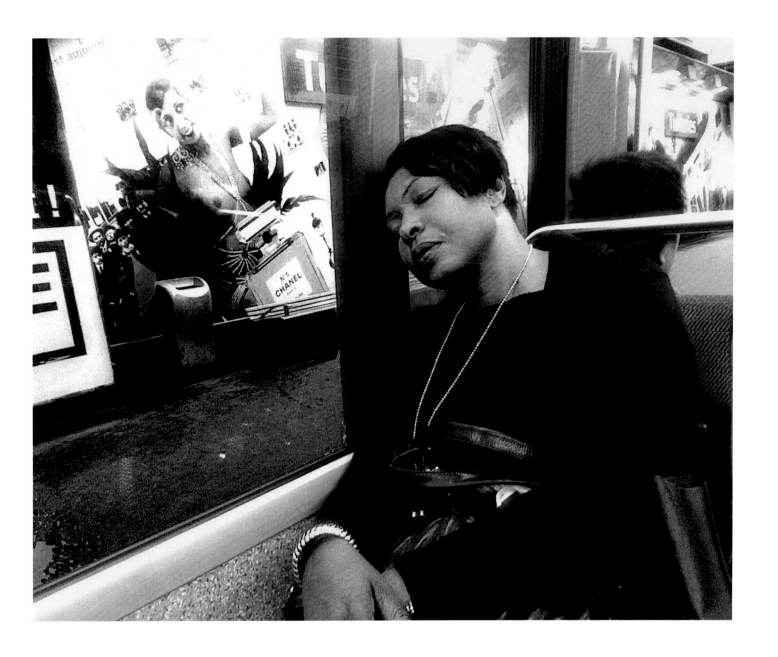

Above and opposite:

CHRIS MARKER - *"Passengers,"* 2008-2010

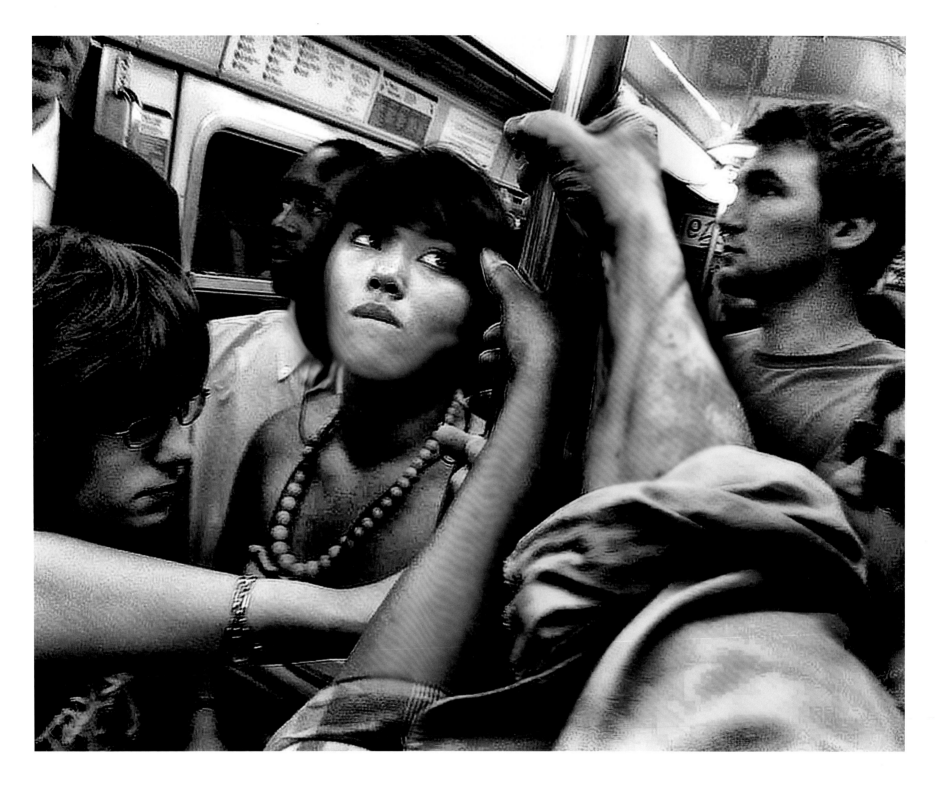

Next pages:

BRUCE GILDEN - *Barbès-Rochechouart station,* 2000

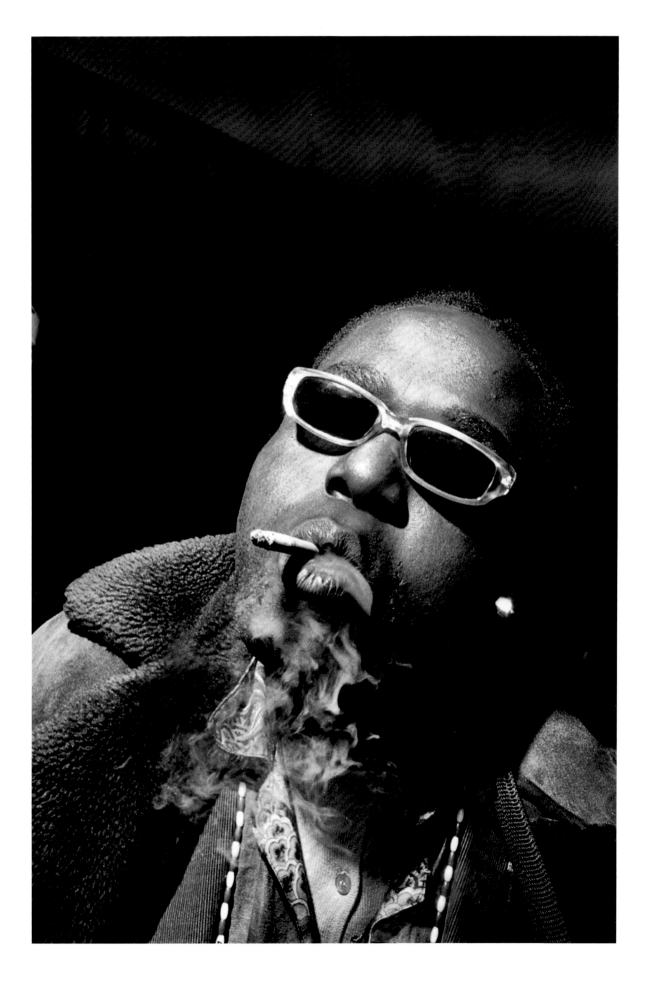

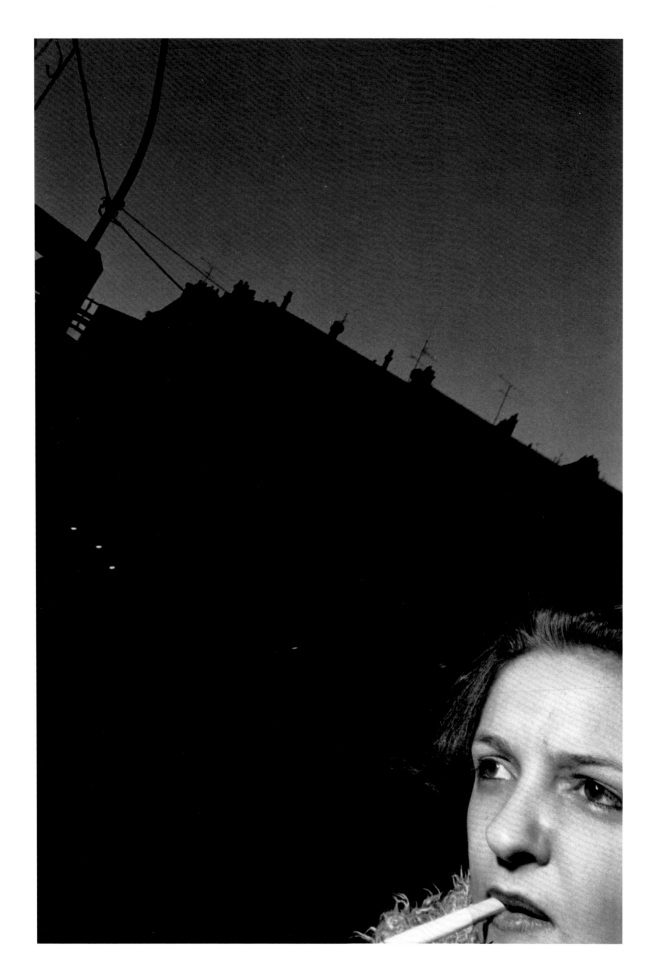

Opposite:

Top: JÉRÔME E. CONQUY - *Found objects in Paris: doll (Métro Line 13, April 2006)*, 2007

Bottom: JÉRÔME E. CONQUY - *Found objects in Paris: Swiss cuckoo clock (Métro Line 12, December 6, 2005)*, 2007

Above:

PAOLO VERZONE - *Lost and Found Department in Police Headquarters: head lost in the Métro*, 2008

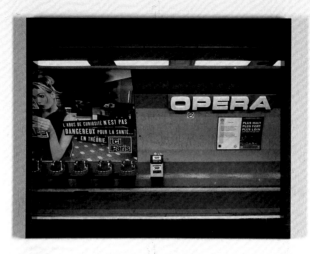

Il y a quarante jours, l'homme que j'aime m'a quittée. Le 25 janvier 1985, à deux heures du matin. Chambre 261, hôtel Impérial, New Delhi. La pièce est grise, poussiéreuse, seul le téléphone, rouge vif, détonne. Je viens de passer dix heures à tenter de le joindre, pour savoir. Cela faisait trois mois que nous étions séparés et, la veille, il m'avait confirmé notre rendez-vous en Inde. Je n'avais jamais été aussi heureuse, j'allais enfin le revoir. A l'aéroport, on m'a tendu un message. Il avait eu un accident, je devais appeler mon père qui est médecin. Tout ce que je pouvais imaginer, c'était une collision sur la route d'Orly. Et quand je l'ai trouvé, chez lui, qu'il a dit qu'il souhaitait me prendre dans ses bras pour m'expliquer certaines choses, j'ai tout de suite compris ce que cela signifiait : il me quittait. Seulement, le lâche ne s'est pas montré. Il ne s'est pas compliqué la tâche, il a fait ça par téléphone. Quant à l'accident, il s'agissait d'un panaris.

C'était une fin d'après-midi hivernale, en 1974. Je ne me souviens ni du mois ni du jour. Ce devait être un samedi. Une demi-heure plus tôt, rue Scribe, alors que j'étais follement épris de lui, T. m'avait annoncé notre rupture. Je ne sais plus quels mots il avait employés, mais ils avaient un caractère définitif. Je me suis retrouvé seul, place de l'Opéra. J'ai descendu les marches du métro, tandis que sortait de mon estomac, sortait de ma gorge, sortait de ma voix, une voix que je n'avais jamais entendue. Je poussais des braillements qui me stupéfiaient, me tordaient le ventre, ouvraient grande ma bouche. Je hurlais dans le métro. Par hasard, j'avais entre les mains une pile de quarante-cinq tours : les tubes de l'été. Je me suis effondré sur un banc. Alors, un Noir assis à côté de moi m'a retiré très doucement les disques des mains, il en a lu les titres à haute voix, en les chantonnant au fur et à mesure. *Love me Baby, Sugar Baby Love…* Le métro est arrivé, j'ai repris les quarante-cinq tours. Mes cris avaient cessé, mes larmes ruisselaient.

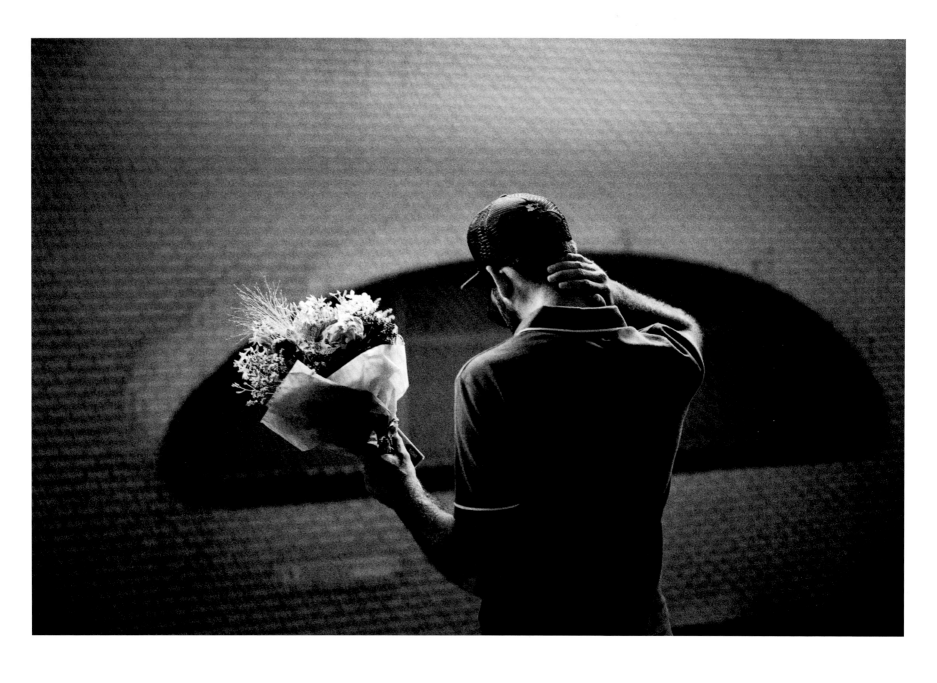

Opposite: SOPHIE CALLE - *"Exquisite Pain,"* 2003

Above: STÉPHANE BURLOT - *The bouquet (from the "Métro-Burlot-Dodo" series),* 2015

SCOTT STULBERG - *"Subway Lovers,"* 2014

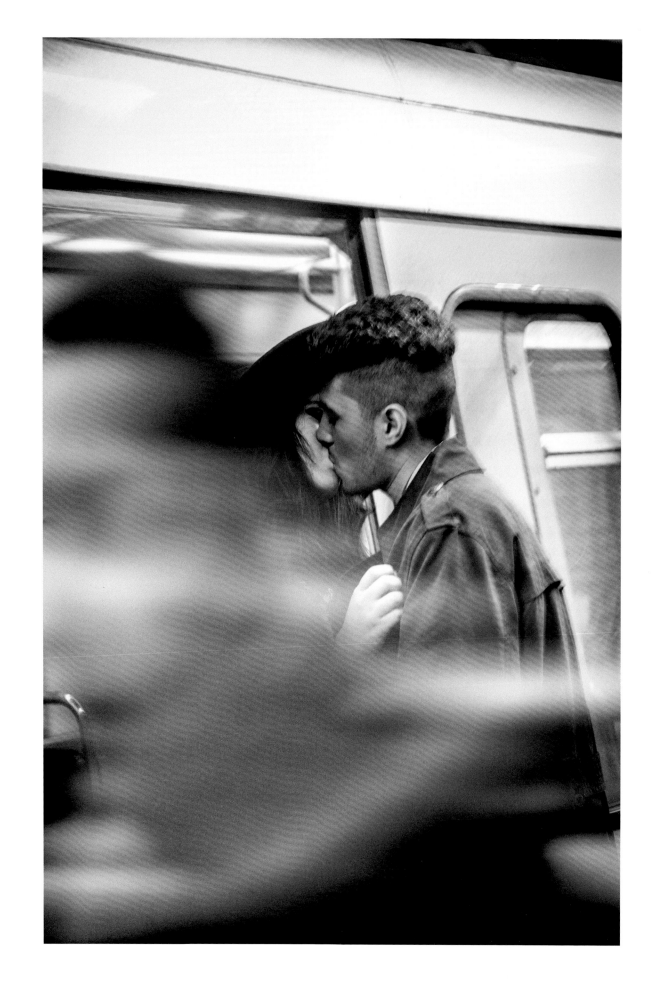

GUEORGUI PINKHASSOV - *"Métro, Paris,"* 2008

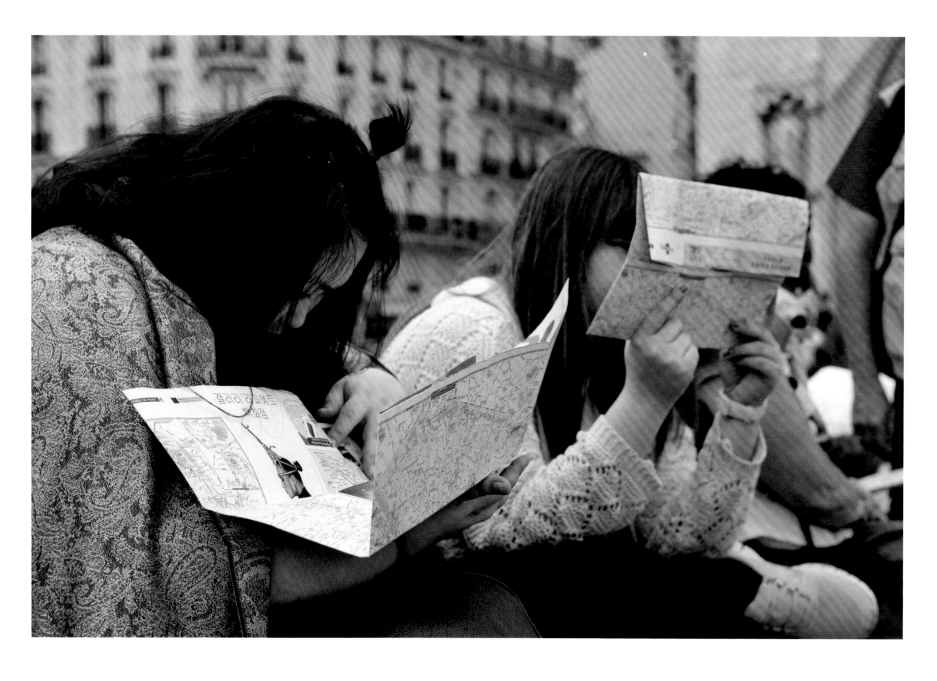

MARTIN PARR - *"Paris, Notre-Dame,"* 2012

CHRISTOPHER MORRIS - *"Fashion Week" (leaving the Elie Saab show)*, 2013

TONY DAOULAS - *"Ghost" (from the "Paris Underground" series)*, 2012

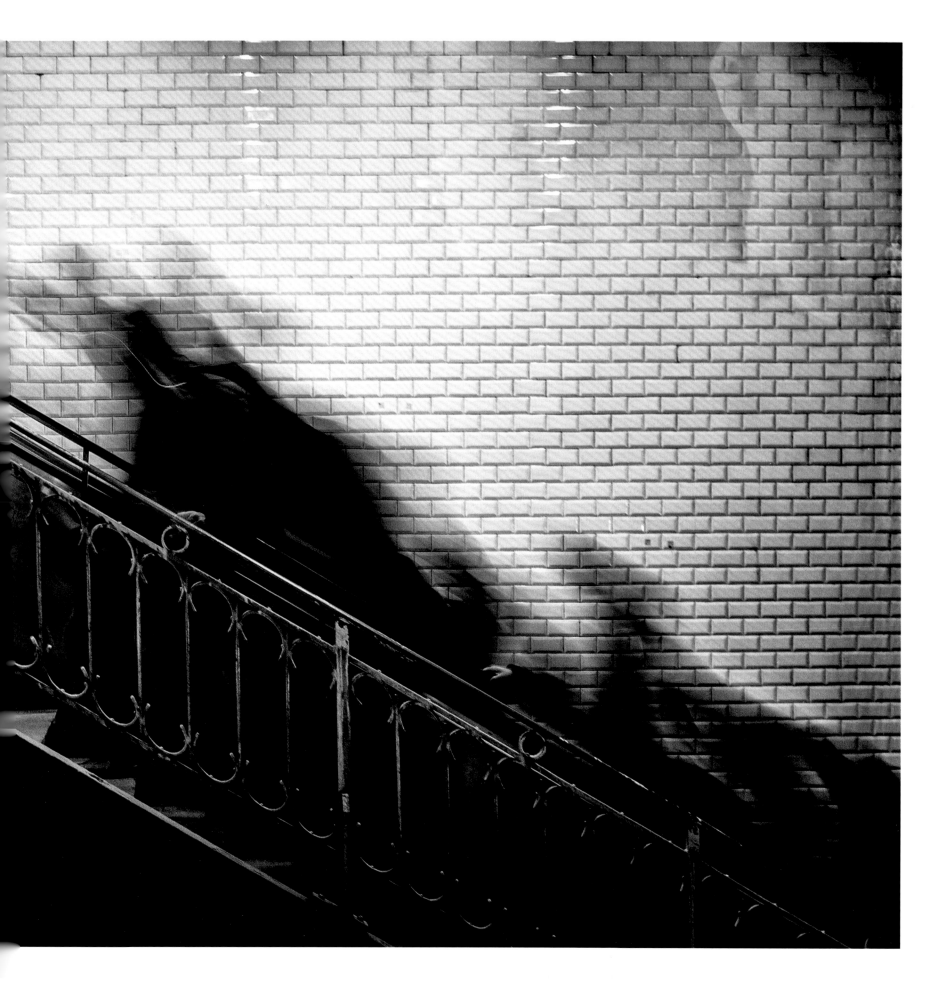

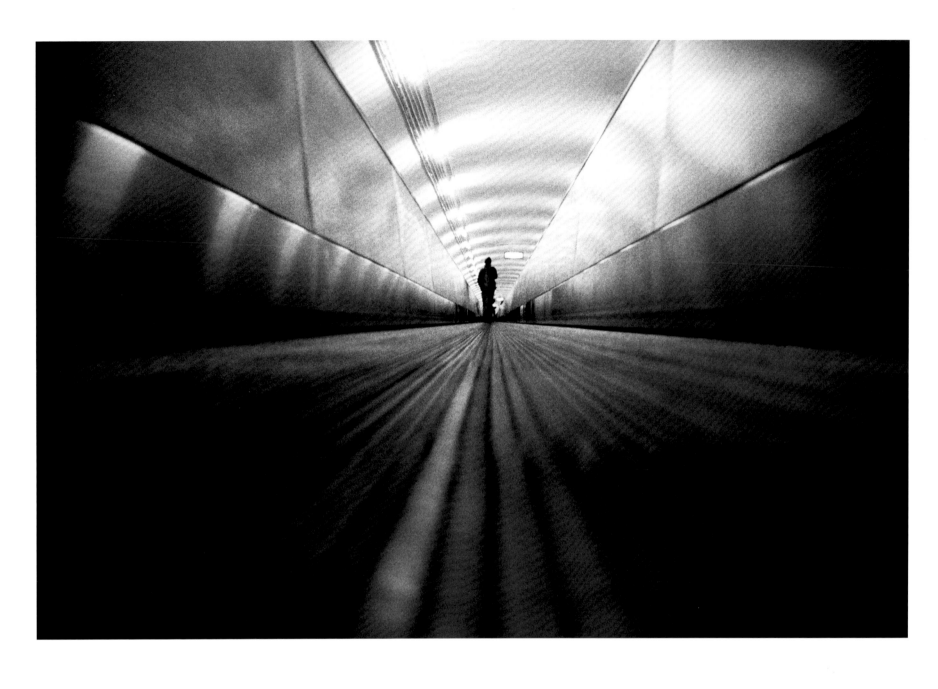

Above: JOHANN SOUSSI - *"U-Tube" (from the "Round Trip" series)*, 2007-2010

Opposite: TONY DAOULAS - *"Convergence Lines" (from the "Paris Underground" series)*, 2012

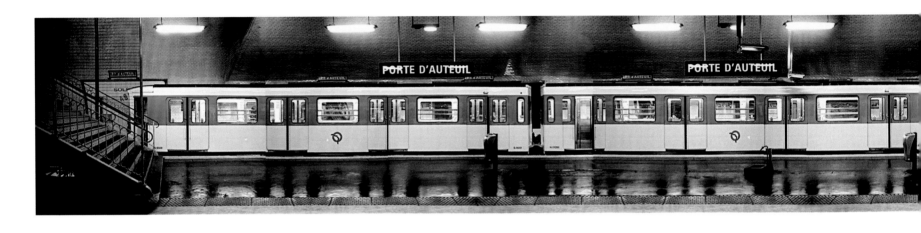

LARRY YUST - *"Porte d'Auteuil, Line 10" (from the "Photographic Elevations" series)*, 2002

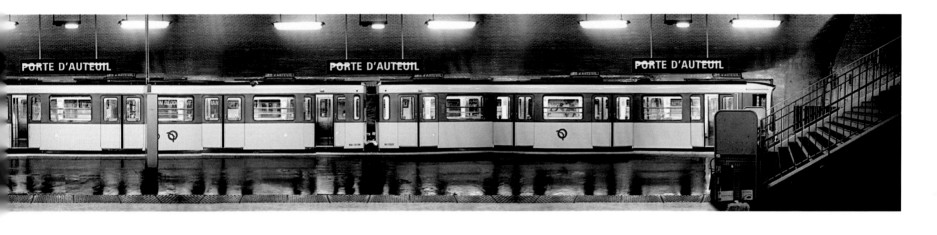

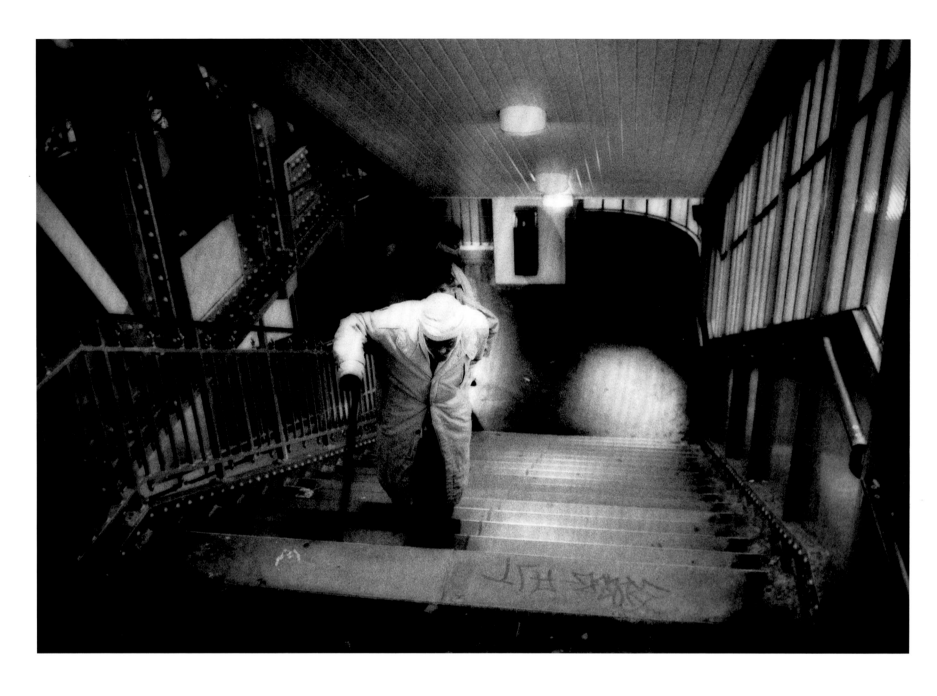

JAMES WHITLOW DELANO - *"En route…,"* 2010

ARNO BRIGNON - *Métropolitain*, 2008

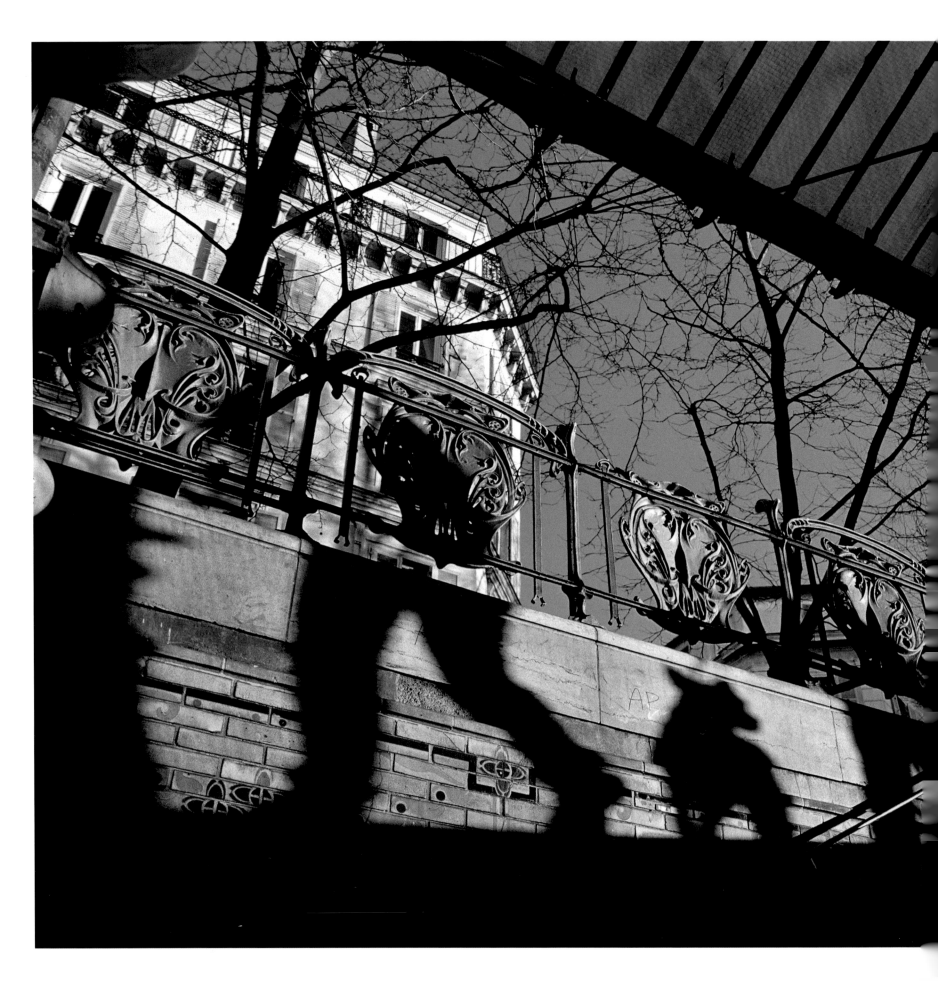

GUEORGUI PINKHASSOV - *"Place des Abbesses,"* 2001

PHILIPPE LOPPARELLI - *Torn poster*, 2015

BERTRAND MEUNIER - *Old advertising poster in a station no longer in service*, 2010

LORENZO CASTORE - *Barbès station (from the "Present Tense" series)*, 2013

Following double page:

NICOLAS FRUCTUS - *"The Métro" (from the "Memory of Disturbed Worlds" series)*, 2008

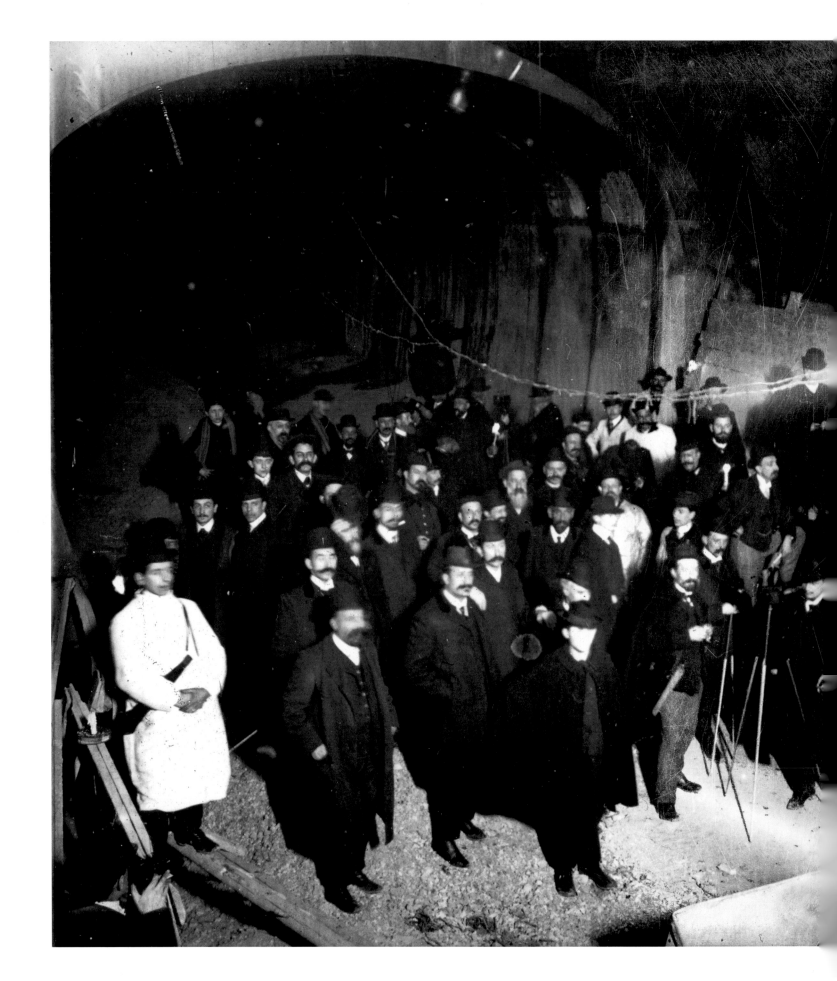

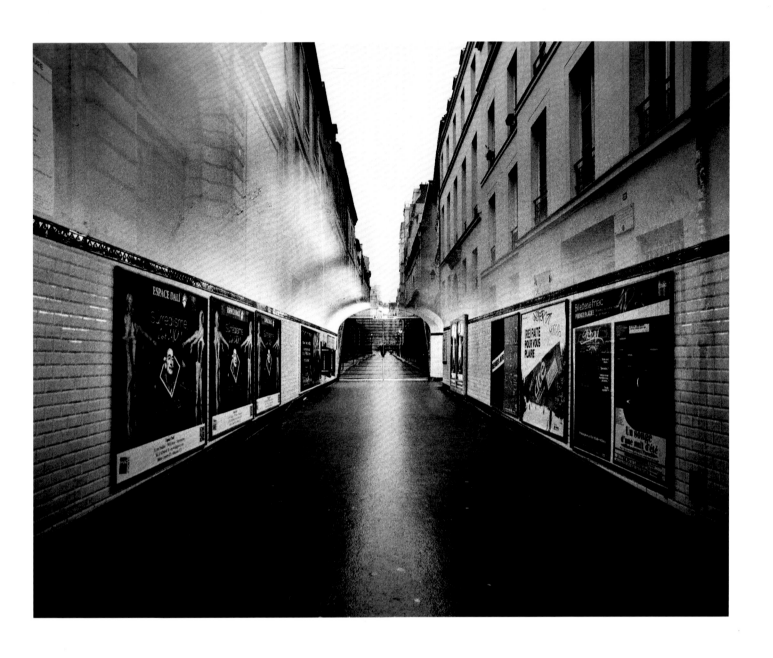

Above and opposite:

JÉRÉMIE DRU - *"The Uncertain Traveler,"* 2010

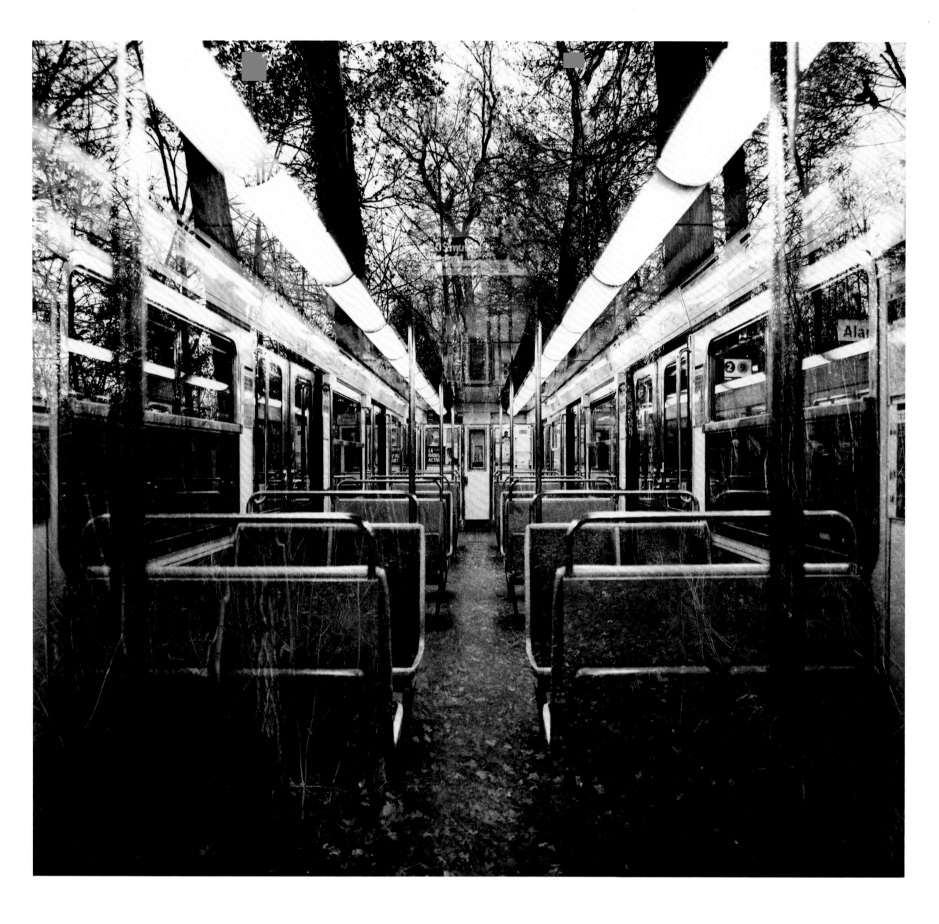

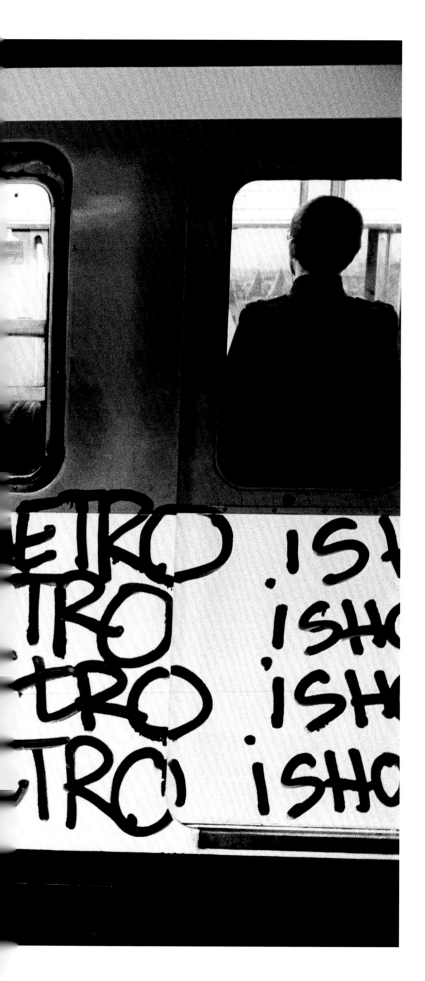

BERTRAND MEUNIER - *"Métro, Paris, France" (from the "Distant Man" series)*, 2010

INDEX OF PHOTOGRAPHERS

Préfecture de police de Paris: © Roger-Viollet – 43 • Krzysztof **Pruszkowski:** © Krzysztof Pruszkowski/Museum Associates - LACMA. Licenciée par Dist. RMN-Grand Palais - Image LACMA – 329 • **René-Jacques:** © René-Jacques/ RMN-Grand Palais – 125 ; © René-Jacques/ Roger-Viollet – 124, 188 • **Reporters associés:** © Reporters associés/Gamma – 246-247 • Bruno **Réquillart:** © Donation Bruno Réquillart, ministère de la Culture, France/Diffusion RMN-Grand Palais – 263 • Bettina **Rheims:** © Bettina Rheims – 343 • Agence **Rol:** © Agence Rol/ Bibliothèque nationale de France – 47, 77, 81 • Willy **Ronis:** © Succession Willy Ronis/Diffusion Rapho – 163, 164, 199, 200, 242 • Maison **Roux:** © Maison Roux/Collection RATP – 22, 28, 30, 33, 36, 58, 59, 61, 62-63, 64, 65, 66, 67, 68, 69, 78 • Christian **Sappa:** © Christian Sappa/Hoa-Qui – 306-307 • Serge **Sautereau:** © Serge Sautereau/ SAIF/Parisienne de photographie – 313 • Roger **Schall:** © Roger Schall/Roger-Viollet – 94, 97 • Kees **Scherer:** © Kees Scherer/Maria Austria Instituut – 174 • Ferdinando **Scianna:** © Ferdinando Scianna/Magnum Photos – 270-271, 272 (top), 324-325 • Frères **Séeberger:** © Frères Séeberger/Ministère de la Culture, France/Diffusion RMN-Grand Palais – 40-41 • Mark **Shaw:** © Mark Shaw/Mptvimages.com – 213 • Johann **Soussi:** © Johann Soussi – 347, 367, 368, 386 • André **Steiner:** © Nicole Steiner-Bajolet – 110 • Christer **Strömholm:** © Christer Strömholm Estate – 231 ; © Christer Strömholm Estate/Agence VU' – 265 • Scott **Stulberg:** © Scott Stulberg – 353 ; © Scott Stulberg/Corbis via Getty Images – 379 • Denis **Sutton:** © Denis Sutton/ Collection RATP – 323 • Jean-Louis **Swiners:** © Jean-Louis Swiners/Rapho – 250-251 • Maurice **Tabard:** DR – 184 • Joël **Thibaut:** © Joël Thibaut/Collection RATP – 262 • Patrick **Tournebœuf:** © Patrick Tournebœuf/Tendance Floue – 358 • Peter **Turnley:** © Peter Turnley/ Corbis/VCG via Getty Images – 272 (bottom), 280-281, 303 • **Union photographique française:** © Union photographique française/Roger-Viollet – 22 • Ed **Van der Elsken:** © Ed Van der Elsken/ Nederlands Fotomuseum – 179 • Johan **Van der Keuken:** © Van der Lely - Van Zoetendaal – 175 • Léon Claude **Vénézia:** © Léon Claude Vénézia/ Roger-Viollet – 225, 276-277 • Paolo **Verzone:** © Paolo Verzone/Agence VU' – 375 • Horacio **Villalobos:** © Horacio Villalobos/Corbis via Getty Images – 356 • Raymond **Voinquel:** © Raymond Voinquel/Ministère de la Culture, France/ Diffusion RMN-Grand Palais – 173, 190-191 • Margaret **Watkins:** © Joe Mulholland, Glasgow, Écosse – 106-107 • Sabine **Weiss:** © Sabine Weiss/ Rapho – 144, 221 • Larry **Yust:** © Larry Yust – 388-389 • Patrick **Zachmann:** © Patrick Zachmann/Magnum Photos – 322 • George S. **Zimbel:** © George S. Zimbel/Getty Images – 176 (top) • Michael **Zumstein:** © Michael Zumstein/ Agence VU' – 312 •

SOURCE OF PHOTOGRAPHS

ADOC Photos: 229

Agence VU': 264, 265, 275, 301, 312, 342, 375, 396-397

AKG Images: 112-113, 168, 224

Bibliothèque de documentation internationale contemporaine, Nanterre, France: 53

Bibliothèque de l'Hôtel de Ville, Paris: 24, 29, 34-35, 37

Bibliothèque Forney, Paris: 121

Bibliothèque historique de la Ville de Paris: 43, 44, 45, 124, 188, 202, 254-255

Bibliothèque nationale de France, Département des estampes et de la photographie, Paris: 47, 74-75, 77, 81, 88-89, 137, 167

Centre Pompidou, musée national d'Art moderne, Paris: 84, 85, 96, 111, 117, 123, 134, 186-187

Cosmos: 390

Françoise Besson Gallery, Lyon, France: 326, 332

Gallery Stock: 238-239

Gamma-Rapho-Keystone: 91, 100-101, 102, 103, 126-127, 130, 144, 150, 151, 153, 160-161, 162, 163, 164, 169, 185, 194, 195, 196, 199, 200, 205, 210, 211, 214, 221, 230, 235, 242, 243, 246-247, 249, 250-251, 268, 290, 300, 306-307, 328, 330, 333, 345, 359, 366

Getty Images: 176 (top), 182, 197, 245, 272 (bottom), 280, 303, 356, 379

Gilles Caron Fondation, Geneva, Switzerland: 256, 257

The Hidden Lane Gallery, Glasgow, Scotland: 106-107

Jacques Henri Lartigue Donation, Paris: 172, 273

Julie Saul Gallery, New York, USA: 350-351

Los Angeles County Museum of Art, USA: 176 (bottom), 286, 311, 329

Magnum: 95, 159, 166, 180-181, 198, 240, 252, 266-267, 269, 270-271, 272 (top), 274, 279, 284, 296, 304, 305, 308-309, 310, 317, 320-321, 322, 324-325, 331, 334, 336, 354, 363, 372, 373, 380, 381, 392-393

Maria Austria Instituut, Amsterdam, The Netherlands: 174, 215

Médiathèque de l'architecture et du patrimoine, Charenton-le-Pont, France: 40-41, 87, 104, 105, 122, 140 (top left and right, and bottom left), 141, 173, 189, 190-191, 263

MPTV Images: 213

Musée Carnavalet, Paris: 22 (top), 42, 94, 97, 115, 313

Musée d'Art moderne de la Ville de Paris: 294, 295

Musée d'Orsay, Paris: 25

Musée Picasso, Paris: 79

Nathalie Obadia Gallery, Paris/Brussells: 335

Nederlands Fotomuseum, Rotterdam, The Netherlands: 179

Peter Blum Gallery, New York, USA: 370, 371

Picturetank: 374

Private Collection: 119

Private Collection, Paris: 19, 135, 157, 158, 165, 248, 259

RATP Photo Library, Paris: 22 (bottom), 26-27, 28, 30, 31, 33, 36, 38, 39, 49, 56, 57, 58, 59, 60, 61, 62-63, 64, 65, 66, 67, 68, 69, 70-71, 73, 78, 86, 90, 92, 93, 131, 132-133, 136, 147, 154, 155, 177, 226, 260-261, 262, 278, 289, 323, 348, 365

Rémy Collection, Paris: 109, 110, 116, 118, 125, 138, 140 (bottom right)

Rijksmuseum, Amsterdam, The Netherlands: 175

Roger Therond Collection: 184

Roger-Viollet: 14, 23, 50, 51, 52, 54, 55, 72, 76, 98, 99, 128, 129, 139, 148-149, 183, 207, 225, 258, 276-277, 285, 291, 315

Signatures: 297, 298, 344, 355, 357, 391

Tendance Floue: 292, 293, 299, 302, 316, 327, 337, 349, 358, 360, 361, 394, 395, 402-403

Thomas Collection, Paris: 253

VII Agency: 382-383

Works provided directly by the artist or their estate: 146, 171, 193, 201, 203, 204, 208-209, 216-217, 219, 231, 232-233, 236-237, 241, 318, 319, 339, 343, 347, 353, 362, 367, 368, 369, 376, 377, 384-385, 386, 387, 388-389, 398-399, 400, 401

SCIENTIFIC AND ICONOGRAPHIC DIRECTION:
Julien Faure-Conorton

ICONOGRAPHIC SEARCHES:
Marion Perceval

This book was produced at the initiative of the RATP,
which supports and promotes photography through its cultural policy.

ACKNOWLEDGMENTS

Julien Faure-Conorton wishes to thank: Émilie Bernard, Sylvain Besson,
Geoff Blackwell, Michel Frizot, Anne Jacquinot, Jean-Michel Leblanc, Isabelle-Cécile Le Mée,
Anne de Mondenard, Dr Michael Pritchard, Éric Rémy, Hans Rooseboom, Éléonore Thérond and Michel Thomas.

The publisher wishes to thank Charlotte Pascal-Heuzé for her contribution to the ideas for this book.